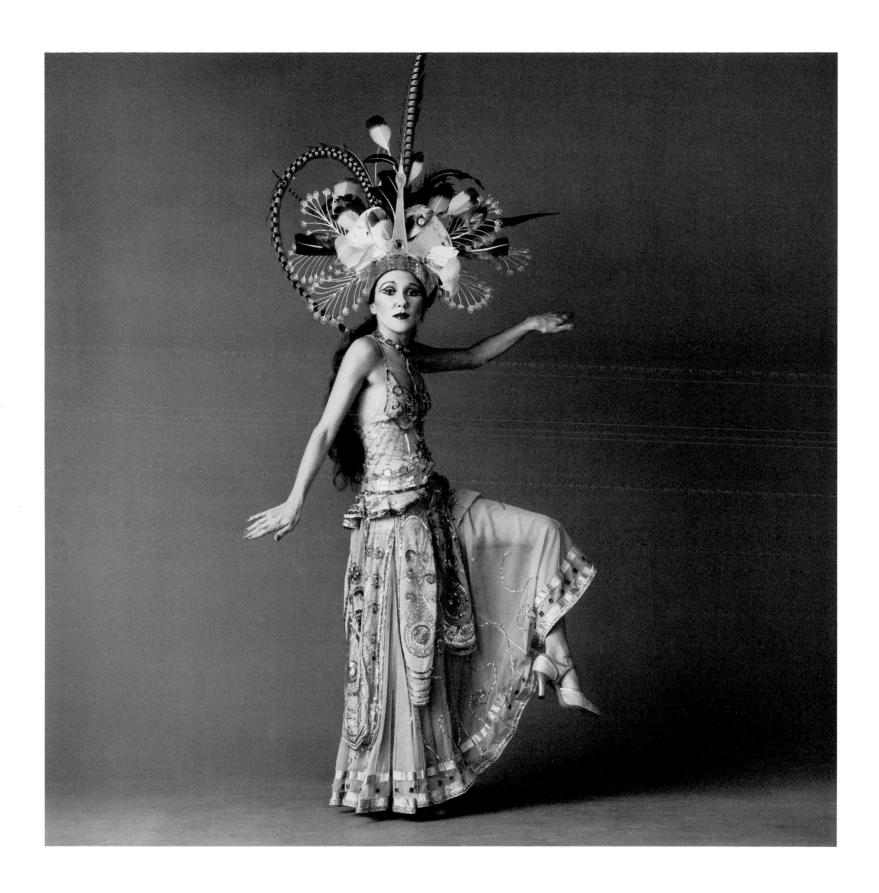

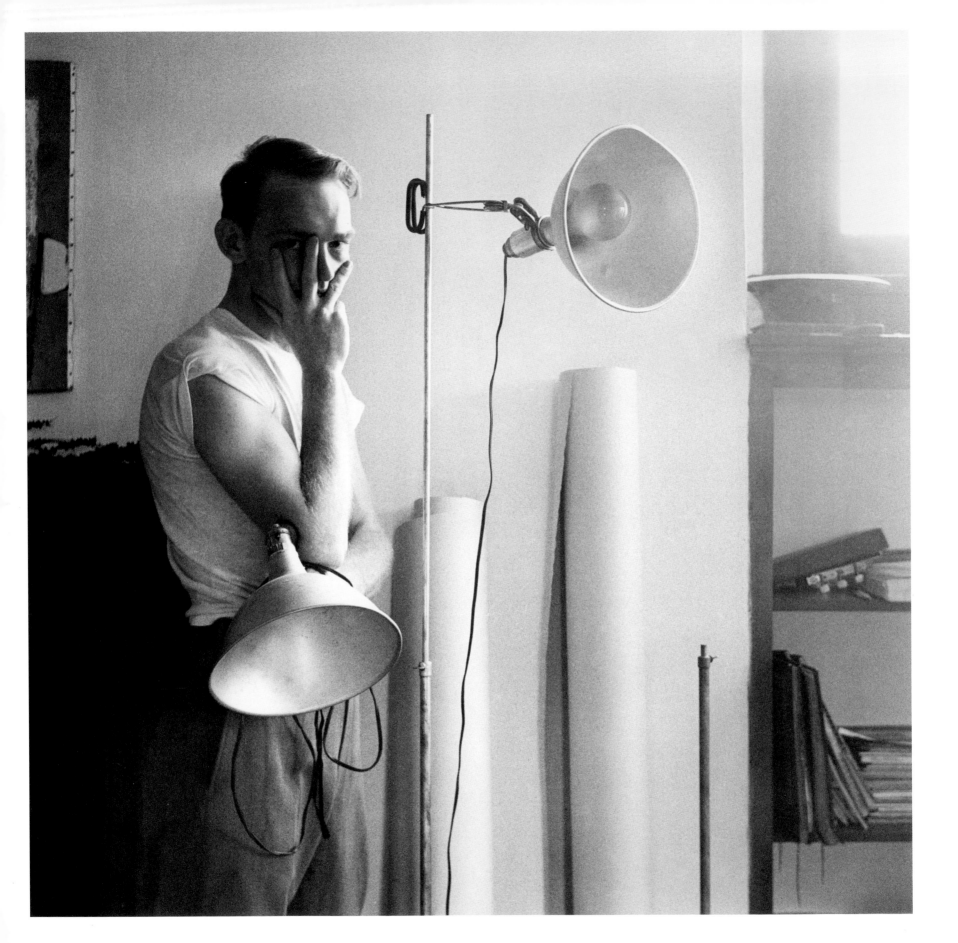

Jack Robinson
On Show
Portraits 1958-72

PALAZZO

First published in 2011 by
Palazzo Editions Ltd
2 Wood Street
Bath, BA1 2JQ
www.palazzoeditions.com

Consulting Editor: Percy Clarke
Designed by Mark Thomson Design
(Mark Thomson and Rob Payne)

All photographs were taken by Jack
Robinson, except for the photograph of
Jack Robinson himself on page 189
(photographer unknown) and the camera
image on page 190 (Gary Walpole, 2011).

Images on prelim pages:
p. 1 Susan Carlson, "Black-Eyed Susan",
as the High Priestess, 1970
p. 2 Jack Robinson, self-portrait,
New Orleans, early 1950s

Extensive quotes in Commentary section
from *Vogue* magazine features are used
courtesy of Condé Nast.

ISBN: 978-0-9564942-2-1

A CIP catalogue record for this book
is available from the British Library.

Printed and bound in Singapore by Imago.

Typeset in Farnham

10 9 8 7 6 5 4 3 2 1

Contents

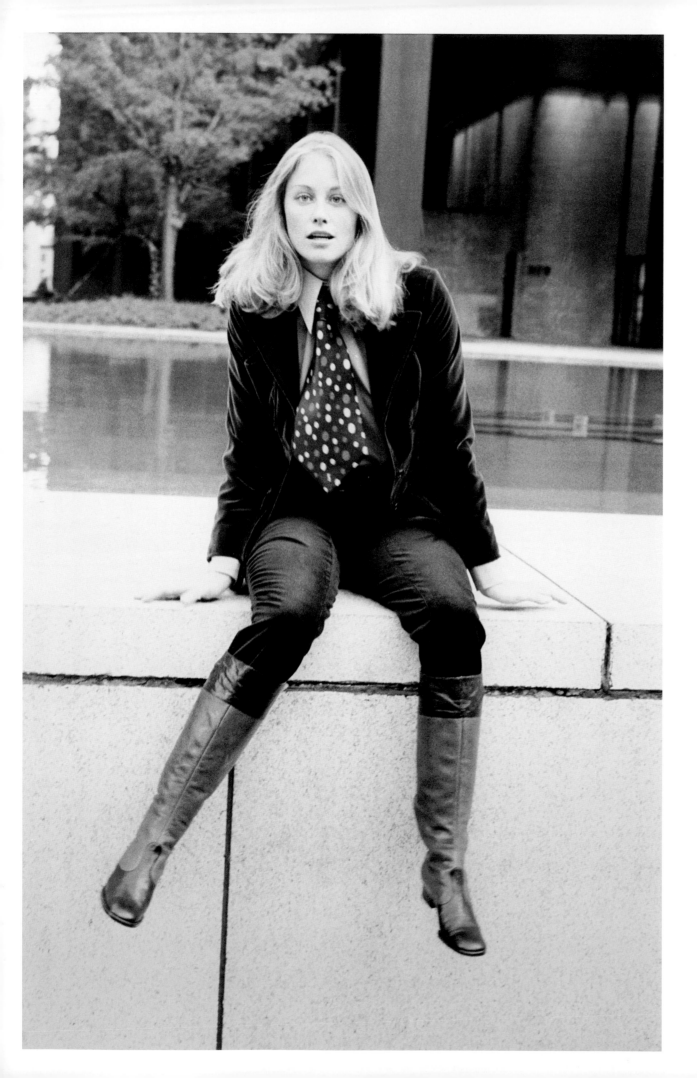

Cybill Shepherd, 1971

Foreword

When I look at these pictures, I remember that time in the 1970s and how many doors were opening for me. The two photos of me in this book were part of a session in October 1971, just one month after the premiere of my first film, *The Last Picture Show*. The photo that appears later in the book reminds me of not only how thrilling that time was, but how joyful it was to open that door and see Jack. My expression in the photo on the opposite page is one of true amazement. Actually, I was amazed that I was able to climb up on that high wall with no assistance ... and that I managed not to fall off. These boots were made for climbing!

Jack and I were both from Memphis, the capital of the Mississippi Delta, home to Elvis, Faulkner, B.B. King, and so many other artists. It was the hub of creativity. Jack and I not only shared the Memphis connection, but a very strong music connection. His beautiful hands photographed all the stunning portraits in this book and many more, and I knew from the start that I was in the best of hands.

The Mississippi River and the Delta get in your blood at an early age. They infuse those who are open to them with a sense of grounding that can carry one through a trying life. They can give you the blues and take you to the highest highs. They introduce you to all people on a common ground. They did that for me and I would suspect they did that for Jack, too. Here's why I believe that:

Being photographed is a highly intimate exchange of emotions and feelings. It's a marriage of sorts—if only for those brief moments. What happens in those moments are feelings captured forever. The photographer looks through his or her eyes and looks into yours with focus and a yearning to make art. And even though there's a machine between you—it doesn't exist because you are one when you are photographed. And, it's a dance, a seduction and an indelibly moving series of moments—ecstatic, lovely, sexy, fun, and memorable. As a person, Jack had all of those qualities and brought them out in me, too.

As a young girl, I knew that I had to leave Memphis in order to survive. I never intended to follow in the traditional mold. I wanted more out of life and my instincts led me to New York. Jack mirrored those instincts and took the same path.

I look at these photos of some acquaintances, some friends, and some I don't know and I feel closer to them than I ever imagined ... all thanks to dear Jack. Jack Robinson, a man with whom I will be connected always—always in my heart.

Cybill Shepherd

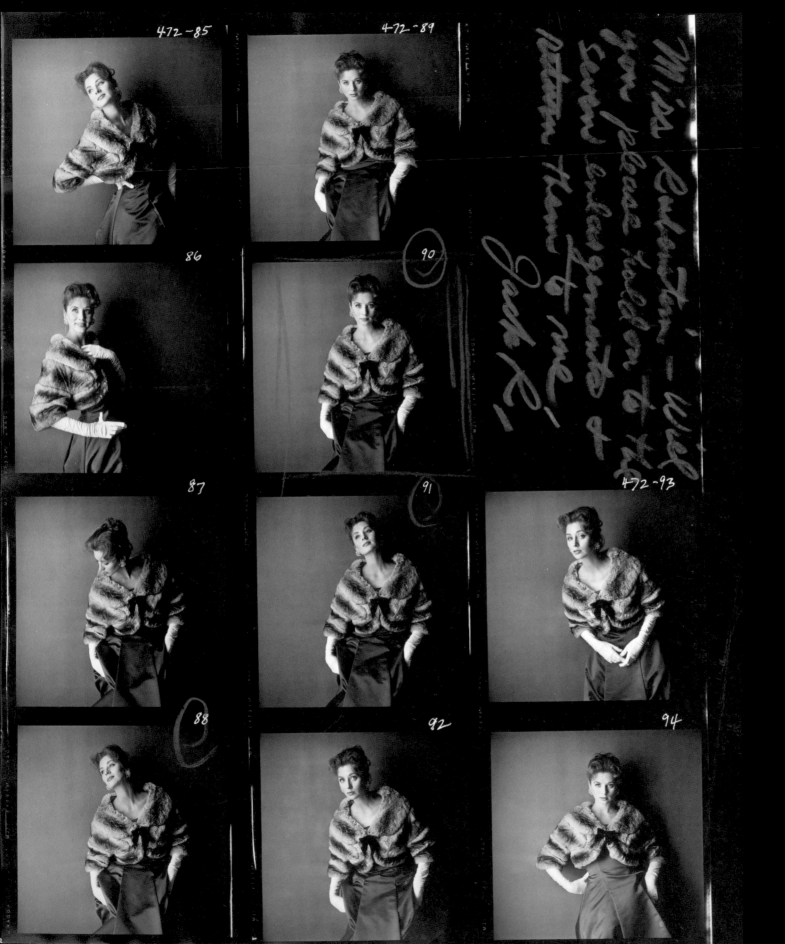

Introduction

For an ambitious photographer, a regular place in the pages of *Vogue* would seem a most desirable attainment, especially in the latter half of the 1960s when photographers of such renown as Richard Avedon, Irving Penn, and Norman Parkinson could be counted on as contemporaries. For Jack Robinson, that aspiration was realized, and in his time he was able to view through his lens the foremost names in arts and letters, the actors, musicians, writers, and directors who were also advancing their artistry, and an appearance in *Vogue* was an appropriate endorsement of success.

His time as a professional photographer was relatively brief, a mere seventeen years, and only in the last half dozen of them was he connected with *Vogue*. He was to spend far more years as a stained-glass designer in Memphis, Tennessee, an entirely separate career path that came into existence after the complete abandonment of his New York life. Few of those who knew him in that post-metropolitan period were even aware that he had once been integral to the glamorous milieu of fashion, and had photographed many of the most famous names in the western world. In Memphis he was reticent, remote, and unassuming, a small, lean man with an eccentric habit of wearing shoes much larger than the size his feet required, and given to occasional bouts of irascibility.

Why did Jack Robinson, having so successfully reached such heights in his profession, then give it all up and disappear entirely? How could he flee the excitement of New York to spend the rest of his life, another twenty-five years, pursuing an entirely different career in a southern city far away from Manhattan?

He was 69 when he died on December 15, 1997, in the Methodist Central Hospital in Memphis. He had been admitted a month earlier after telling his physician that he was suffering severe abdominal pain. It turned out he was in the late stages of pancreatic cancer. After his death there were no relations to claim the body or make funeral arrangements. Eventually a pastor at the hospital telephoned Dan Oppenheimer, the owner of the Rainbow Stained Glass Studio. His was the contact name Jack had given on his hospital admission form. For many years Jack had worked alongside him, and the two men had developed something of a friendship. It was not without difficulty. Jack was a dedicated loner. He made a point of never inviting anyone to his apartment, and rarely referred to his past life. Only Oppenheimer was aware that there had once been a photographic career in New York, but he knew little more.

It fell to Oppenheimer to take care of Jack's affairs, and it turned out that he had been made

Jack Robinson's stained-glass window design,
St. Jude's Children's Research Hospital, Memphis

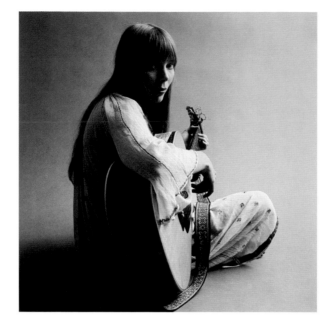

Joni Mitchell, 1968

the sole beneficiary of his will. His first visit to Jack's small apartment in an elegant building in mid-town Memphis was a revelation. It was strangely ordered and tidy, as shipshape as the quarters of a Marine master sergeant. The cutlery, plates, and dishes were sufficient for only one person, with not so much as a second cup to offer a visitor a coffee. Oppenheimer recalled: "It was the most organized and neat studio apartment I have ever seen. Everything was in order, lined up according to size, shape, color, and utility. Even the buttons in his sewing drawer were lined up by size. All white of course, because all his shirts were white tailored dress shirts, either from The Custom Shop in New York or Alfred's, the now defunct men's clothier in Memphis."

It was only after Jack's death that Oppenheimer finally realized that Jack was gay. In all the years that they had worked together, the question of Jack's sexual orientation had never arisen. Traditionally, more chivalrous southerners are reluctant to pry into personal matters, and he had always assumed Jack to be asexual, noting that he seemed little interested in developing intimate relationships. "He tended to close doors on people for reasons I don't think I ever knew," said Oppenheimer. However, his friend had known that there had been an involvement with

Alcoholics Anonymous and that Jack had made a point of carefully avoiding liquor. From this he had inferred that in a buried past were the reasons why he avoided close contacts.

The biggest surprise during the inspection of the apartment occurred when Oppenheimer opened the main storage closet. It was stuffed with cardboard bankers' boxes, each filled to the brim. In them were prints, negatives, contact sheets, appointment books, and back numbers of *Vogue*, together with mounted portraits, letters, and memos, the distillation of the photographic career that had ended twenty-five years earlier. In total some 150,000 images had been hidden away for decades. As Oppenheimer sifted through them, he discovered that Jack had captured the essence of an extraordinarily creative era in music, the performing arts, and literature. The Summer of Love, Woodstock, the British rock invasion, folk rock, the acid generation, all were caught and preserved, not in performance, but in subtle, sensitive portraiture of its leading exponents. The entire collection had been bequeathed to Oppenheimer in the trusting expectation that he would ensure its survival for posterity. Accordingly, he would go on to devote many years to realizing his wishes, and today the remarkable Jack Robinson Archive is at the heart of the

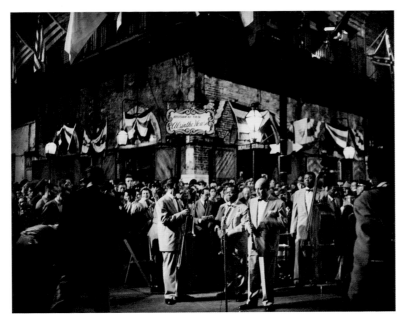

Louis Armstrong, The Absinthe House, New Orleans, early 1950s

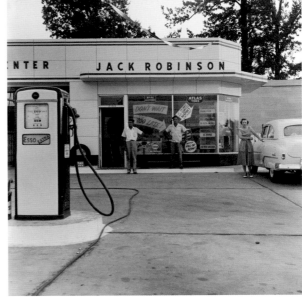

Jack Robinson's father's service station, Memphis, date unknown

Robinson Gallery of Photography on South Front Street, Memphis.

Jack was born on September 18, 1928, near Meridian, Mississippi. His father, Jack Robinson Senior, at the time made his living selling farm implements for International Harvester. Young Jack was the second son, and his mother, Euline Jones Robinson, seems to have been the strongest influence in his early life. His early childhood and adolescence was spent in Clarksdale, Mississippi, and he attended high school there, graduating in 1946. He was regarded by his fellow students as shy and distanced from the social life, with no interest in sports but having a developing talent for drawing and painting. While at high school he also became interested in photography.

Clarksdale is home of the crossroads of the blues and rock 'n' roll, and played an important role in Jack's music appreciation. His record collection contained Broadway show tunes, opera, classical music, rock 'n' roll and a disproportionate amount of blues, and rhythm and blues. He went on to Tulane University, New Orleans, taking a pre-med course with the intention of eventually becoming a doctor. In New Orleans he got a job at an advertising agency designing ads. He was an accomplished graphics artist and photography was his side passion and hobby. Lee Bailey

(1926–2003), an author, artist and designer, who later became a regular contributor to *The New York Times* and contributing editor of *Food and Wine* magazine, was his confidant and promoter in those days and was in no small part responsible for promoting Jack as a portrait photographer to the city's social elite of the day.

New Orleans in the proto-beatnik era of the late 1940s had an intensely energetic artistic community centered on the French quarter. In the era of Tennessee Williams, Dixie's Bar of Music on Bourbon Street was a hangout for artists, writers, and musicians, and the focus of a flourishing gay scene that would have been stifled by the law in almost every other American city. In the easy-going, raffish haze of New Orleans, Jack began his professional photographic career, his reportage of nightlife and Mardi Gras subsidized by commissioned portraits of social notables.

After several years of mingling with artists and musicians, he embarked on a trip to Mexico in the company of some friends, including Betty Parsons, a prominent New York art dealer who was known as "the den mother of abstract impressionism". Her West 57th Street gallery had shown Pollock, Rothko, Rauschenberg, and others. Parsons, an encourager of talent, urged

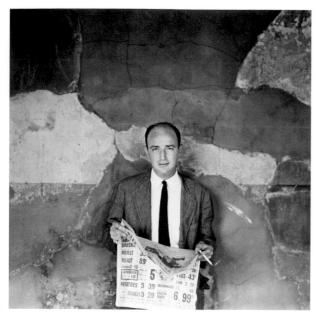

Lee Bailey, early 1950s

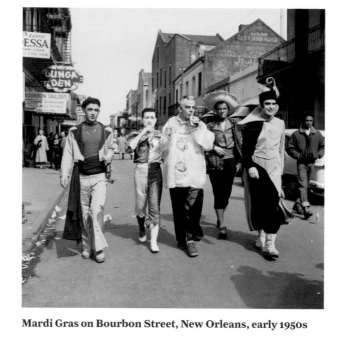

Mardi Gras on Bourbon Street, New Orleans, early 1950s

the twenty-six-year-old Jack to forsake the bohemian south and move to New York and, with a few well-chosen introductions, attempt a plunge into fashion photography there. Her assistance provided the necessary lift-off, and his talent was soon recognized by the business, with lucrative advertising commissions (for which, with Seymour Chwast and Milton Glazer at Push Pin Studios, he would later win awards) as well as fashion reportage allowing him to gain a foothold in a highly competitive field. Carrie Donovan, who in late life became a national figure on the strength of her appearances in Old Navy commercials, and then an influential fashion writer at *The New York Times*, took a shine to him, and they worked together on many stories, occasionally traveling to Europe to report on the fashion scene. Through other connections, he achieved a cover for *Life* in 1959, a photograph of the elegant model Isabella Albonico wearing an elaborate choker for a fashion special.

In 1965 Donovan joined the staff of *Vogue*, then under the editorship of the doyenne of the fashion world, Diana Vreeland. Born in Paris in 1903, raised in New York by her American socialite mother and well-connected British father, Vreeland had for over thirty years reigned supreme as the fashion editor of *Harper's Bazaar*,

creating an entirely new aesthetic for fashion photography in which the clothes were imaginatively contextualized by brilliant art direction. She defined fashion as youth, flamboyance, and fantasy, and extended its appeal across the social spectrum. One of her most celebrated coups had occurred in 1943 when she had selected a nineteen-year-old New York model and dressed her simply for a *Harper's* cover. The subsequent image won the girl an immediate summons to Hollywood and a contract to star in a new film opposite Humphrey Bogart—it was the transformation of Betty Joan Perske into Lauren Bacall.

Vreeland achieved immortality of a sort in a 1957 Hollywood musical. In *Funny Face*, Fred Astaire played a photographer modeled on Richard Avedon and Kay Thompson was an autocratic fashion editor clearly inspired by the Vreeland persona. When she decrees "think pink" it seems as if the entire planet suddenly erupts in vivid hues of fuchsia.

Sam Newhouse bought Condé Nast, publishers of *Vogue*, in 1959, and in 1962 Vreeland was appointed editor-in-chief, taking up her post at the beginning of the following year. *Vogue* was the ultimate bi-weekly fashion magazine, a faithful arbiter of taste and mirror of its time. Its authority

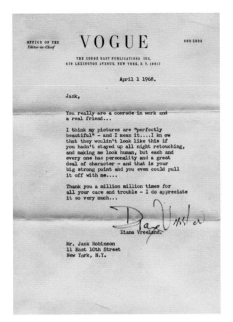

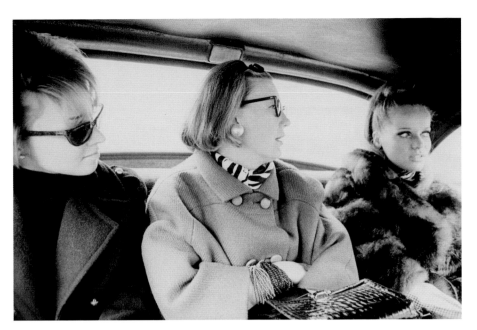

Diana Vreeland's letter to Jack Robinson, April 1, 1968

Vogue style editor Carrie Donovan (center) and model Veruschka (right), *c.*1966

was unquestioned and Vreeland assumed the most powerful position in decreeing what should be worn. Allegedly she had once pulverized her art department by brandishing the layout of a double-page spread with a nude model lying face down on a beach, a hat resting on her buttocks, and the headline "Spend the summer under a big black sailor".

The 1960s were a perfect time for her, an explosive age of transition when fashion flourished alongside art, music, literature, media, and social mores in the sudden and intensive exploration of fresh possibilities. The new jet age of travel had brought the entire world within a few hours' reach, and budgets expanded to meet the demands of ever more extravagant imaginations and locations. The star photographers of the time included Irving Penn, Richard Avedon, Norman Parkinson, David Bailey and, following Carrie Donovan's introduction of him to the magazine, Jack Robinson. Because Vreeland had so successfully plugged into the *zeitgeist*, *Vogue* was a principal style-setter, promoting its favorites, be they Warhol or Dylan, Lauren Hutton or Veruschka, and providing a media platform where Joni Mitchell and Leonard Cohen could mingle with Jacqueline du Pré and Daniel Barenboim.

Jack worked hard for *Vogue*, establishing

a particular niche on account of his easy access to celebrities. In contrast with his later life, he seems to have been a gregarious member of the trendsetting elite. He contributed with regularity to the "People Are Talking About" section, a particular pet of Vreeland's where her finger anointed the up-and-coming figures expected to storm the heights of fame, a process that would be significantly assisted by *Vogue*'s approval. He also shot a great deal of fashion, much of it for another regular feature, "*Vogue*'s Own Boutique", in which, under Carrie Donovan's direction, celebrities disported themselves in carefully chosen clothes and were shot spontaneously on the street or in various boutiques across town. While models knew how to deliver in such circumstances, movie stars and untrained socialites required harder work. Vreeland was highly appreciative of his talent. "You really are a comrade in work and a real friend," she wrote to him after he had photographed her. "I think my pictures are 'perfectly beautiful' and I mean it," she continued, and paid tribute to his skill in reaching for the character, even pulling it off with her. "Thank you a million, million times."

His skill as a portraitist attracted many renowned sitters. Not all of them posed for *Vogue*. Gloria Vanderbilt's family commissioned him

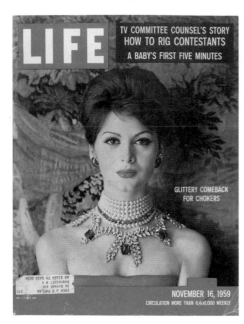

Jack Robinson's photograph of Isabella Albonico on the cover of *Life*, published November, 1959

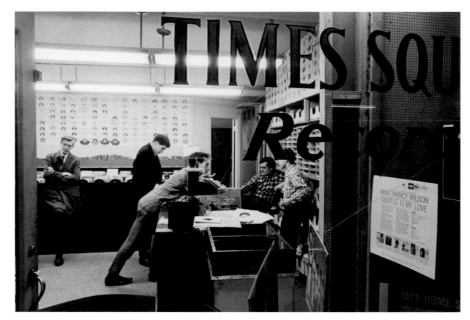

Times Square Records, New York City, early 1960s

privately. He is known to have photographed Berry Berenson for Revlon's first "Charlie" campaign. His address books were crammed with personal numbers of the famous. Photographers who are "in" enjoy attention not so much for whatever charm they may possess as for their ability to make their subjects look good. Jack seemed to strike the right notes with those he photographed, but at times could be singularly charmless to others. He was known to berate underperforming assistants rudely in front of sitters, or suddenly to fall out with loyal friends and disappear into a private world. It could be that drugs were having an effect.

He began as a pot-smoker but was very likely exposed to harder stuff, which was readily available in that era. Starting in 1966, he became acquainted with the extravagantly eccentric Andy Warhol circle of hip high life, centered on the Factory, the infamous 47th Street studio, with its aluminum-foil-covered walls and a constant rotation of bohemian figures, the Warhol superstars. Later there would be more parties, wild weekends on Fire Island. Paradoxically, it was a transition from marijuana to Scotch that really began Jack's fall. Dan Oppenheimer has observed from the preserved appointments books how his handwriting began to deteriorate, as though synapses were starting to malfunction.

In journalism, as in life, all things must come to an end, and in 1971 Vreeland was suddenly fired from *Vogue*, after having defiantly ignored the prescient warnings from Carrie Donovan that she was in danger. It was a decision made by the Condé Nast business administration, concerned that her extravagant style was not being countered by increasing advertising revenue, and a fear that she was no longer the cynosure of the age. Here was a convincing marker that the 1960s were finally over, and for many the 1970s would be its hangover time. Vreeland was succeeded by her assistant, Grace Mirabella, and a new, more down-to-earth era began, with US *Vogue* becoming a monthly. Mirabella would reign for another seventeen years when, after tripling the circulation, she also was dismissed, and replaced by Anna Wintour.

Not long after Vreeland's departure, Jack entered a crisis induced by his chaotic lifestyle. His drinking seriously affected his work and his assignments trickled away. Beset by financial problems, he first sold his Steinway, a treasured possession, and then relinquished his studio, which was on a fashionable block of East 10th Street in Greenwich Village. It was as 1972 concluded that he turned his back on New York and returned to his southern roots, broken, bitter, and alcohol dependent.

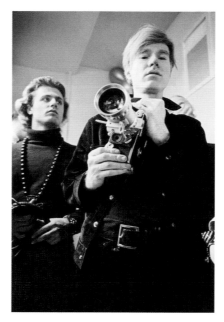

Andy Warhol and Gerard Melanga, 1966 **Jack Robinson, self-portrait, 1960s**

He settled in Memphis, to be close to his mother who was dying, and even though he lived in poor accommodation, he still found the resources to feed his addiction. Gradually, however, he sobered up. Having already dabbled with Alcoholics Anonymous in New York, he enrolled in a program at the instigation of a friend. He moved into a better apartment and resumed painting. Eventually he ceased to drink and took a job as design assistant to the artist Dorothy Sturm at Laukhuff Stained Glass.

Memphis sits on a bluff of the Mississippi River looking across to Arkansas and is Tennessee's biggest city, in its day a great cotton trading port and lumber center. Its world fame today derives largely from its music culture, as the launchpad of Elvis Presley, Johnny Cash, Jerry Lee Lewis, Otis Redding, B.B. King, and scores of other illustrious names in rock, blues, gospel, and sharecropper country. It is a city celebrated in literature by many authors, among them William Faulkner, Shelby Foote, Thomas Harris, and John Grisham. Tourist attractions include Elvis's Graceland, Sun Studios, and Beale Street—"the home of the blues" and the twice-daily ritual at the art-deco Peabody Hotel in which a small platoon of ducks waddle to and from the lobby fountain. Memphis is also where Dr. Martin Luther King, Jr. was assassinated in 1968.

The Lorraine Motel where it happened is now the National Civil Rights Museum.

Jack applied himself to the decorative arts medium of stained glass with enthusiasm and, when he met Dan Oppenheimer of Rainbow, his reputation in the business was well known. For a while, he quietly freelanced for Oppenheimer's company before leaving Laukhuff to work with him full time. They both developed improved ways of glass etching, using photography. Some of Rainbow's contracts were impressive. It was from Memphis that the Holiday Inn hotel chain began, and Oppenheimer won contracts for many of their restaurants, along with the first franchised T.G.I. Fridays, an extravaganza of stained glass. A major commission came as a result of the photographic etching process that had evolved from a technique Jack had worked on with Oppenheimer. This method was used by a Memphis glass company to carve the 55,000 names in the Vietnam Veterans Memorial in Washington, D.C. Jack's love of the darkroom and experiments was one of the main reasons he had sought out Oppenheimer. His last big collaboration was a series of windows reflecting Christianity, Judaism, and Islam for the Danny Thomas memorial pavilion at St. Jude's Children's Research Hospital, the dome of which is a prominent Memphis

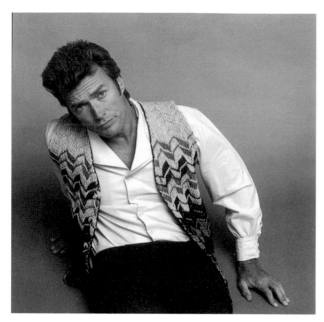

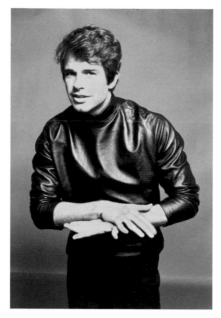

Clint Eastwood, 1969

Warren Beatty, 1967

landmark. It was a project won with Jack's design, following an international design competition. Jack detailed all of the portraits and other painted areas and Susan Reuter did the actual glass painting. The two of them had a falling out and it was at this time that Jack was banished from the studio to work from home. He spent the last two years of his life creating exquisite designs that now attract visitors from all over the world, and Oppenheimer feels that even recent works completed owe much to the inspiration Jack brought to the studio. In the latter stages of his creation, he made the will in which he left everything to Oppenheimer.

The legacy was an extraordinary archive, and Jack's photographs provide an intriguing view of the celebrated figures of the time, positioned invariably in the simplest of settings, and plain background. Usually he wanted his sitters to provide all from within, to project their personality without him defining a context to help them along. It is a technique in complete contrast to the careful portraiture of portraitists such as Arnold Newman, who would usually insert their subjects into an appropriate setting, so making a specific editorial statement. Jack's more austere approach was by no means unique, and was a style frequently employed by Richard Avedon, Irving Penn, and others.

His studio shoots were relatively relaxed. He had an easy way of connecting with his subjects, so that they loosened up until he had the result he was seeking. He used a Hasselblad and 120 film in the studio, expecting to shoot his way through half-a-dozen 12-exposure backs, and from about eighty exposures he would select two or three for the art director. He did not shoot Polaroids first to check lighting and poses but preferred to work instinctively. He prided himself on his knowledge of his equipment and did not bracket his shots by varying the exposure. An examination of his contact sheets shows continuously evolving expressions and movements. When he shot material for the "*Vogue*'s Own Boutique" feature he used 35mm, usually one of his Leicas or a Nikon. He would sometimes resort to flash, but generally preferred the available light, which from time to time would be poor. Nevertheless, he would carry on shooting his unposed subject, aware that he would later have to push the negative in the dark room, using an enhancer such as the highly toxic Victors Mercury Intensifier.

He did not crop much, judging by the few marks made with his red grease pencil on his contact sheets. His compositions were usually created in the viewfinder. Most of his shots are direct, unfussy, and very rarely furnished with

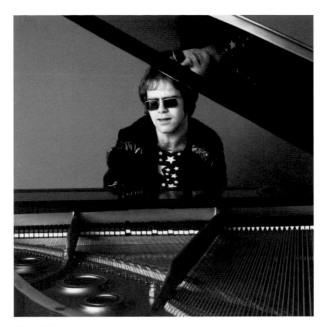

Elton John, 1970

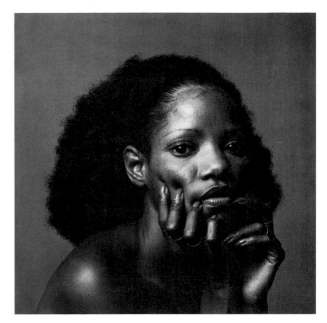

Melba Moore, 1971

props, the exceptions often being instruments—Elton John's piano, Joni Mitchell's guitar.

There is an explorative sensitivity in his work, which could be a consequence of his sexuality. Some of his portraits are remarkable in that, with even the most macho of men, a trace of the feminine side of their psyche seems to emerge. Warren Beatty, then the most celebrated of Hollywood womanizers, becomes in black leathers a gay icon, and when revealed donning his neckwear, a narcissistic fop. Has anyone else ever thought of disporting Clint Eastwood in knitwear? Or having Michael Caine strike a camp pose with one elbow on a mantelpiece?

His women on the other hand, even when he goes in close, are more distanced, sometimes even sculptural in form, as in the case of Melba Moore, or Tina Turner and her Medusa mane, and the simple elegant profile of Julie Harris. Occasionally he departs from the plain, uncluttered approach and deposits or, more realistically, finds his subject in a confused setting—Diana Vreeland's office, Lauren Bacall's drawing room, for instance—but the location is so personal that it is simply an extension of their essence. His studio portraiture is superior to his reportage because he is able to control the myriad factors that make a good

photograph. Yet his lighting technique is straightforward, with key, fill, and back lights deployed in most cases in the standard manner. He does not allow dramatic effects to subvert the impression given by his sitter, which is why his pictures so many years later retain their fresh appeal.

It is his sense of composition, often the quality that defines an excellent from an average photographer, that places him in the foremost rank. A portraitist requires much more than technical skills. Essential is the ability to bond with his sitters. For Jack to acquire his desired results, he needed to establish a relaxed and comfortable rapport with them. He may well have sensed that this ability was beginning to elude him, until he was forced to turn his back on the brief career that for a few years had flourished. He is not the only artist to have quit completely. That he was able subsequently to pursue an entirely different creative occupation that owed little or nothing to his former one was a considerable achievement. Fortunately, his important photographic legacy has been satisfactorily preserved, making it possible to continue savoring his precise glimpses of moments in time.

George Perry

17

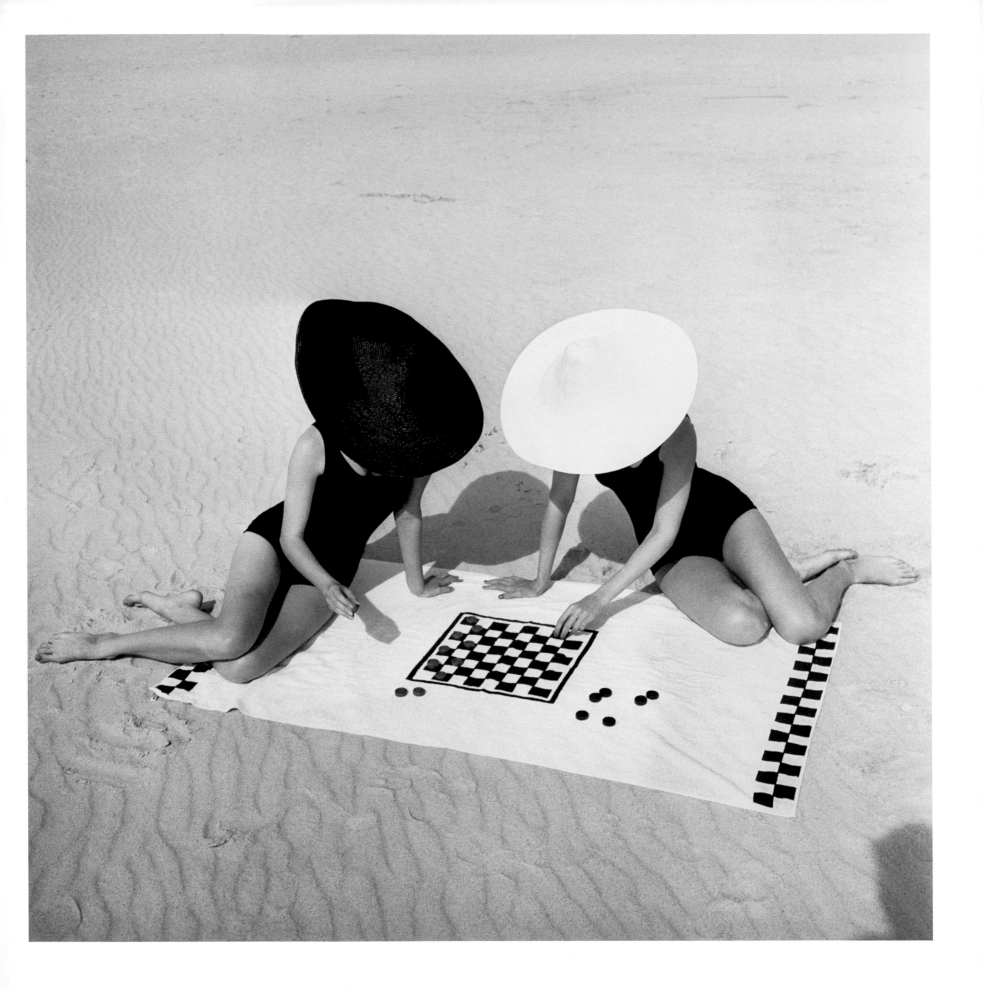

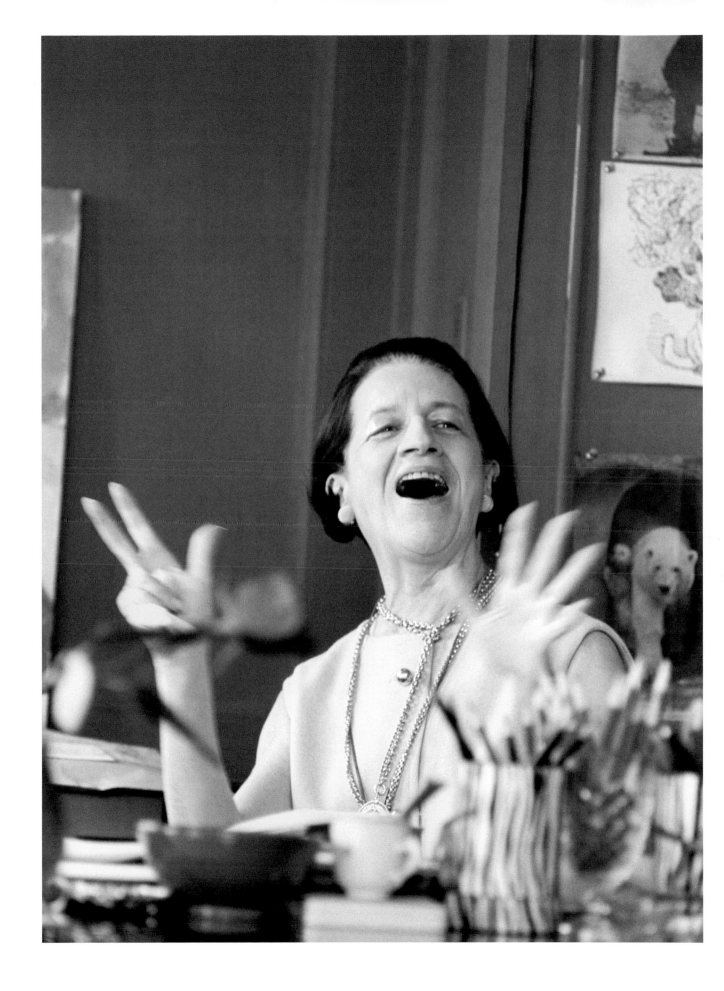

19 Diana Vreeland

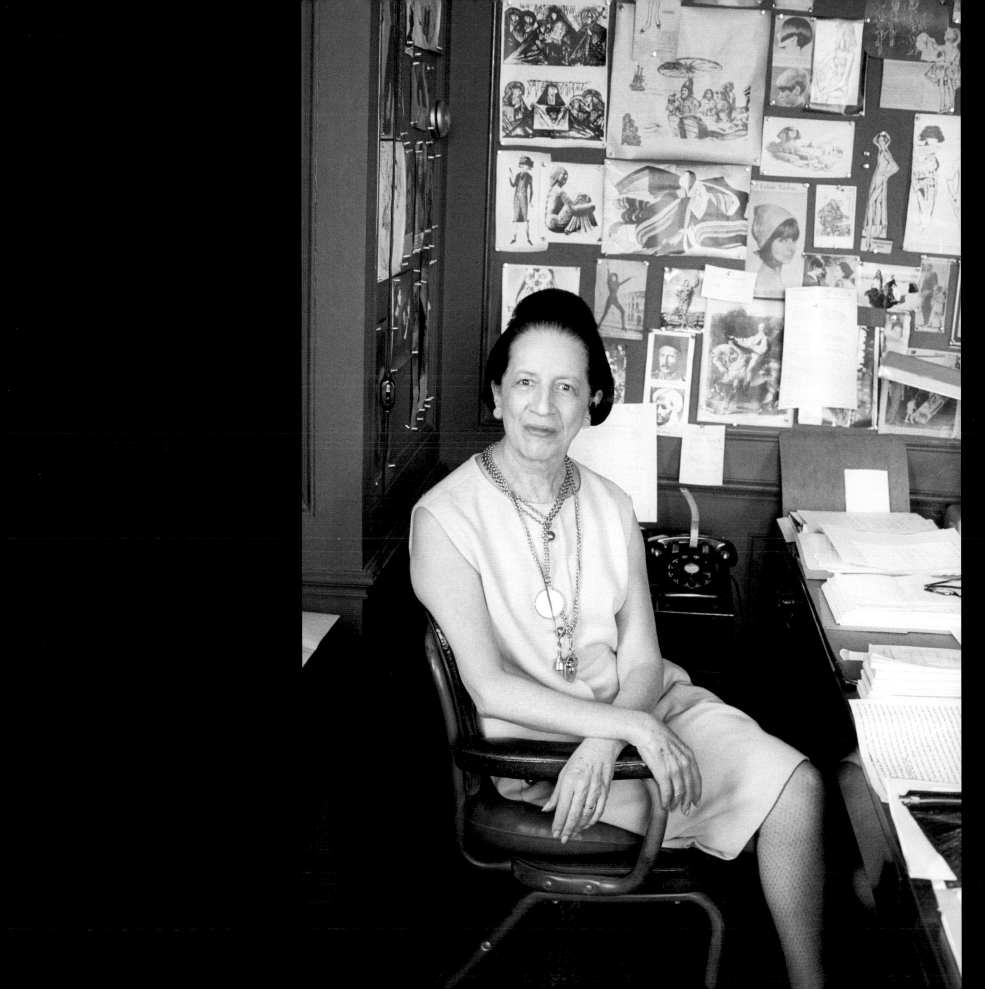

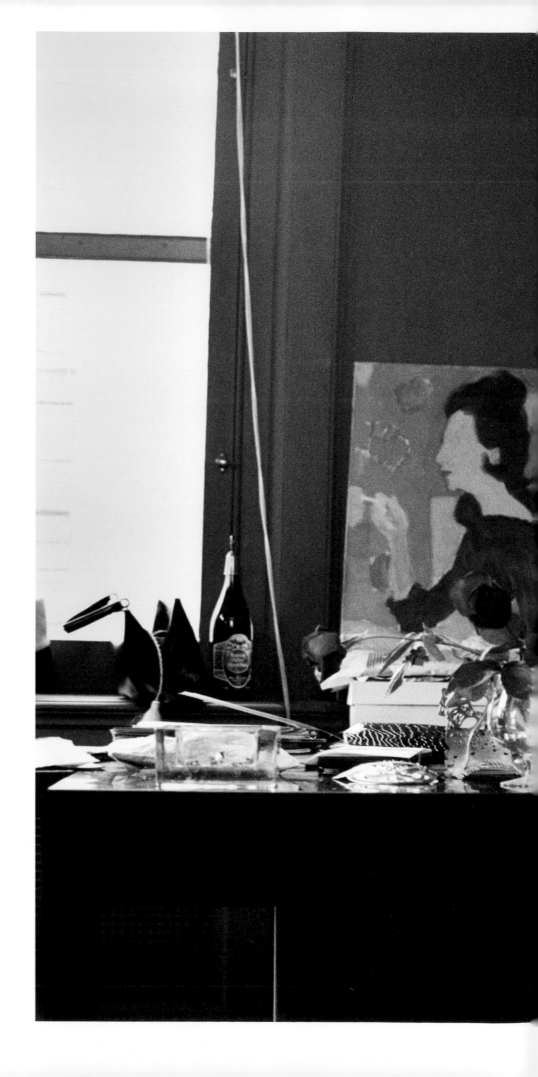

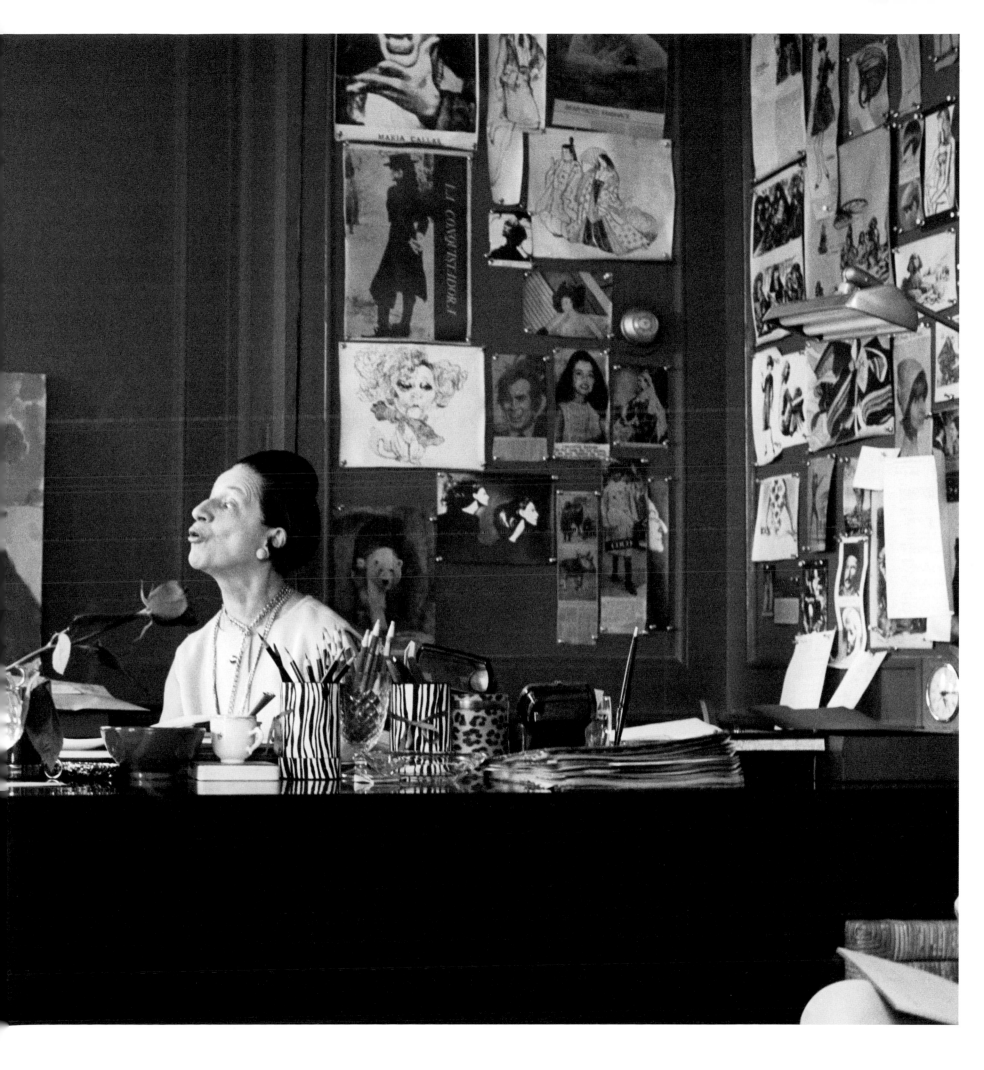

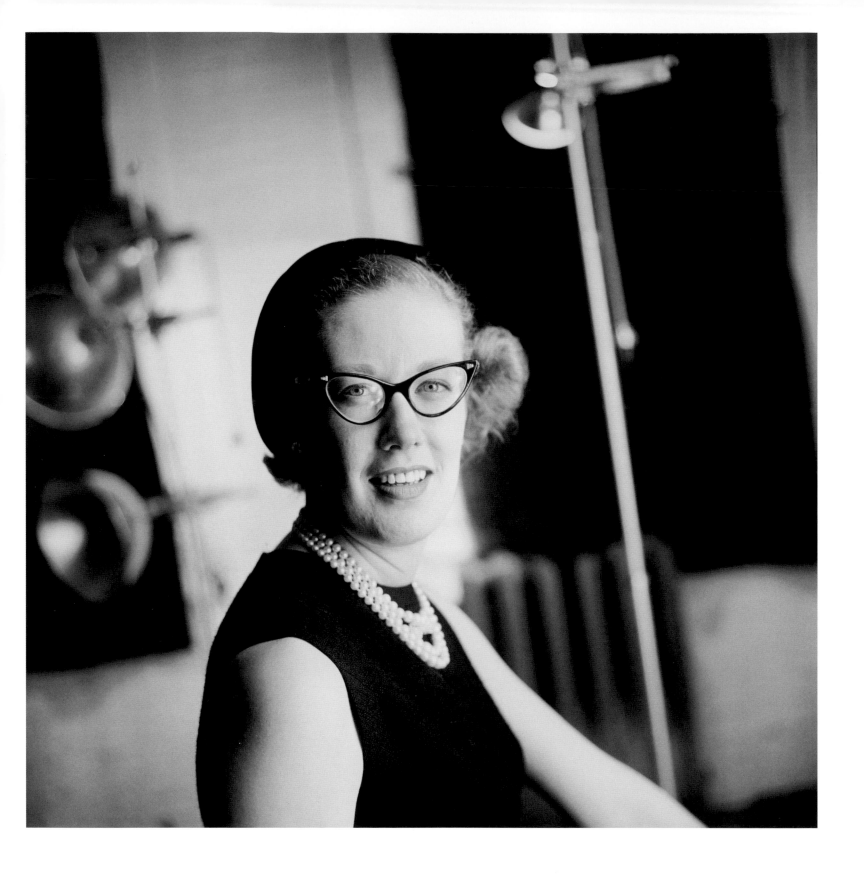

24 Carrie Donovan

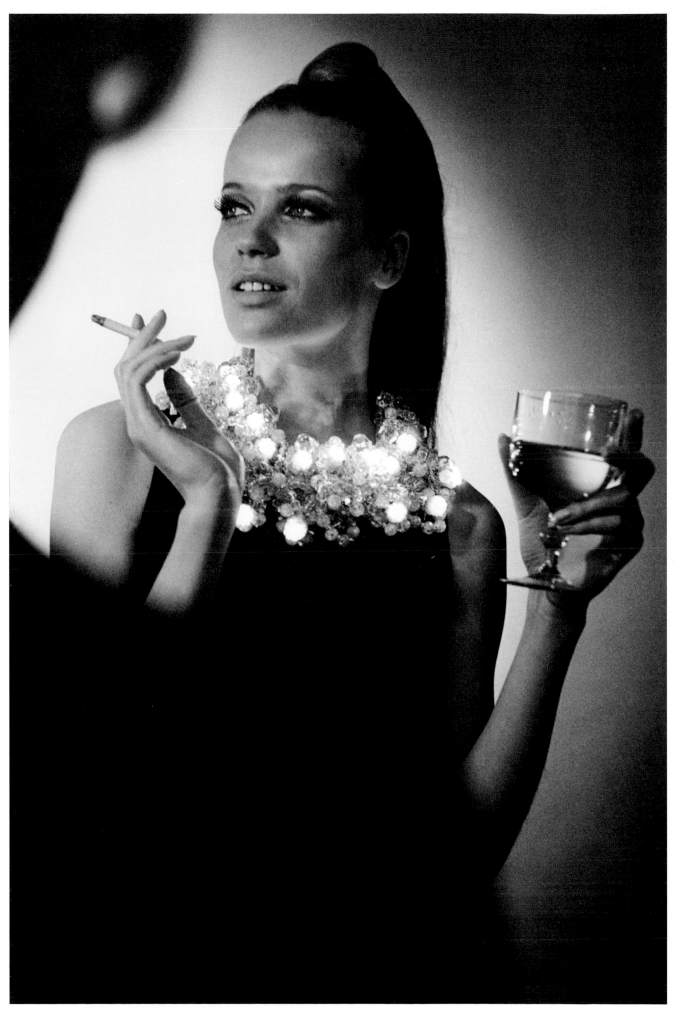

25 Vera Gräfin von Lehndorff-Steinort ("Veruschka")

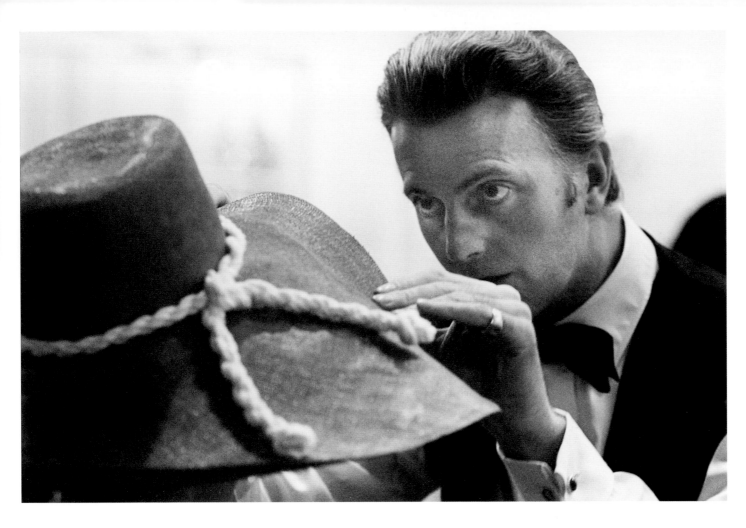

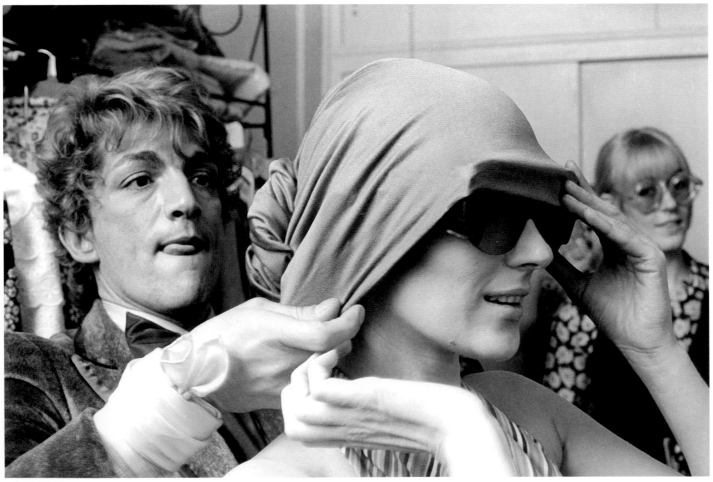

26 Above: Hubert de Givenchy Below: Giorgio di Sant' Angelo

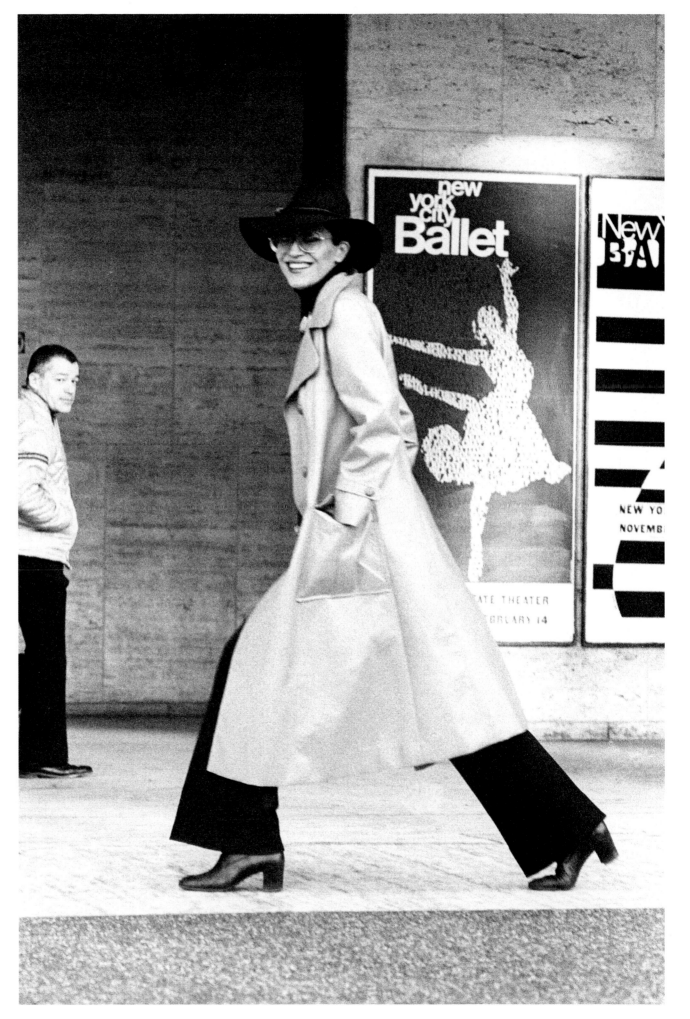

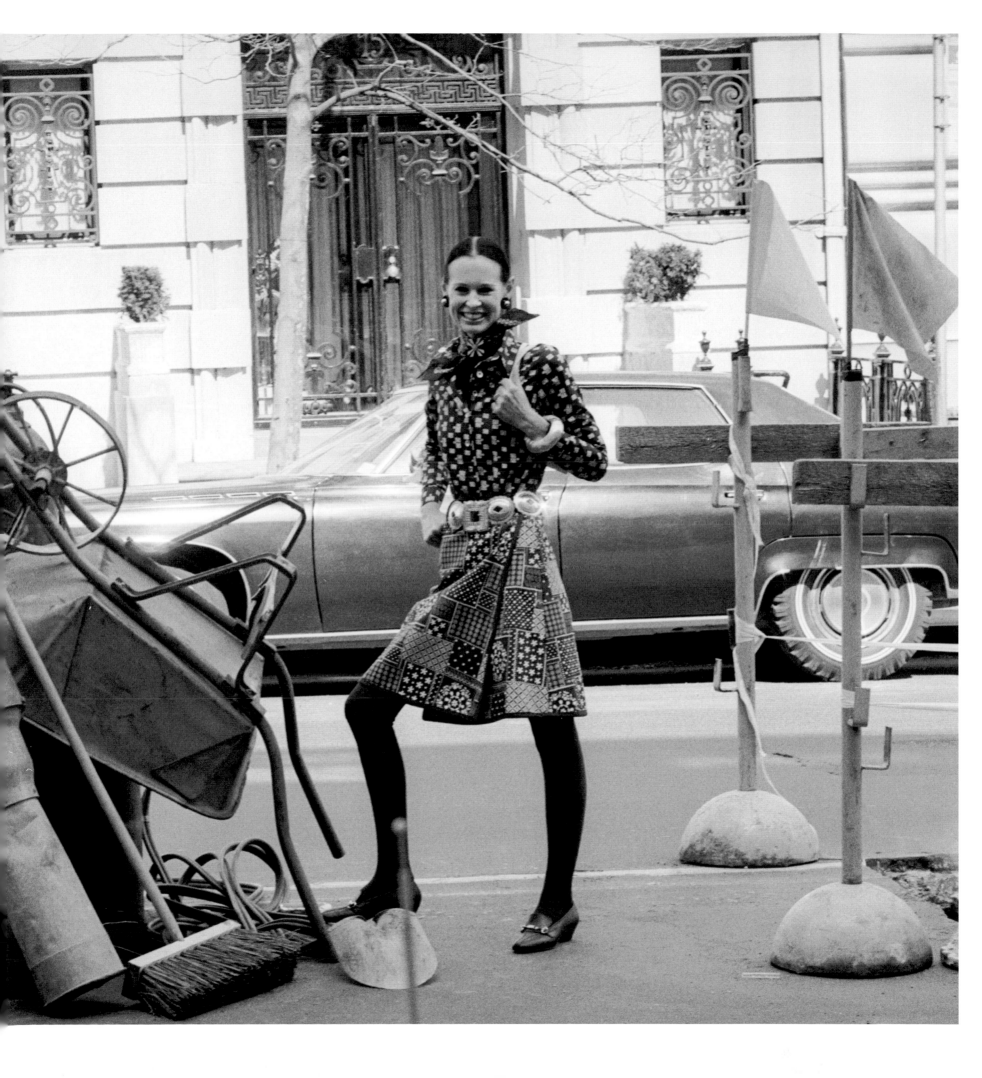

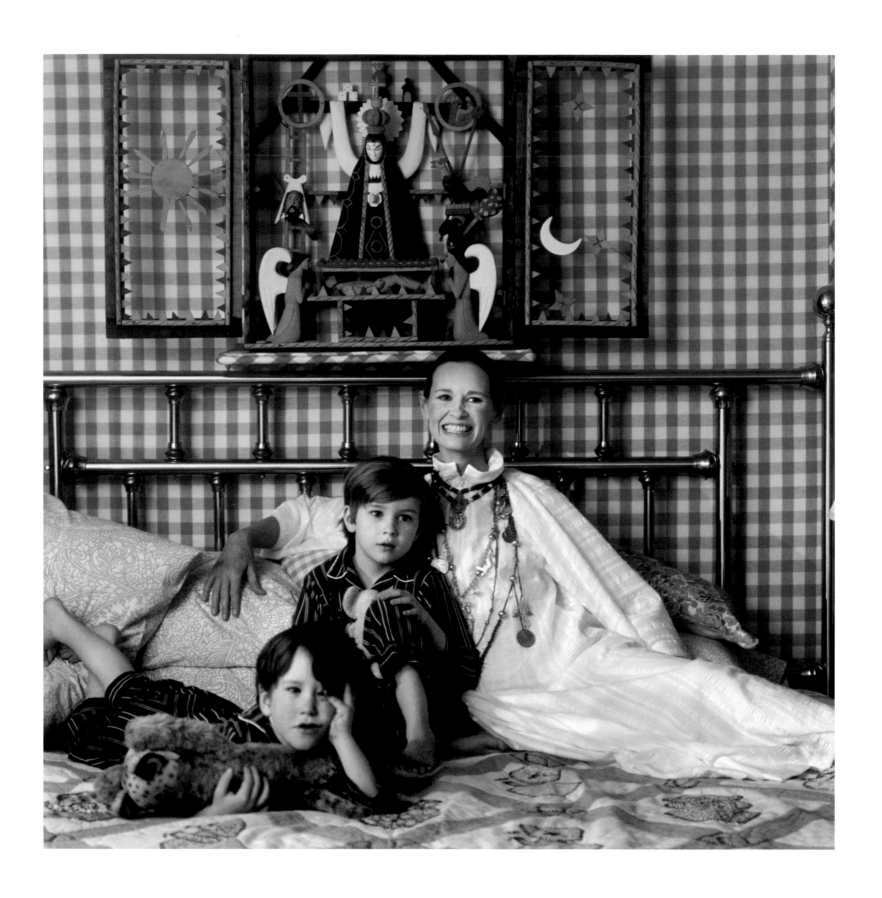

Gloria Vanderbilt with her sons Carter and Anderson Cooper

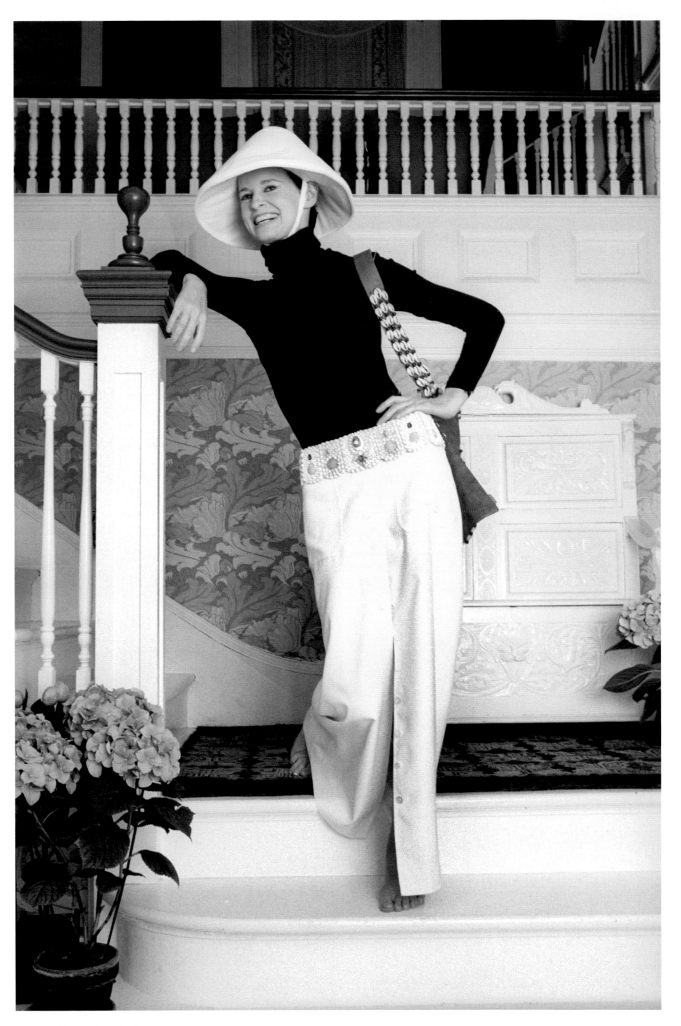

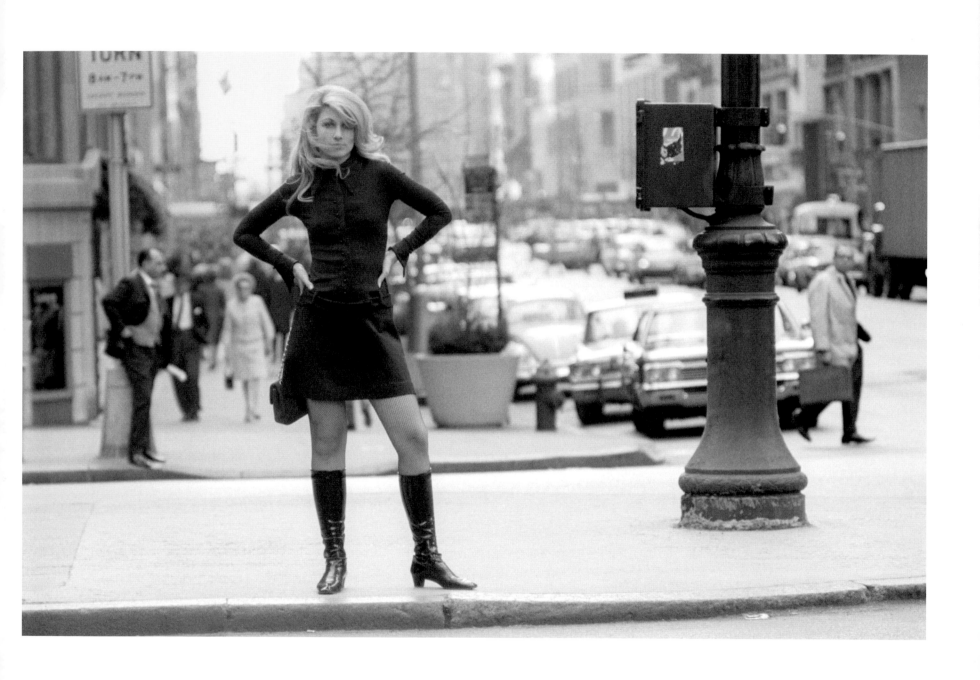

32 Above: Jane Holzer Opposite: Emilio Pucci and his models

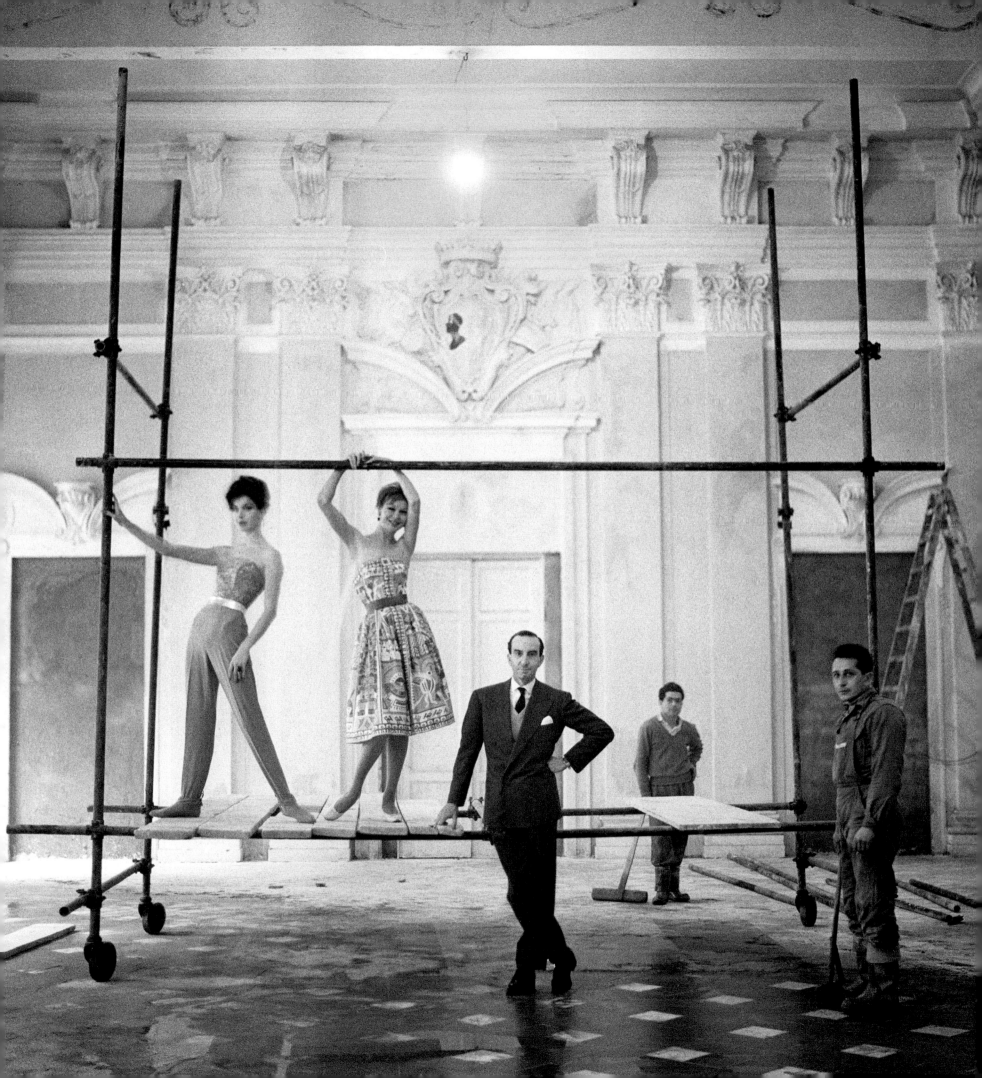

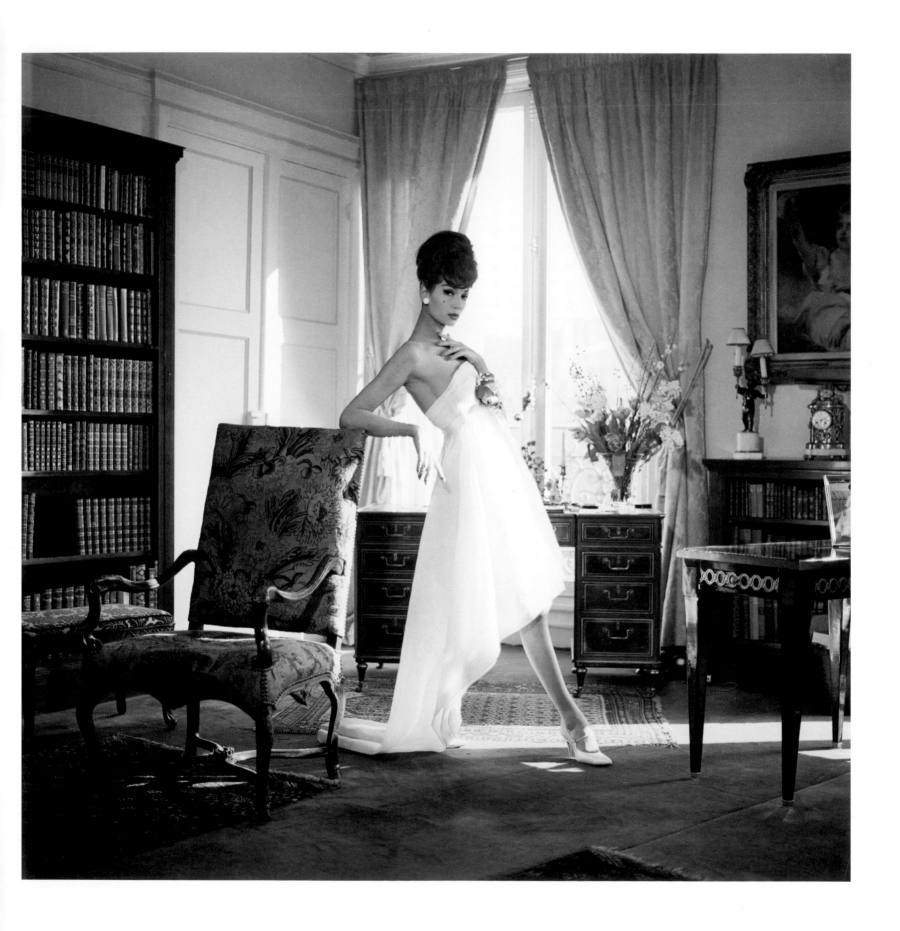

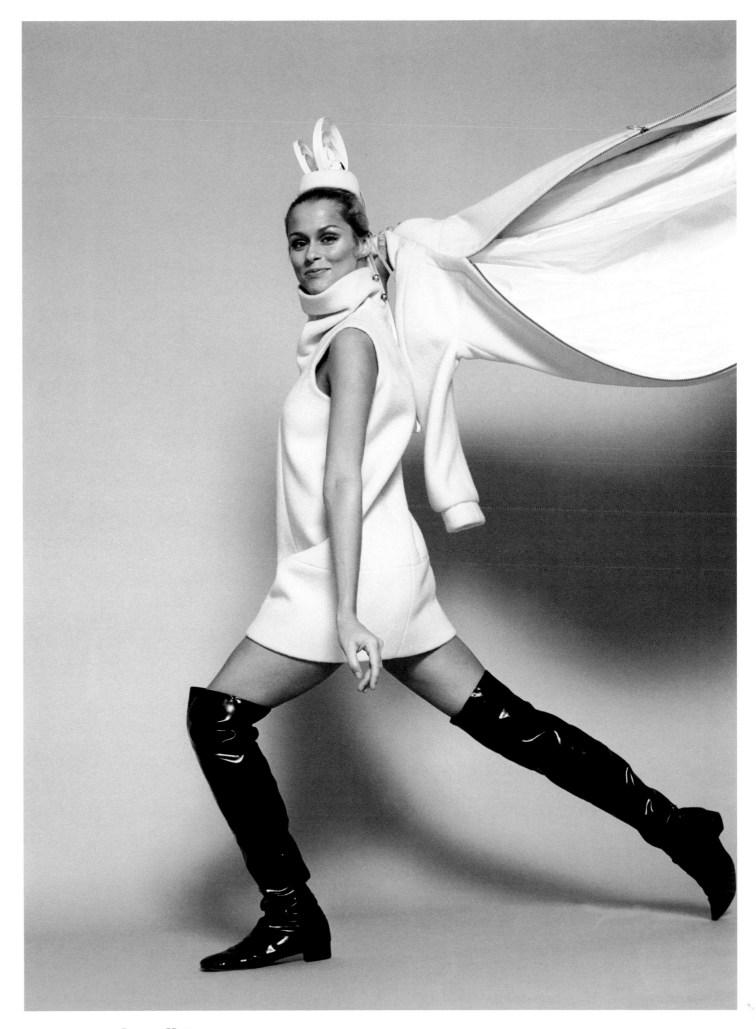

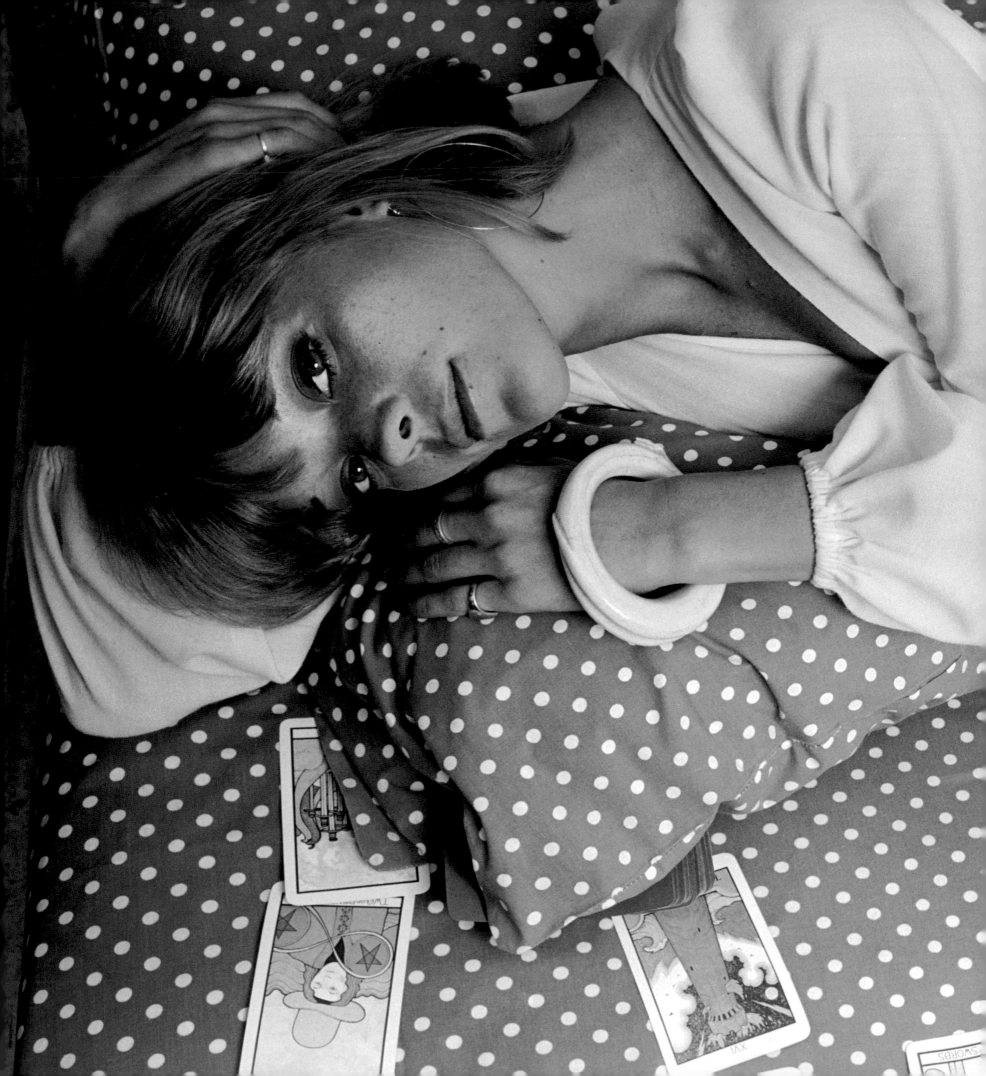

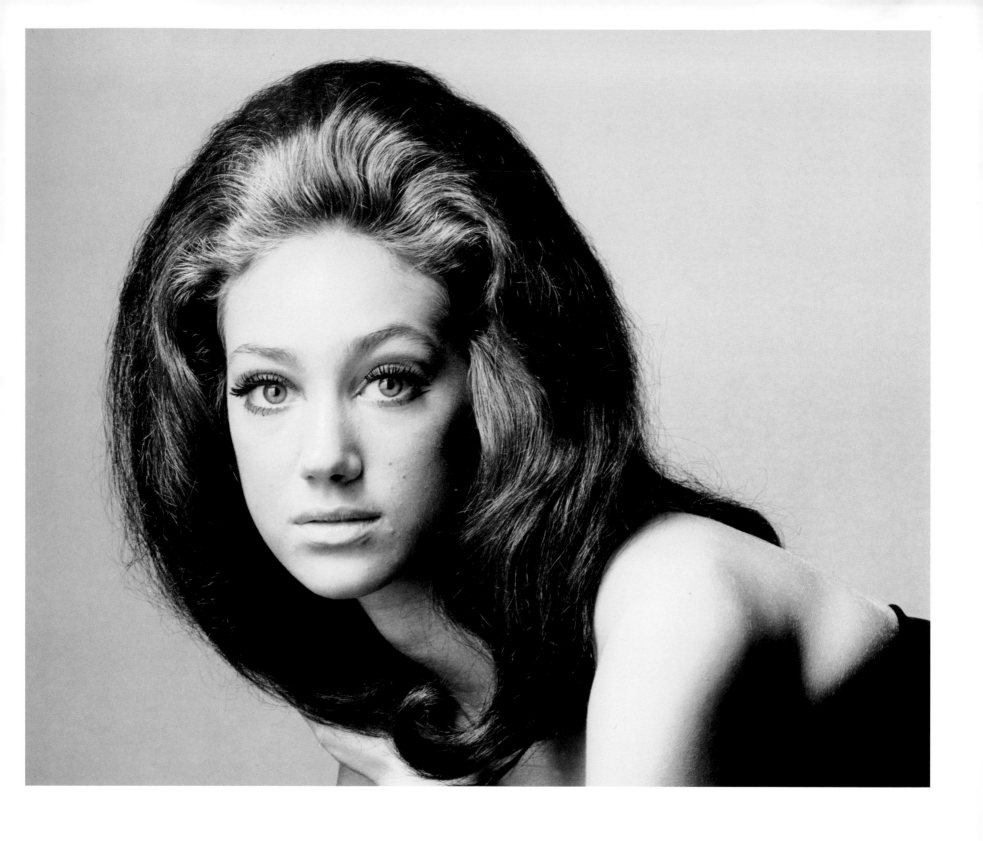

Previous page: Berry Berenson Above: Marisa Berenson

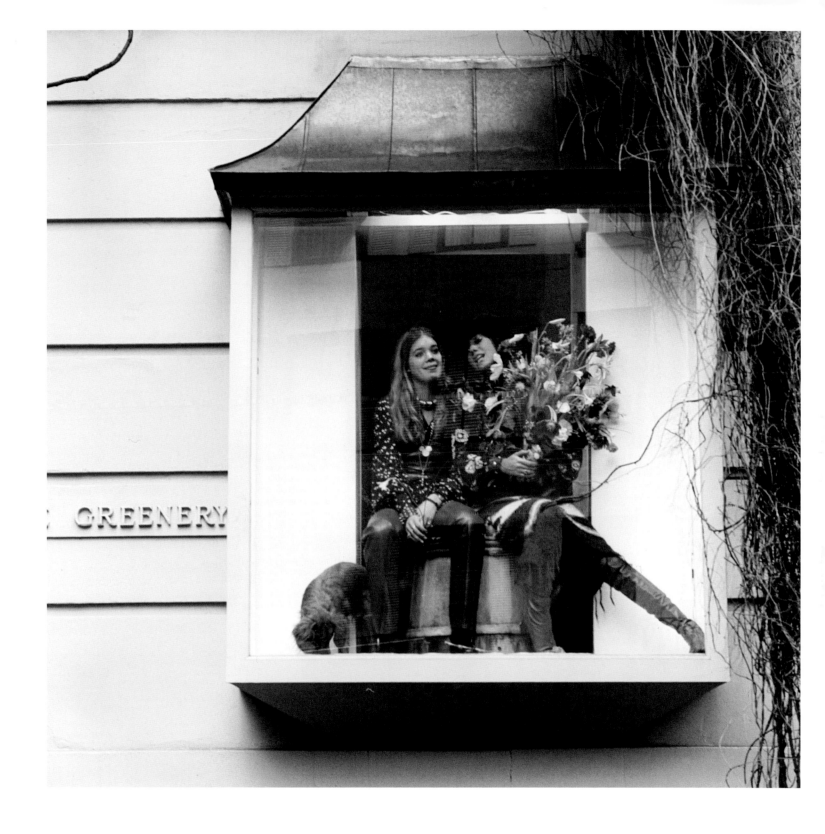

39 Berry and Marisa Berenson

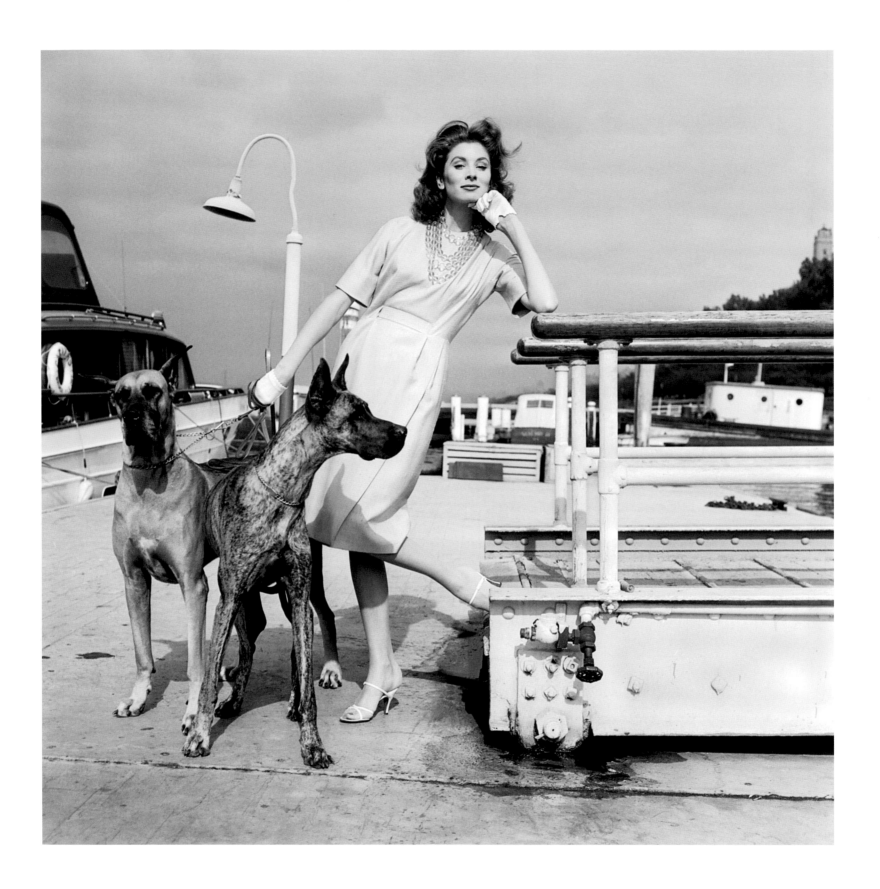

Above and opposite: Suzy Parker

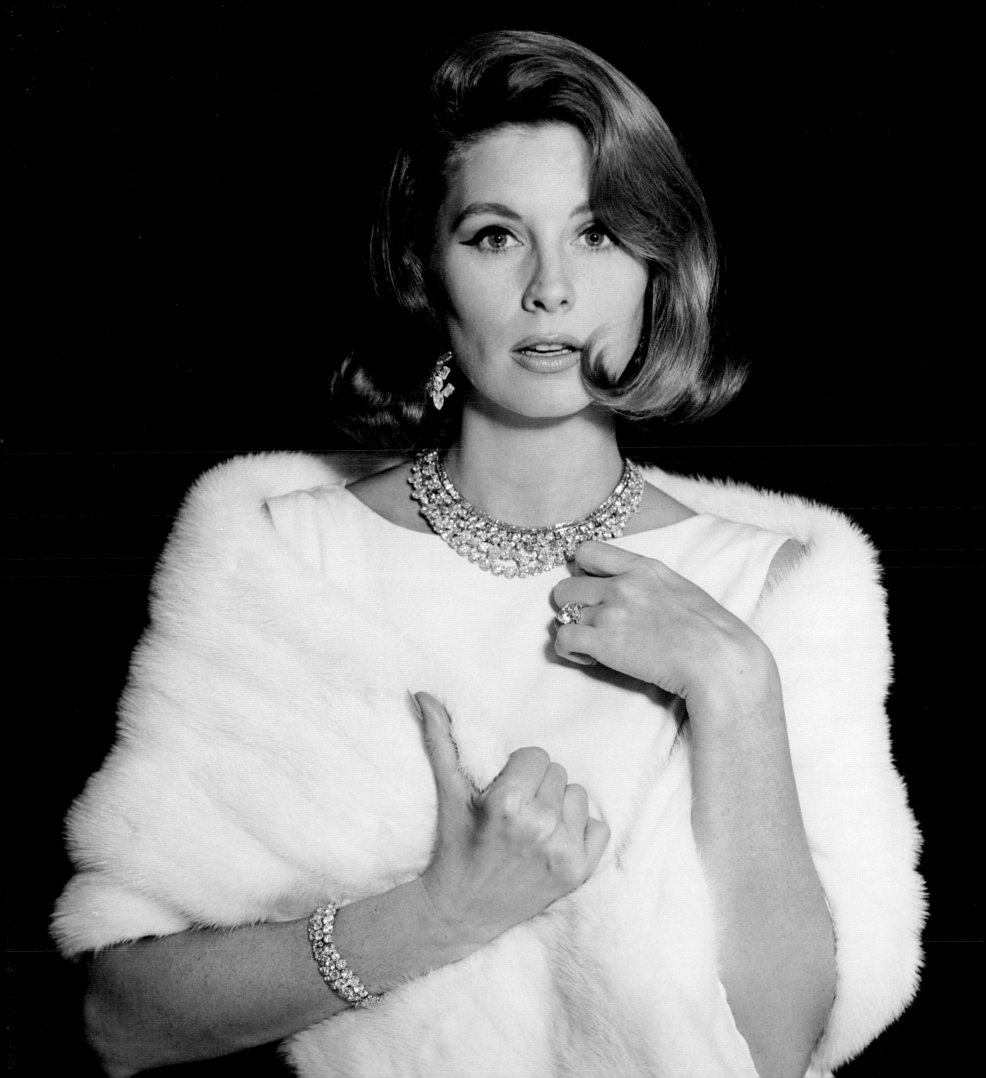

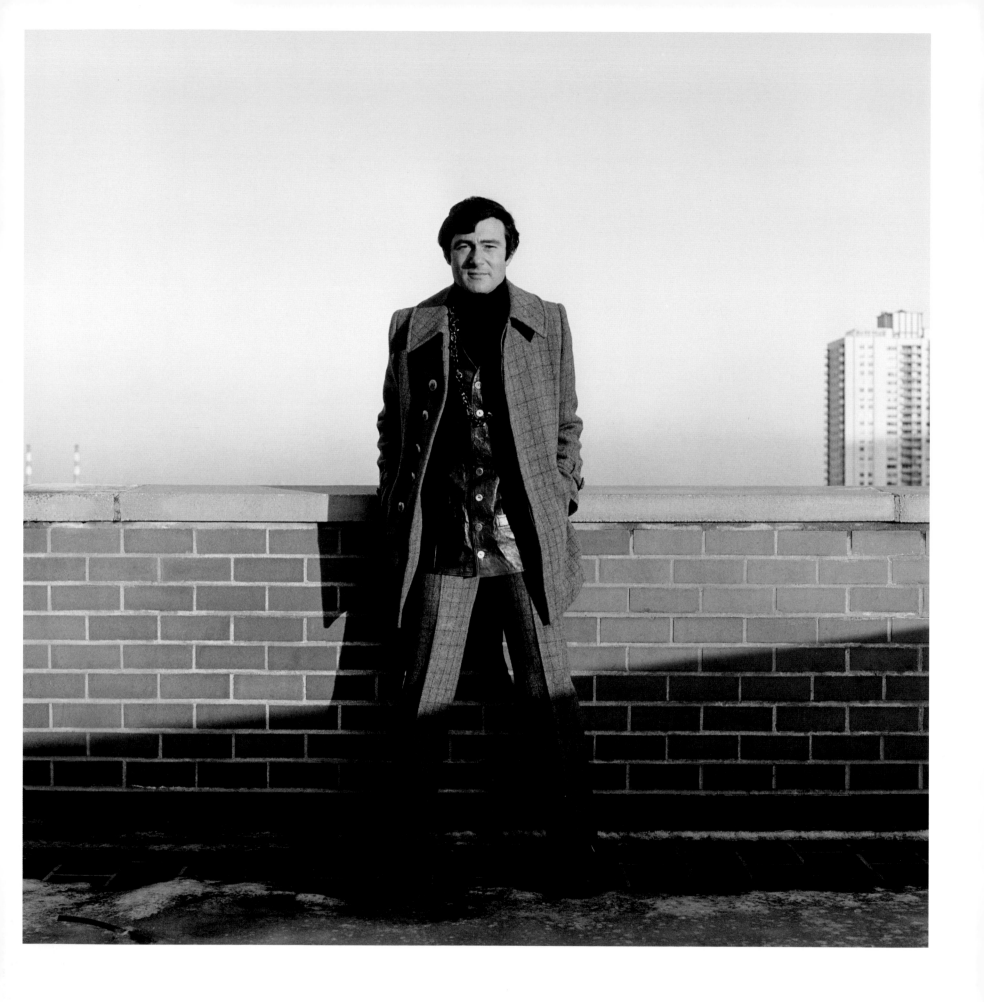

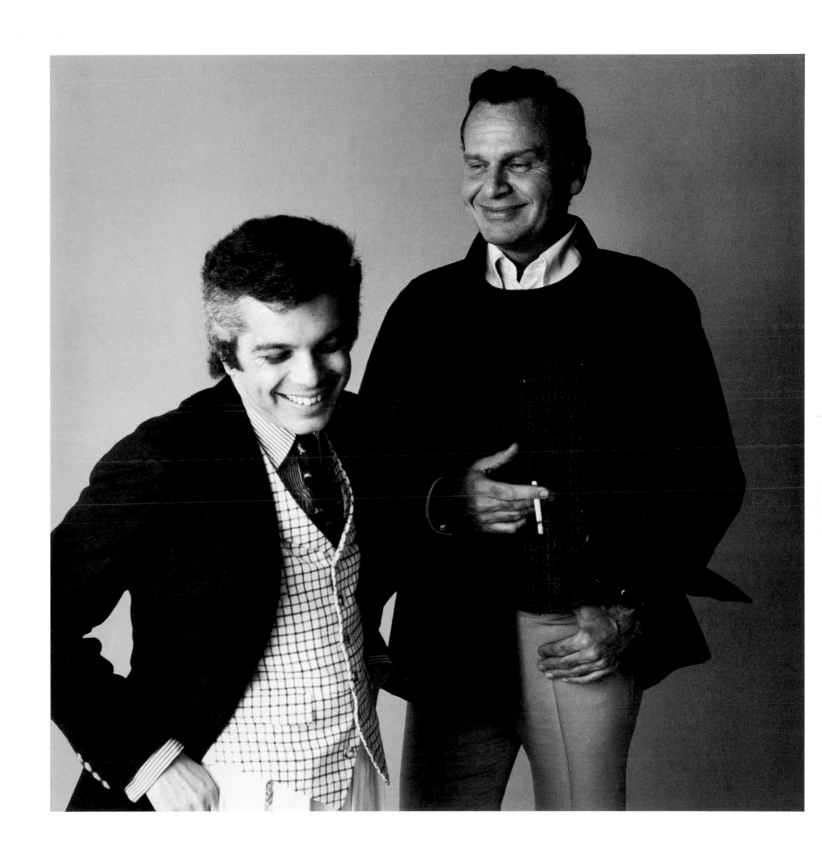

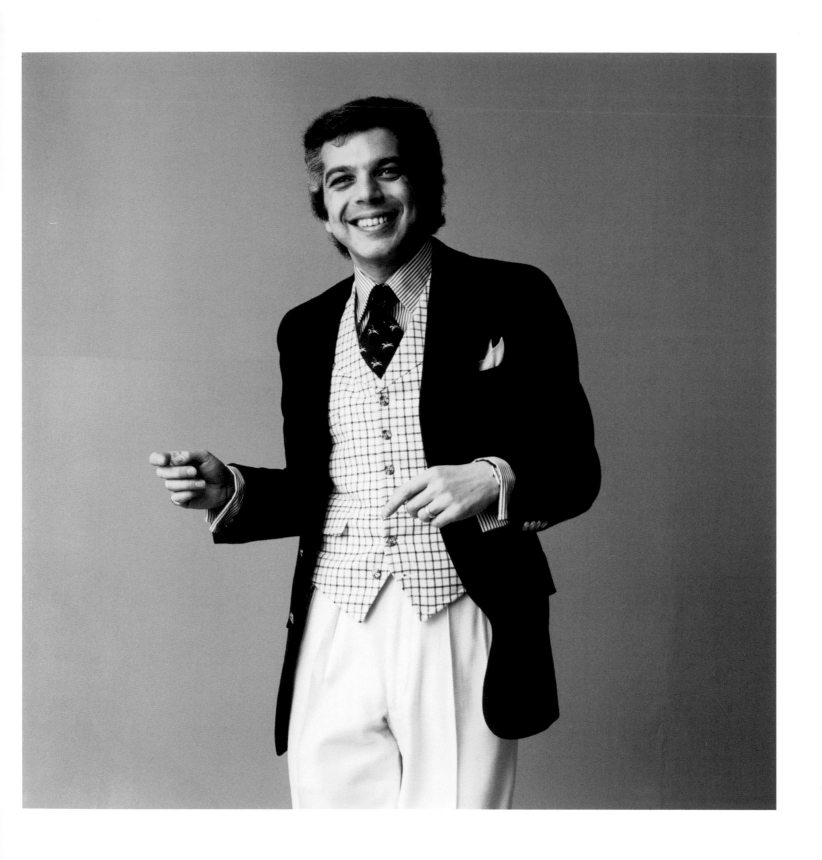

44 Ralph Lauren

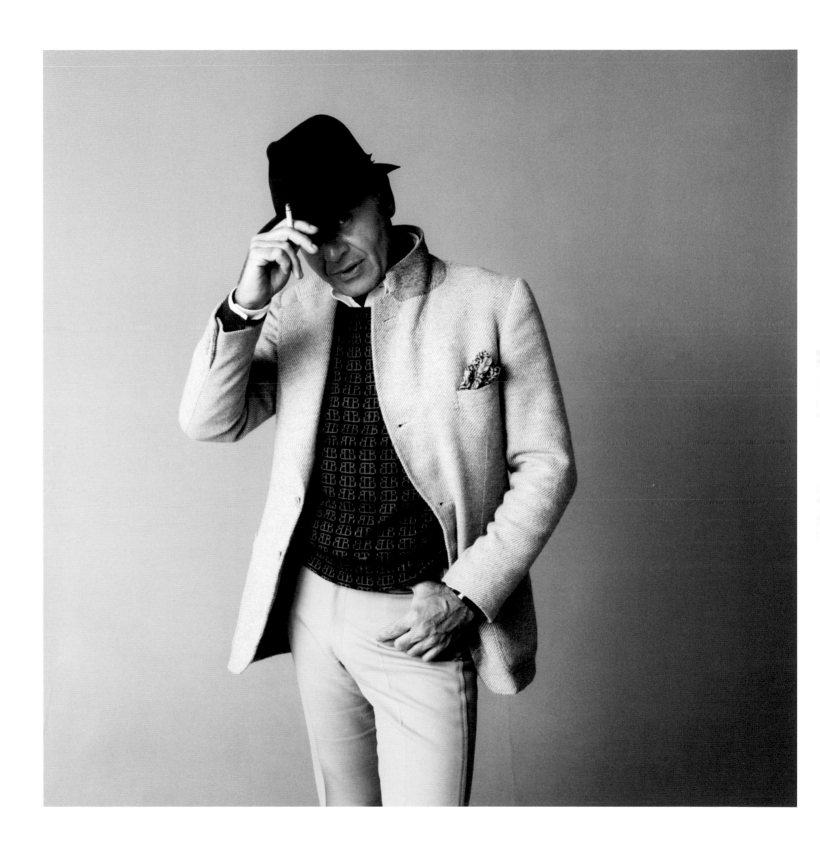

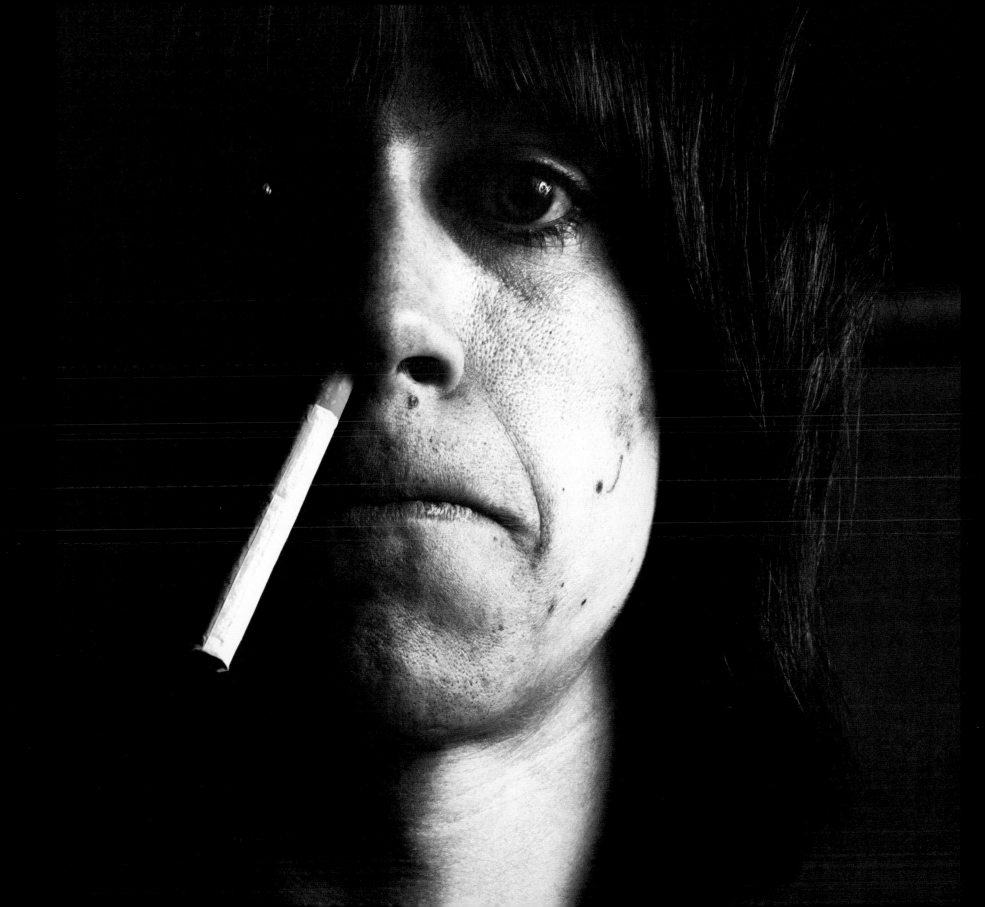

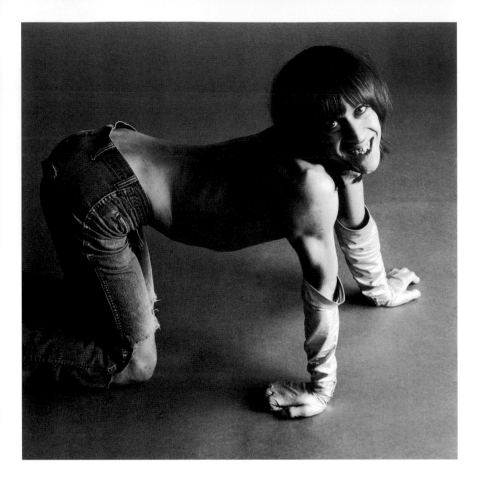
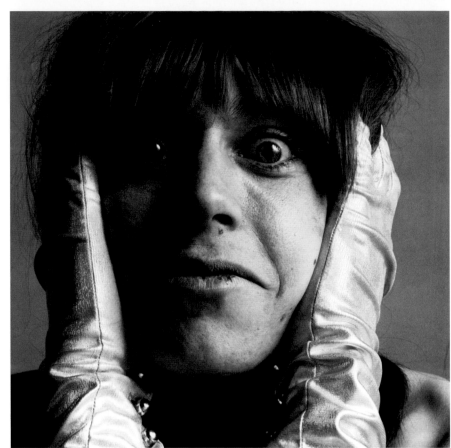
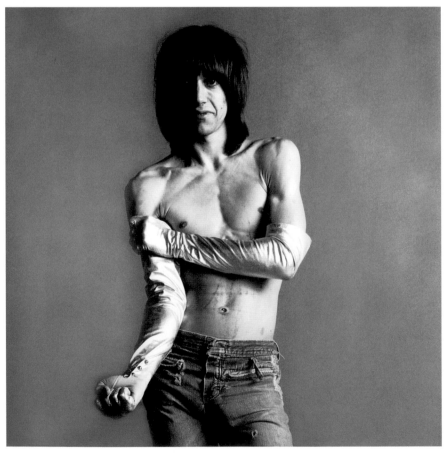
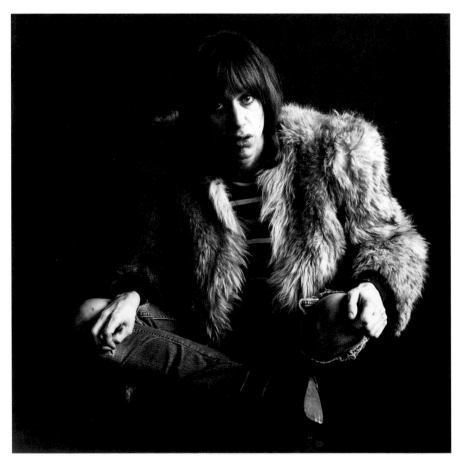

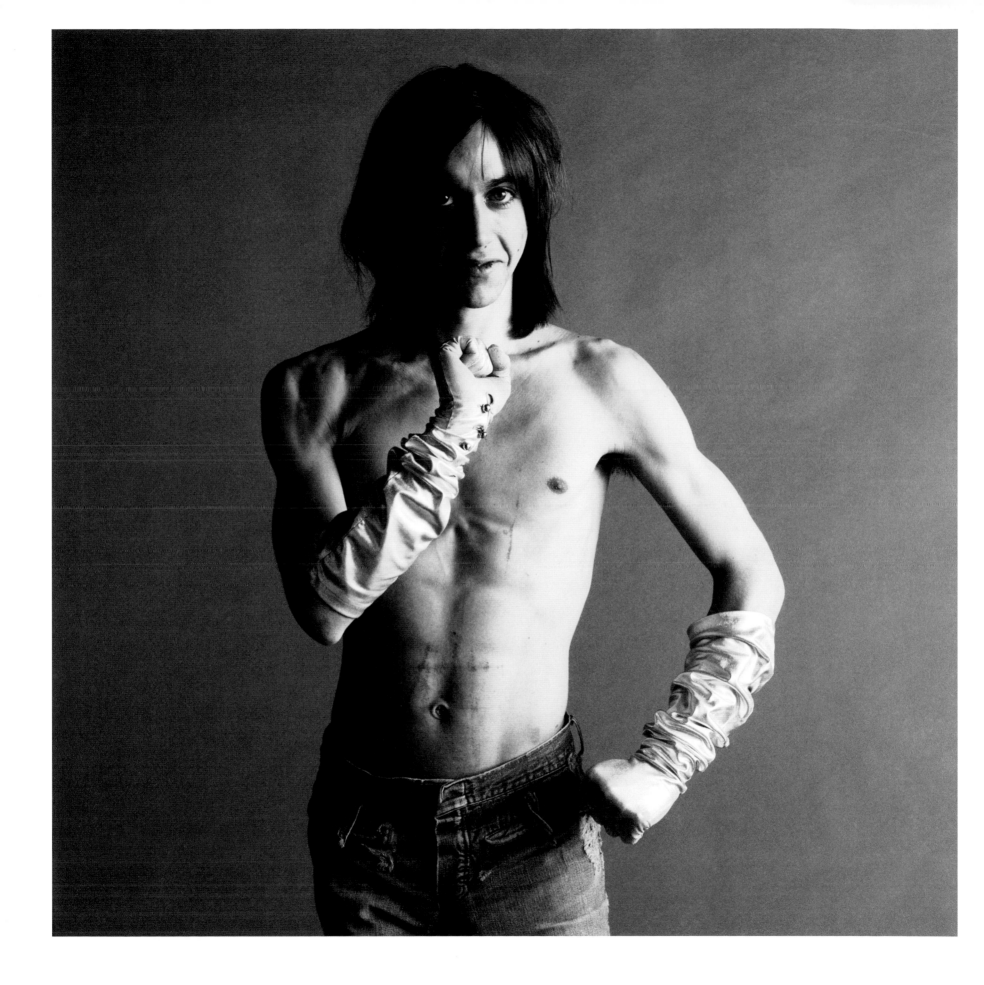

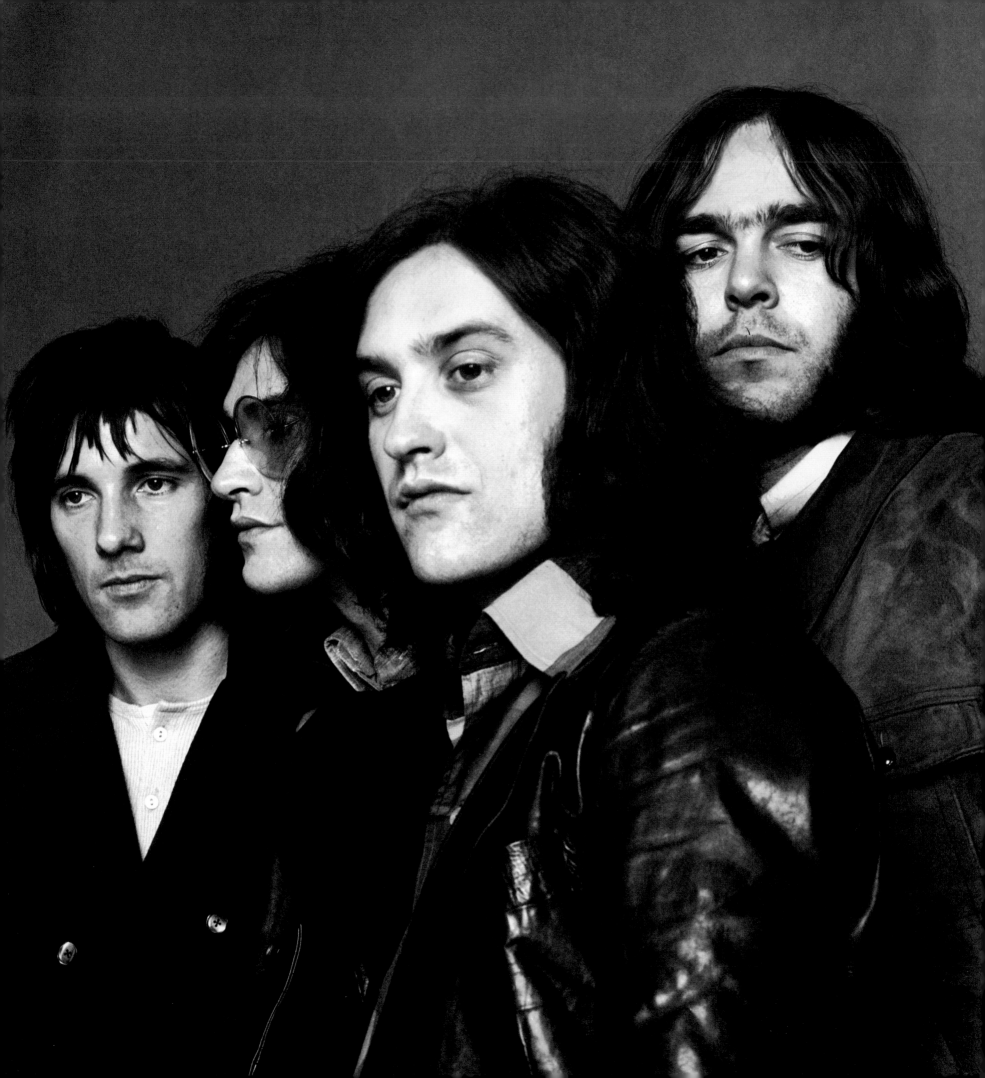

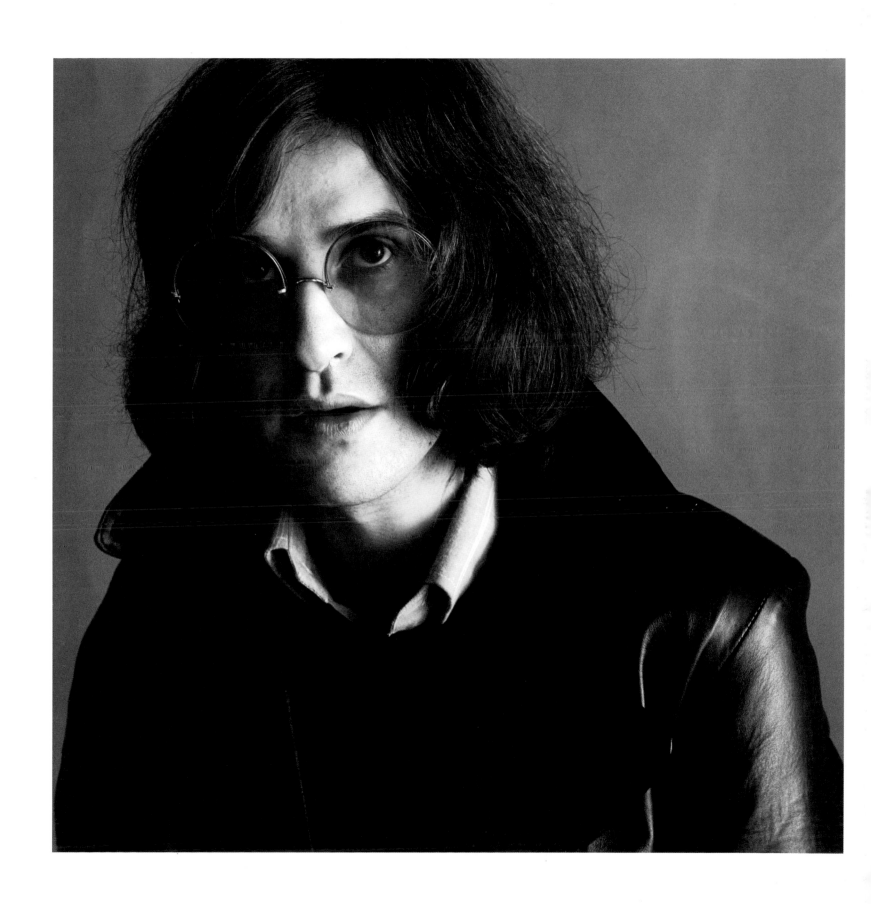

51 Opposite: The Kinks Above: Ray Davies

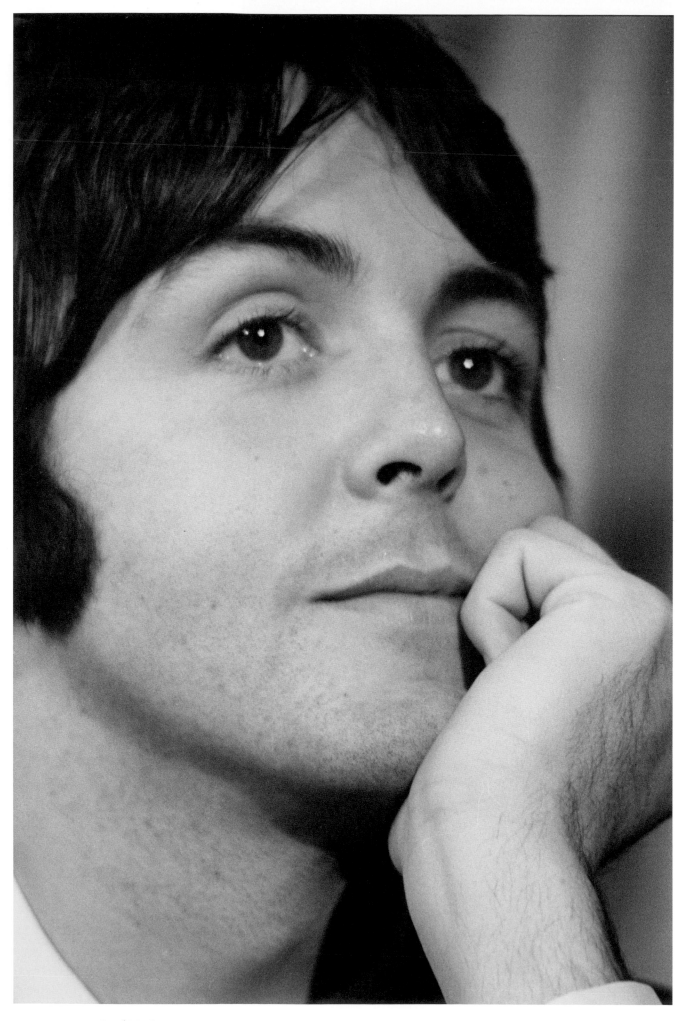

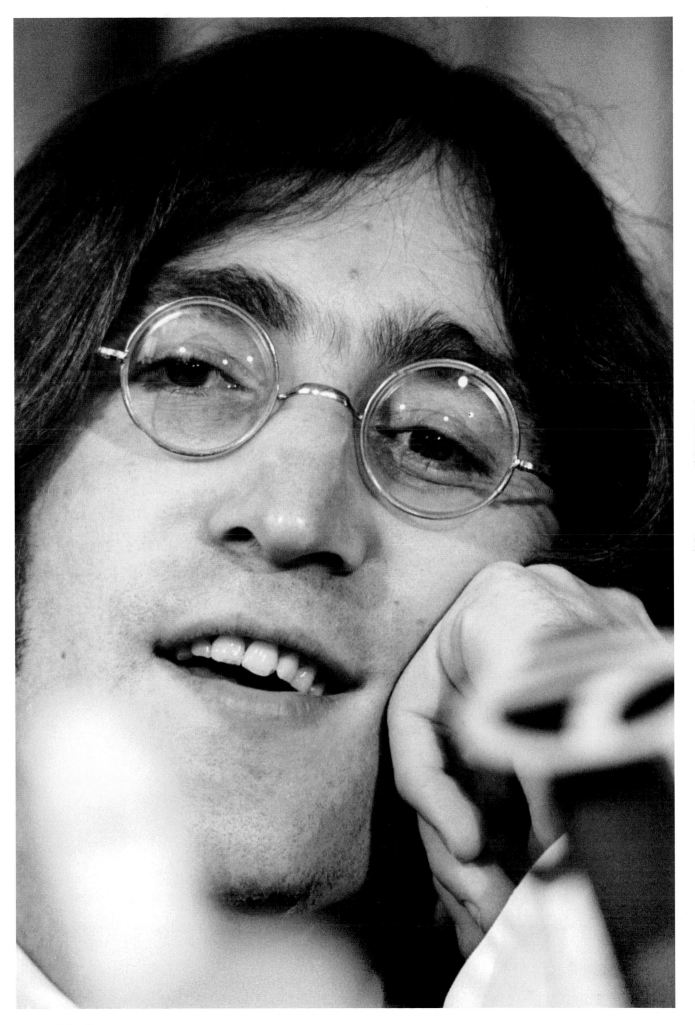

53 John Lennon

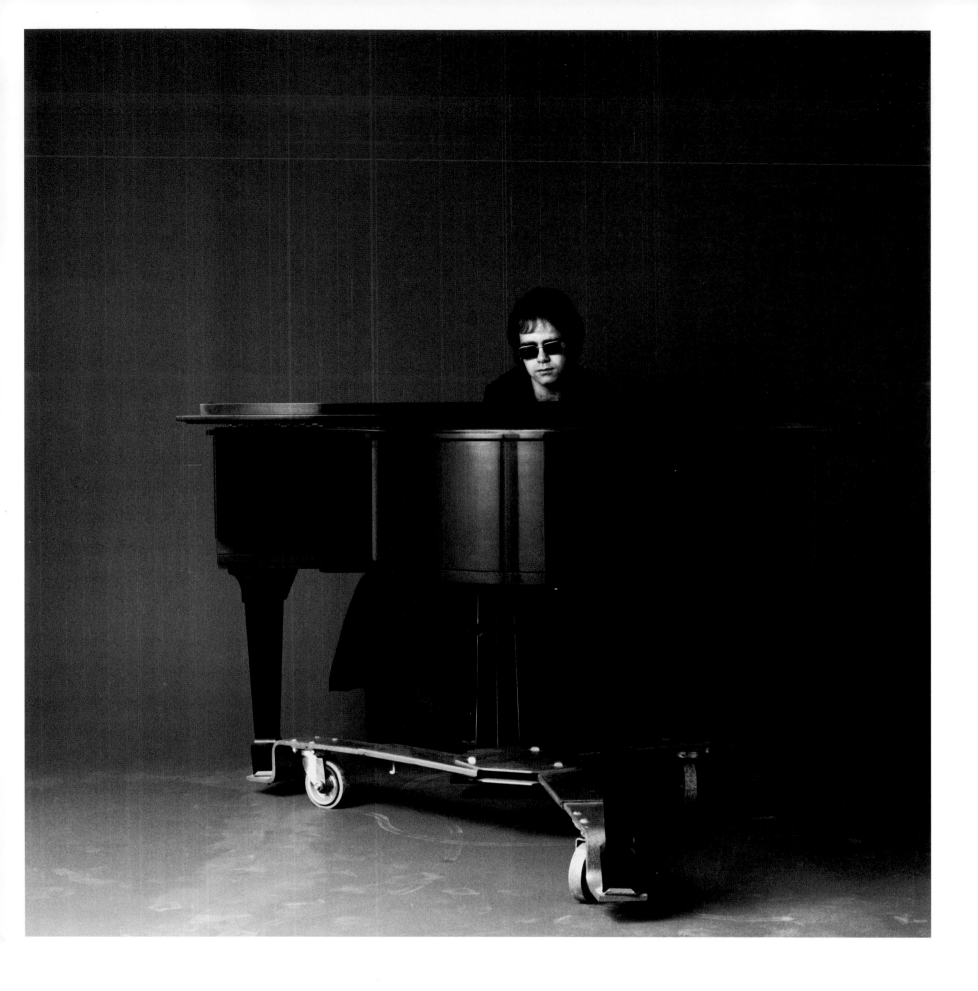

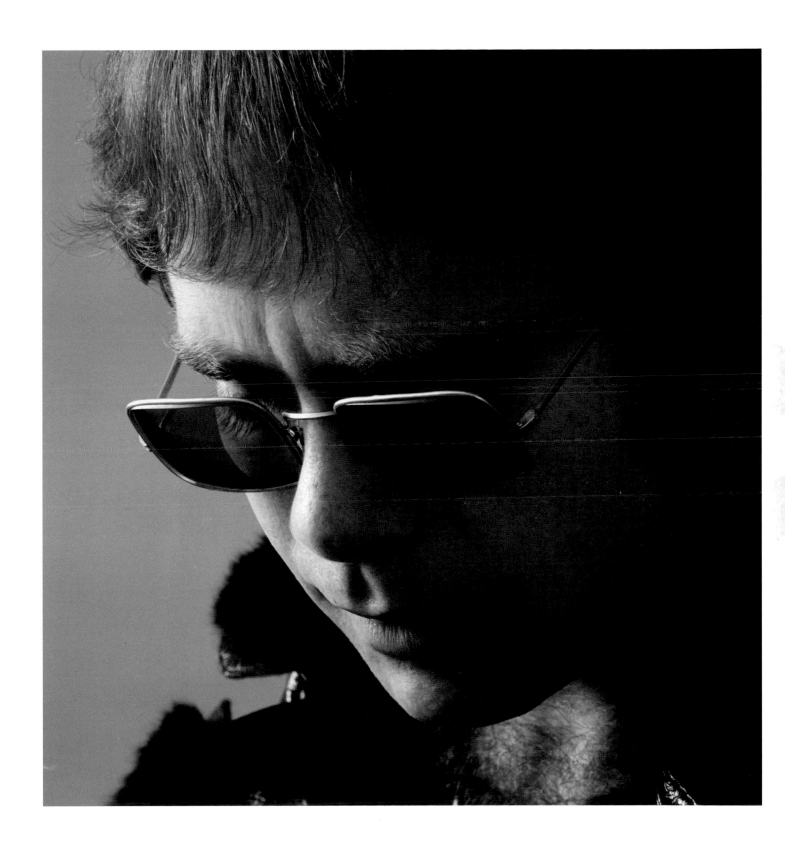

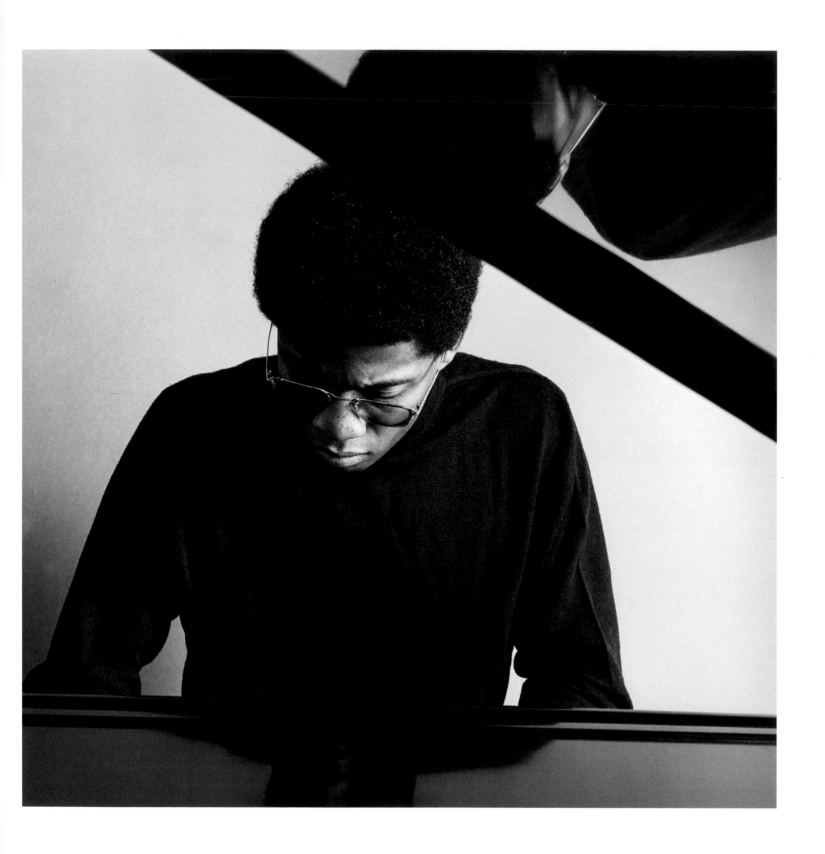

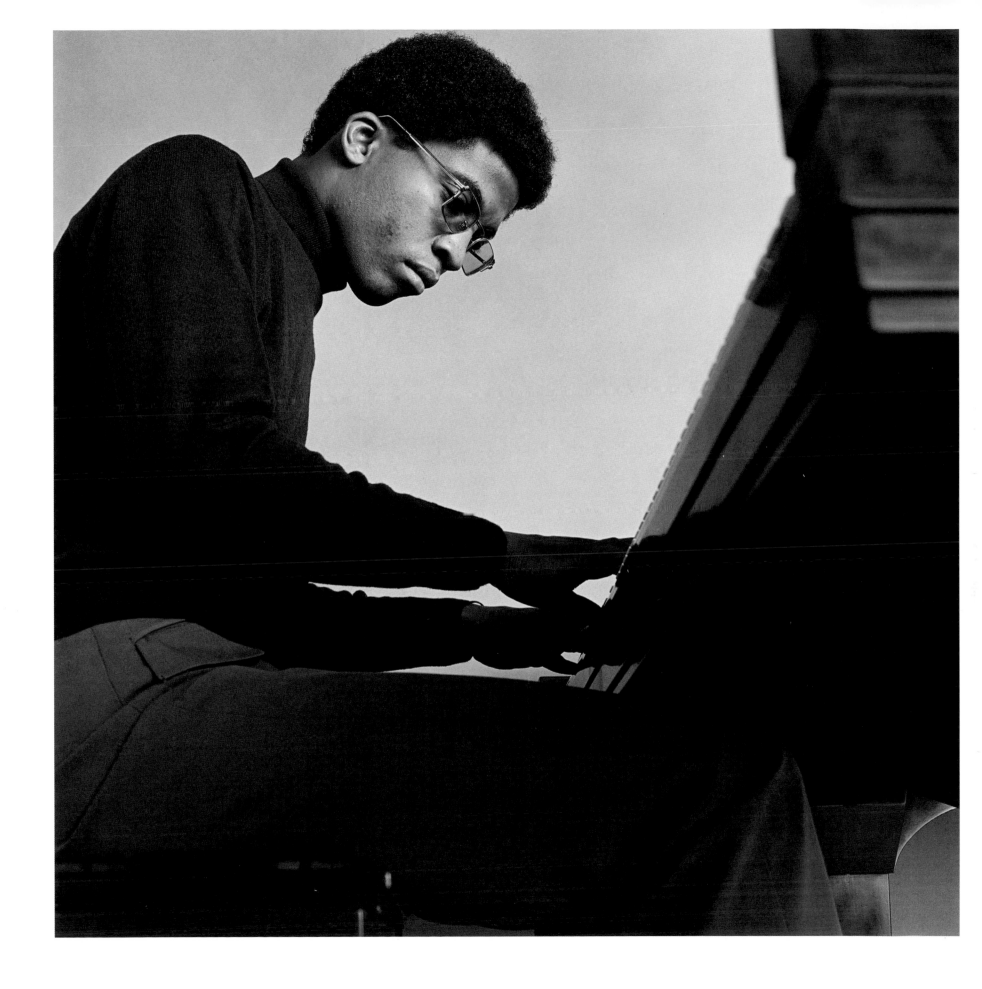

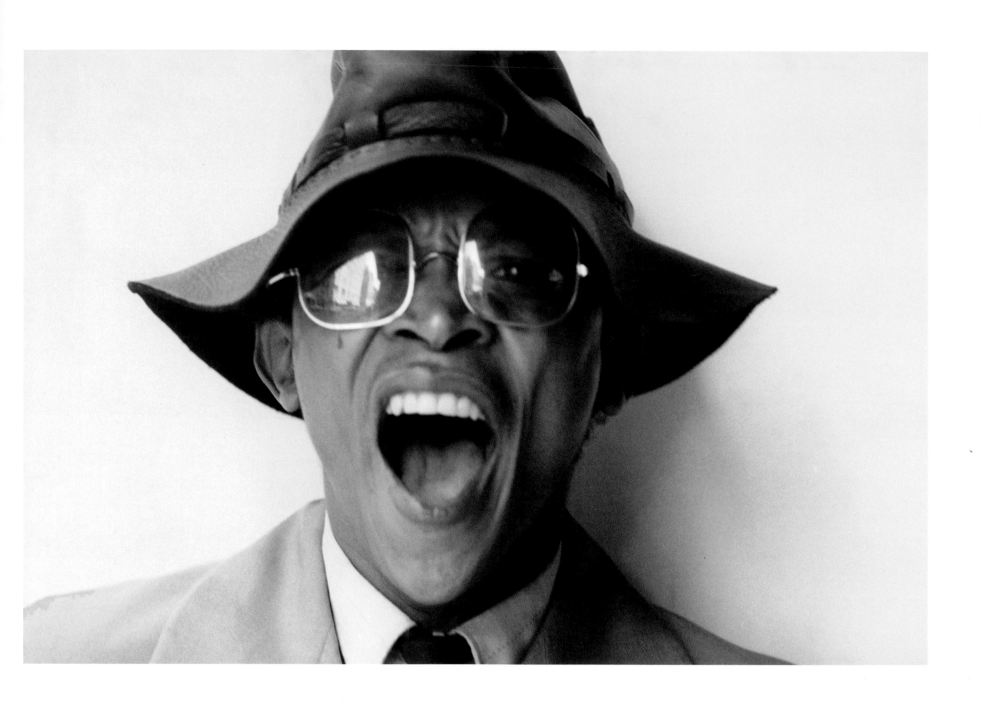

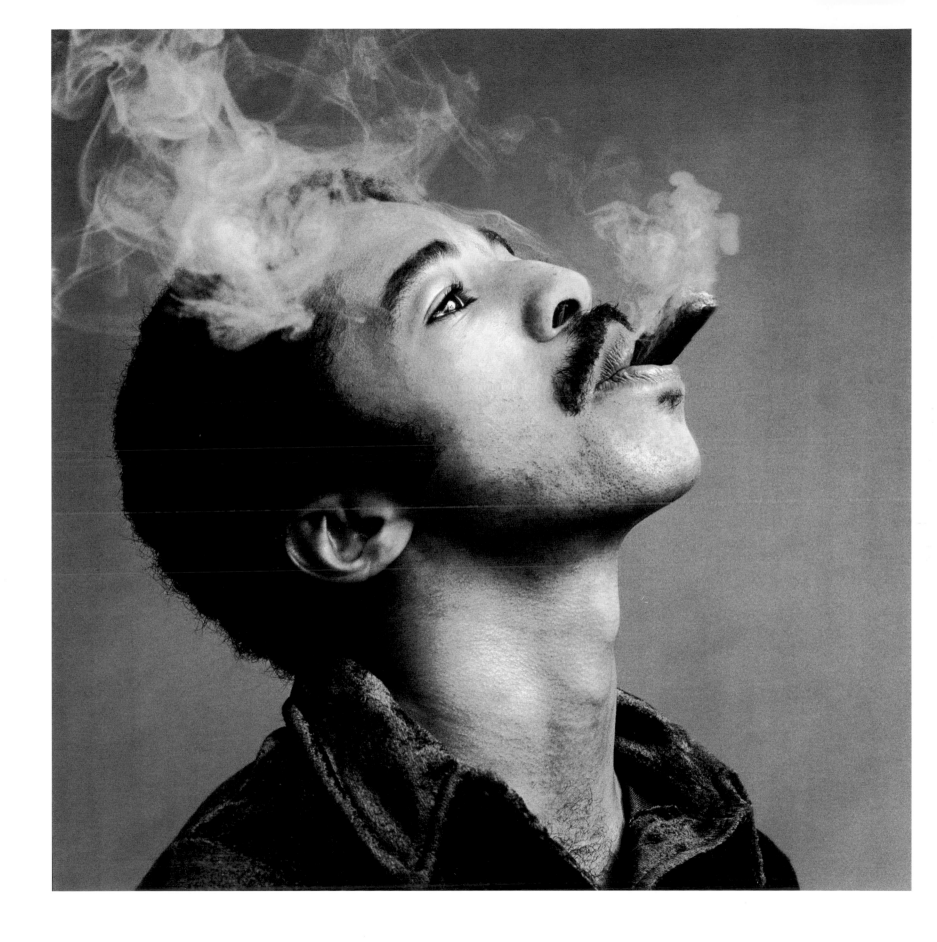

61 Tony Williams

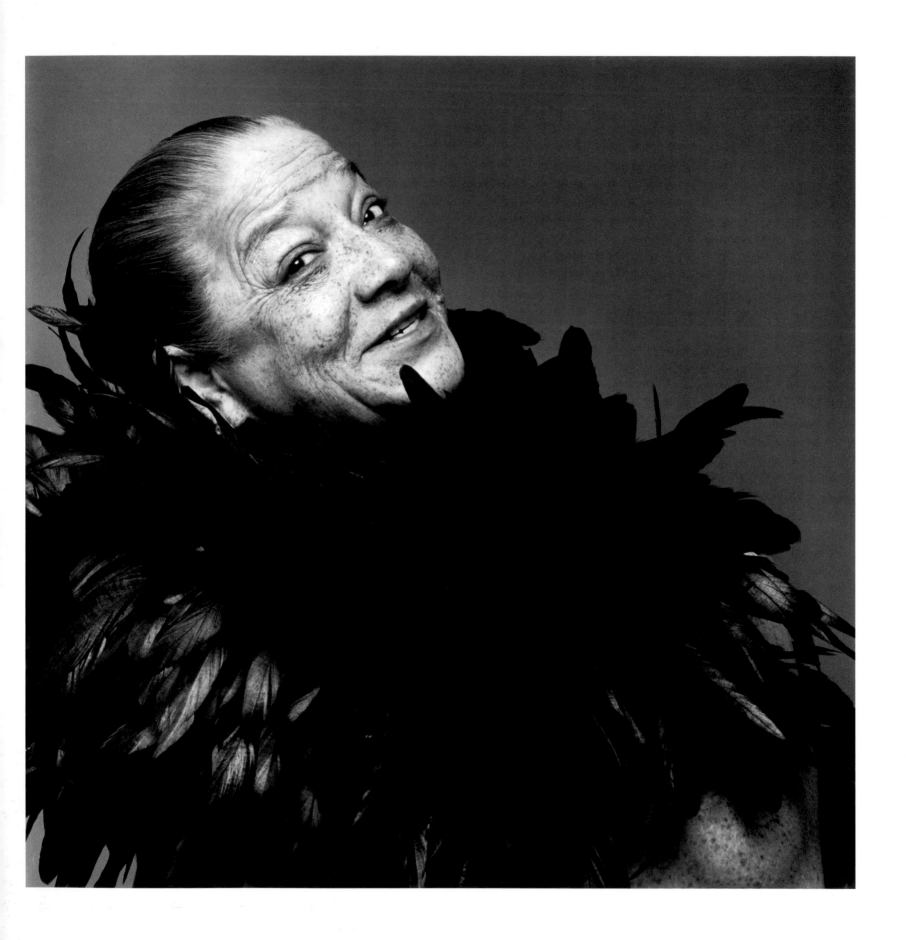

Above: Bricktop Opposite: Roberta Flack

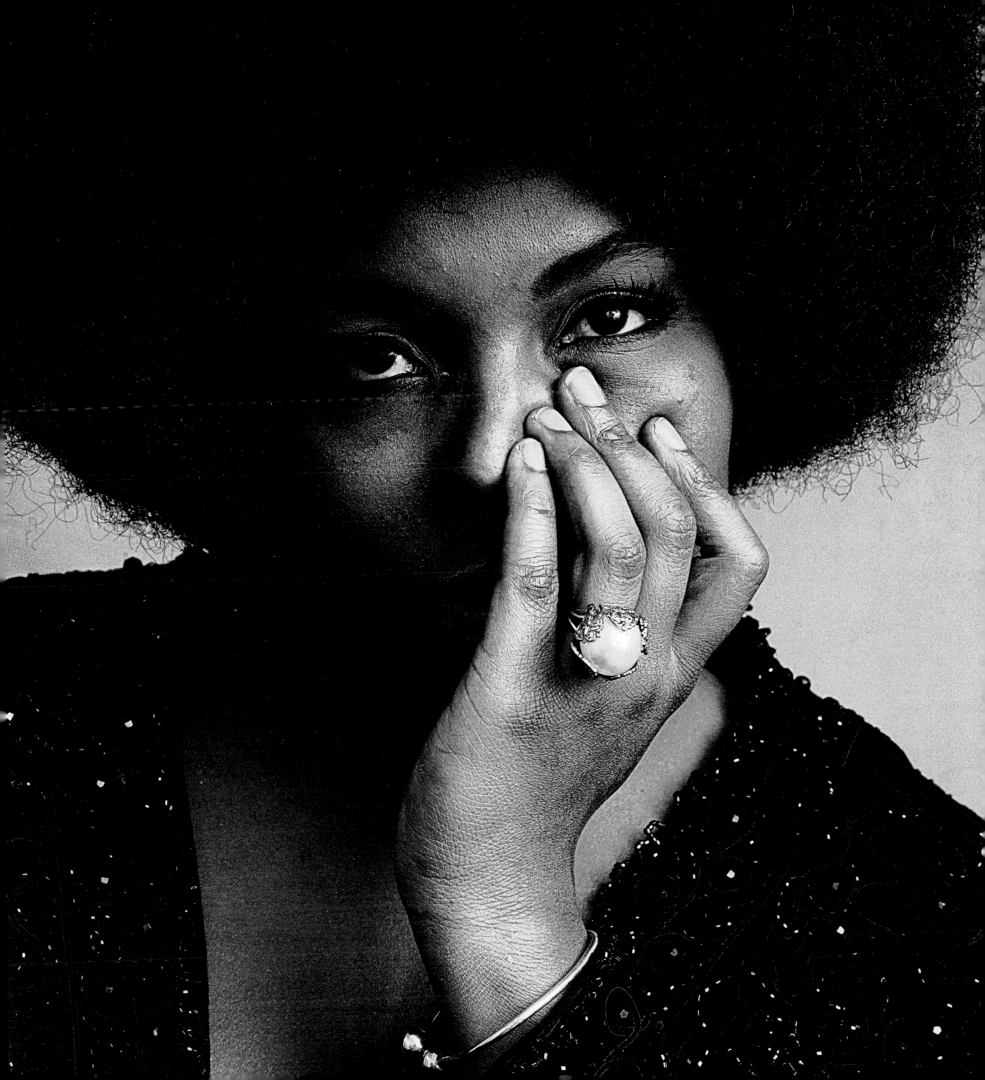

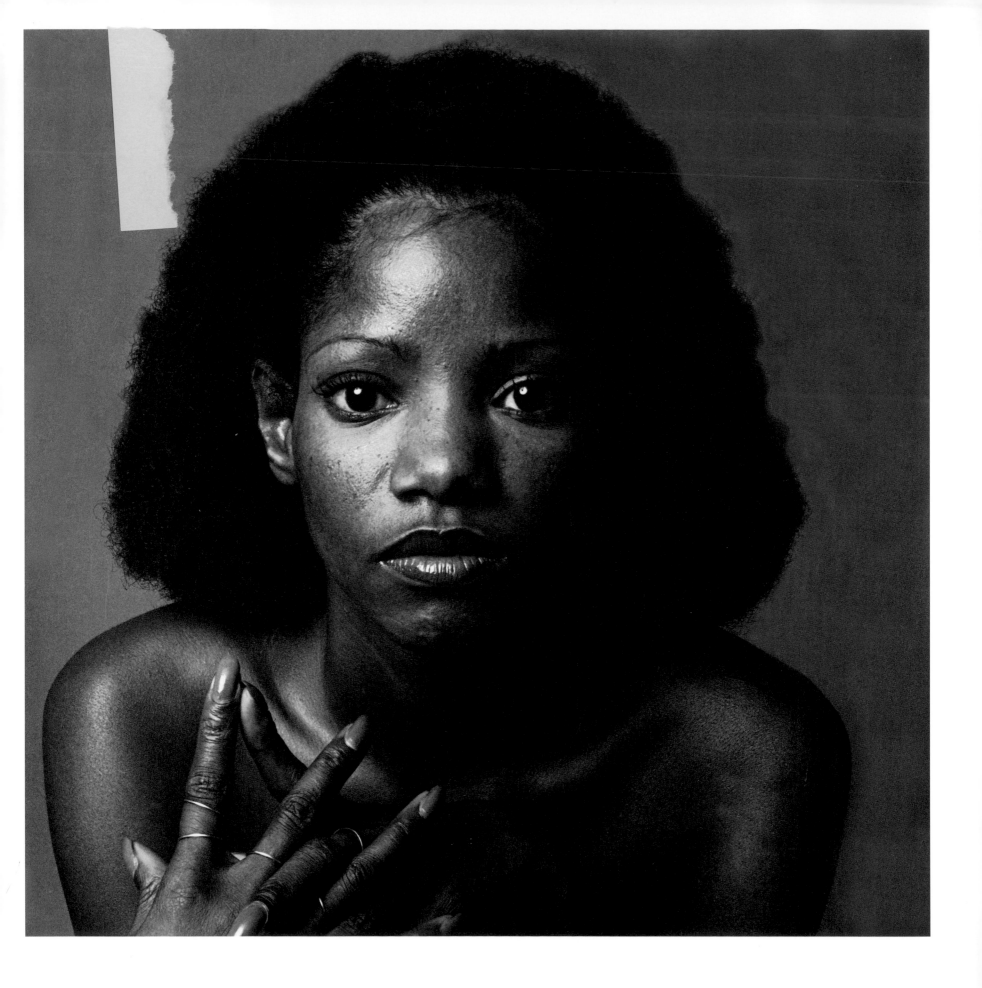

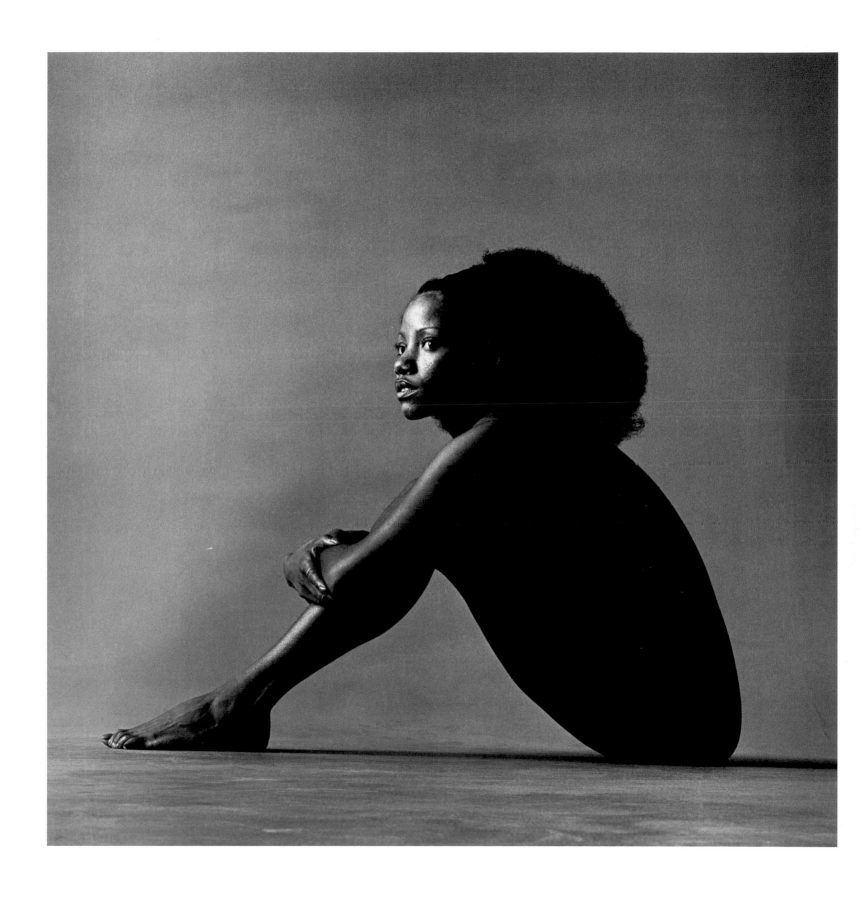

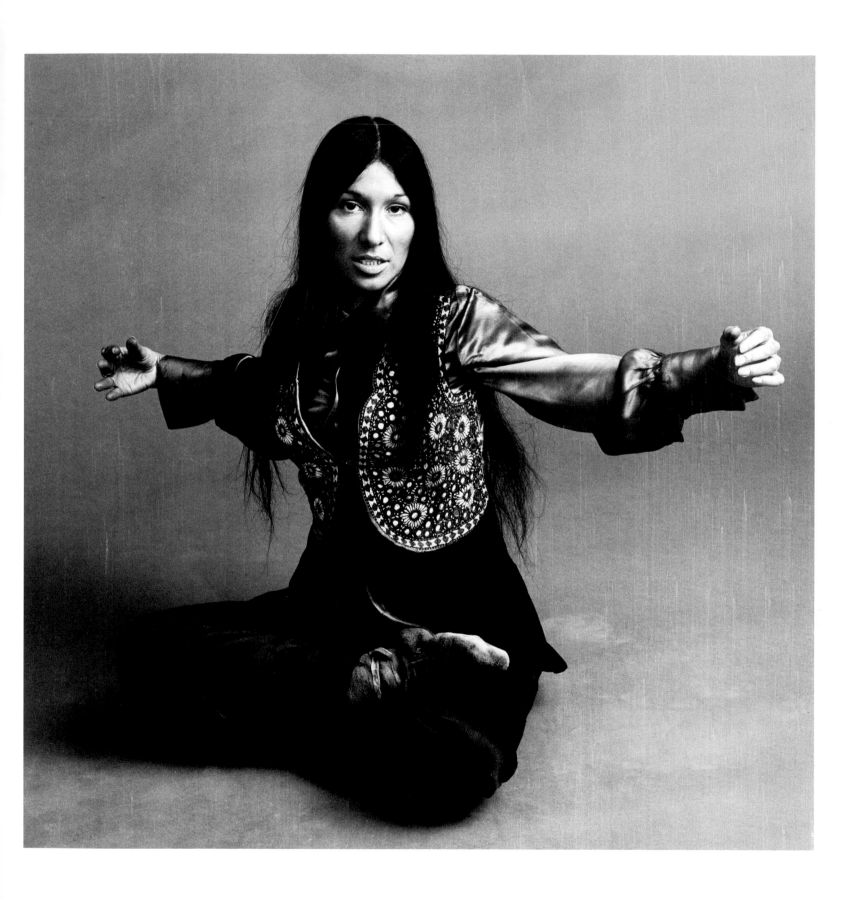

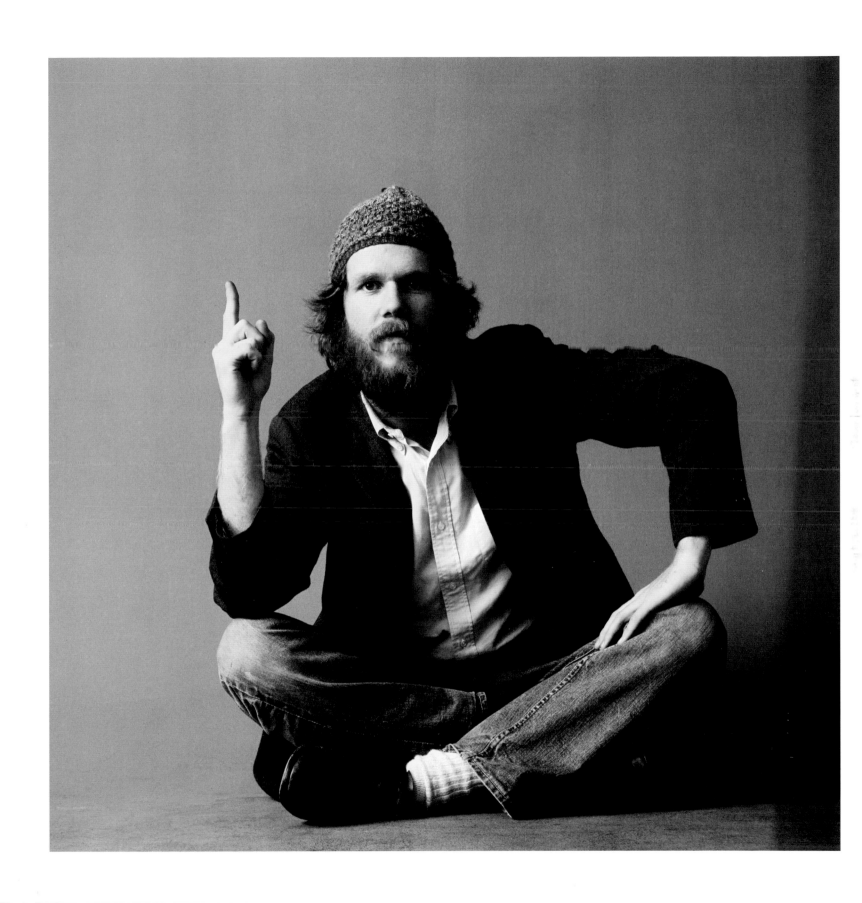

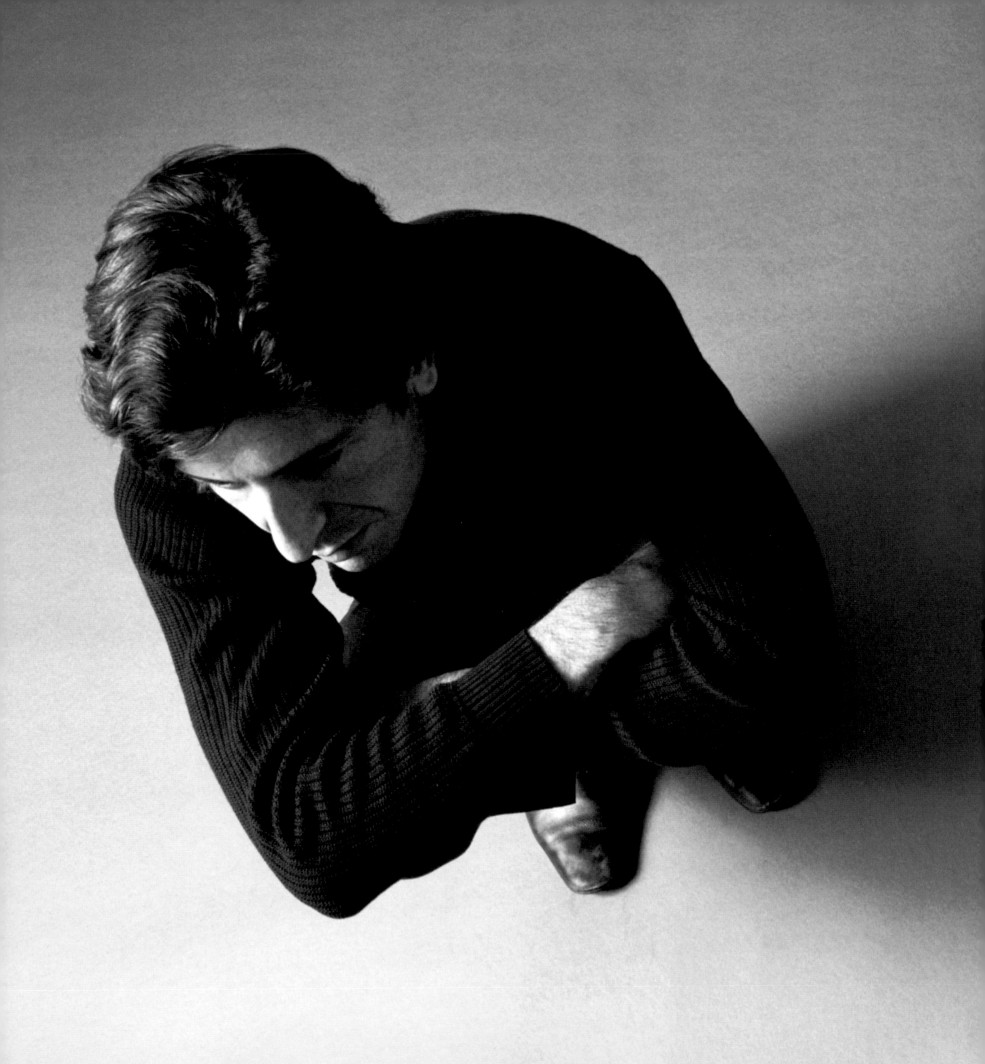

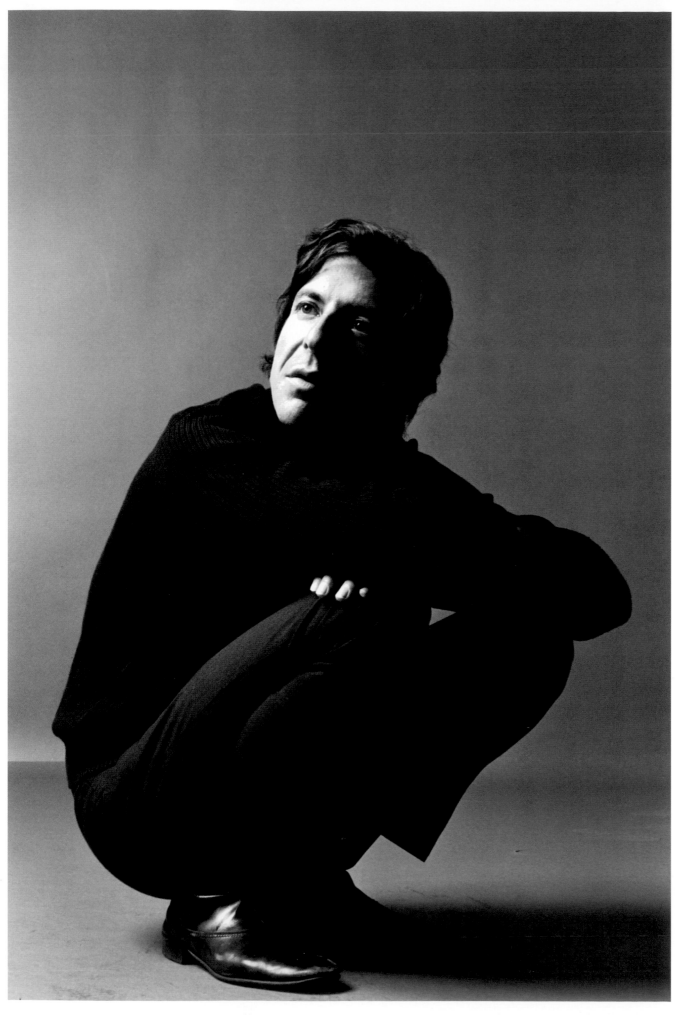

Previous page and above: Leonard Cohen

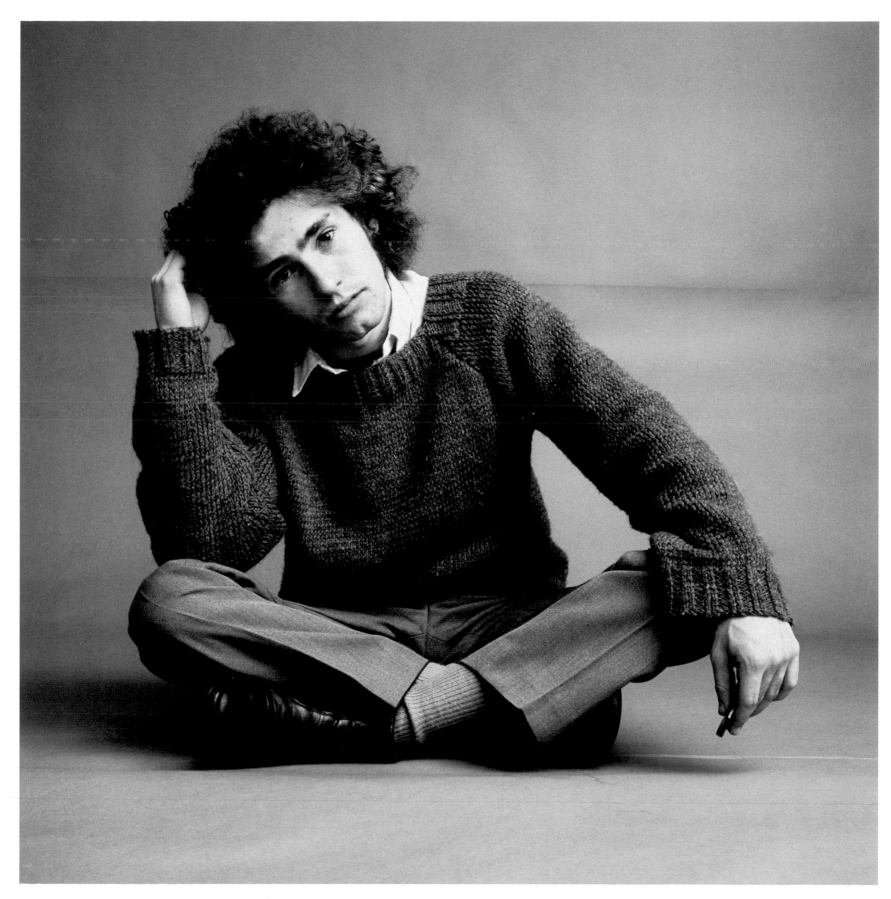

71 Tim Buckley

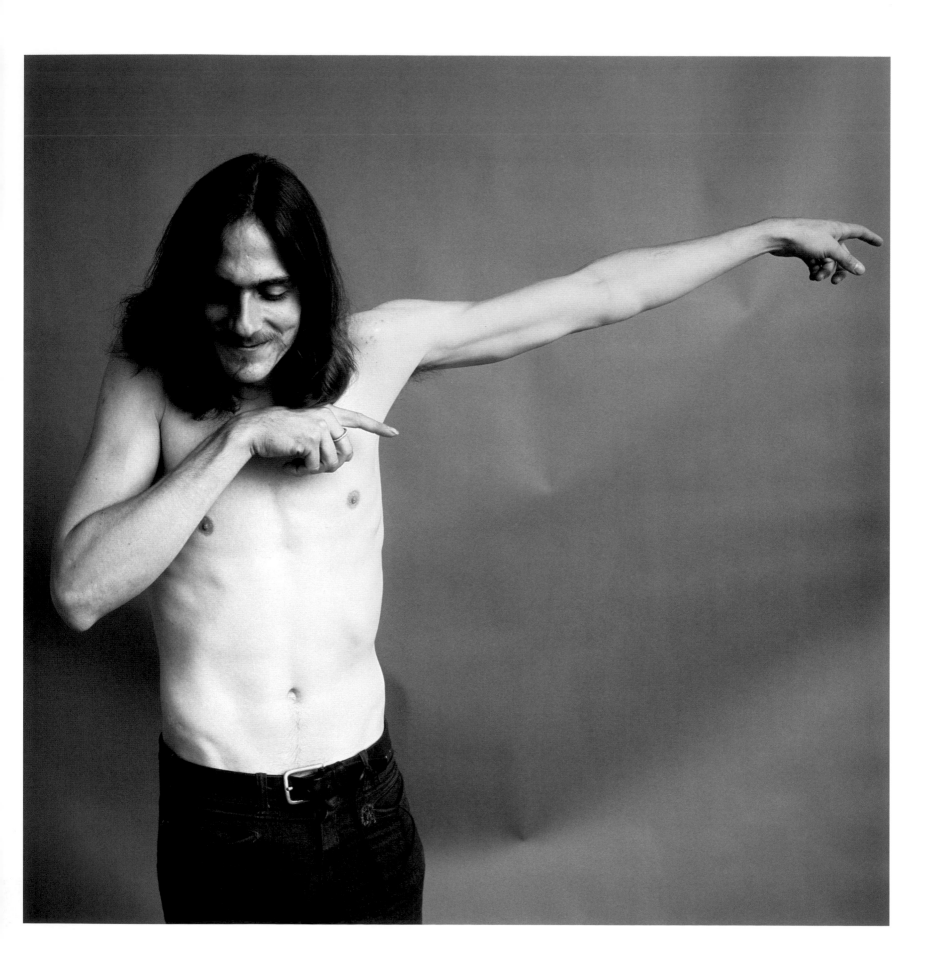

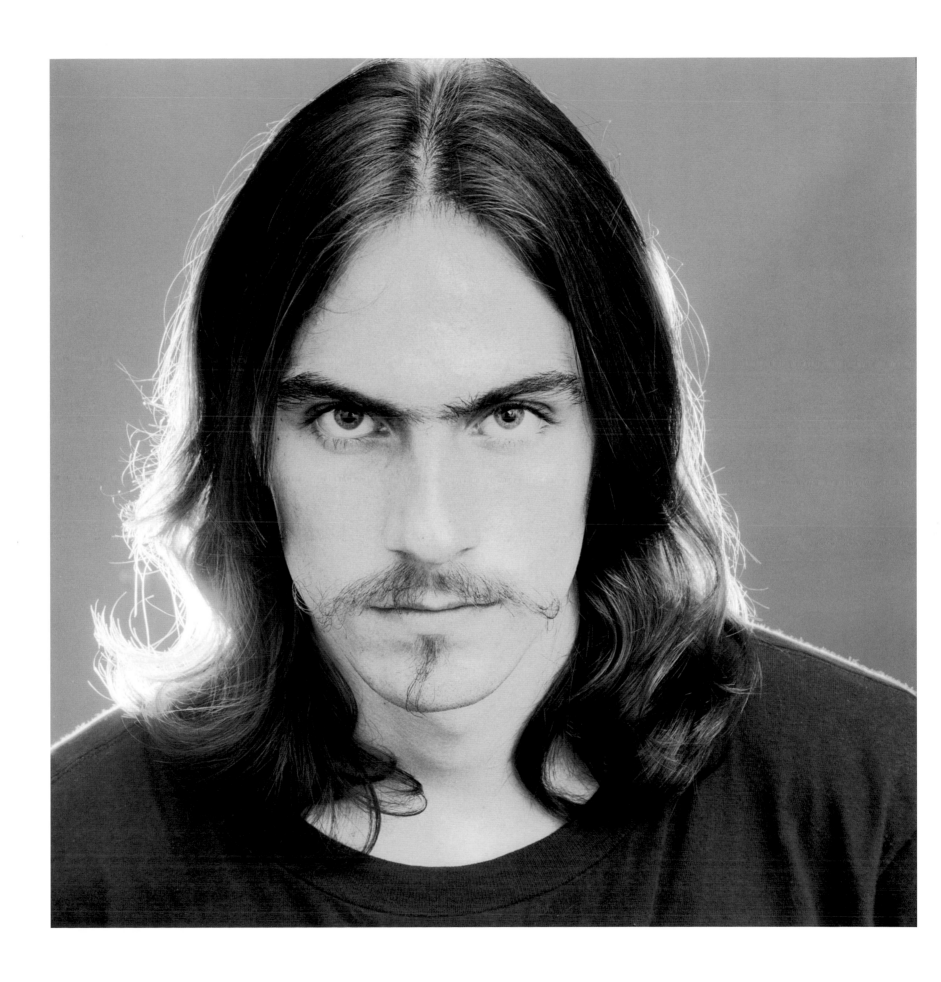

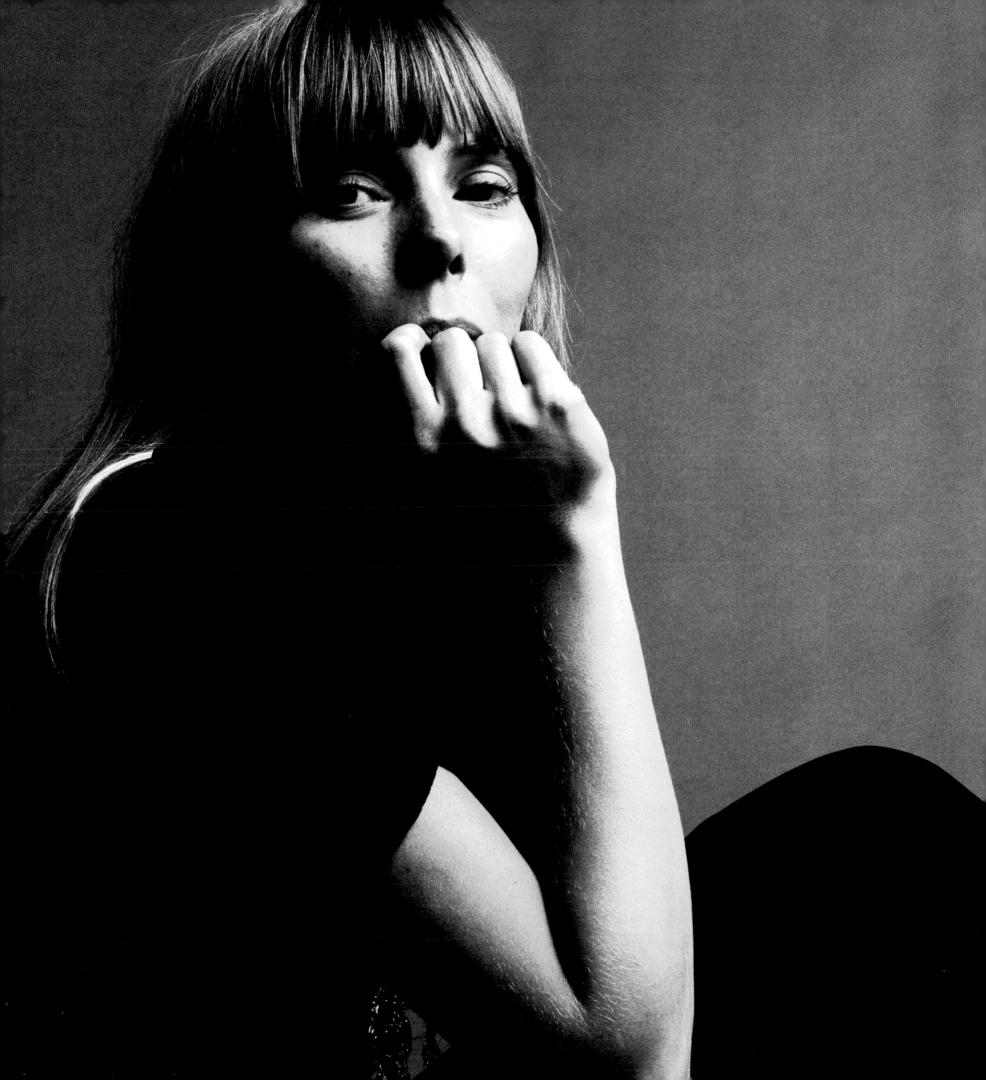

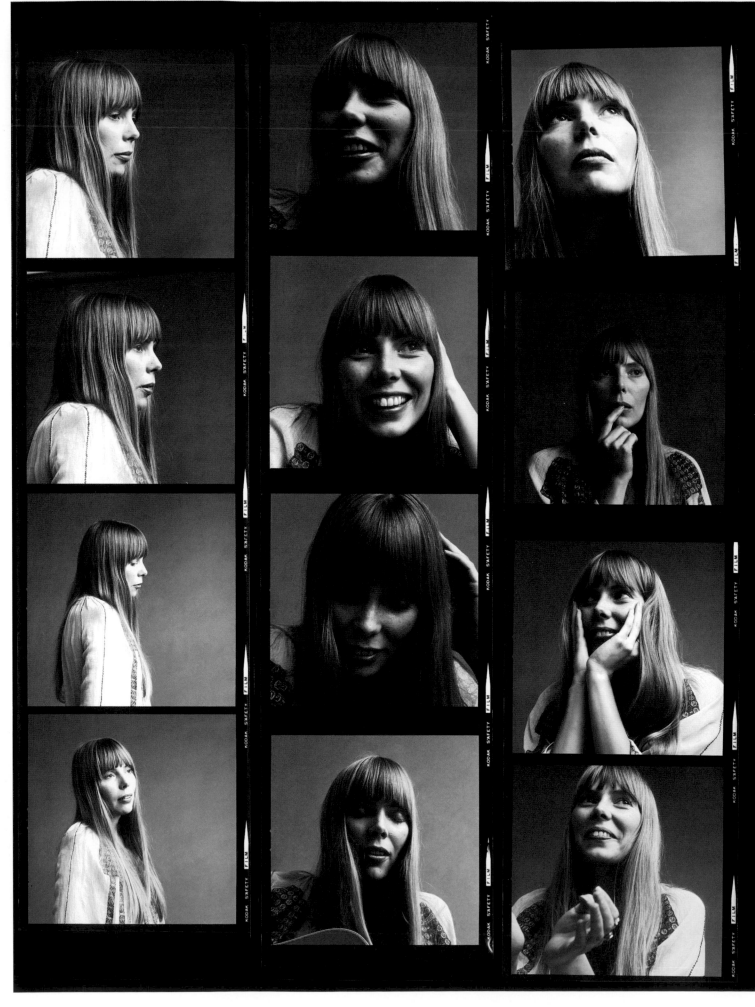

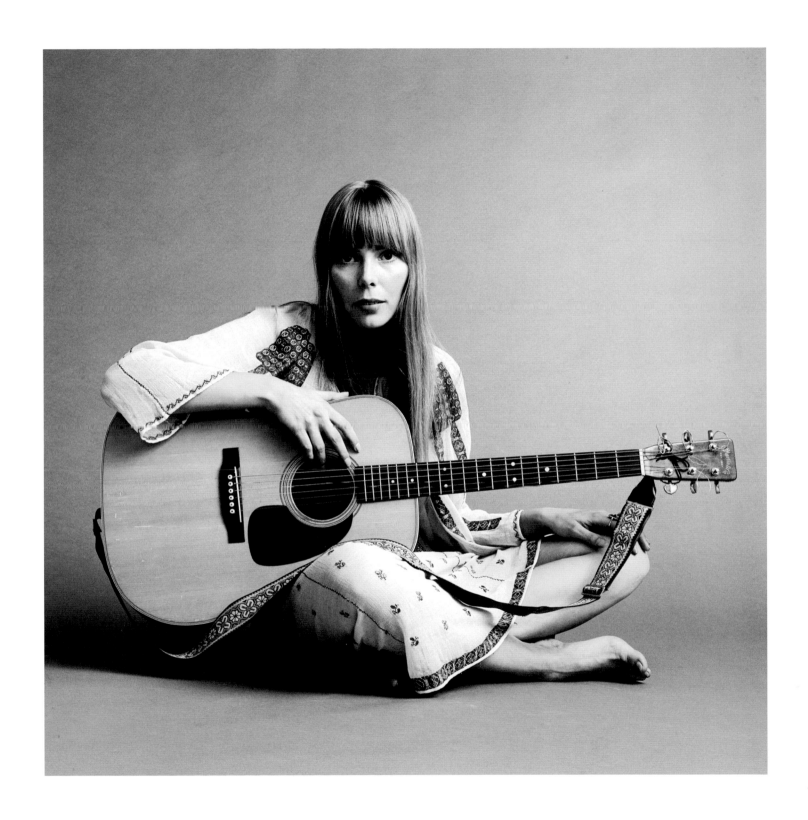

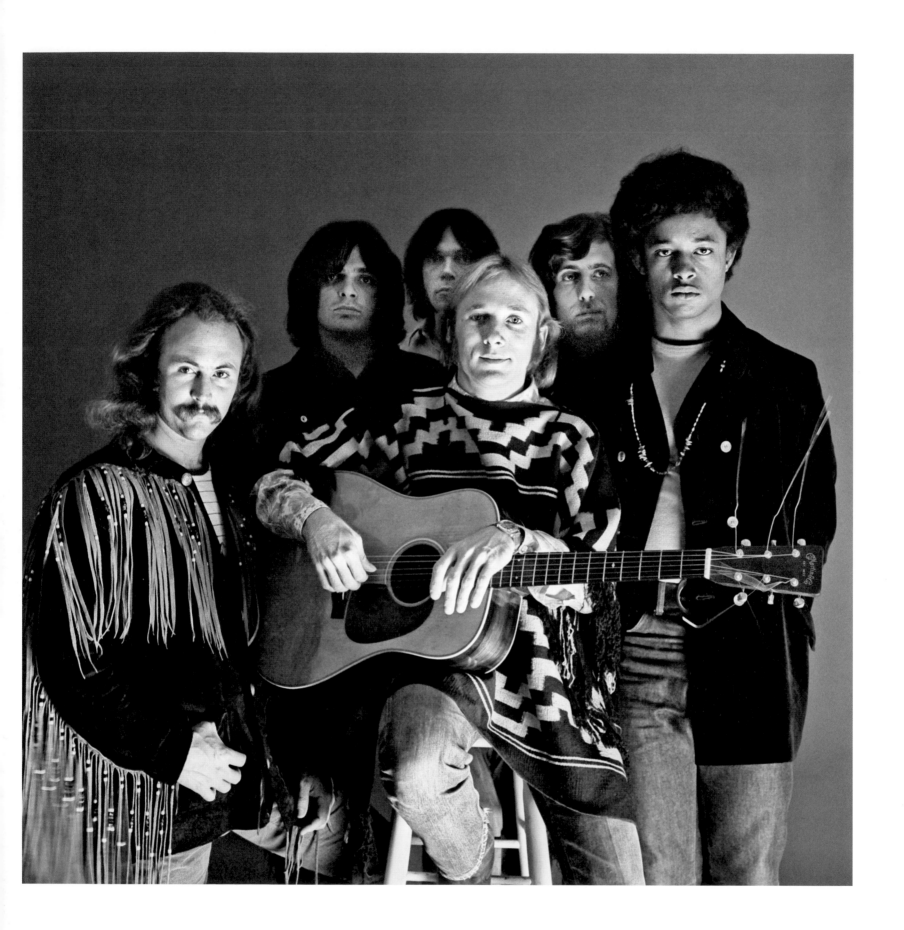

Above: Crosby, Stills, Nash & Young Opposite: Graham Nash

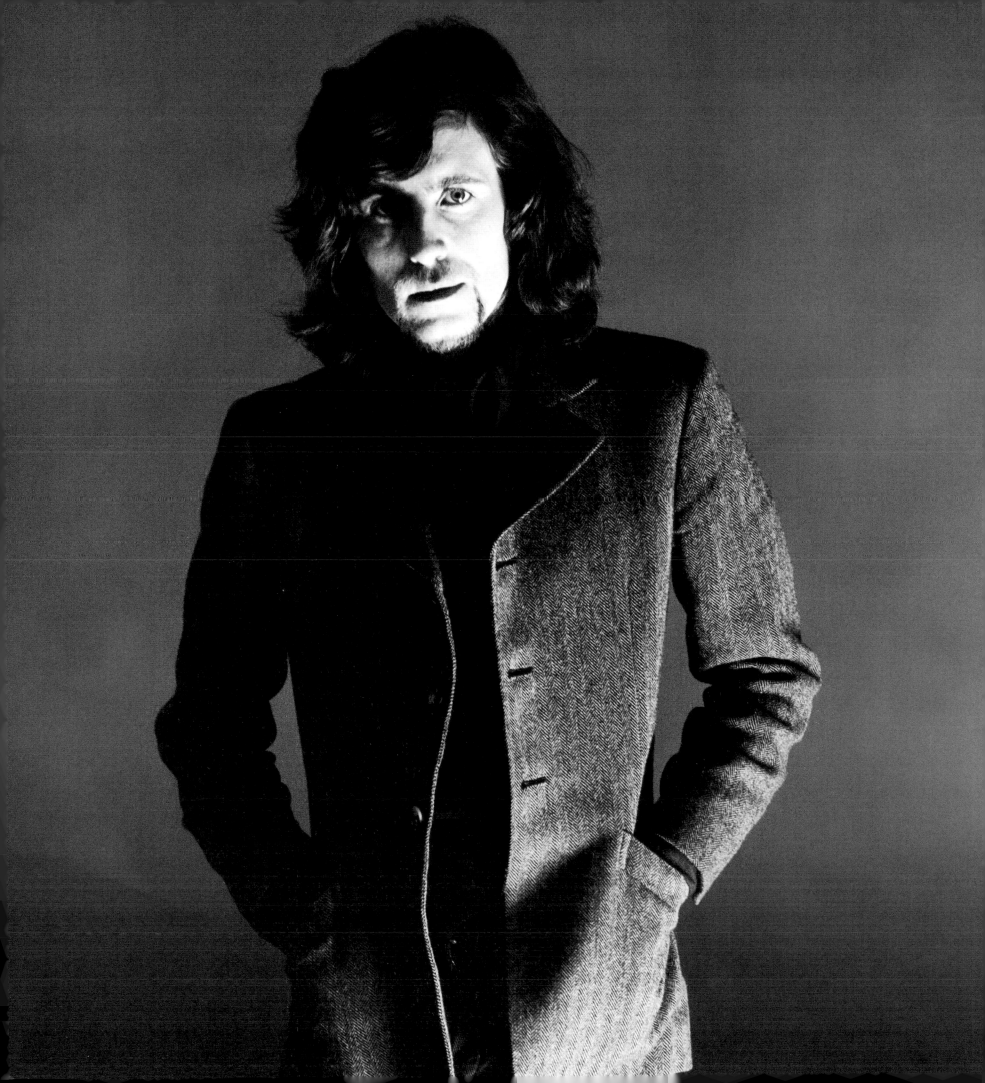

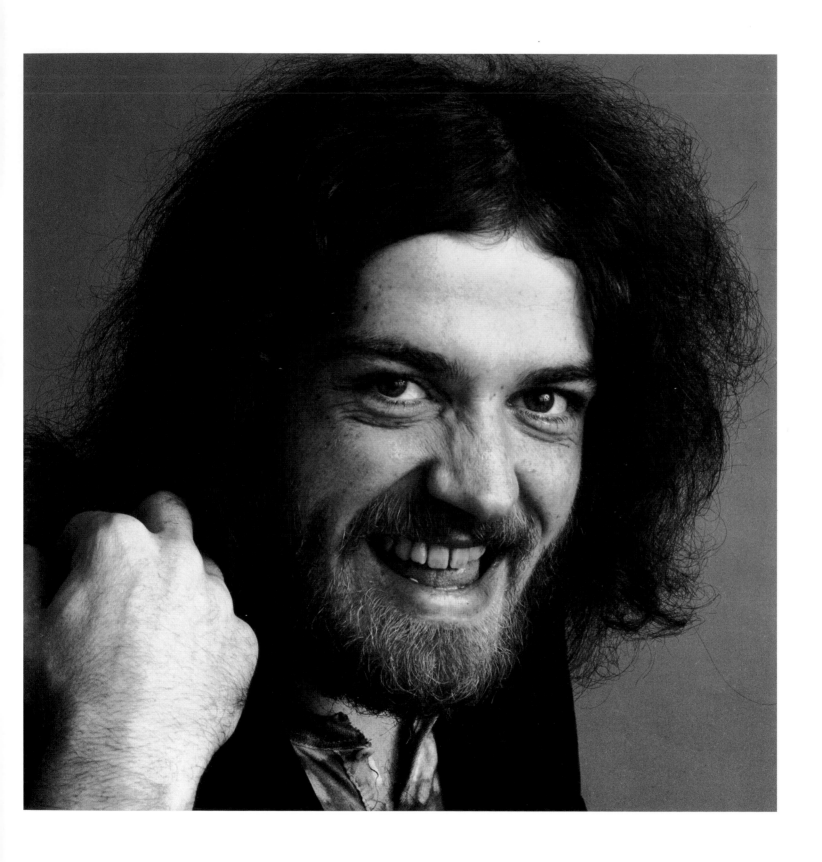

Above: Joe Cocker Opposite: Johnny Winter

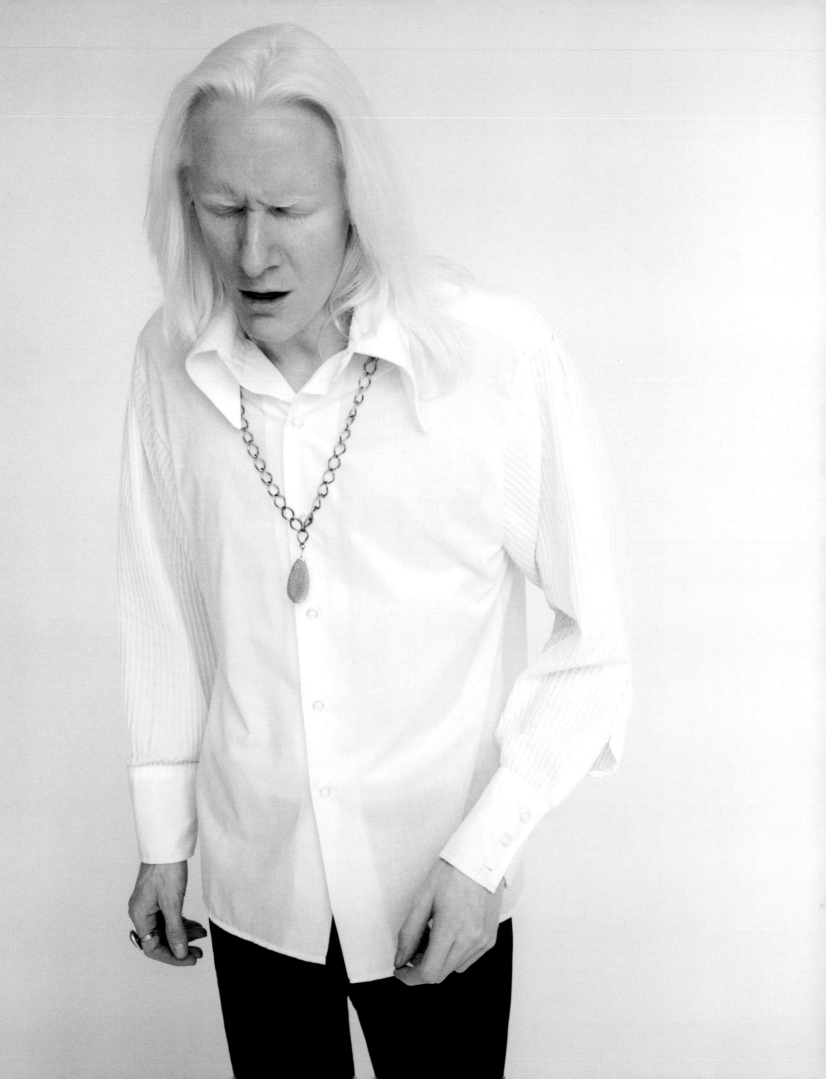

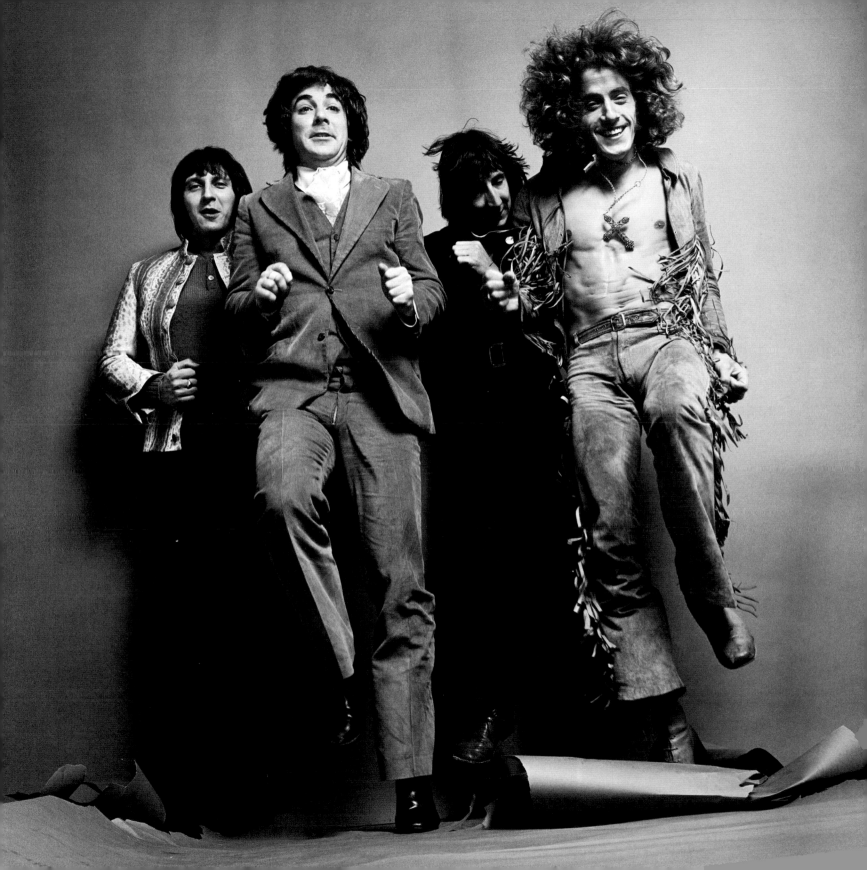

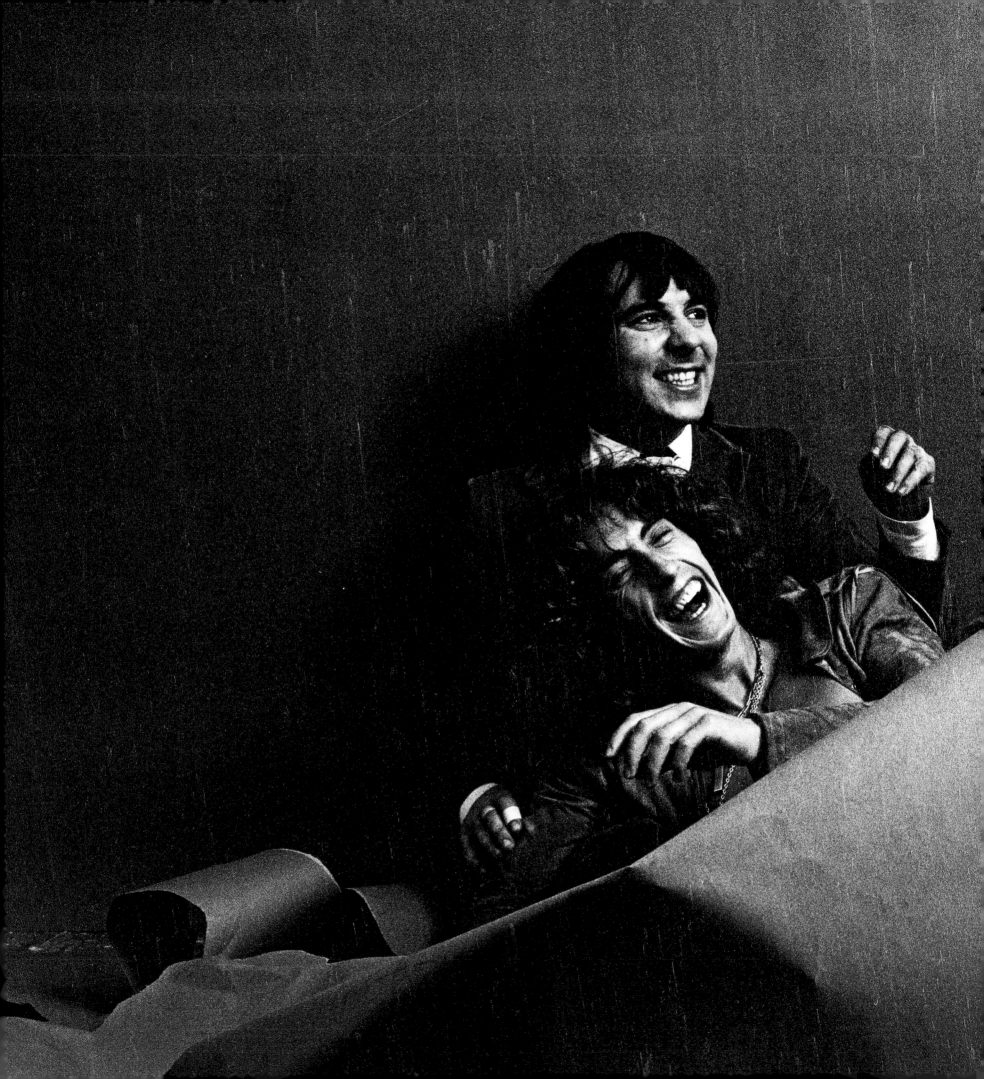

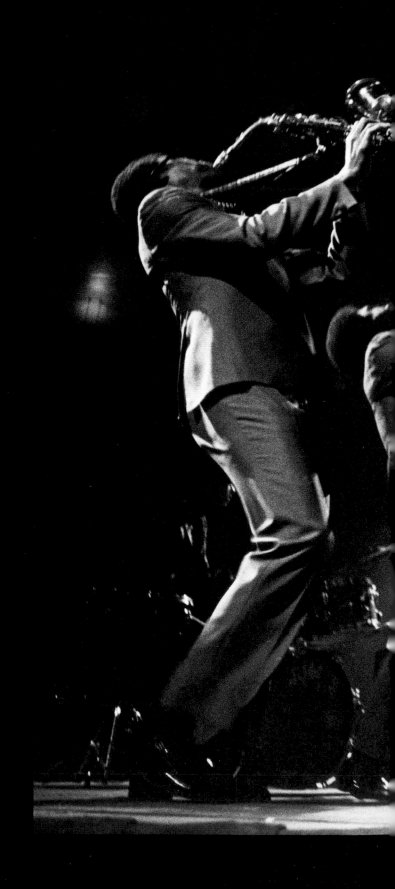

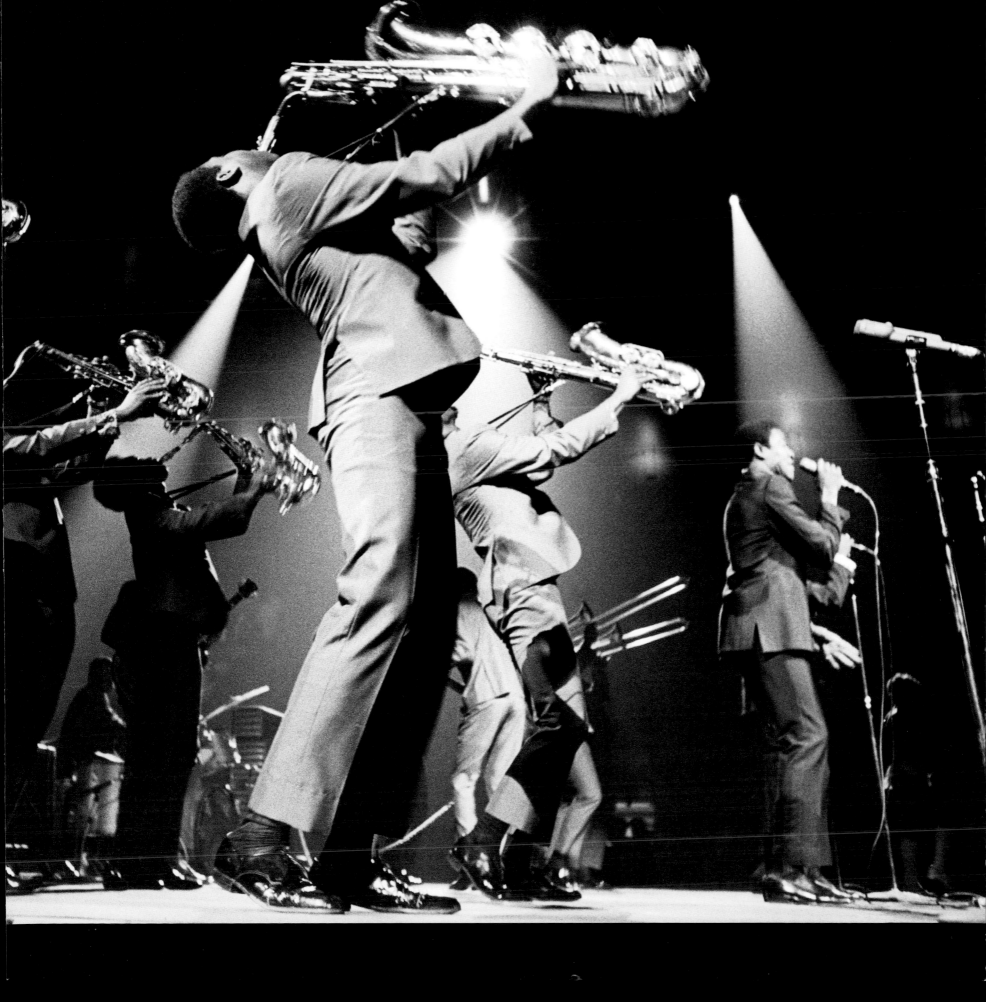

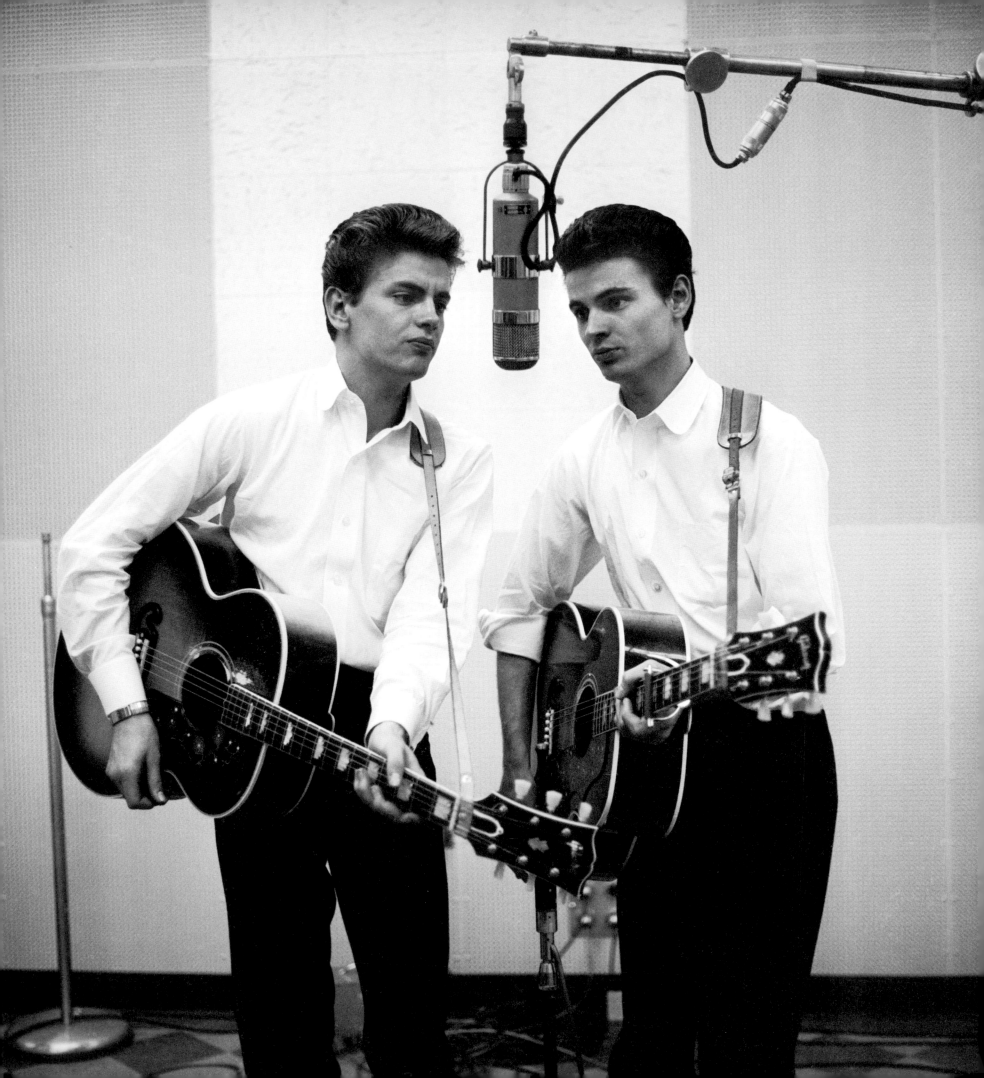

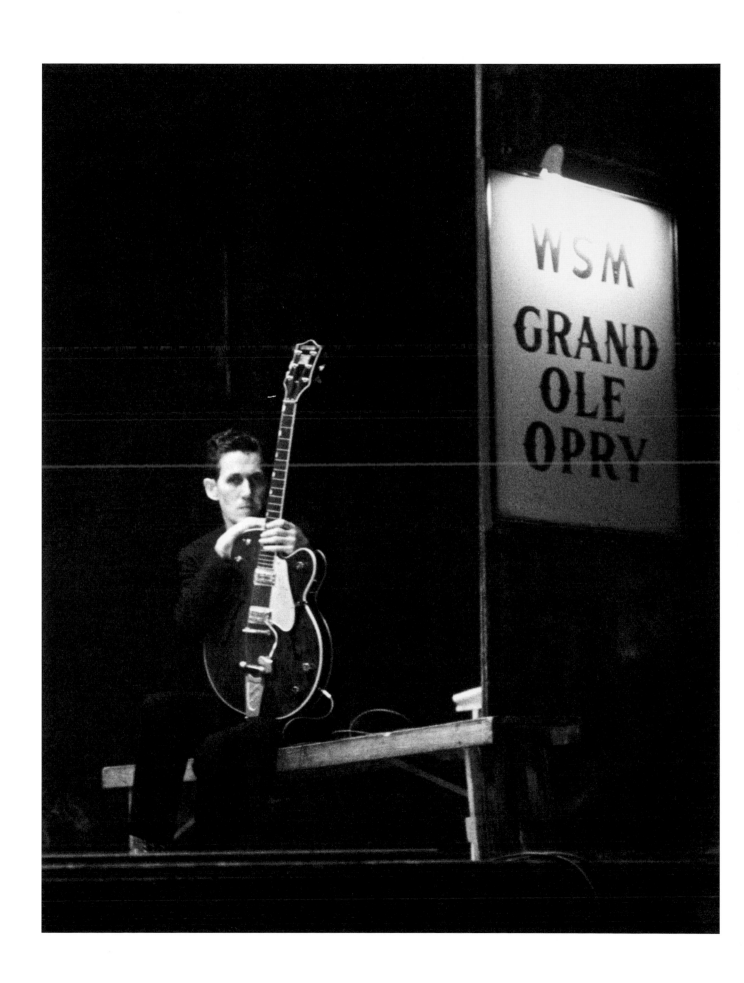

89 Opposite: The Everly Brothers Above: Chet Atkins

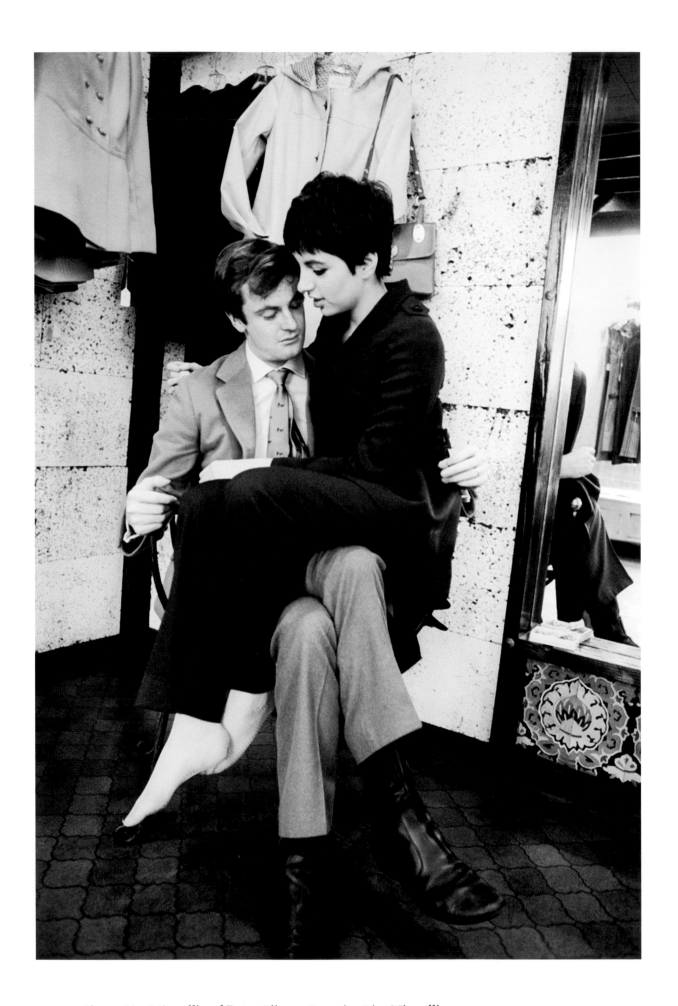

90 Above: Liza Minnelli and Peter Allen Opposite: Liza Minnelli

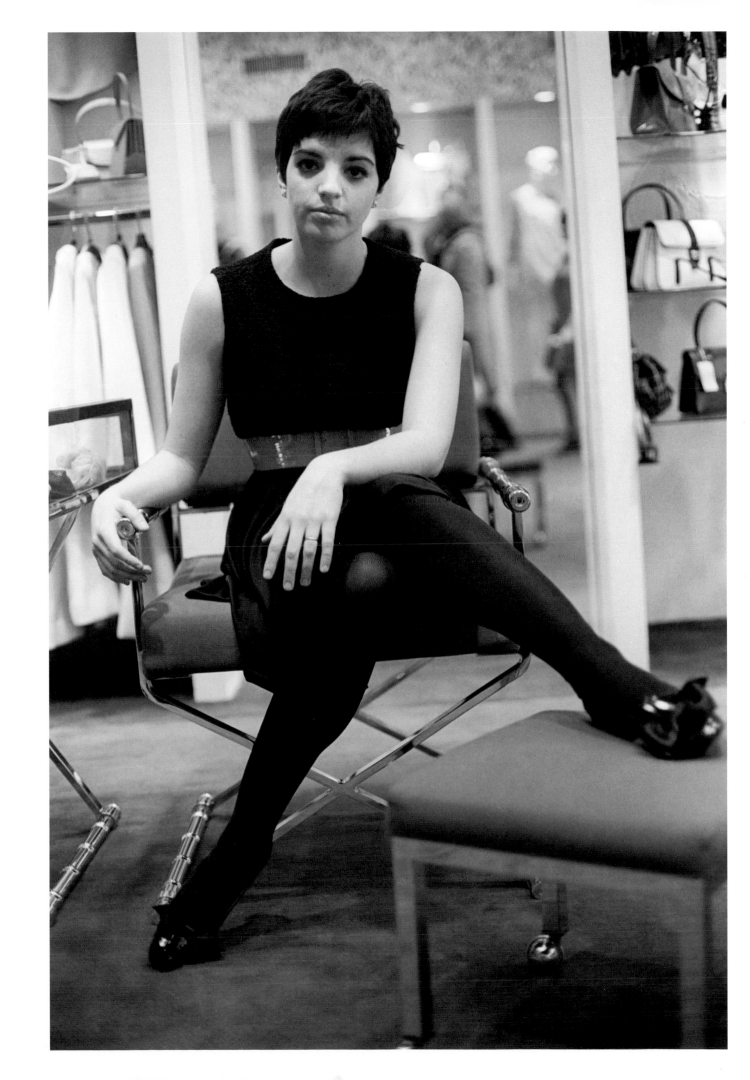

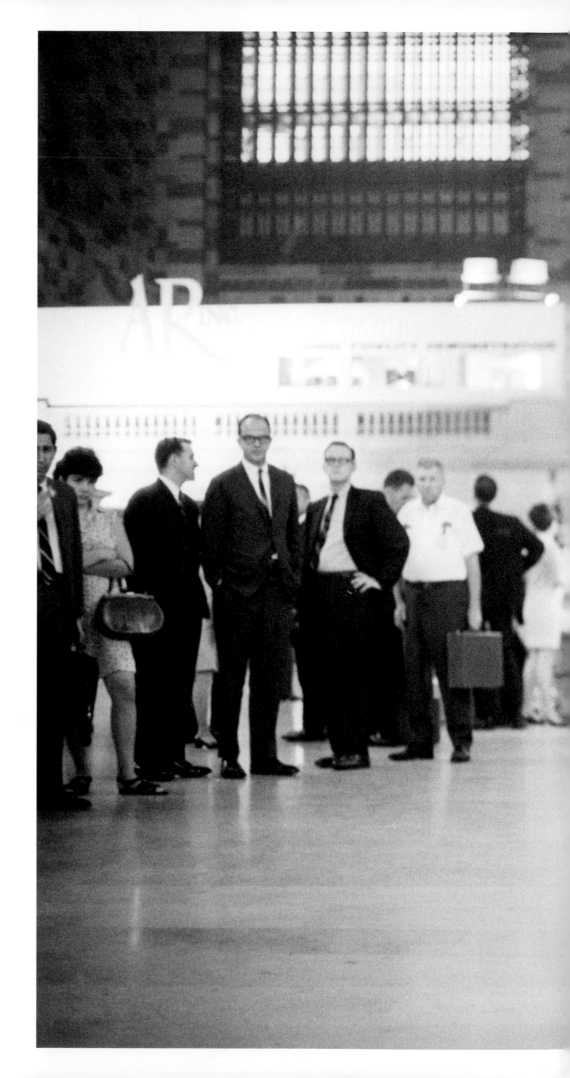

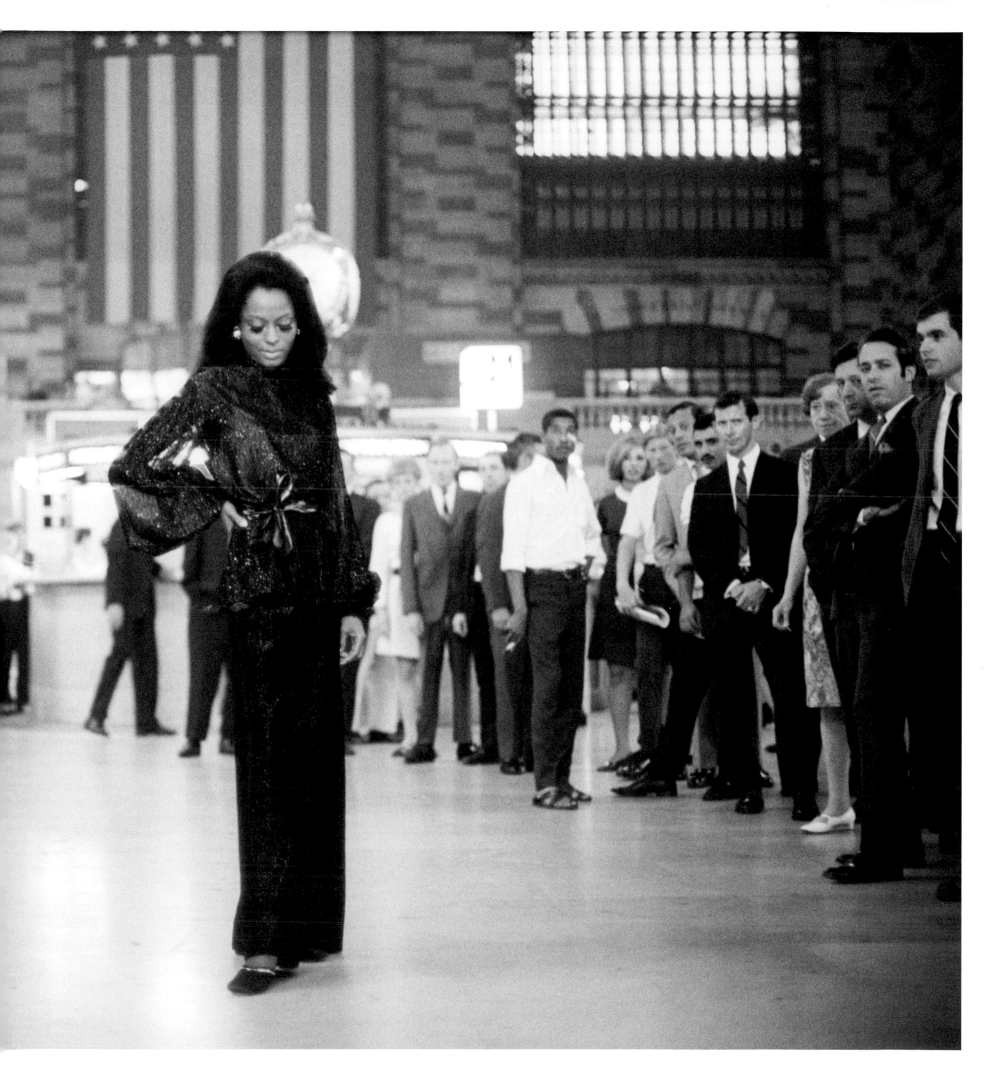

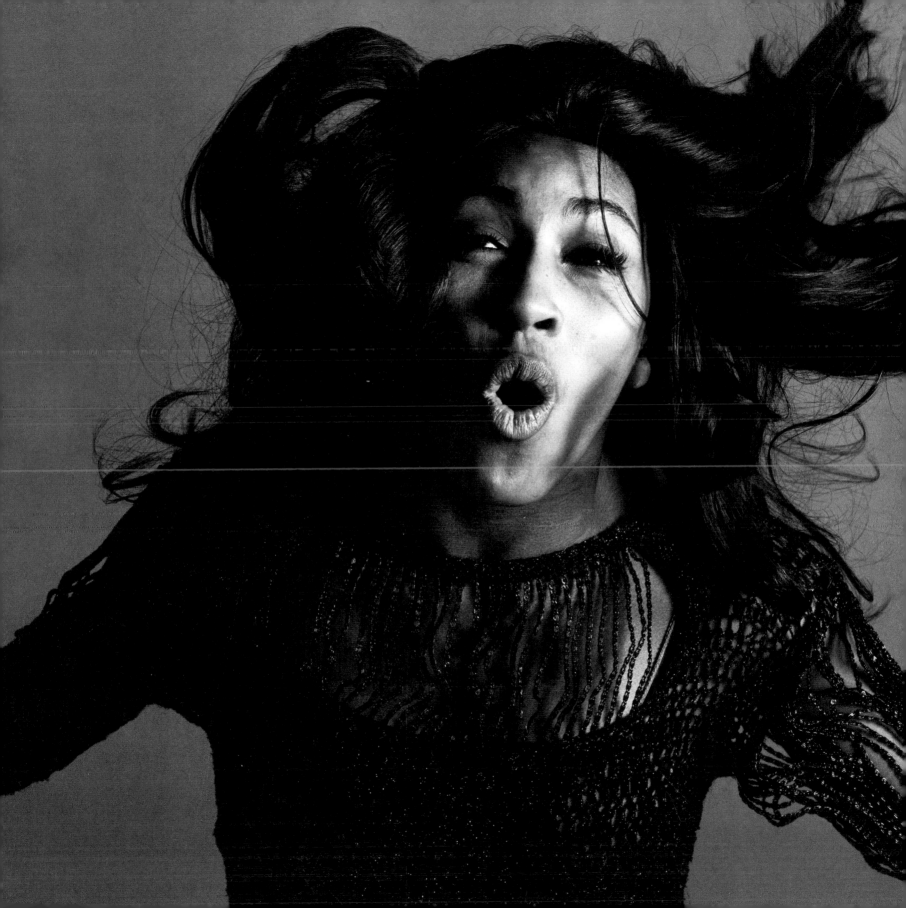

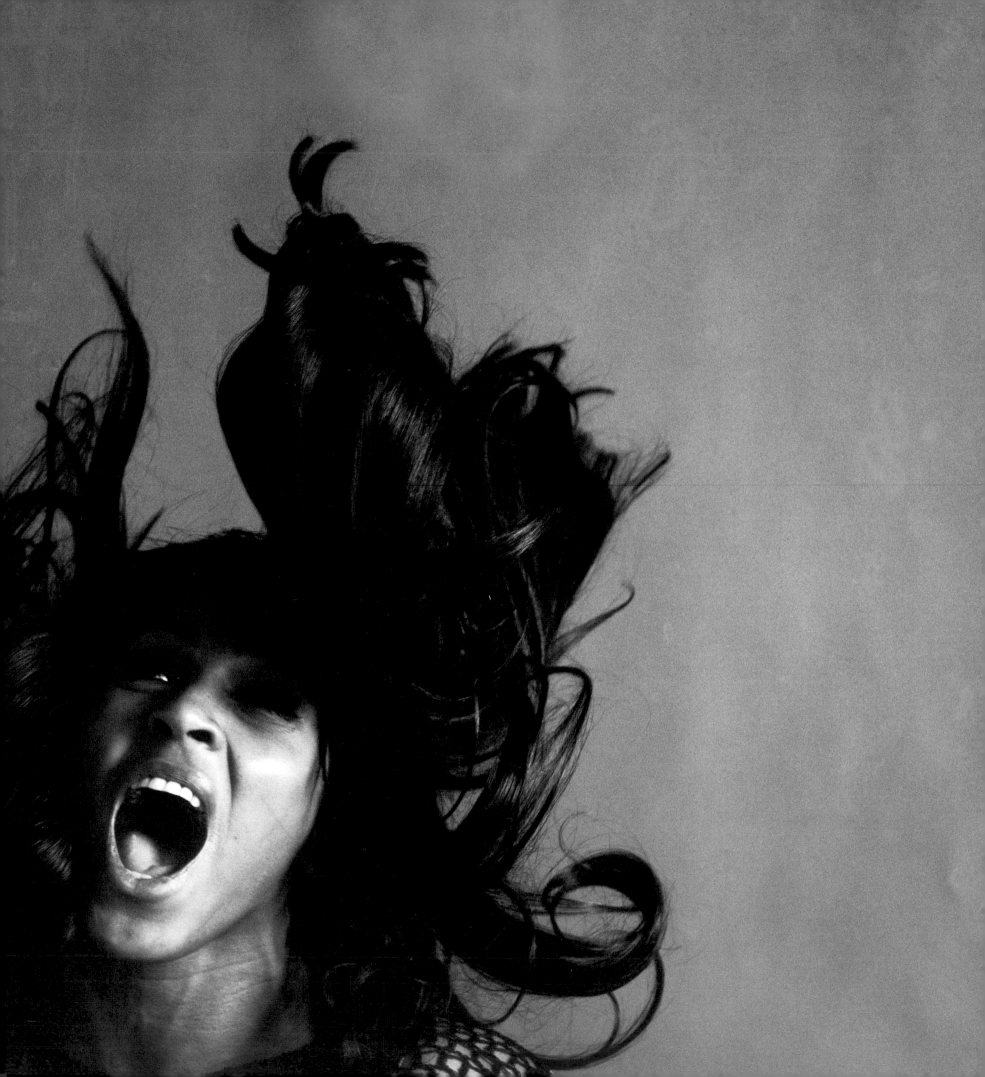

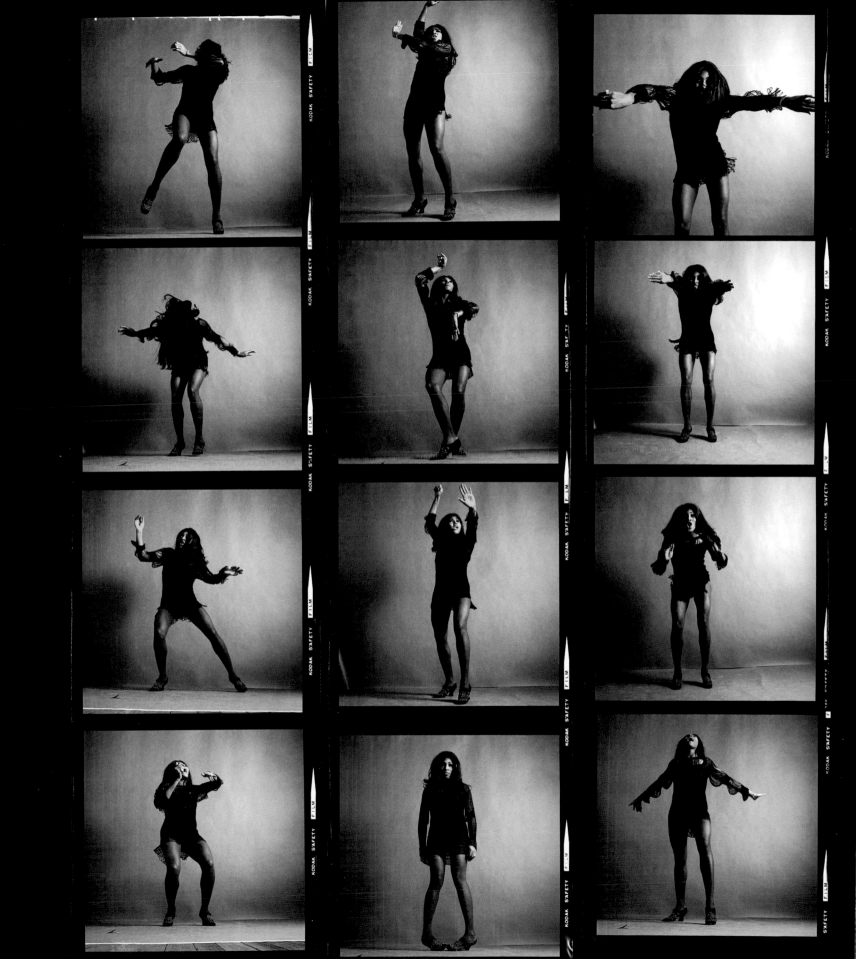

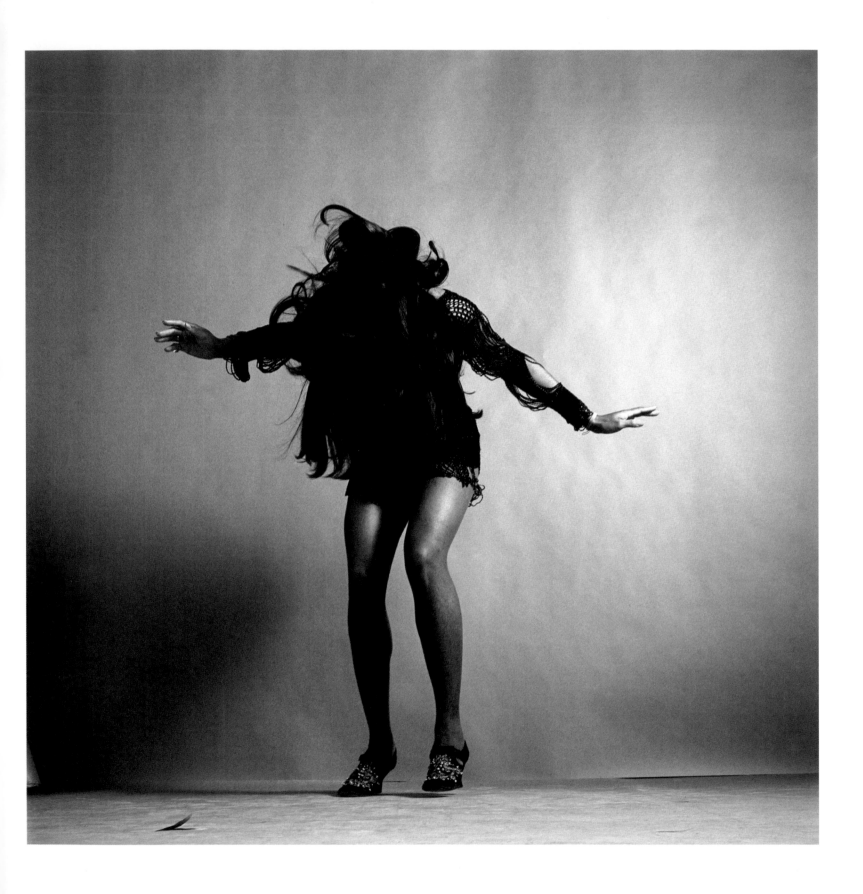

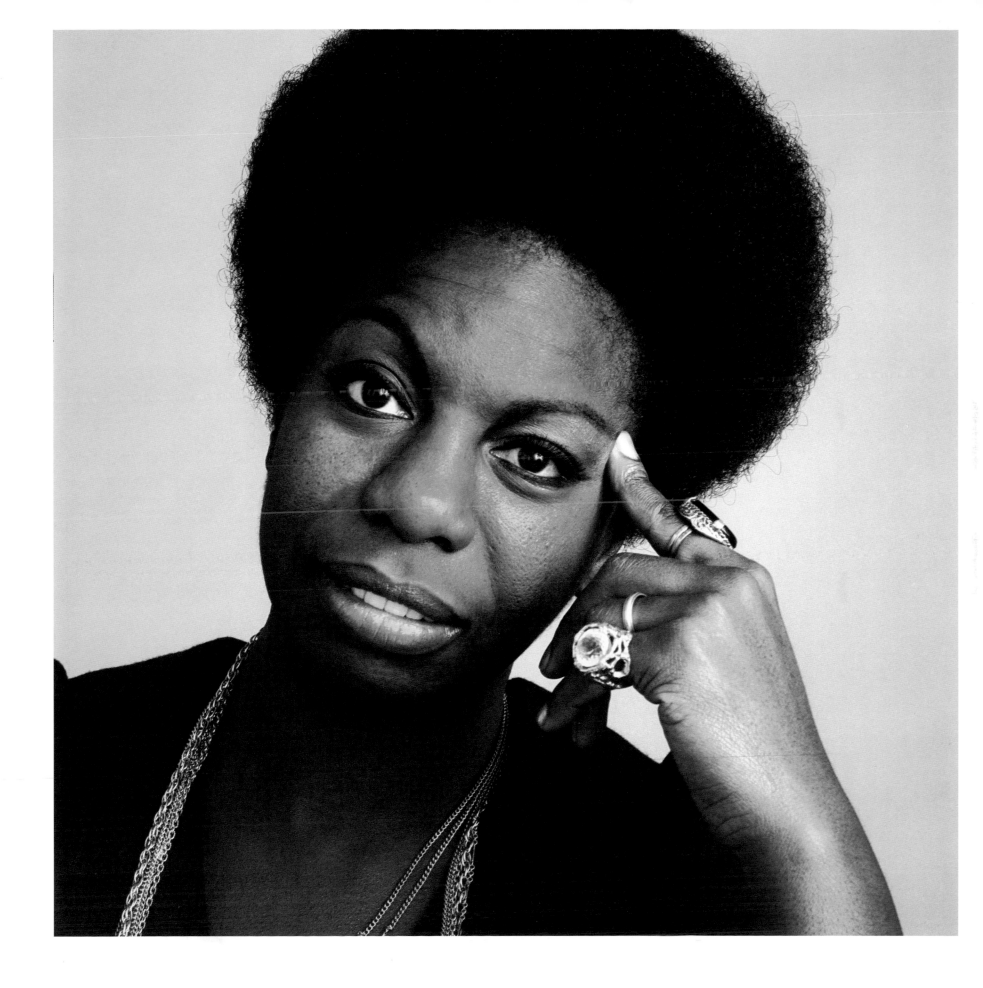

99 Nina Simone

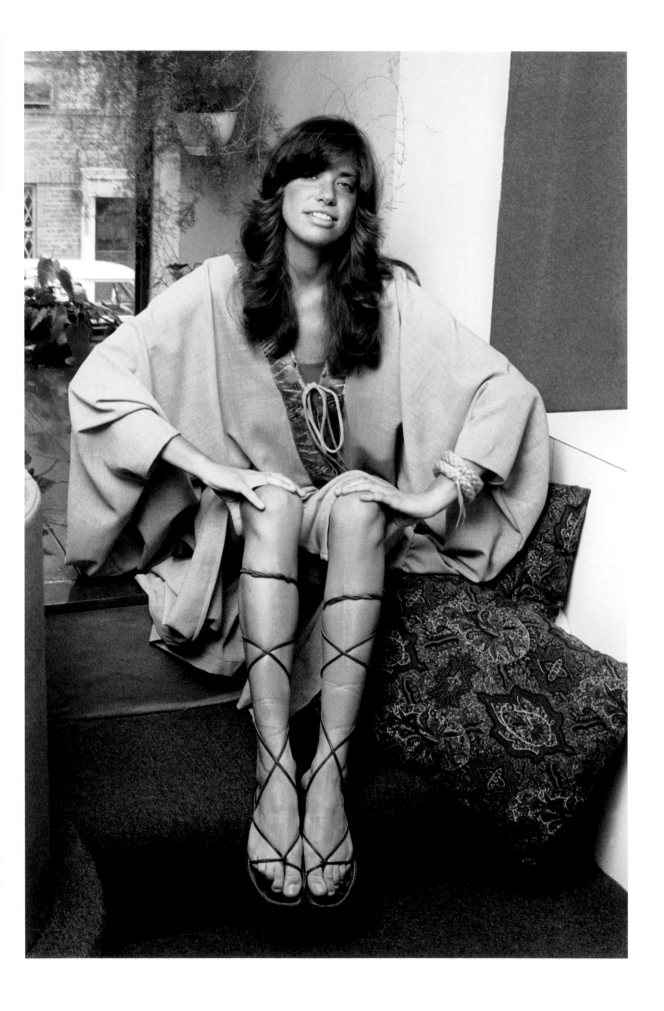

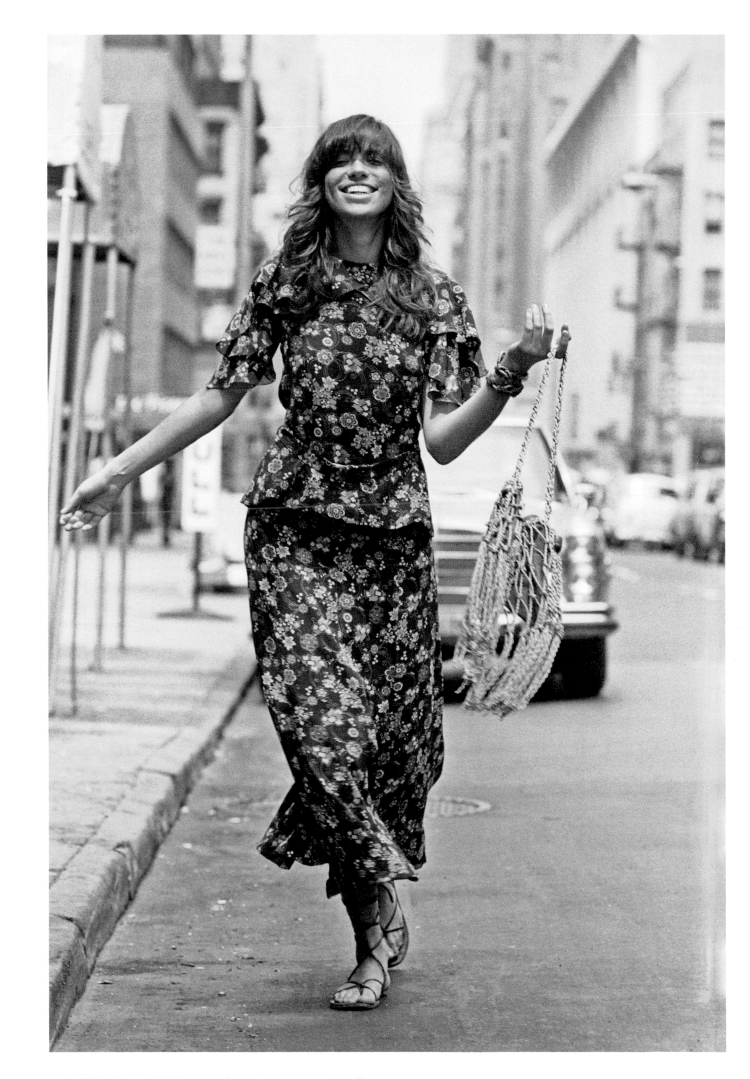

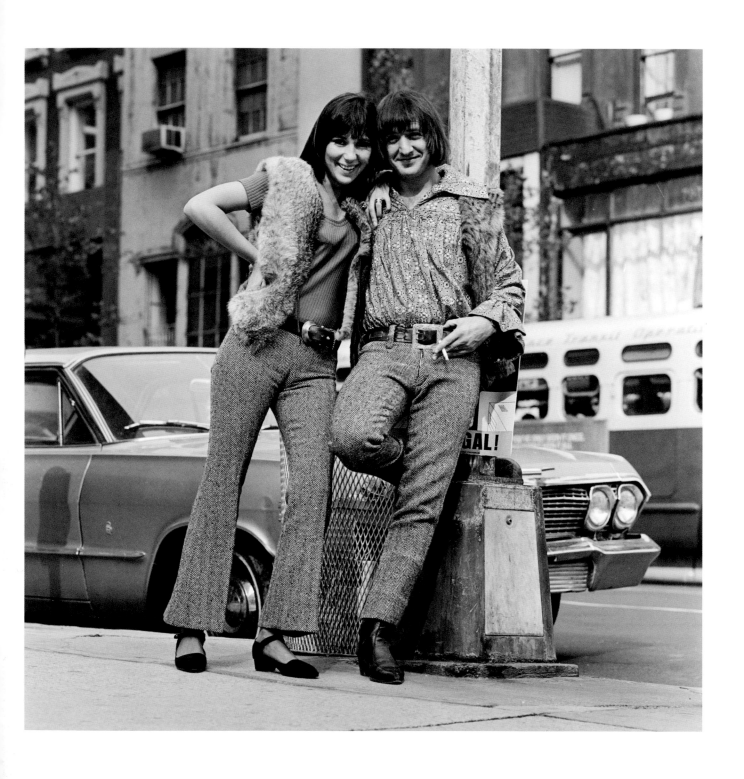

102 Above: Sonny and Cher Opposite: Cher

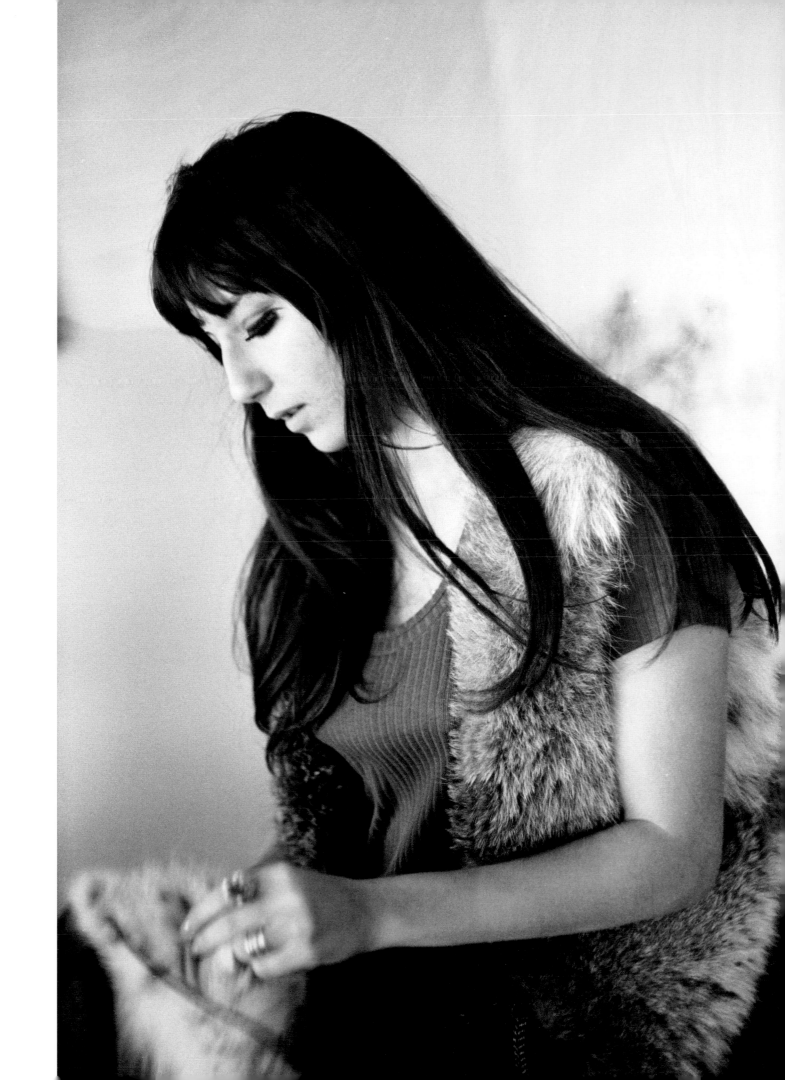

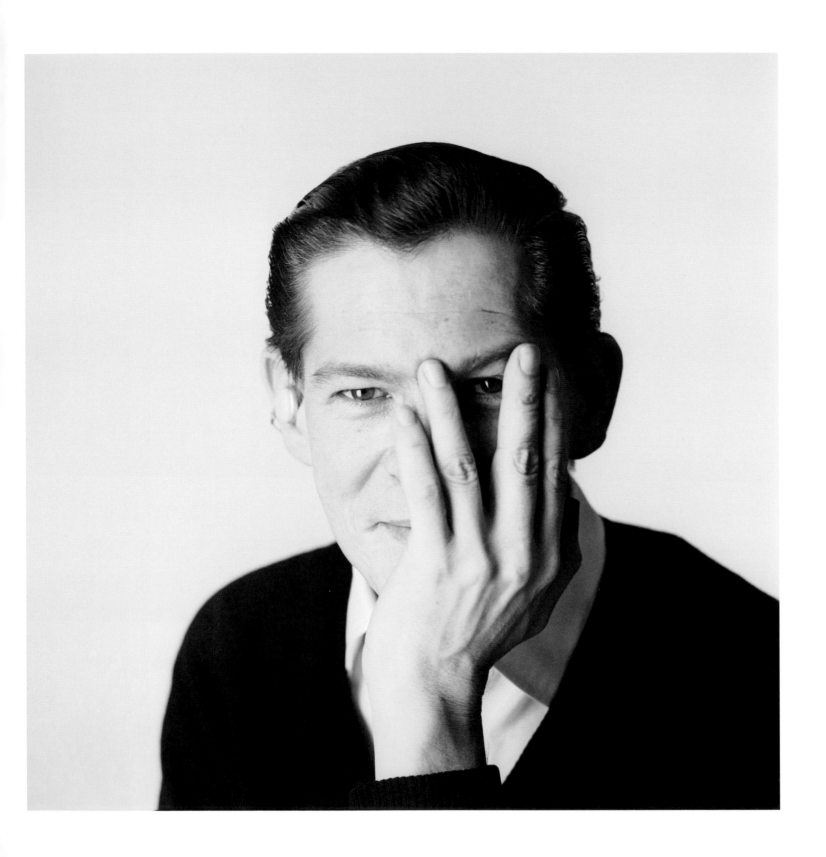

104 Johnnie Ray

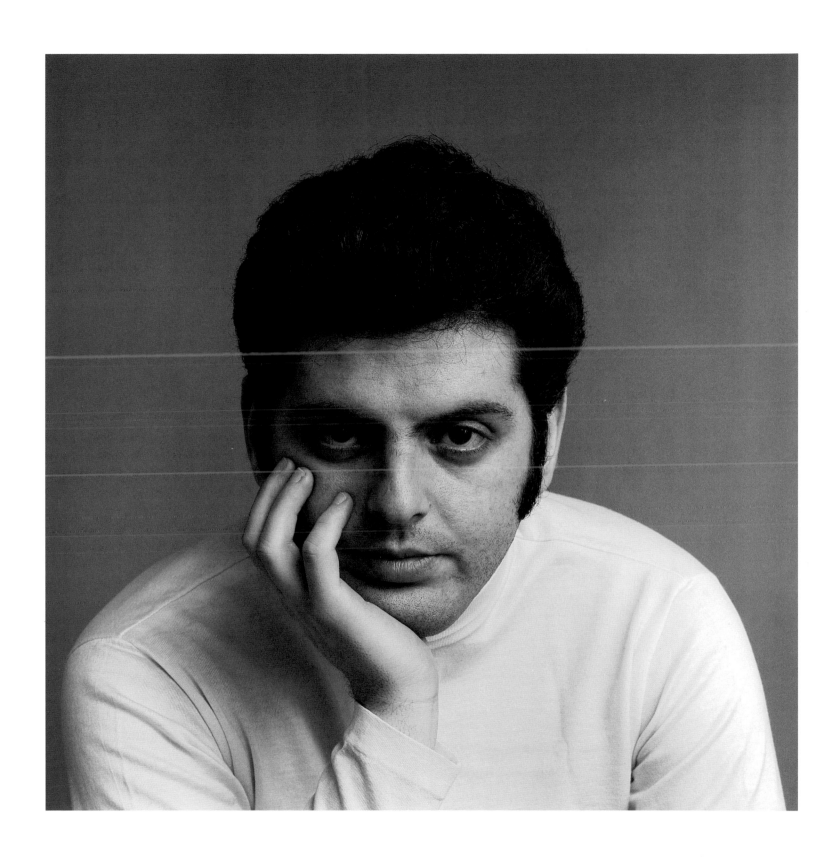

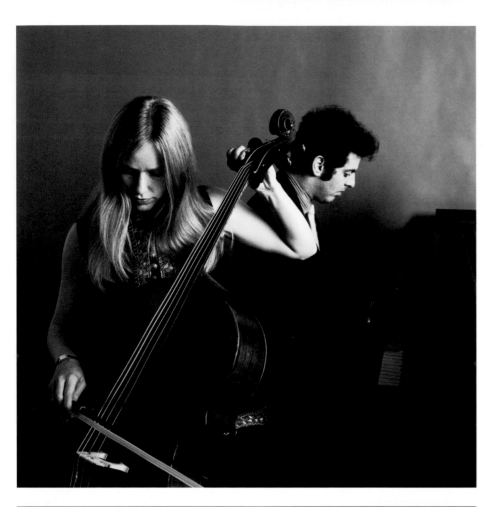

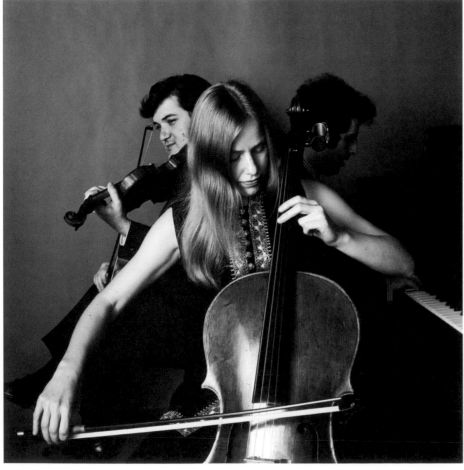

Above top: Jacqueline Du Pré and Daniel Barenboim

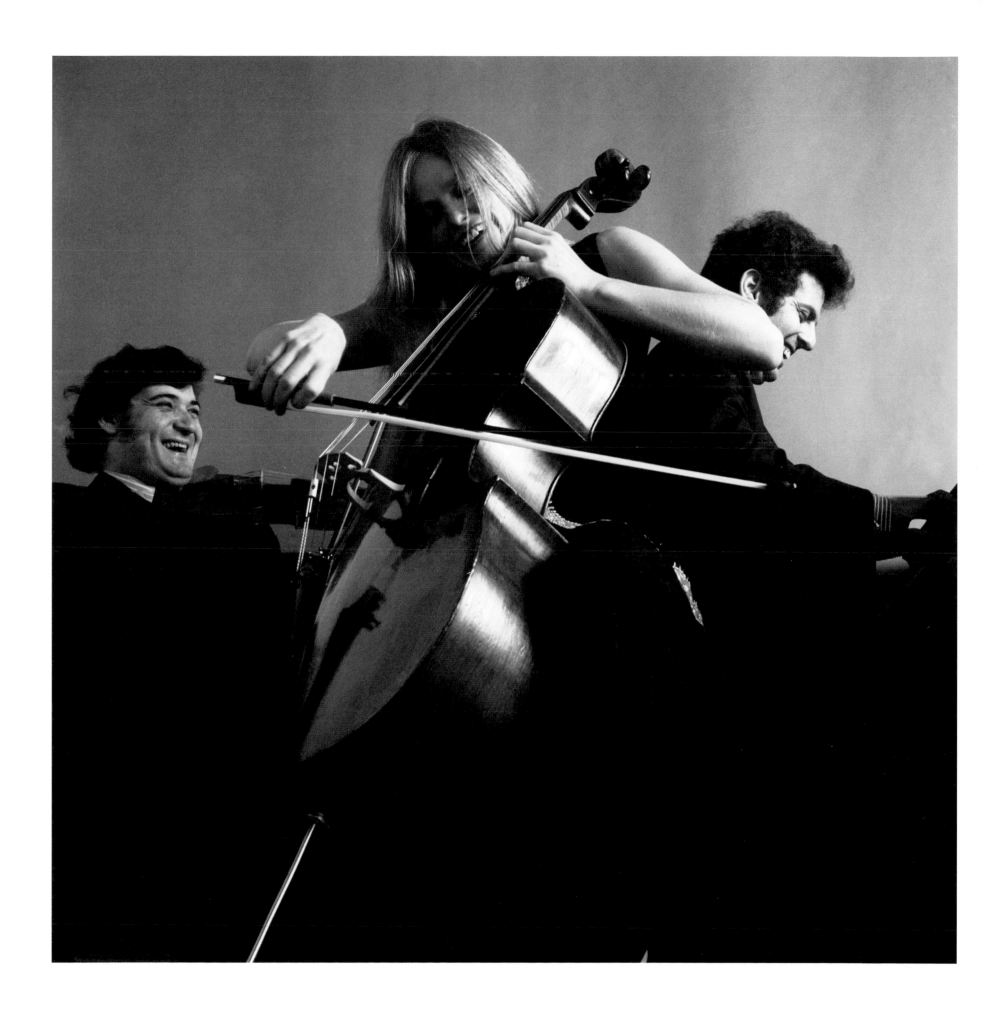

107 Above and opposite below: Pinchas Zuckerman, Jacqueline Du Pré, and Daniel Barenboim

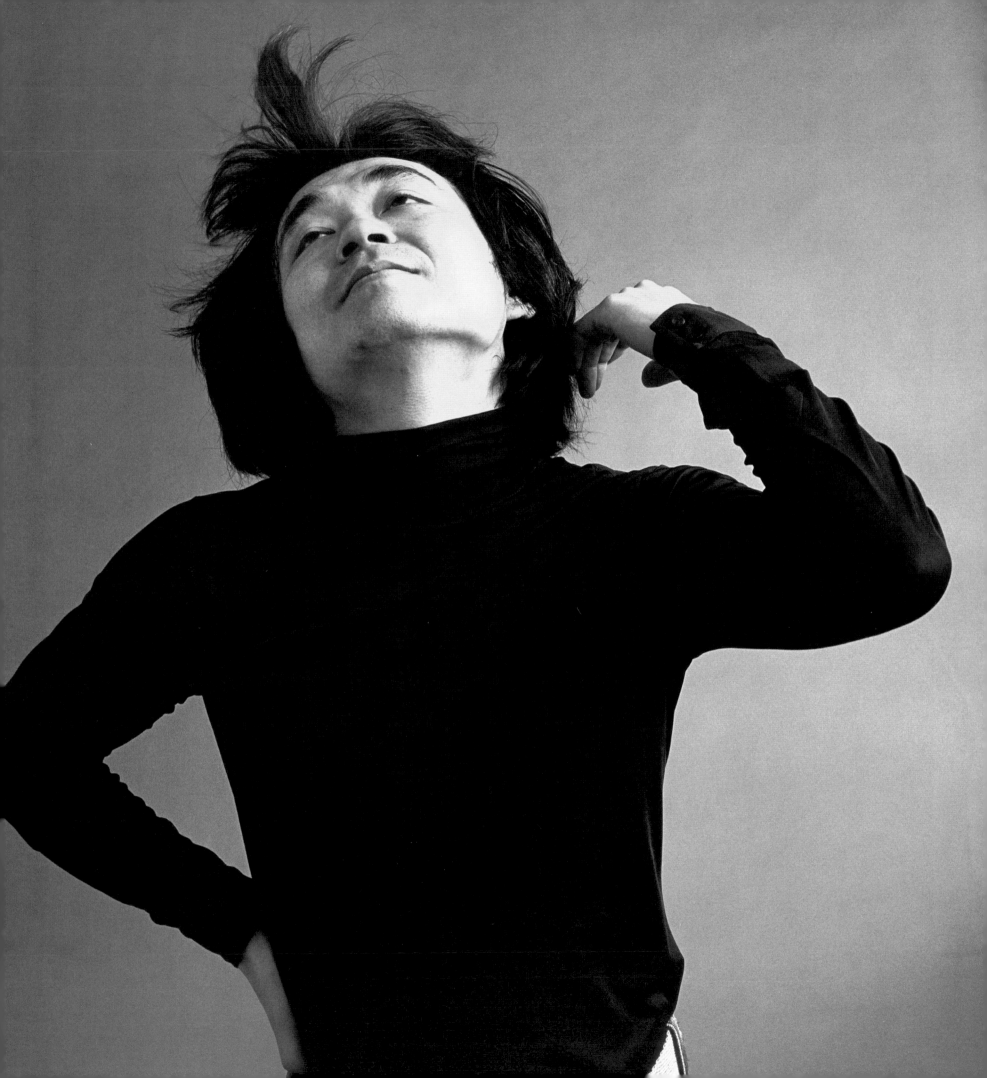

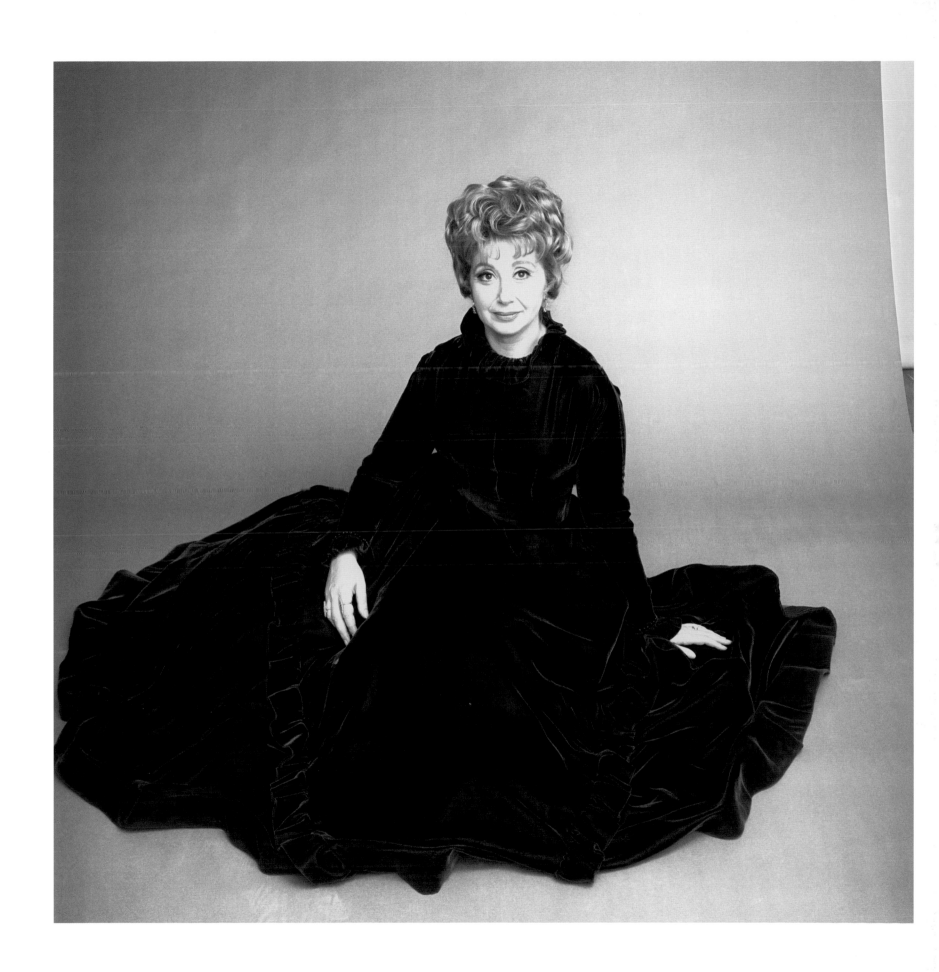

Opposite: Seiji Ozawa Above: Beverly Sills

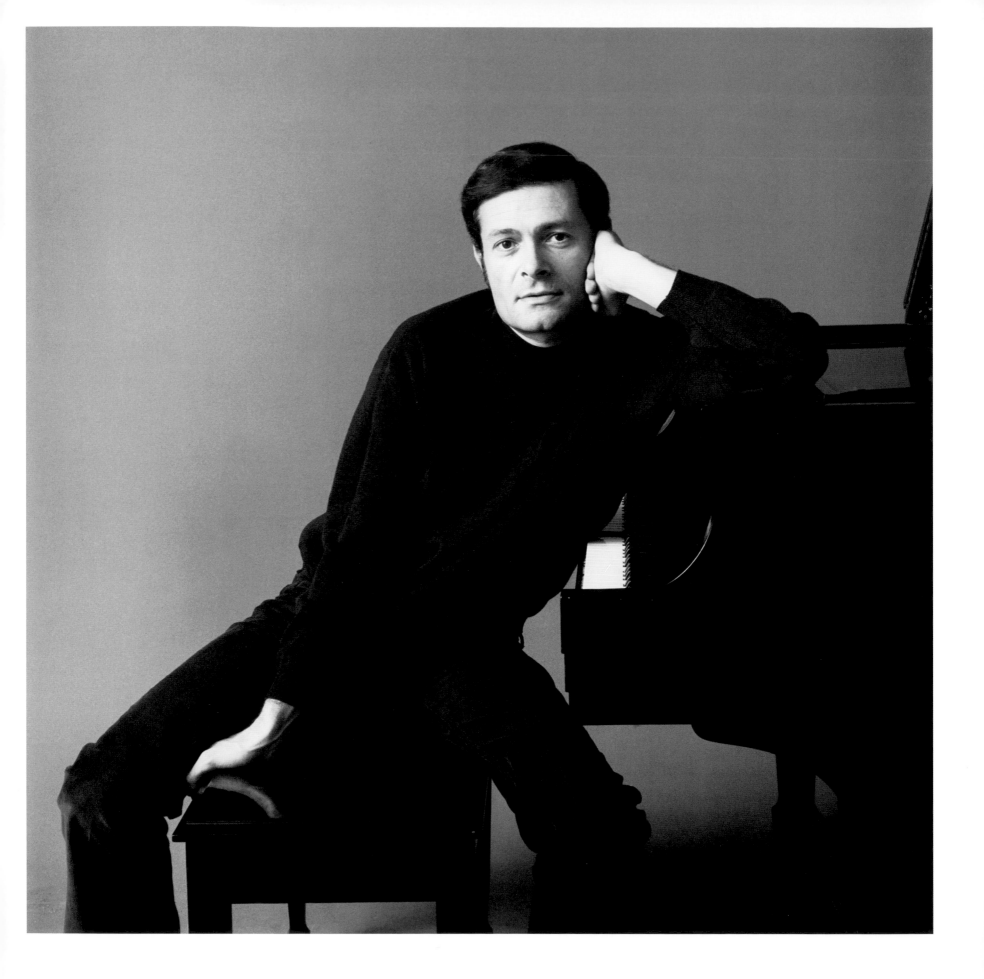

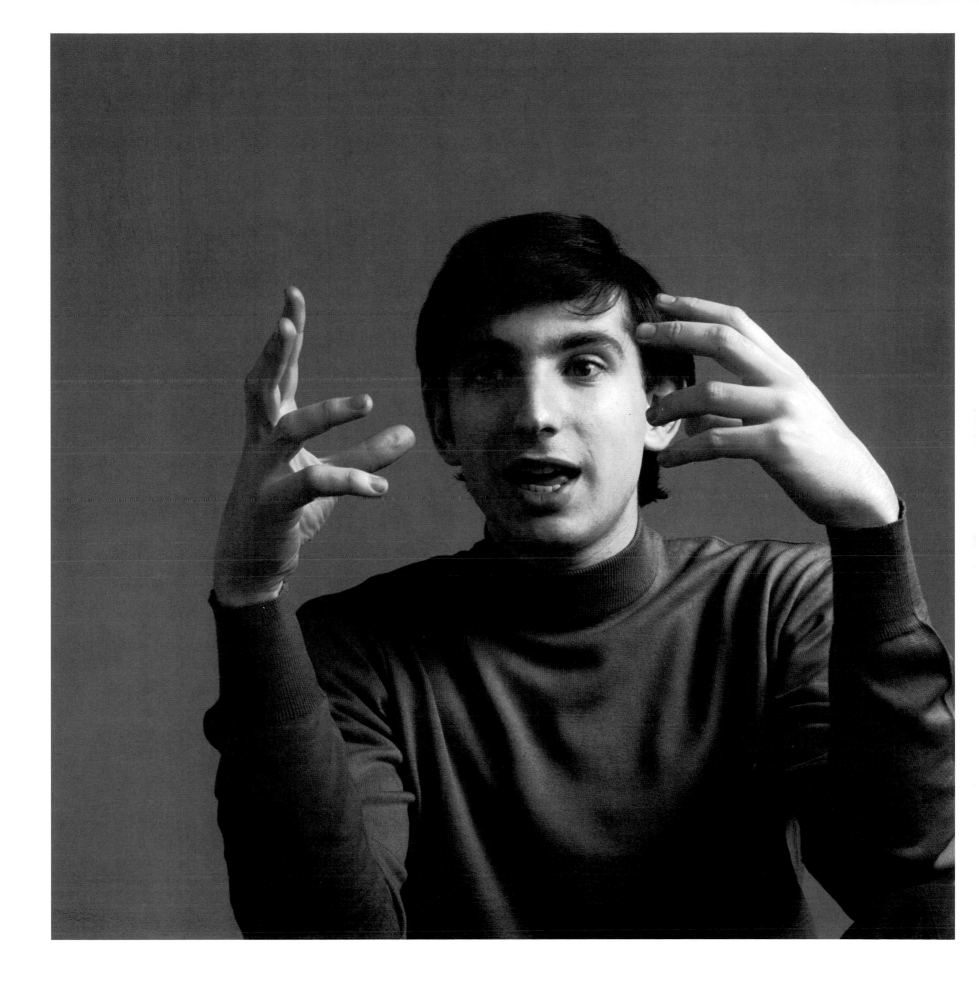

111 Michael Tilson Thomas

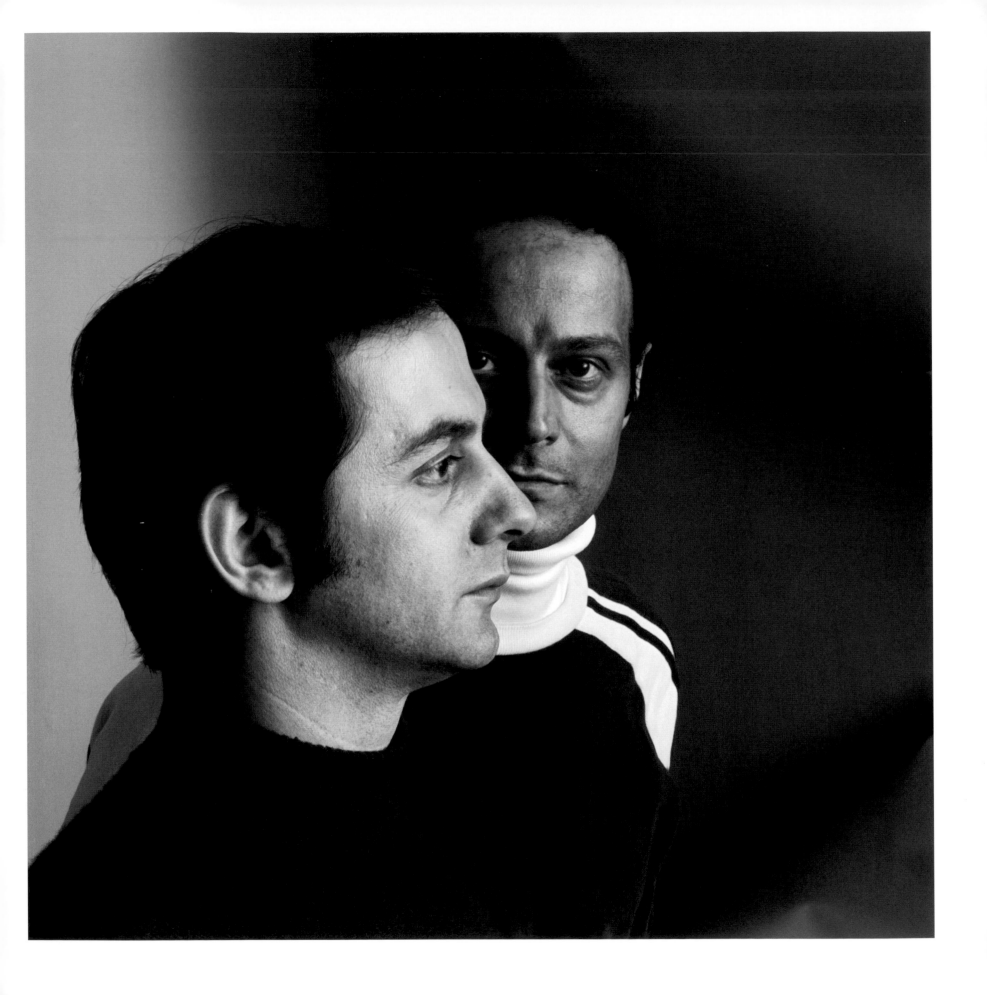

112 Robert Joffrey and Gerald Arpino

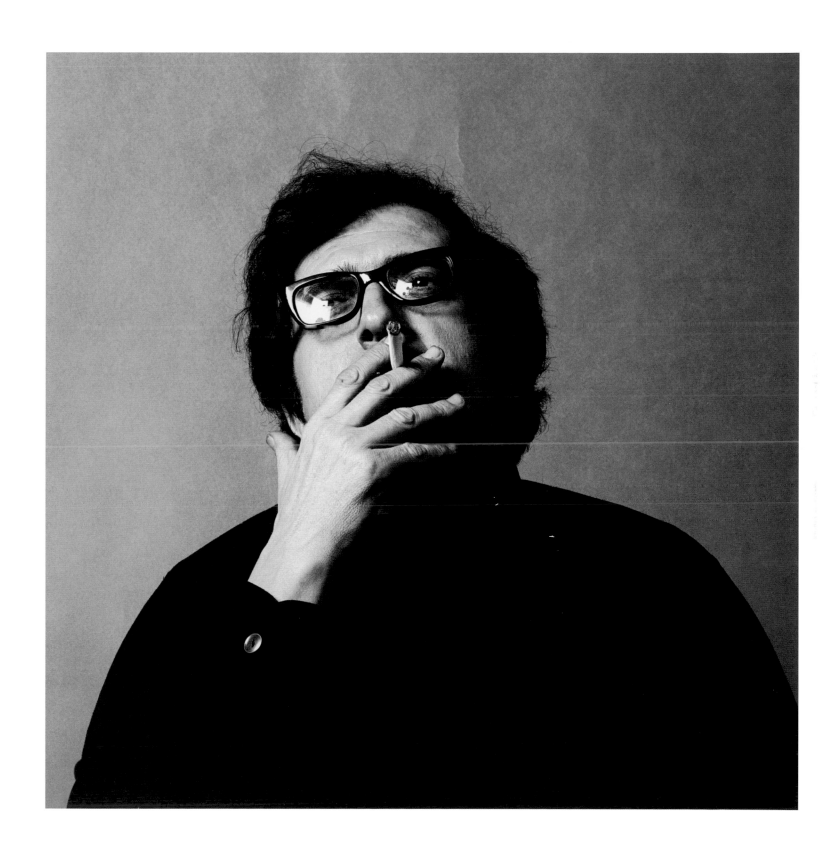

113 Luciano Berio

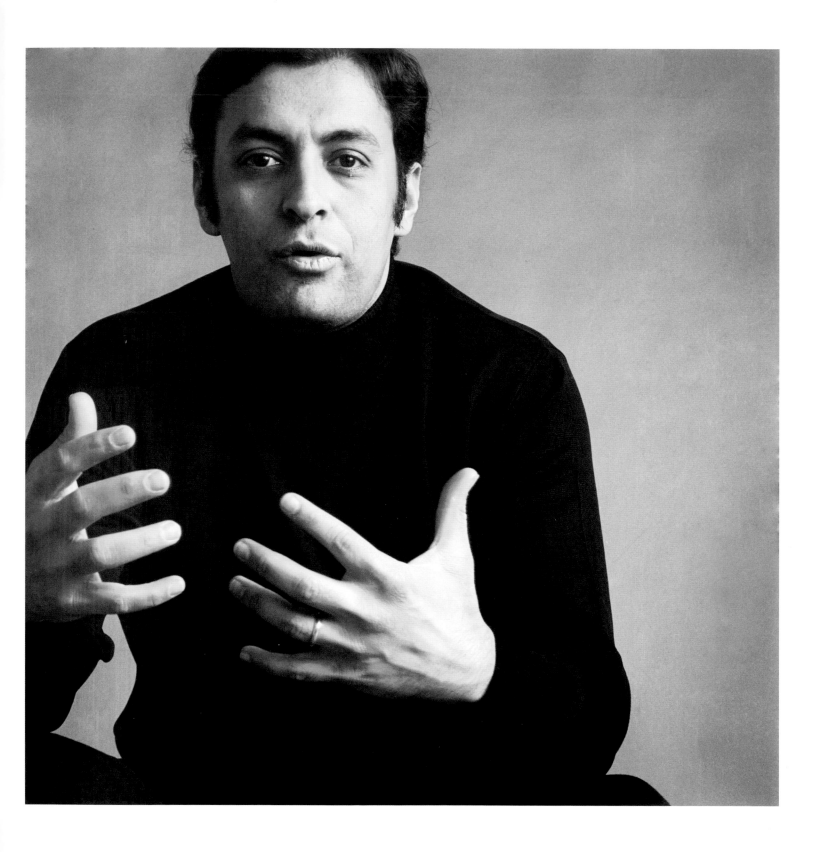

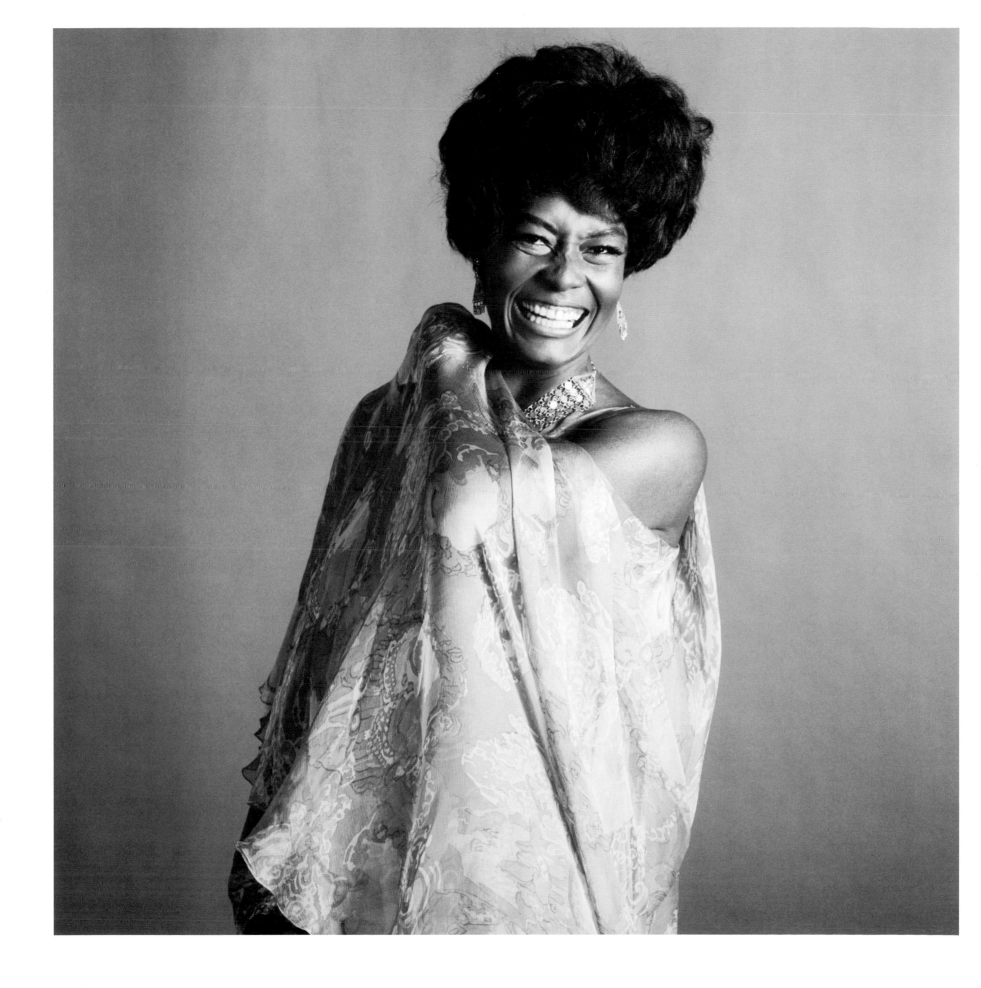

Adrienne Kennedy with her son

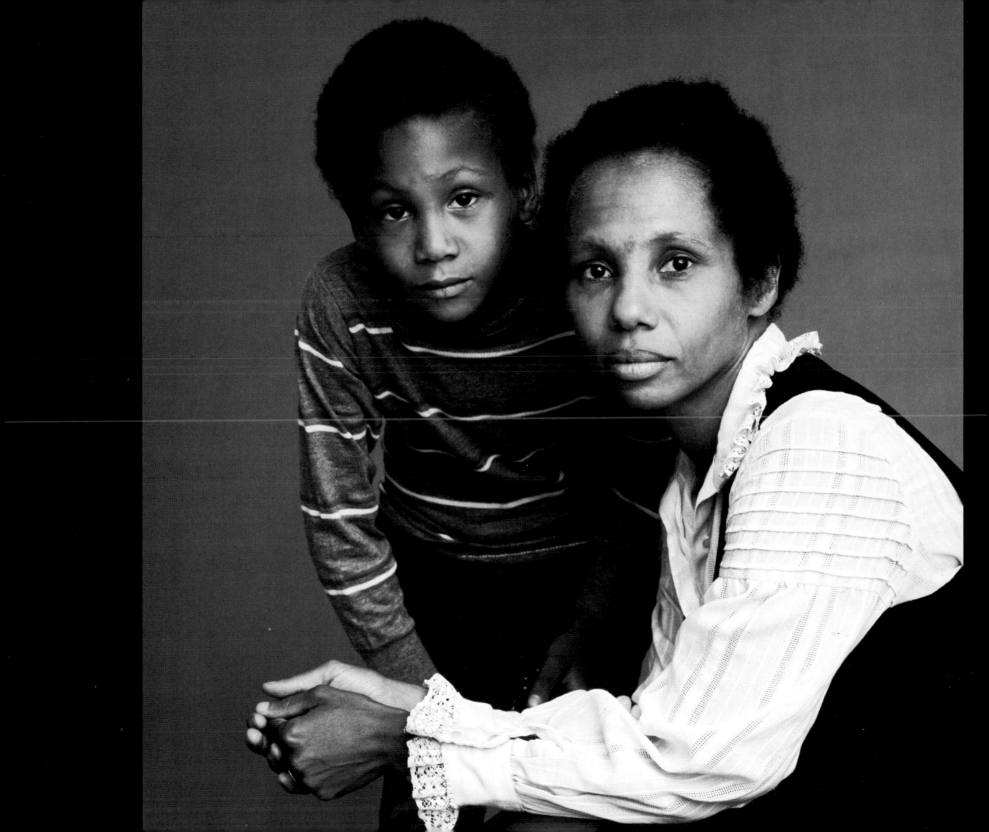

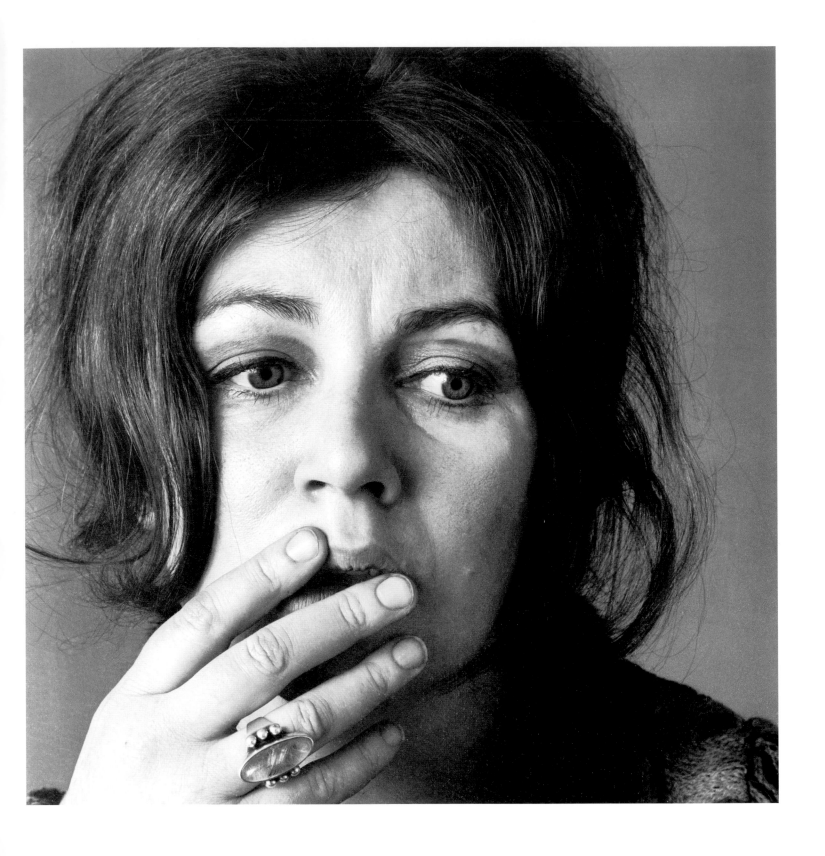

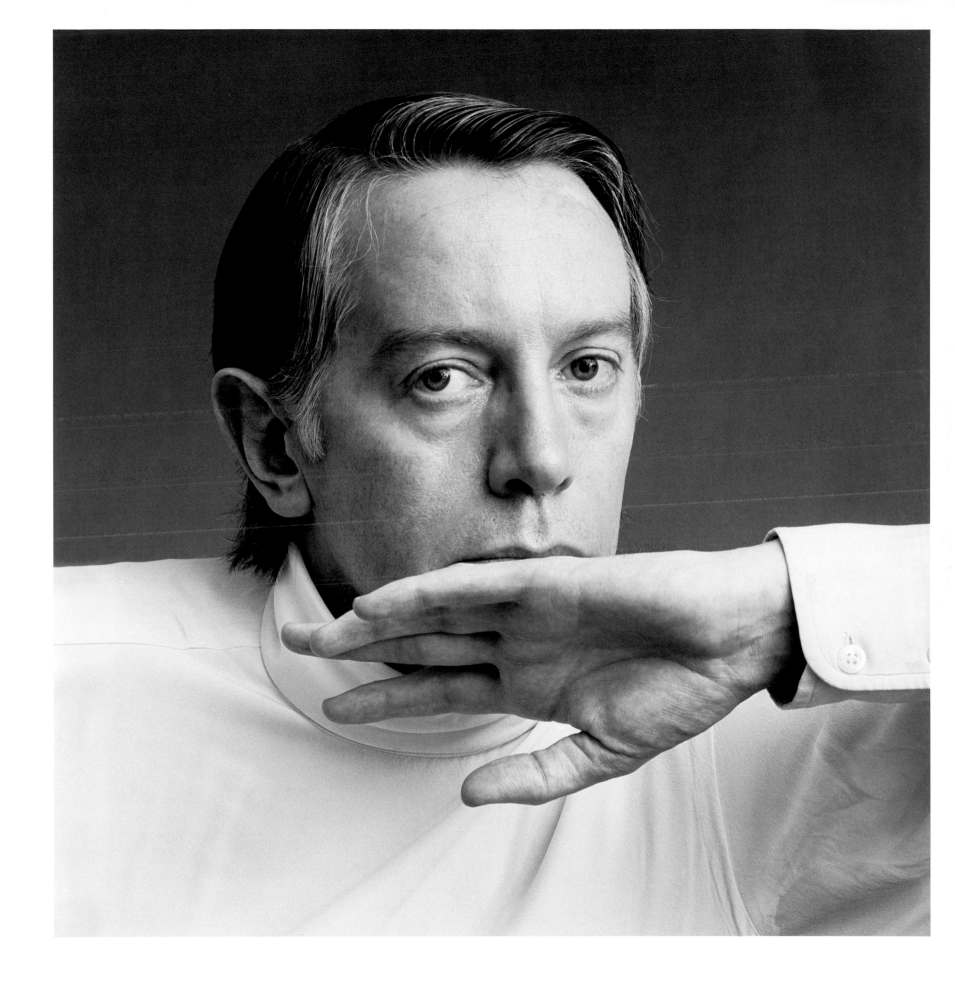

119 Kenneth Tynan

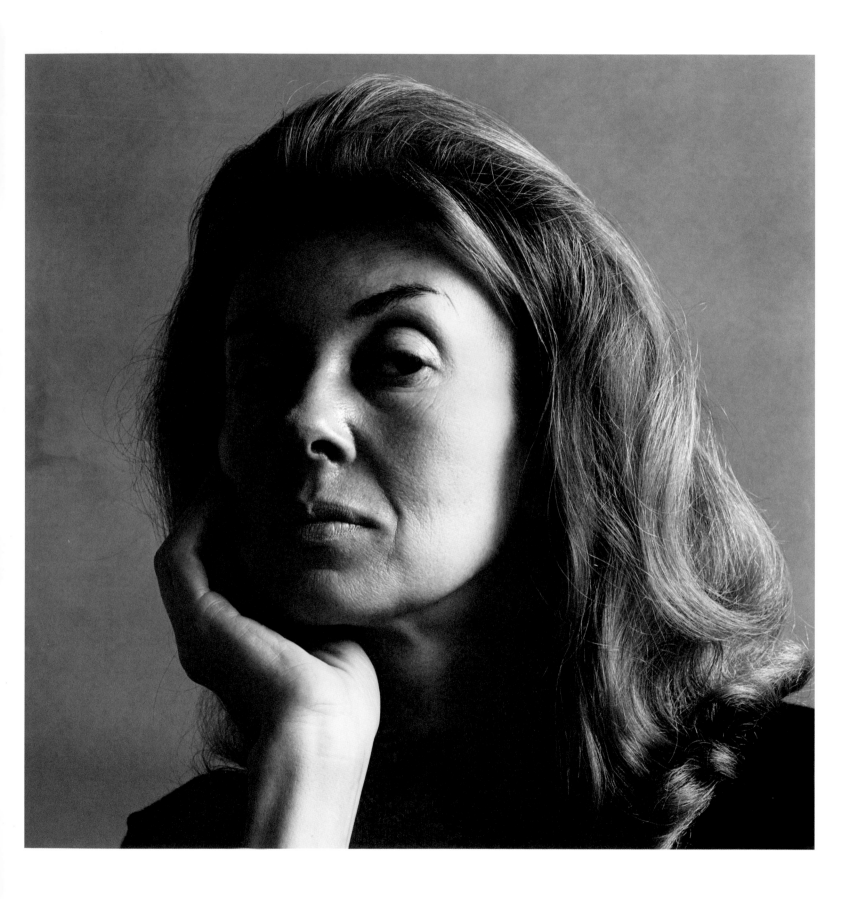

Francine du Plessix Gray

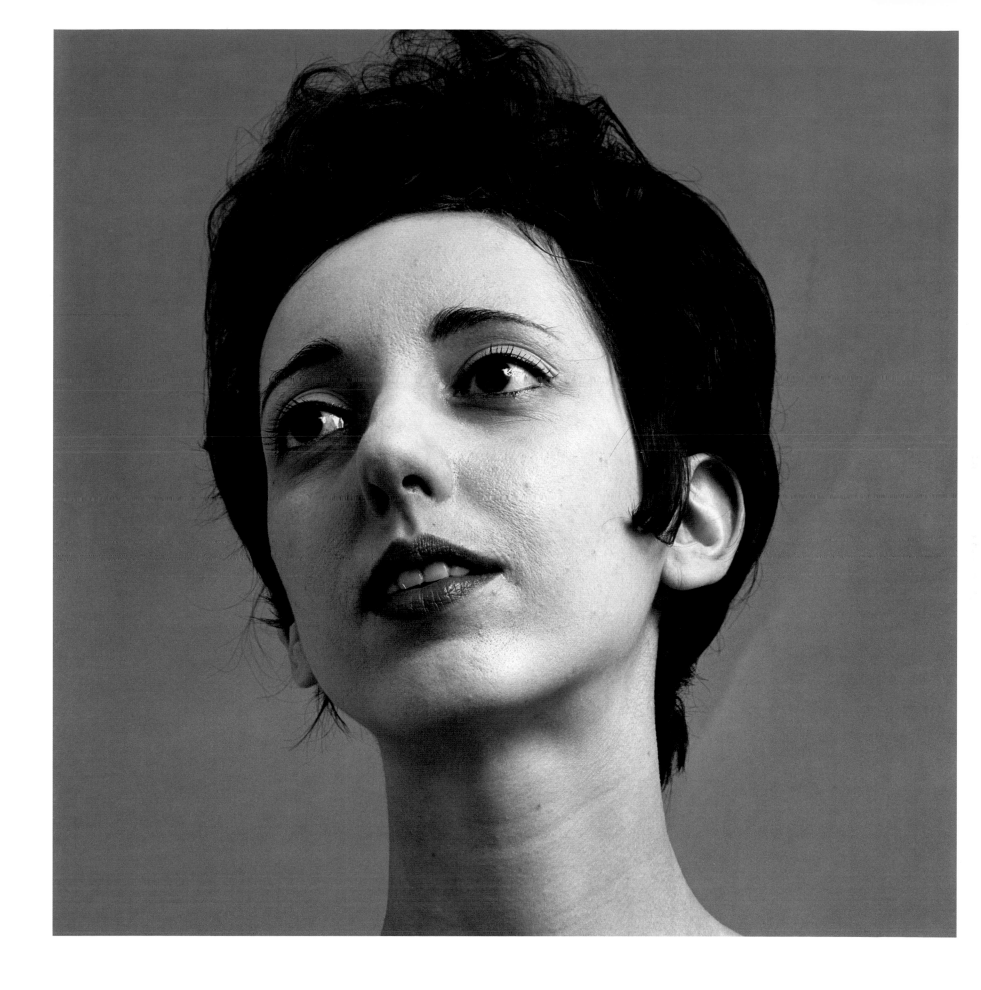

121 Joyce Carol Oates

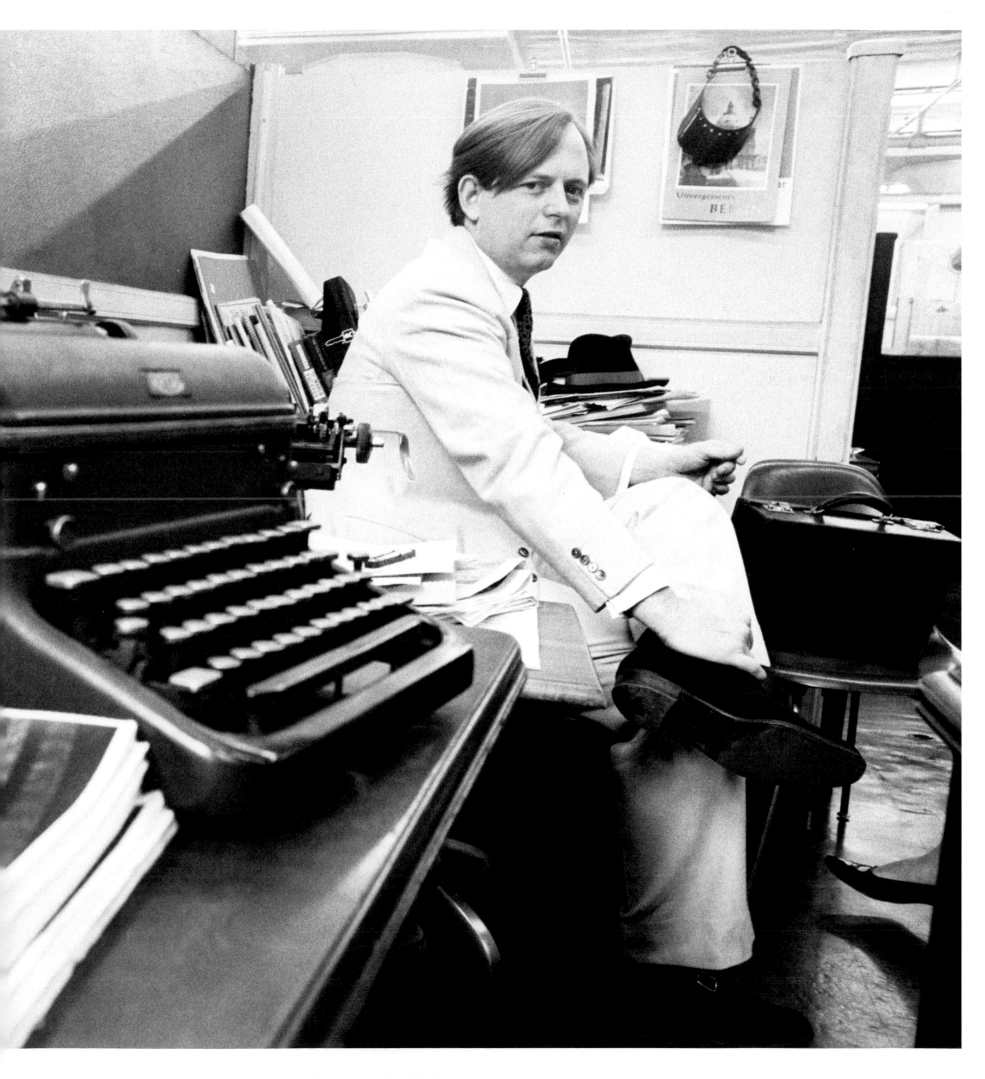

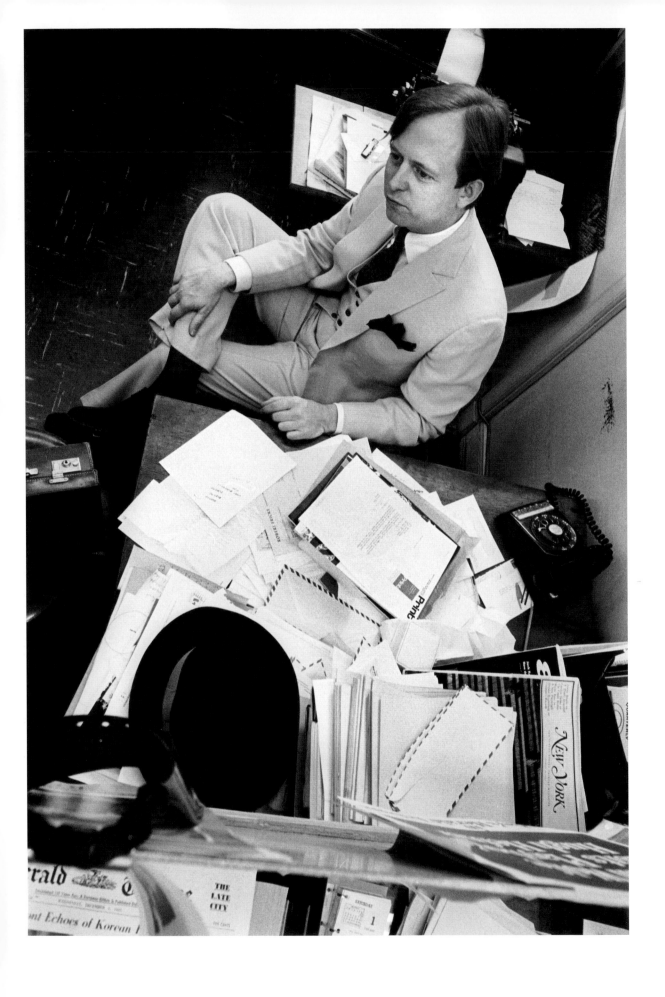

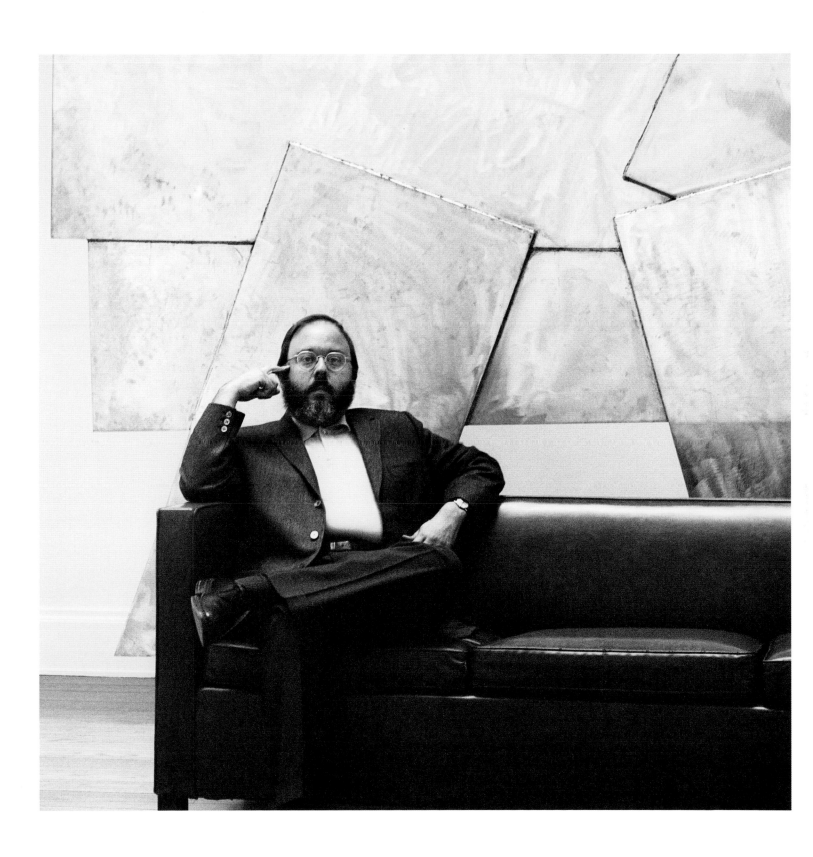

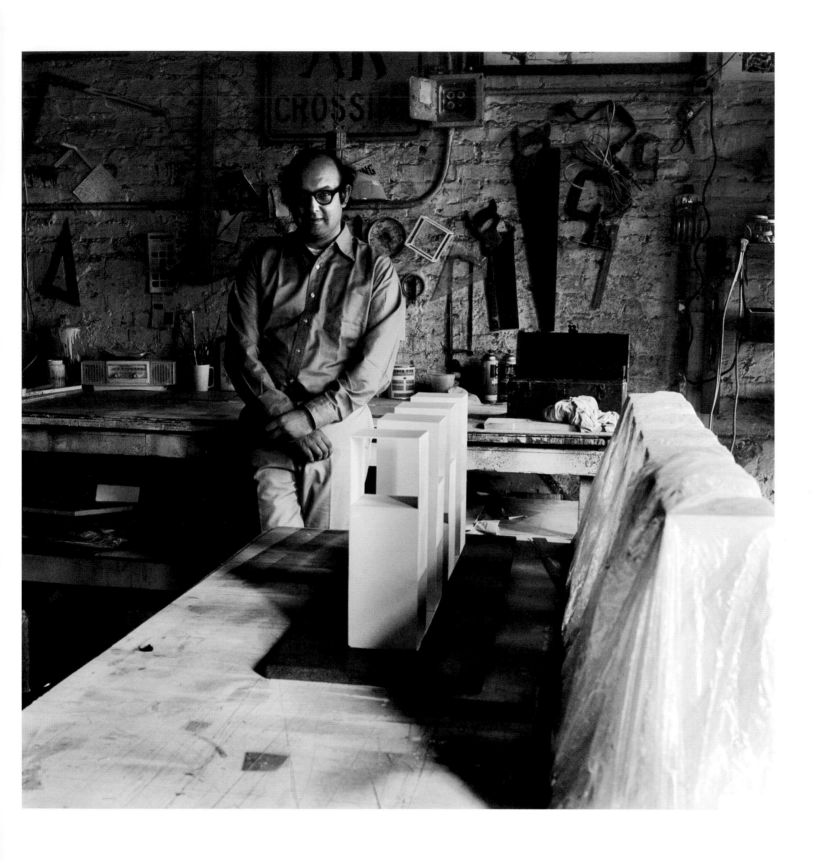

Solomon "Sol" LeWitt

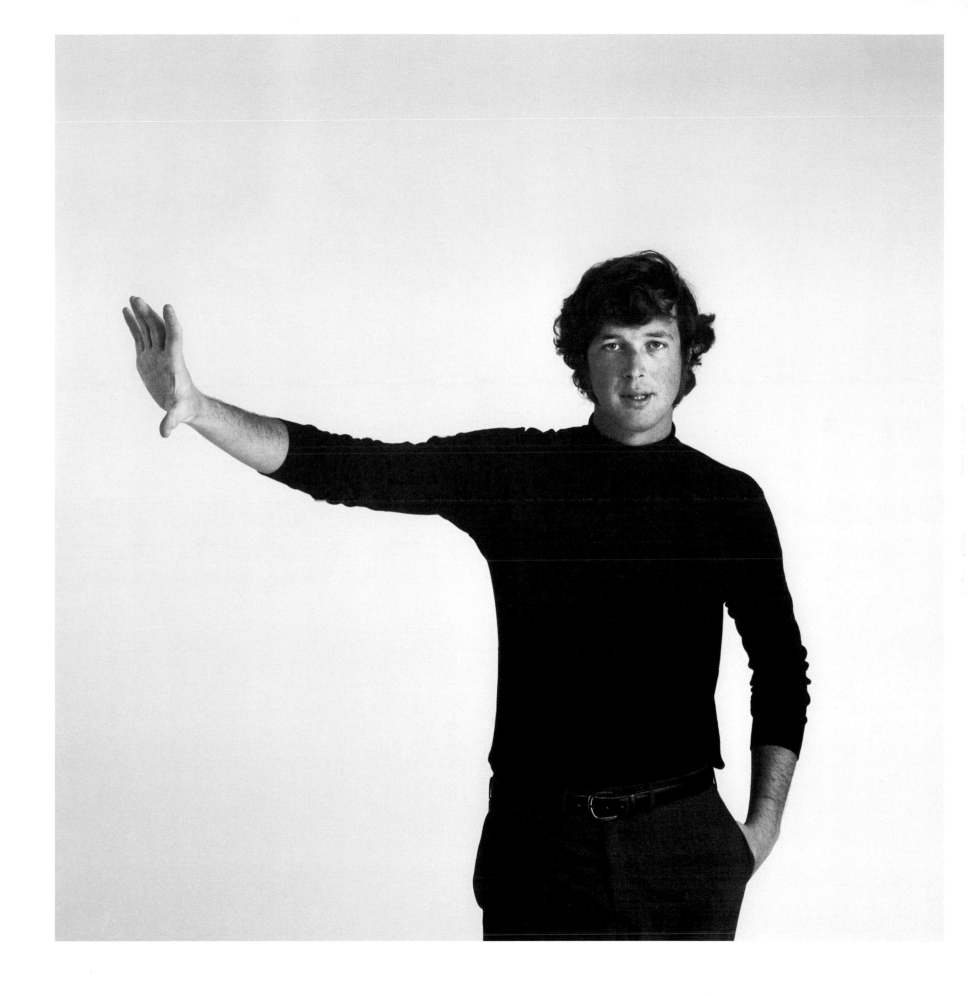

127 Michael Crichton

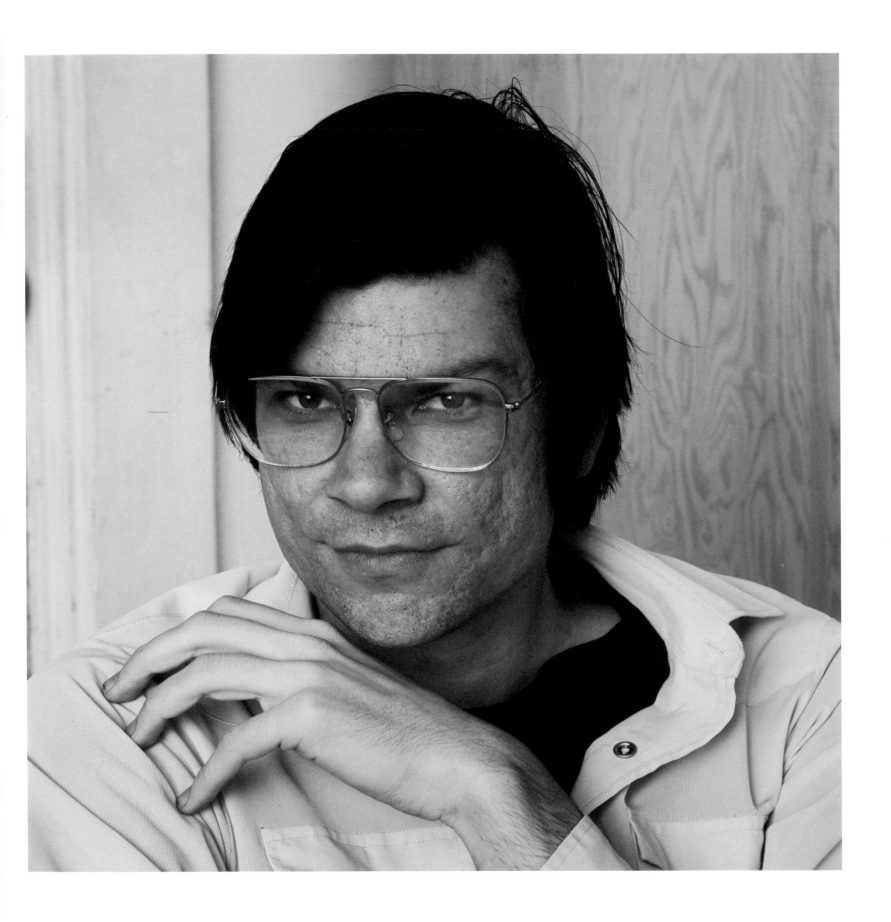

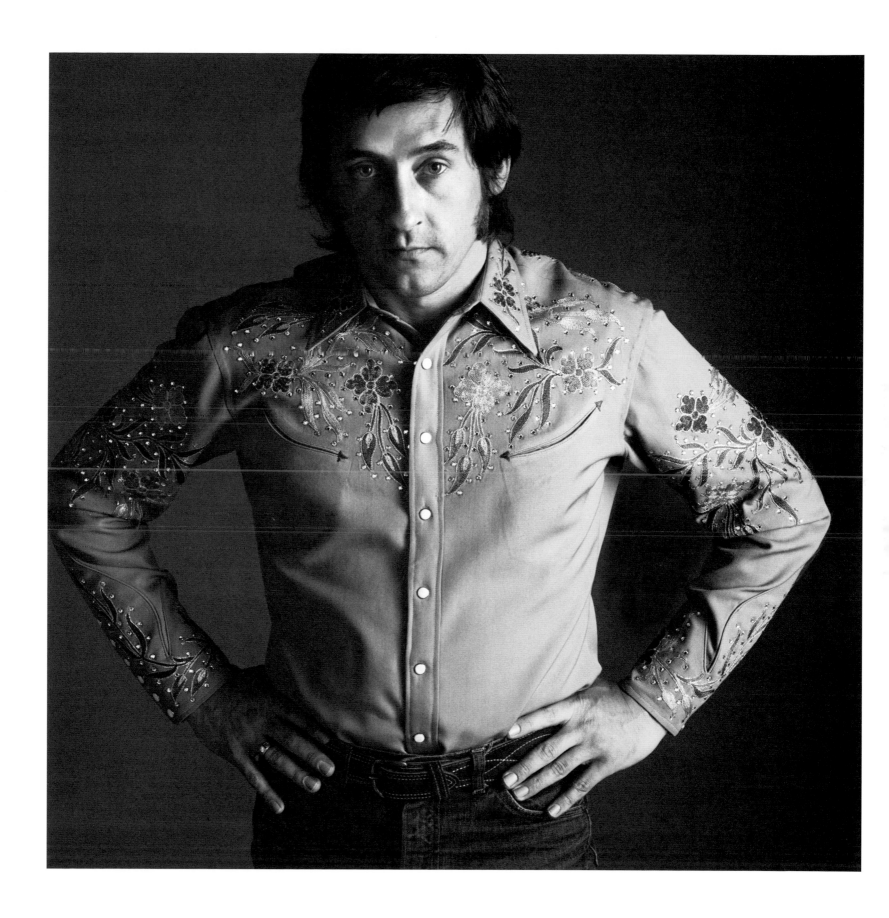

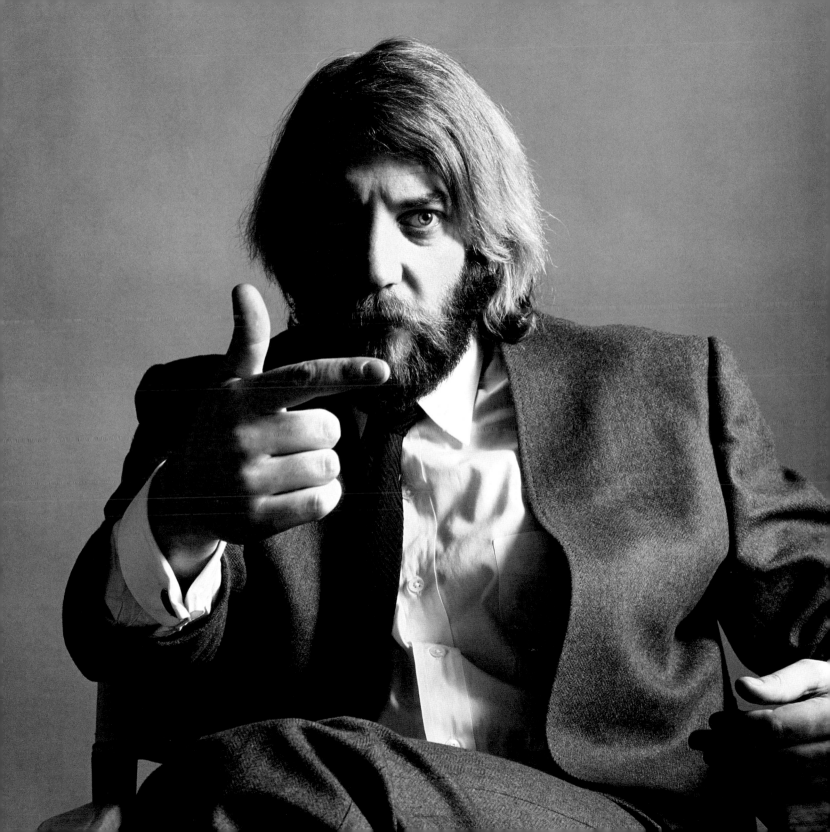

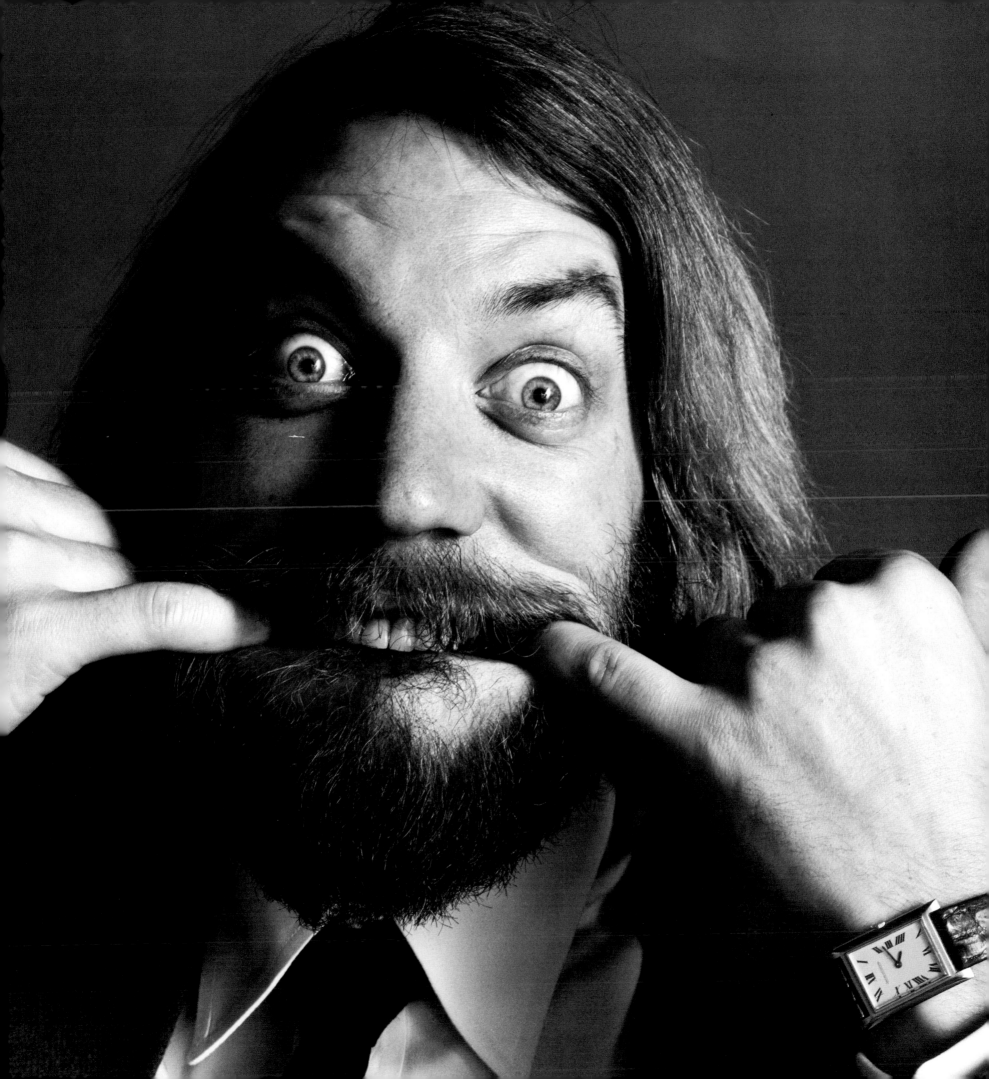

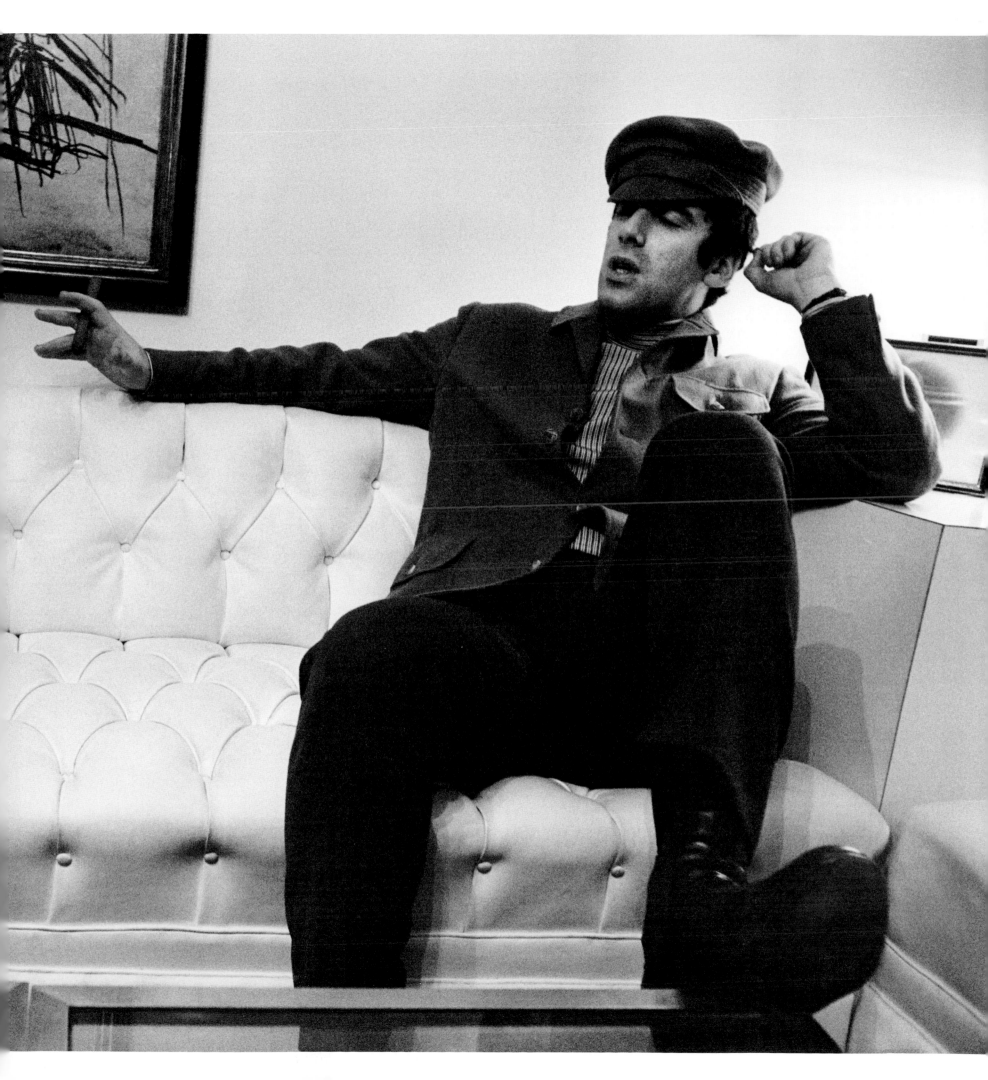

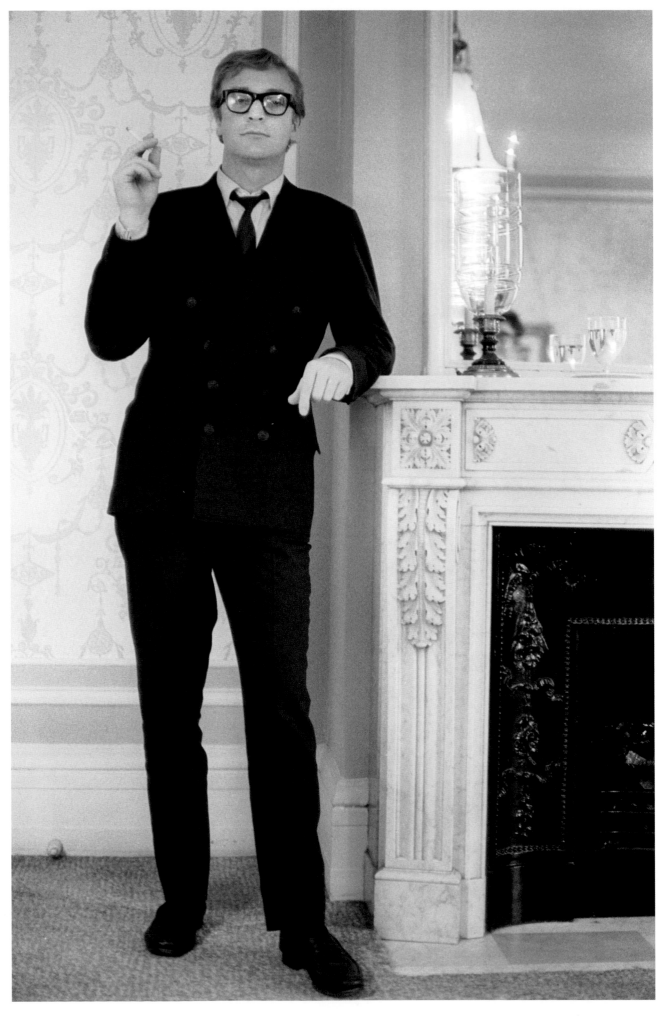

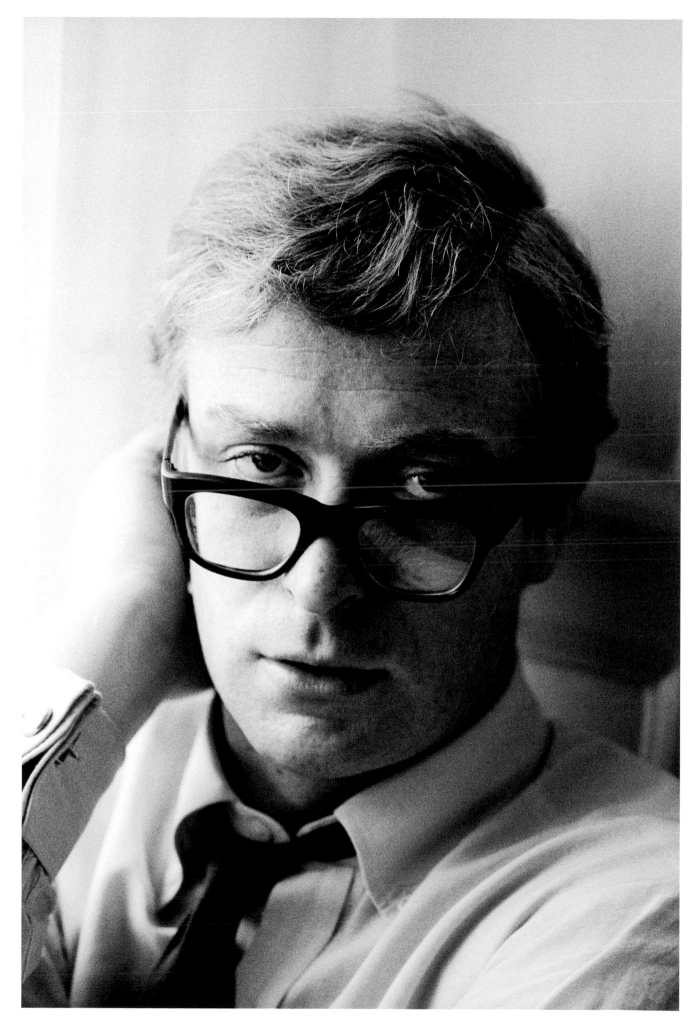

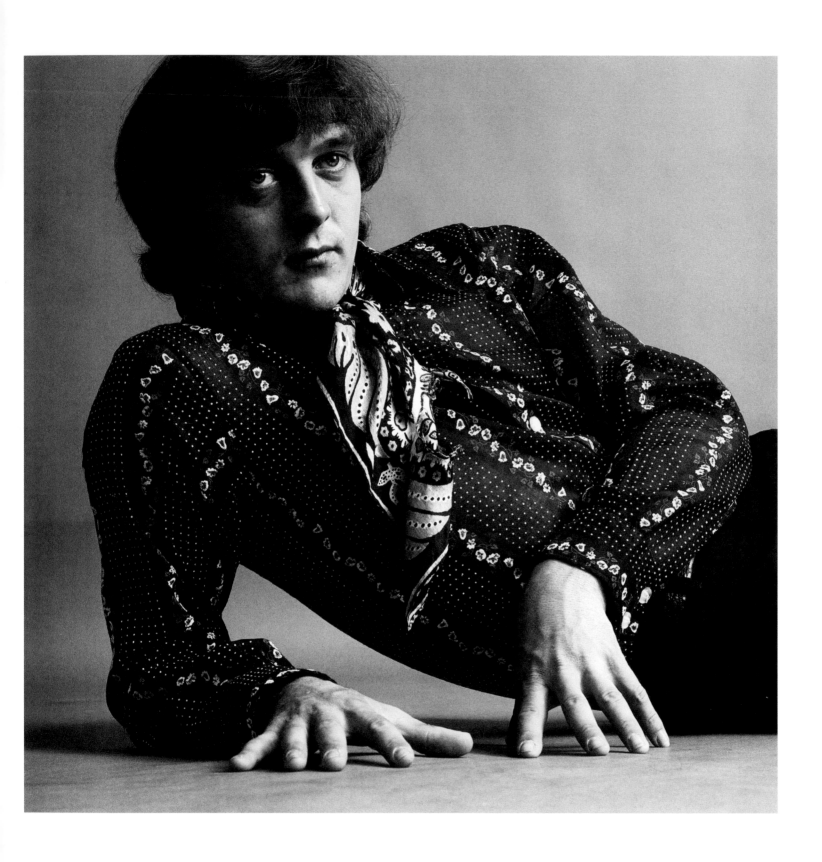

138 Above: David Hemmings Opposite: Dirk Bogarde

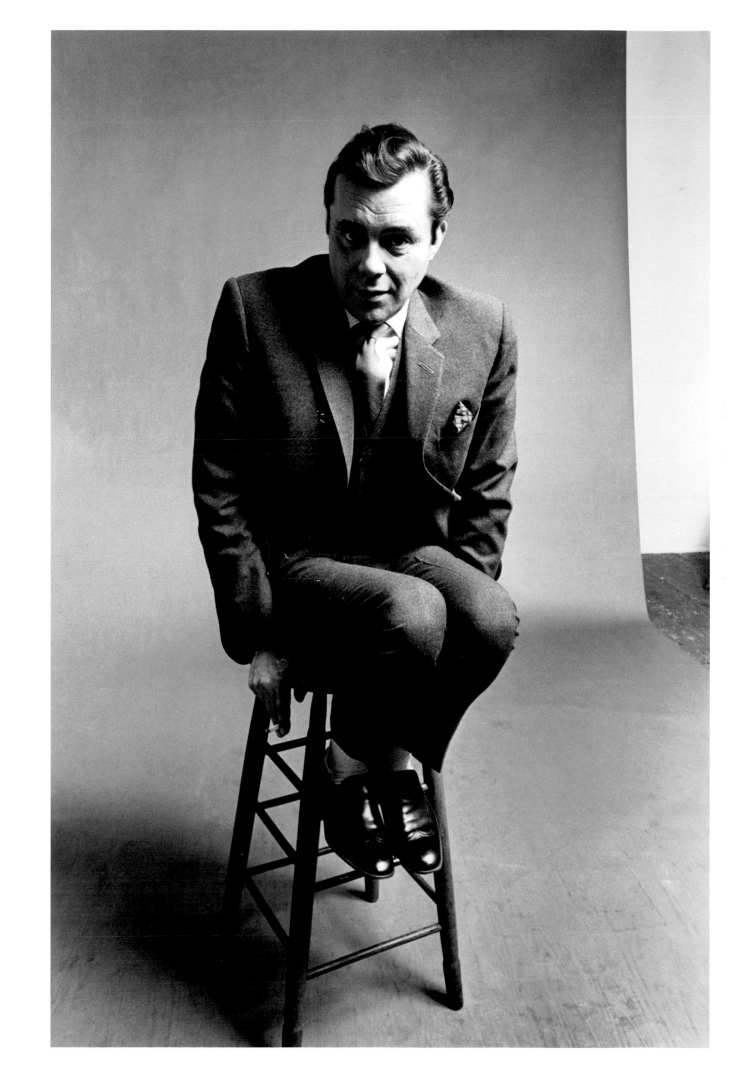

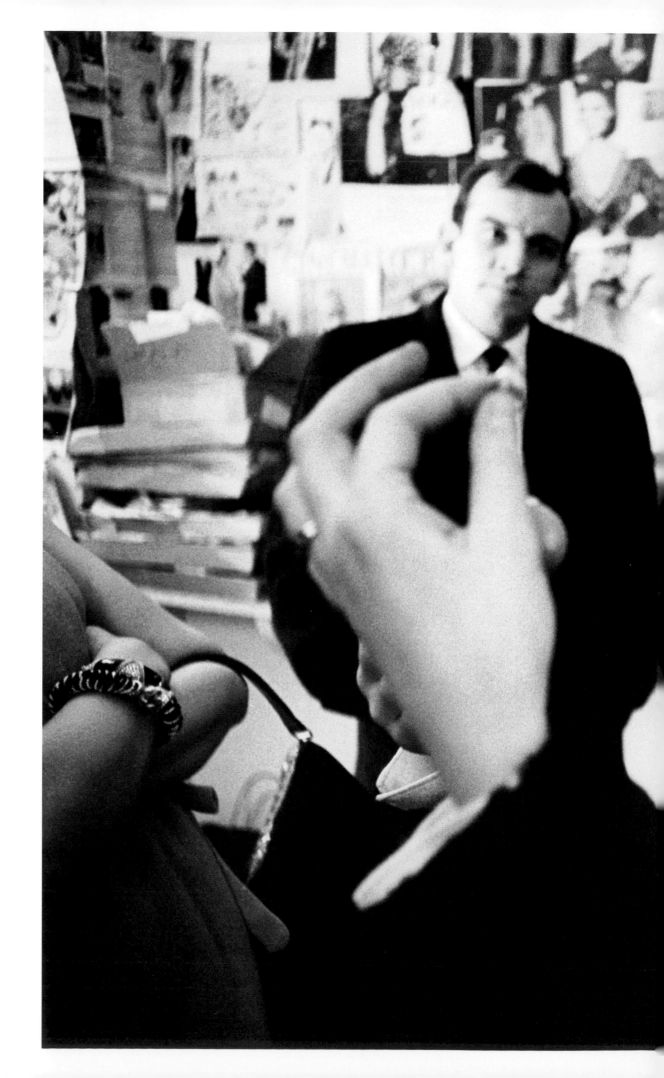

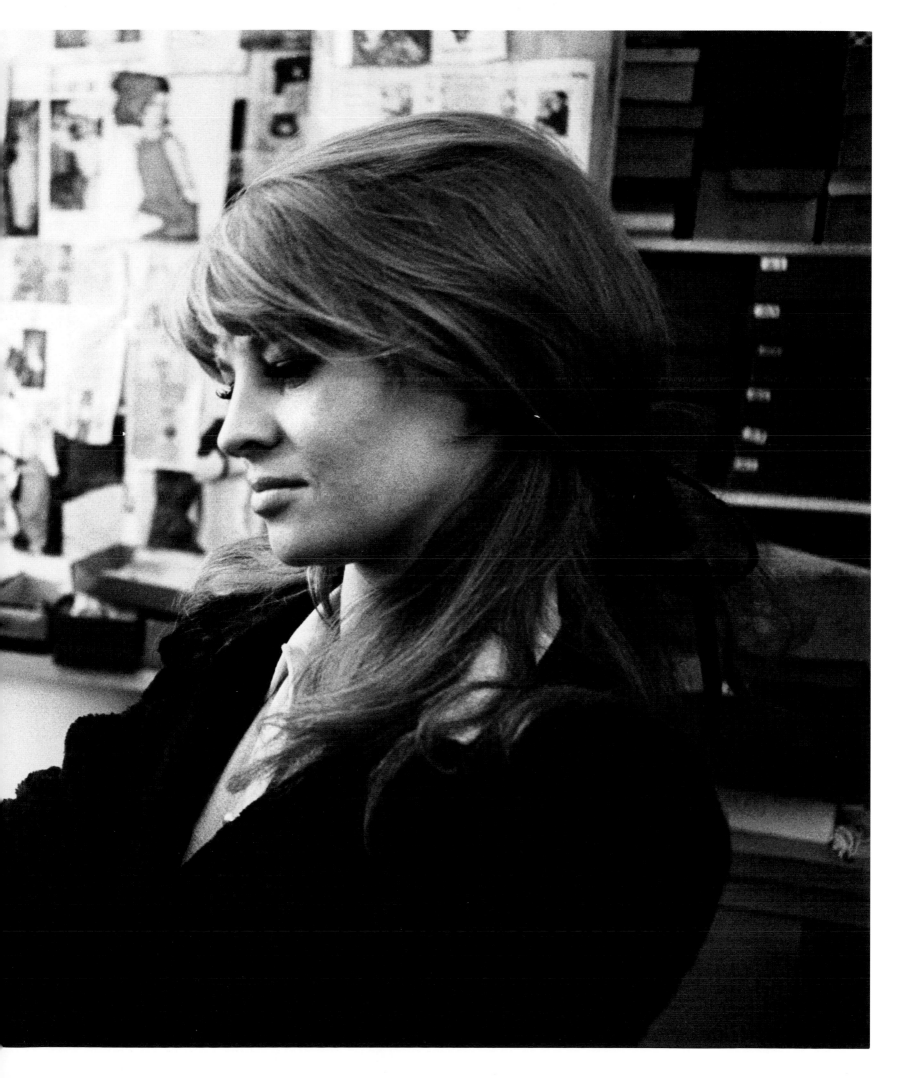

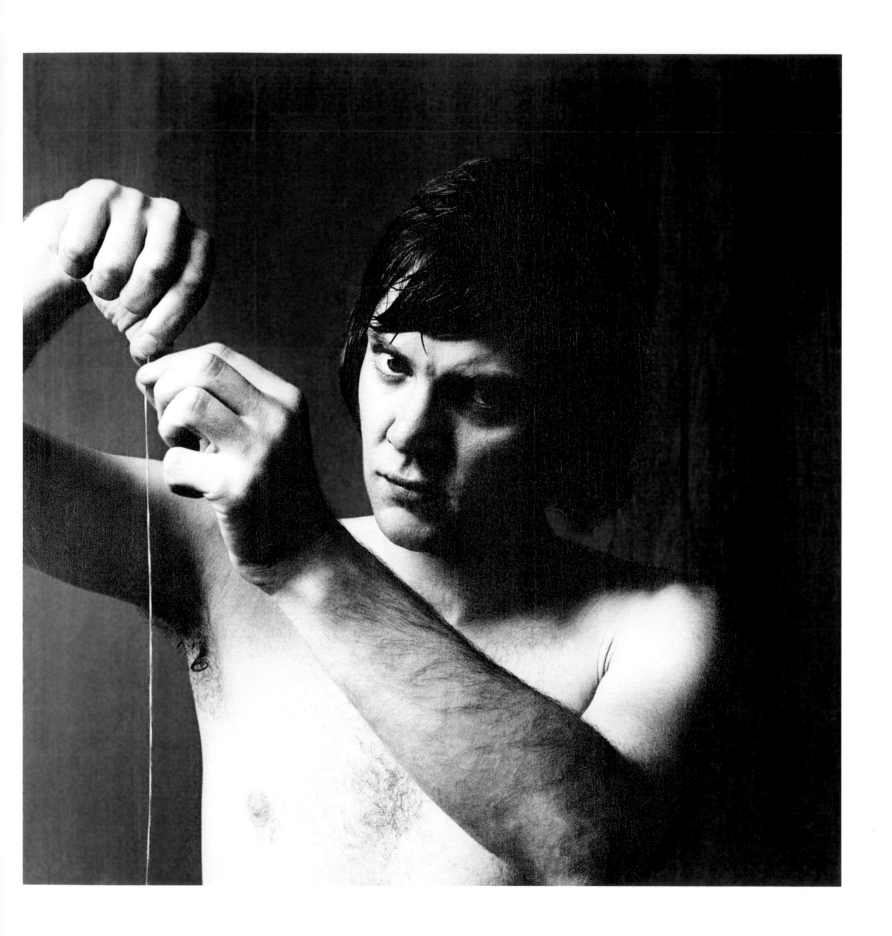

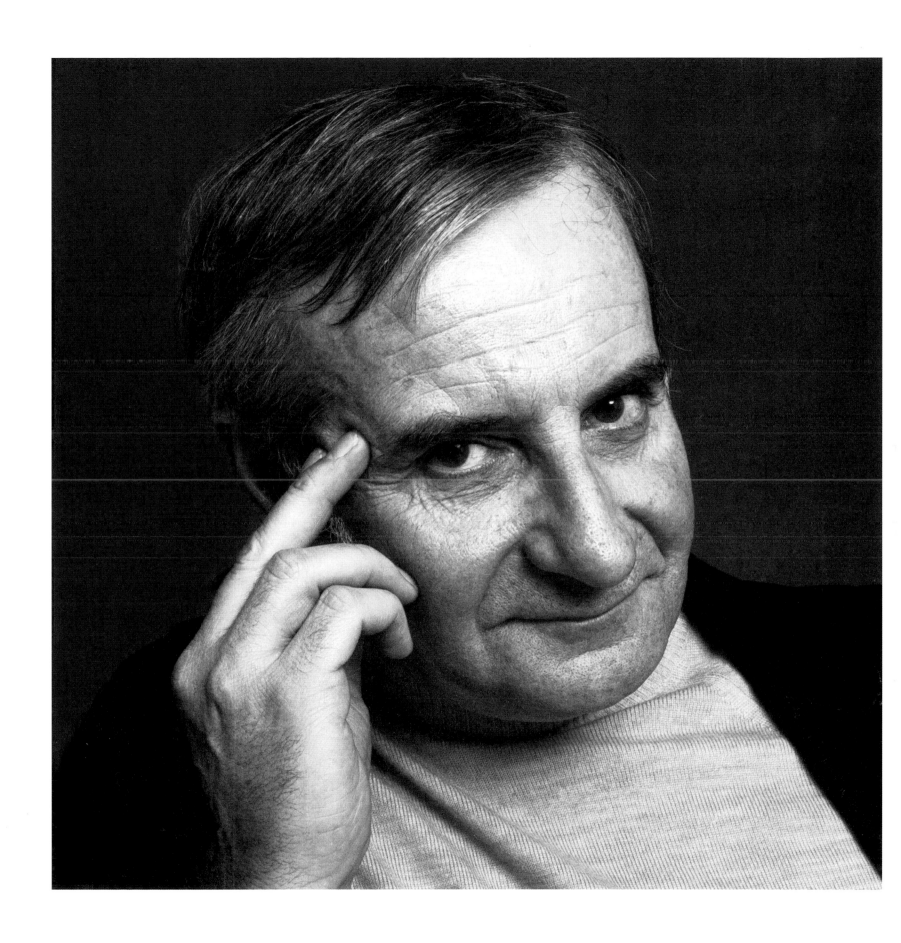

143 Lindsay Anderson

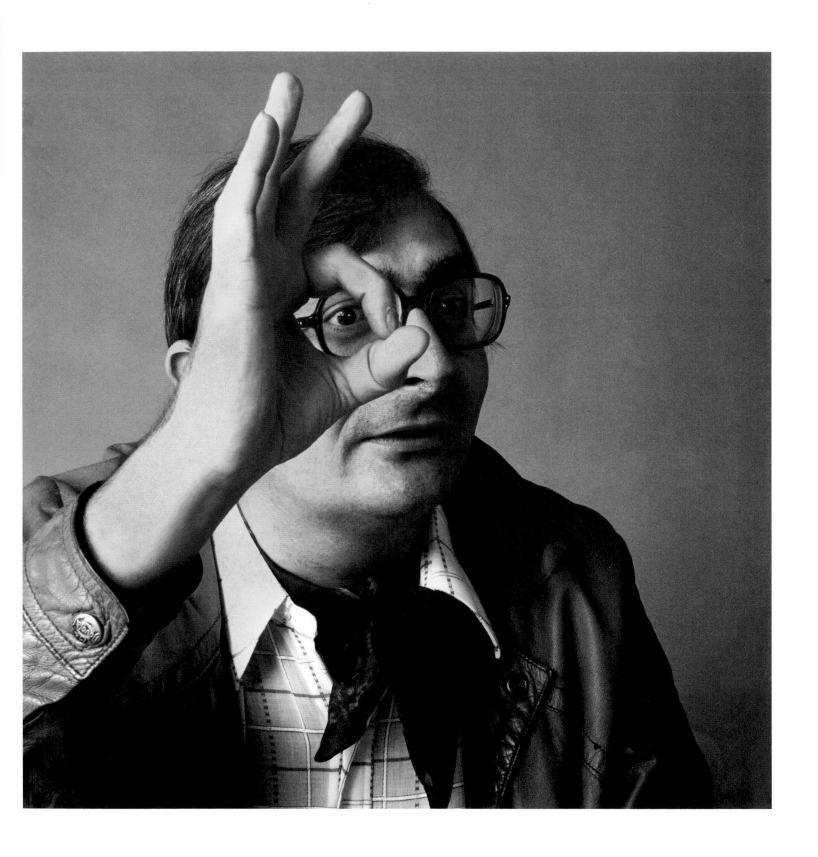

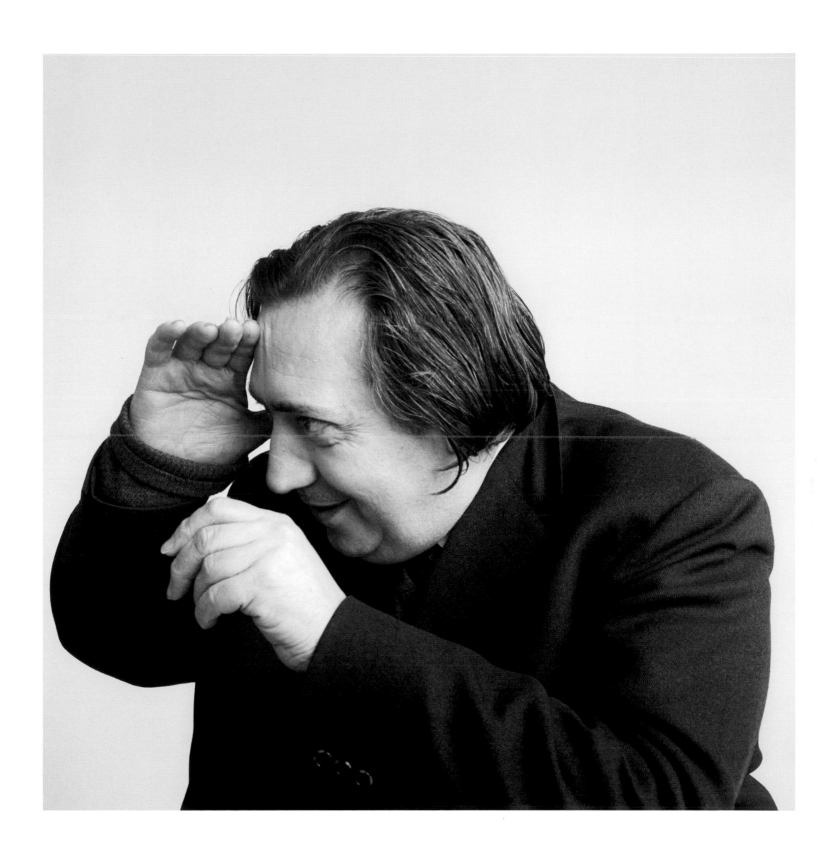

145 Henri Langlois

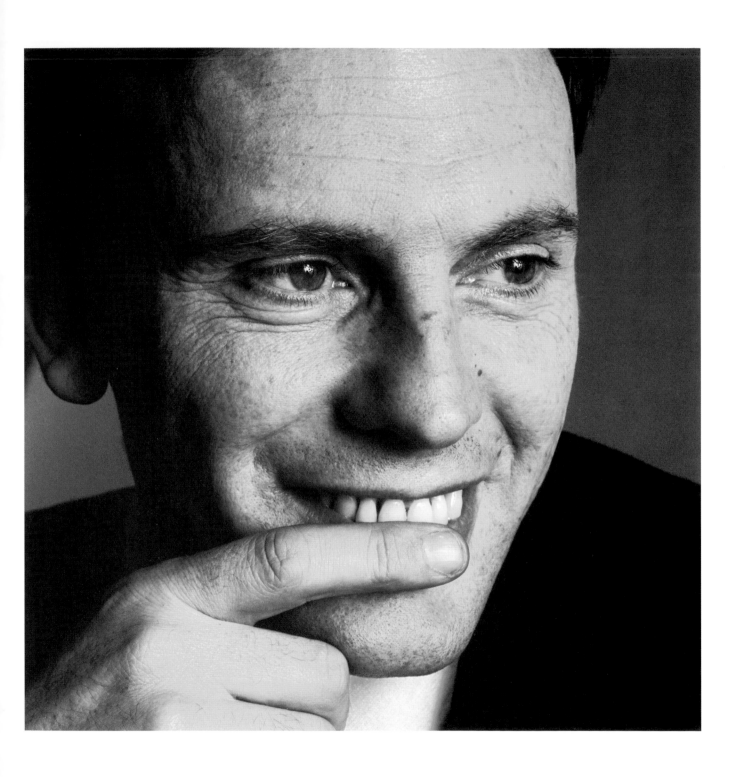

146 Jean-Louis Trintignant

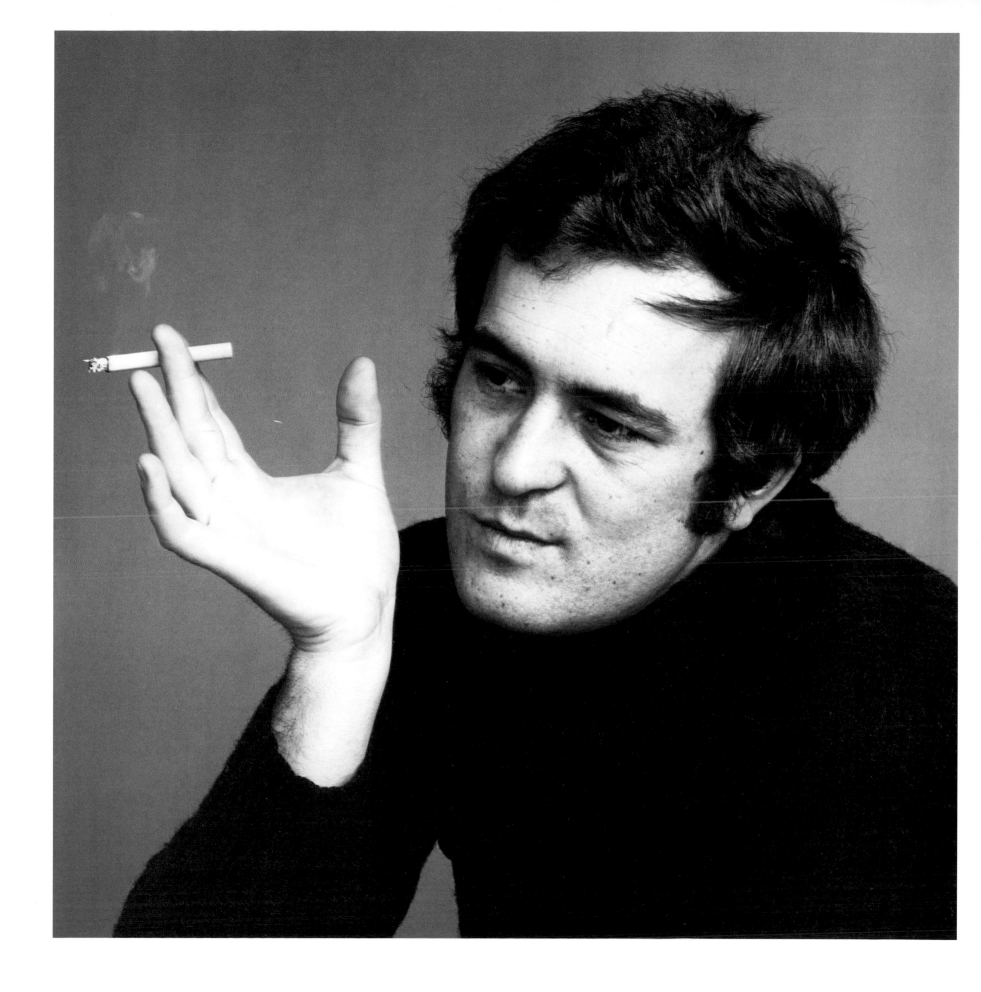

147 Bernardo Bertolucci

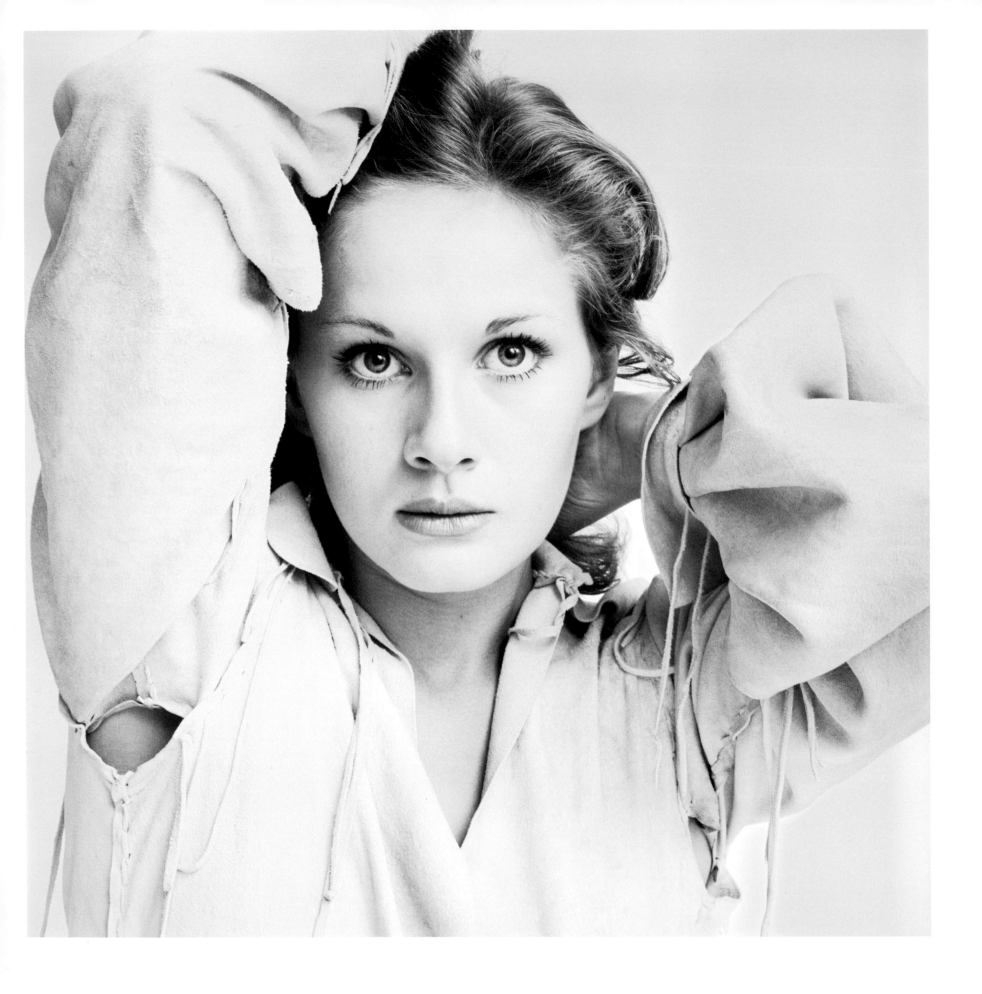

148 Dominique Sanda

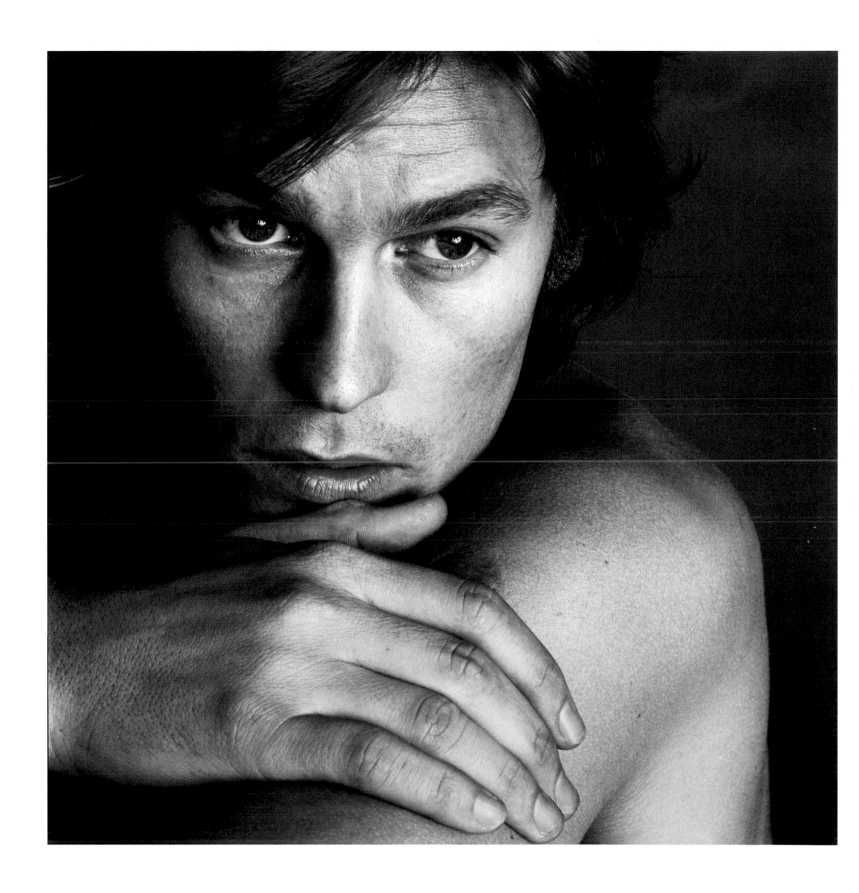

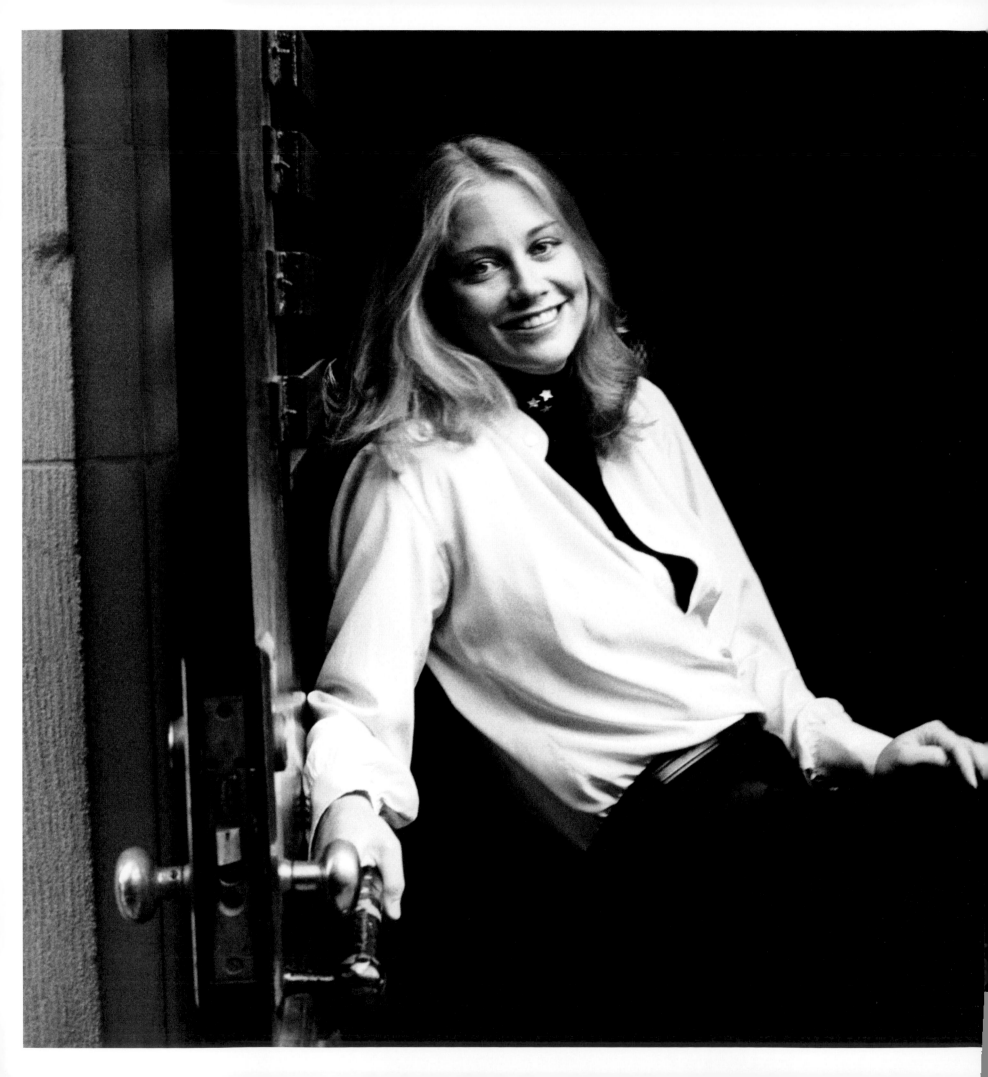

Cybill Shepherd

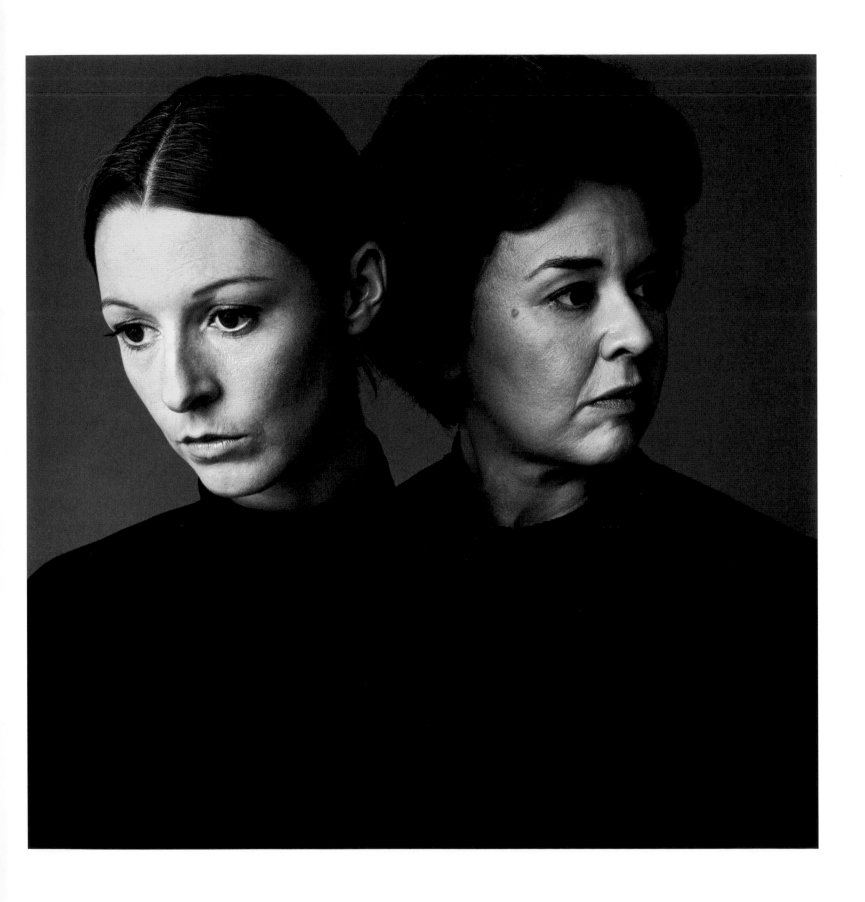

Above: Jane Alexander and Sada Thompson Opposite: Mia Farrow

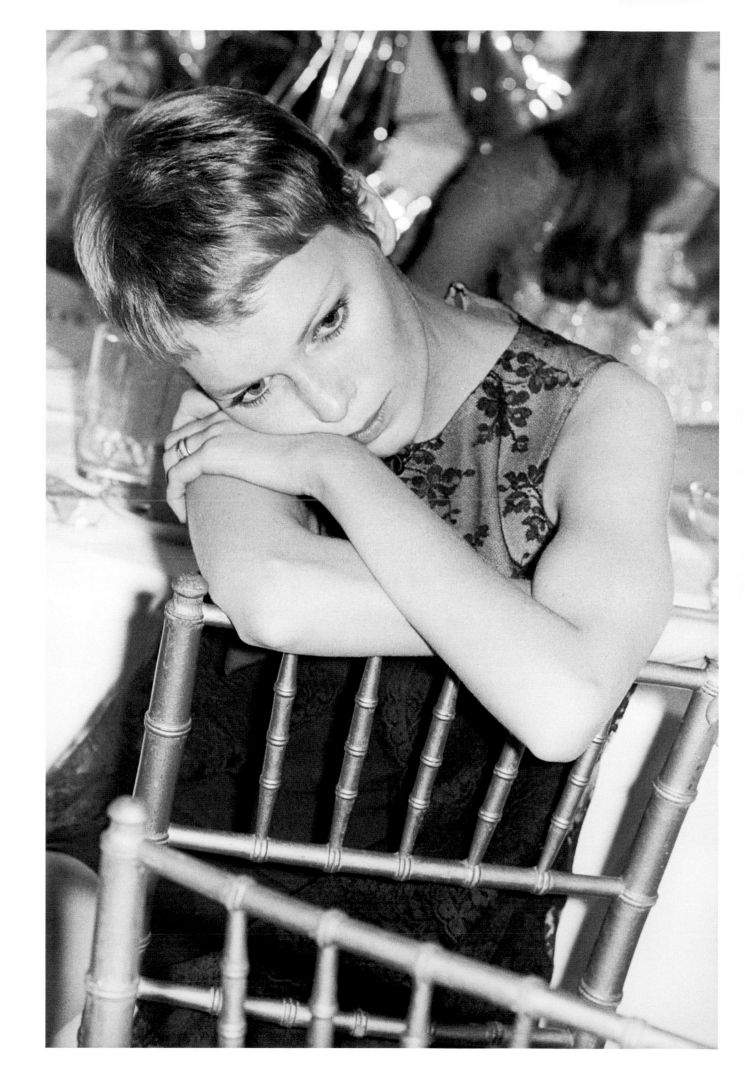

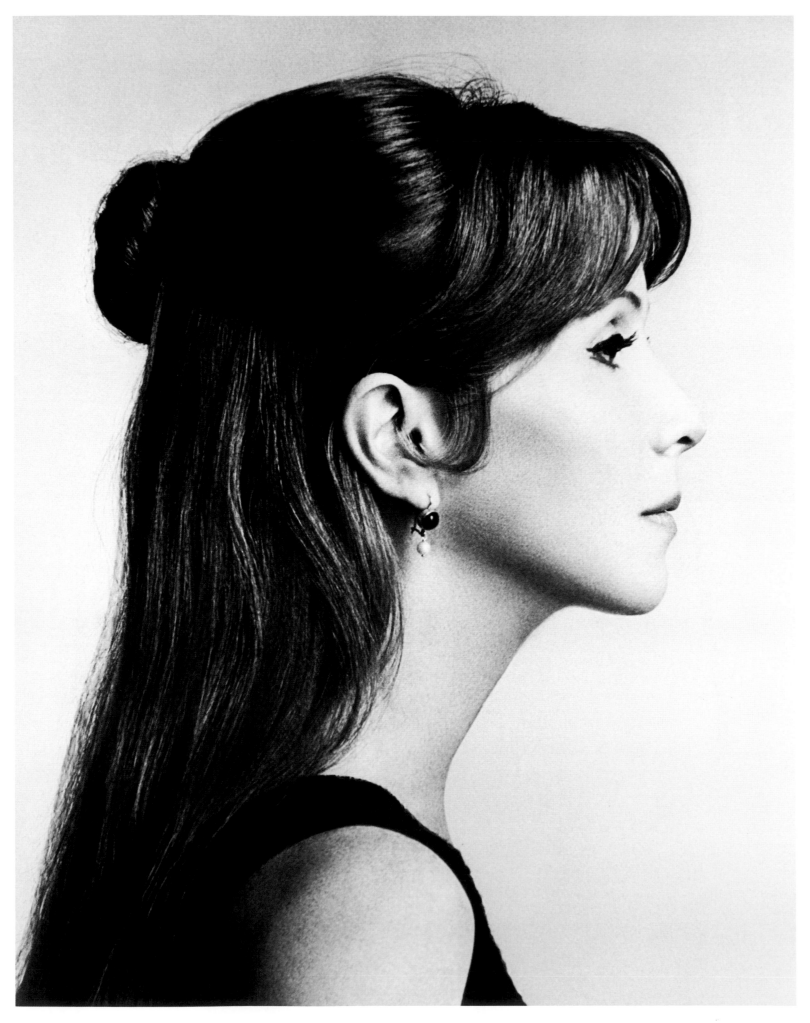

154 Julie Harris

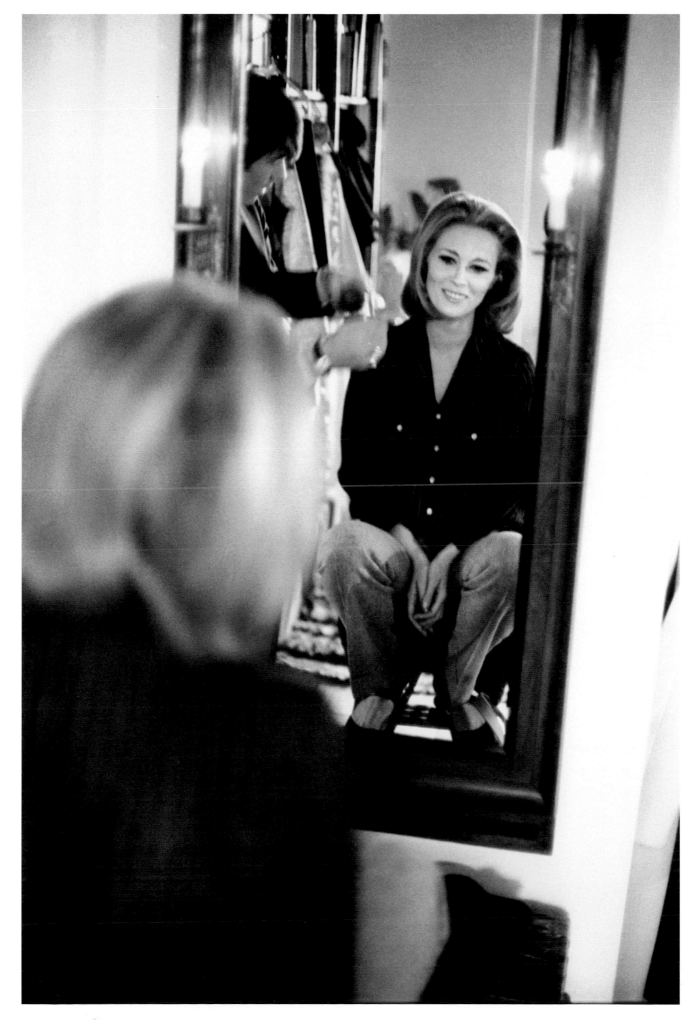

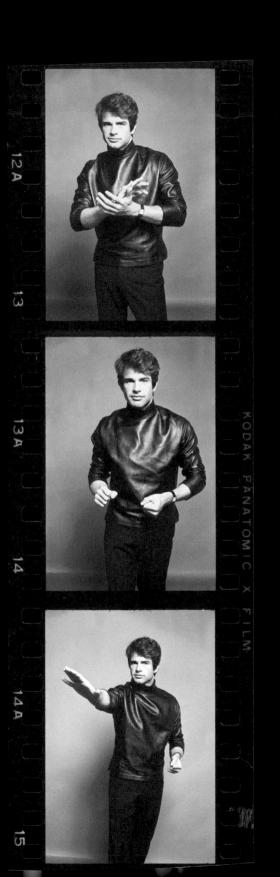
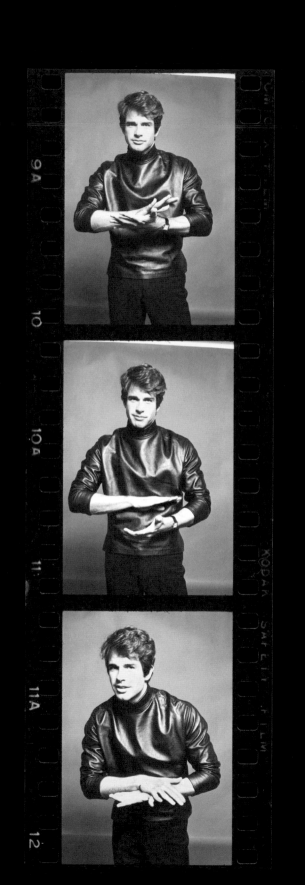

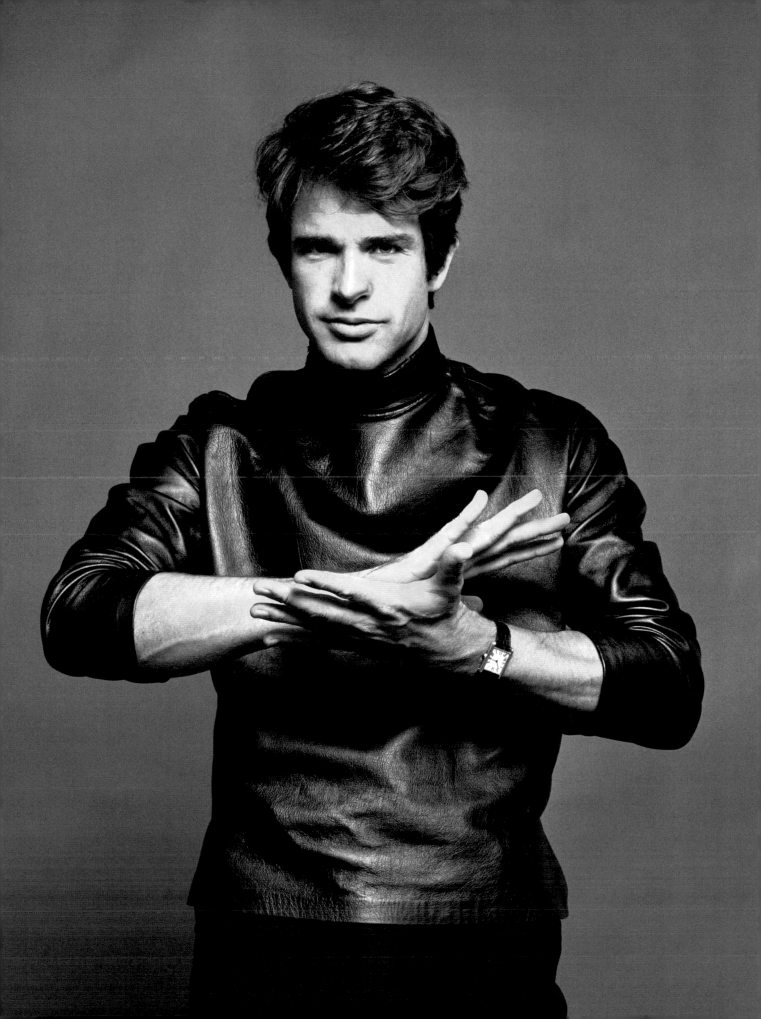

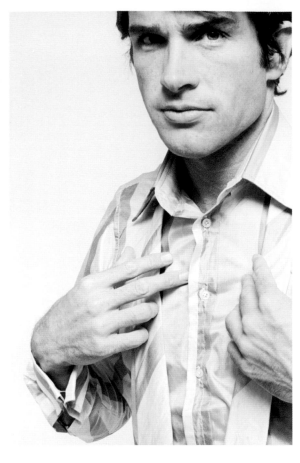
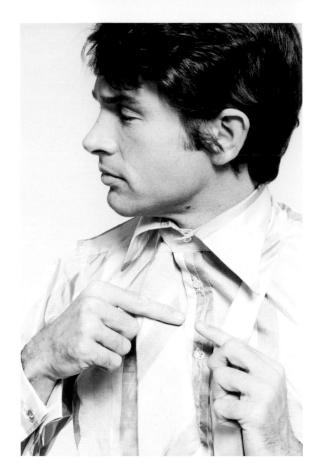
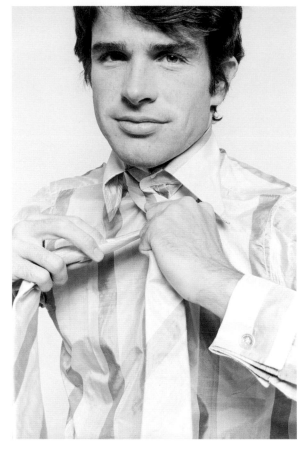
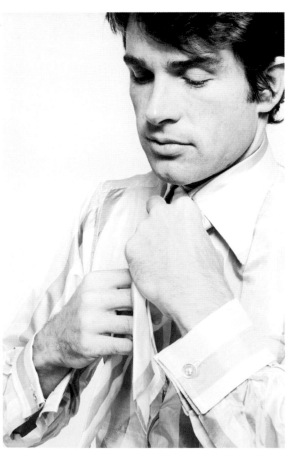
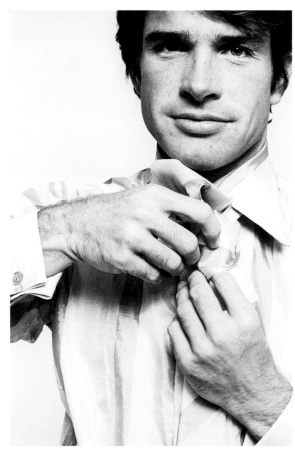
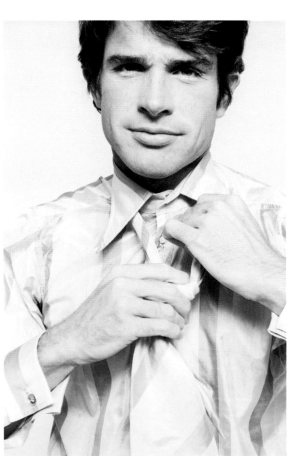

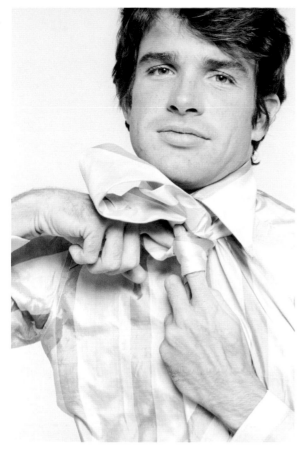
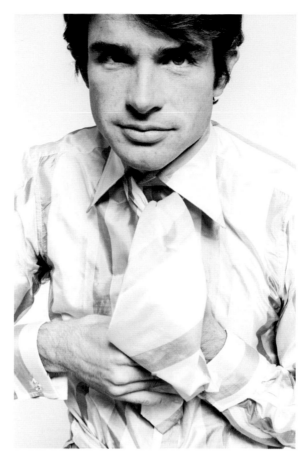
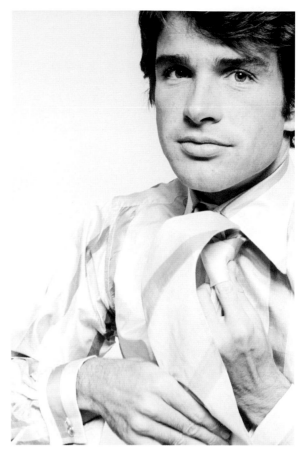
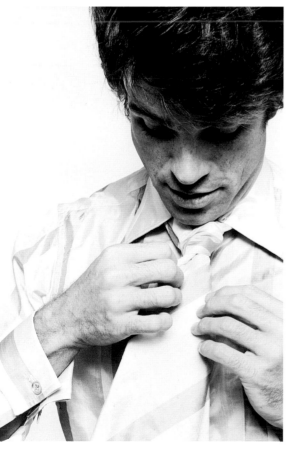
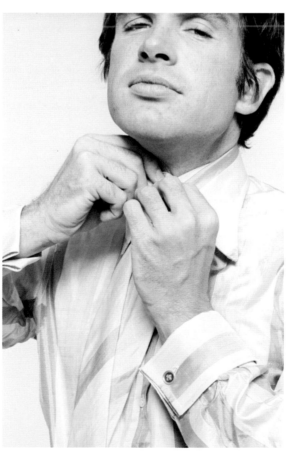
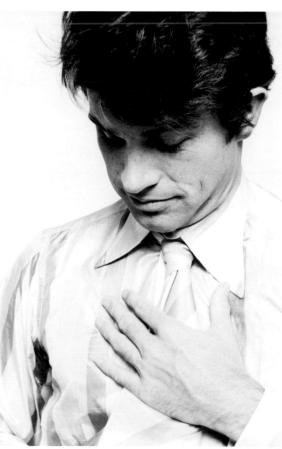

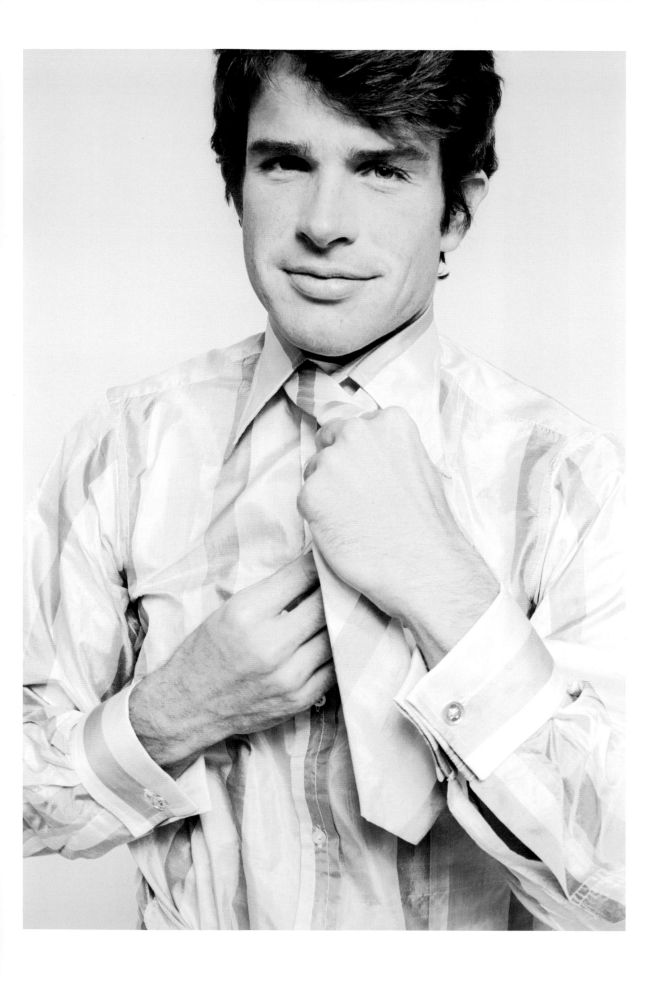

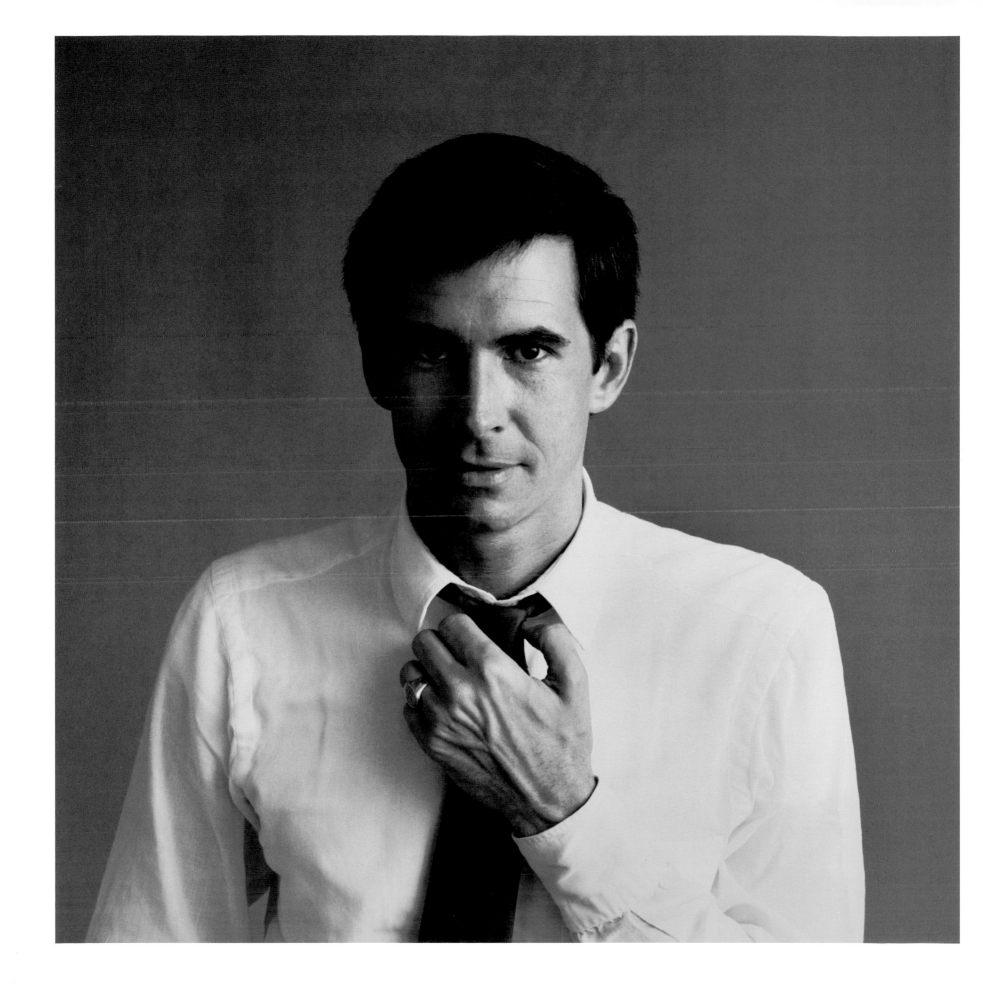

161 Anthony Perkins

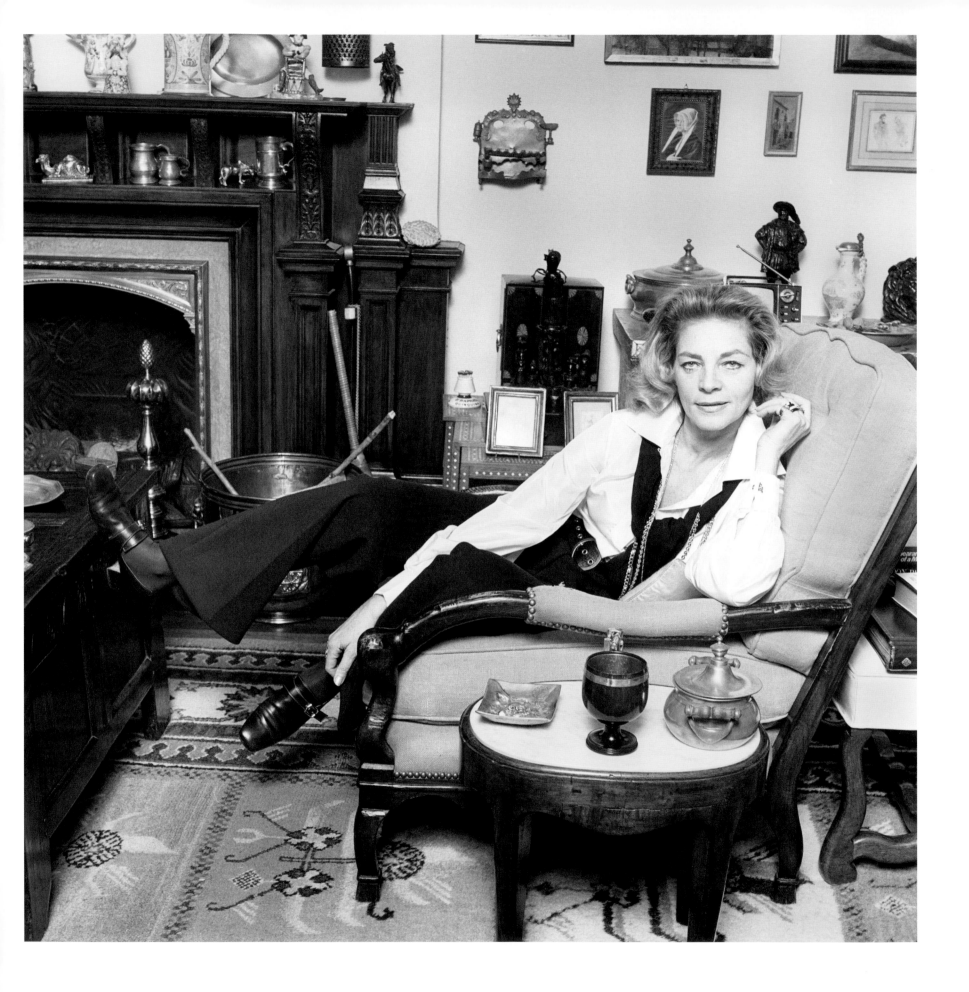

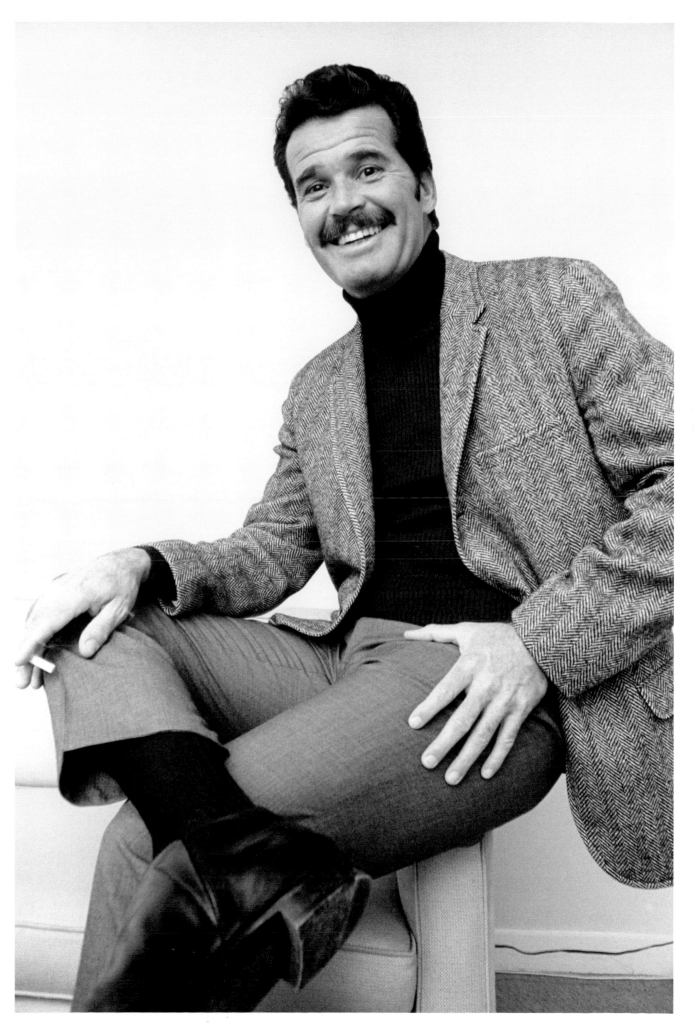

163 James Garner

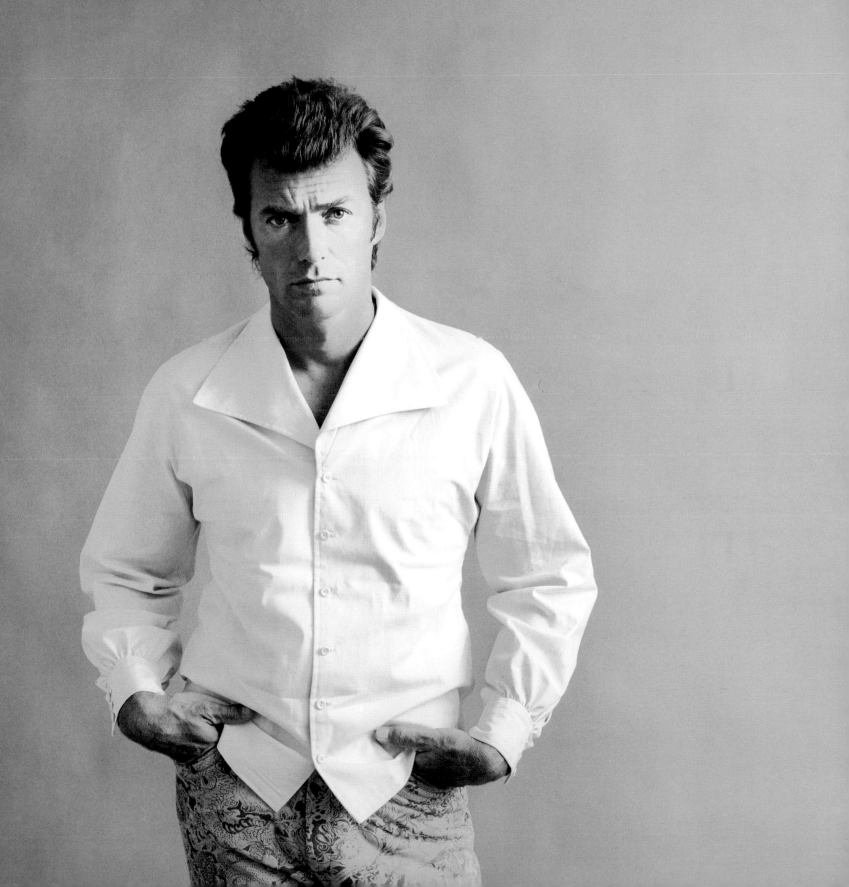

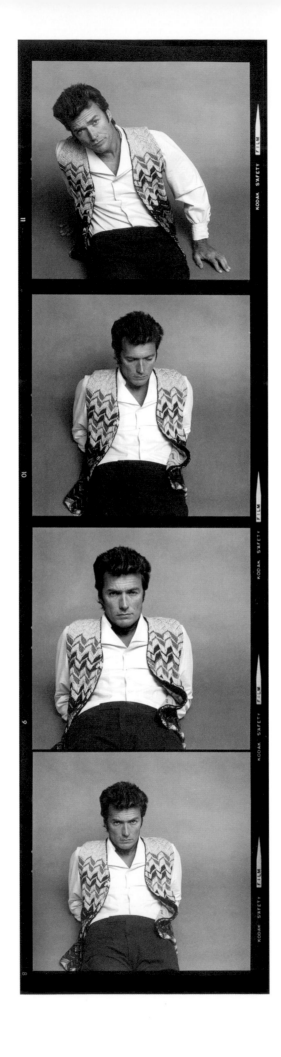

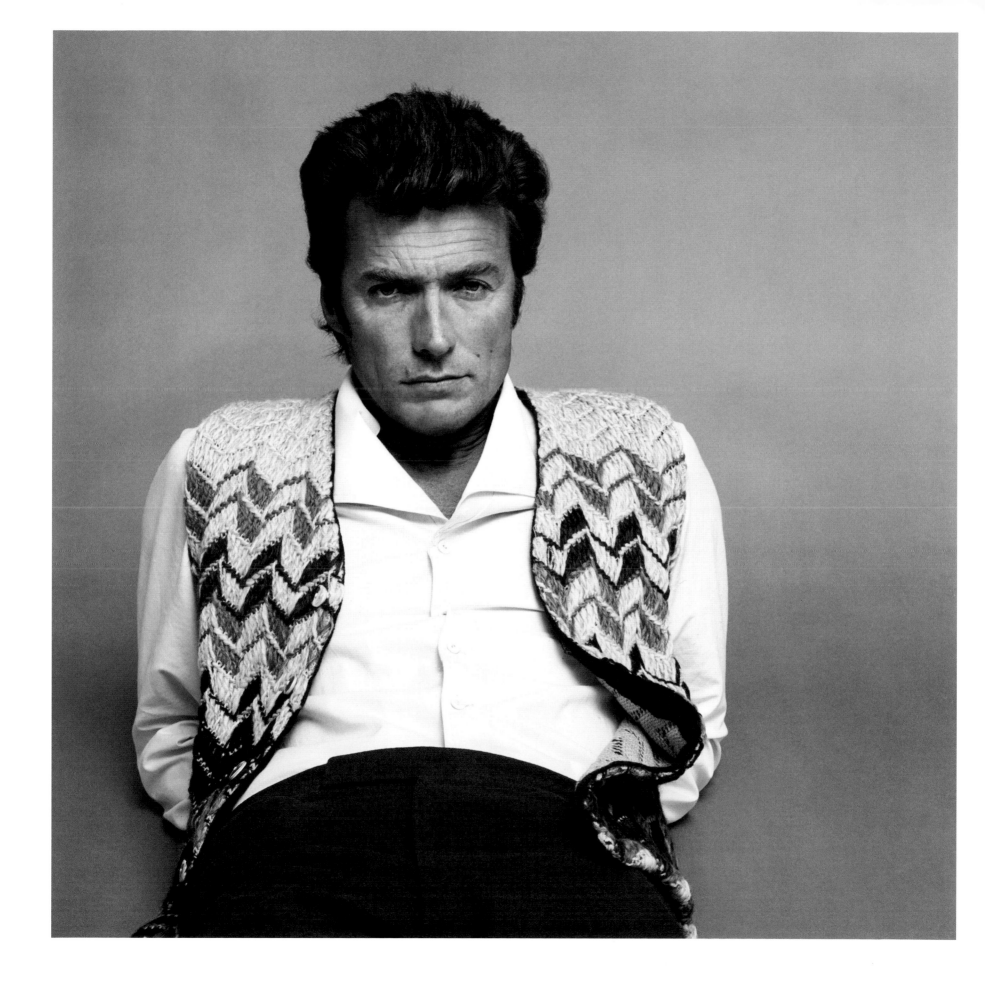

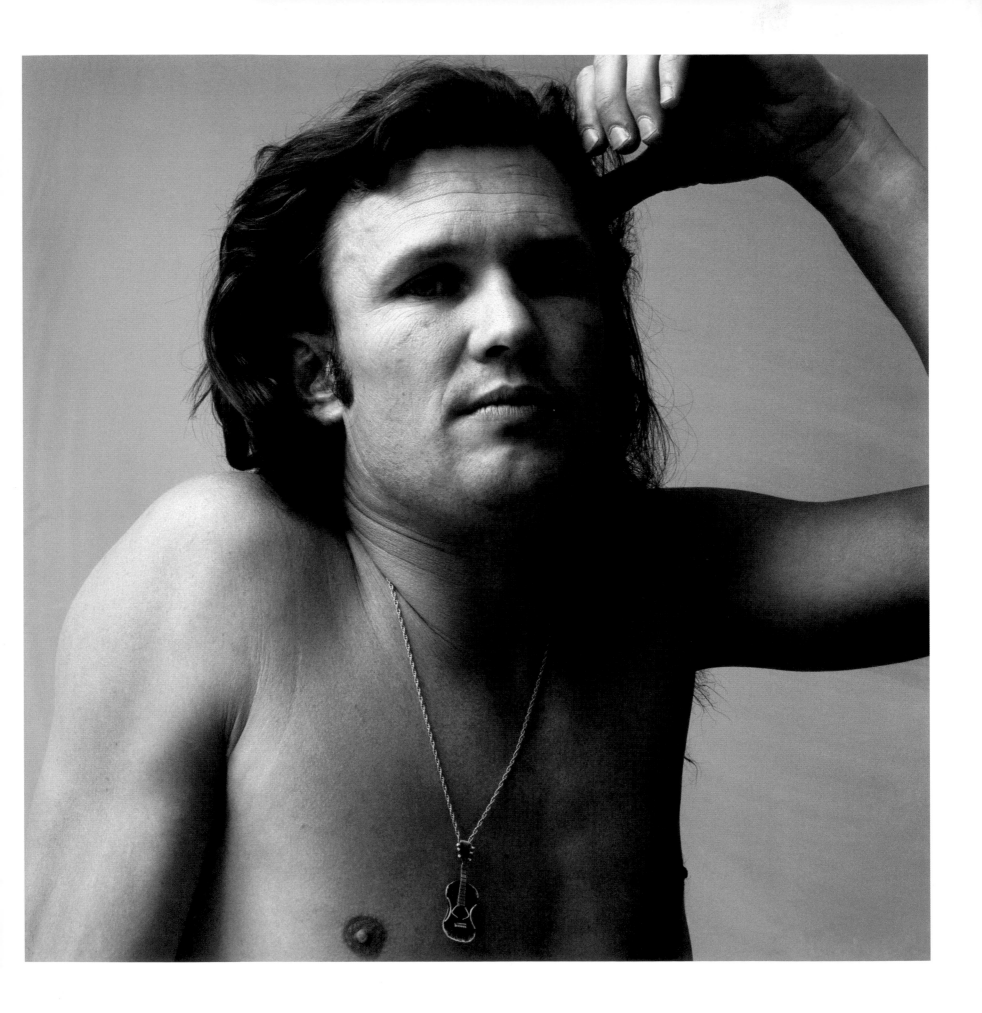

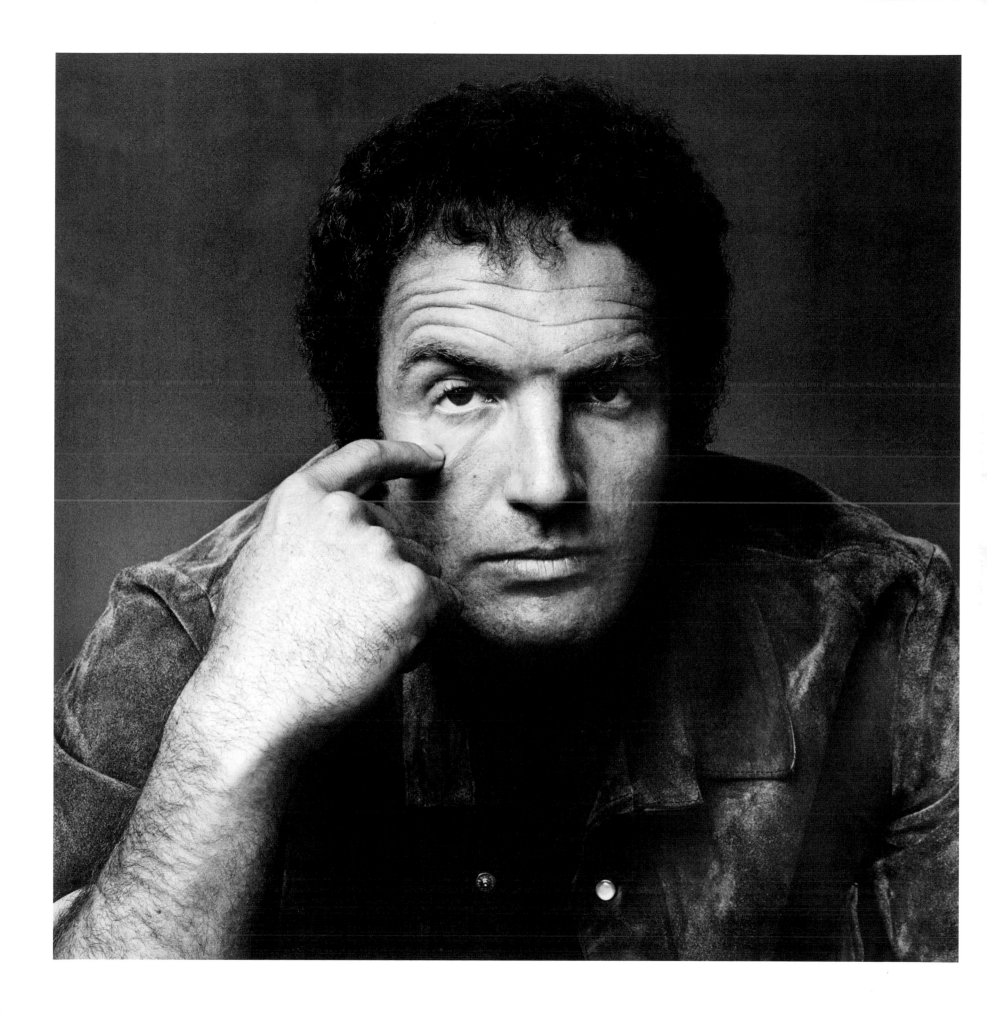

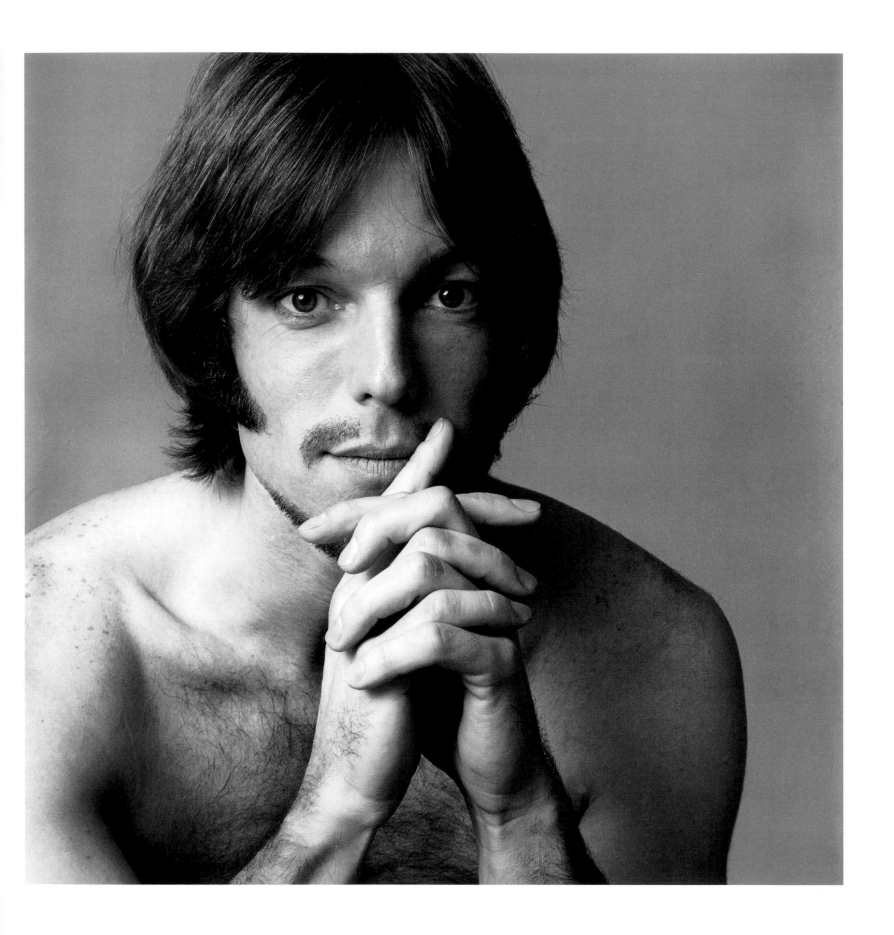

Richard Chamberlain

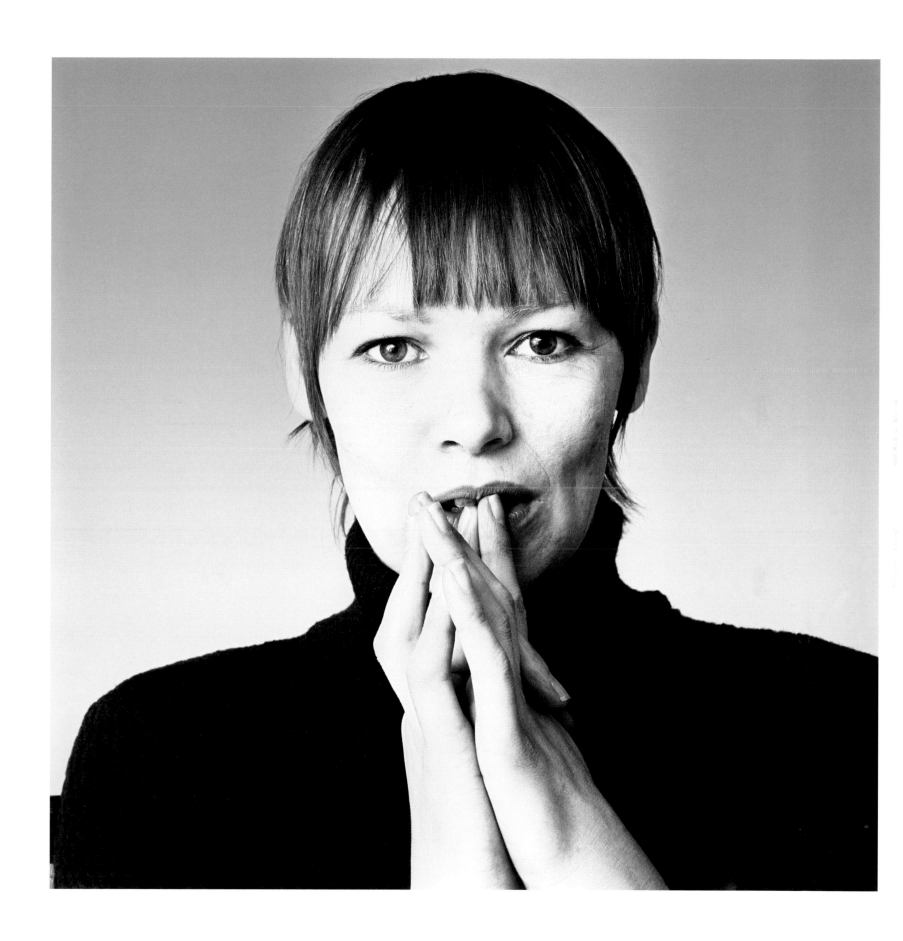

171 Glenda Jackson

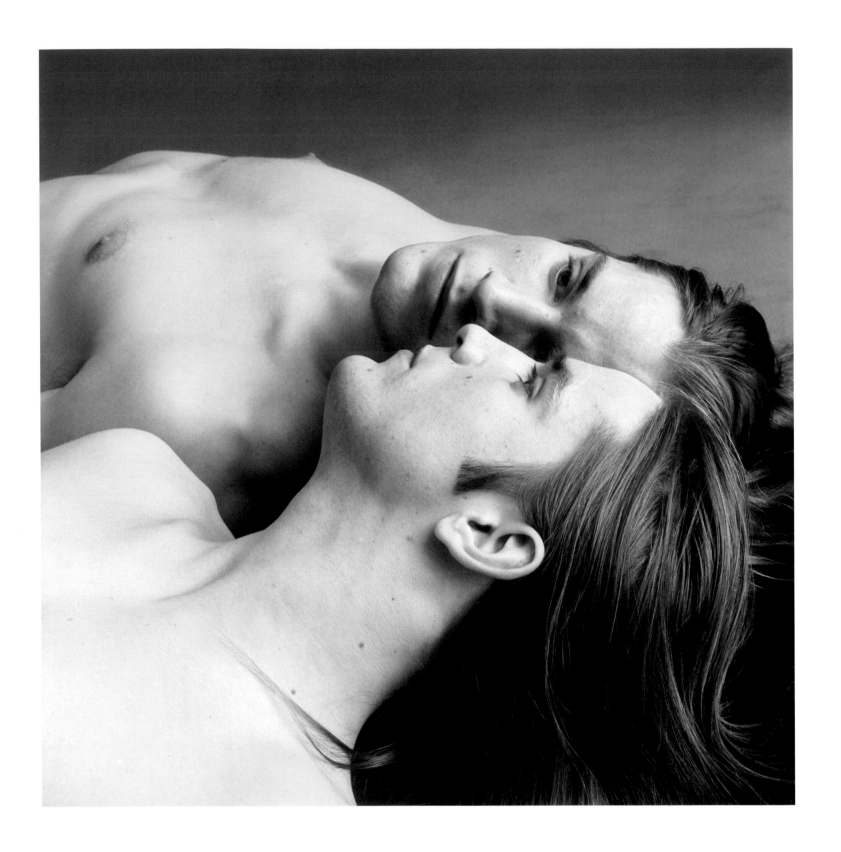

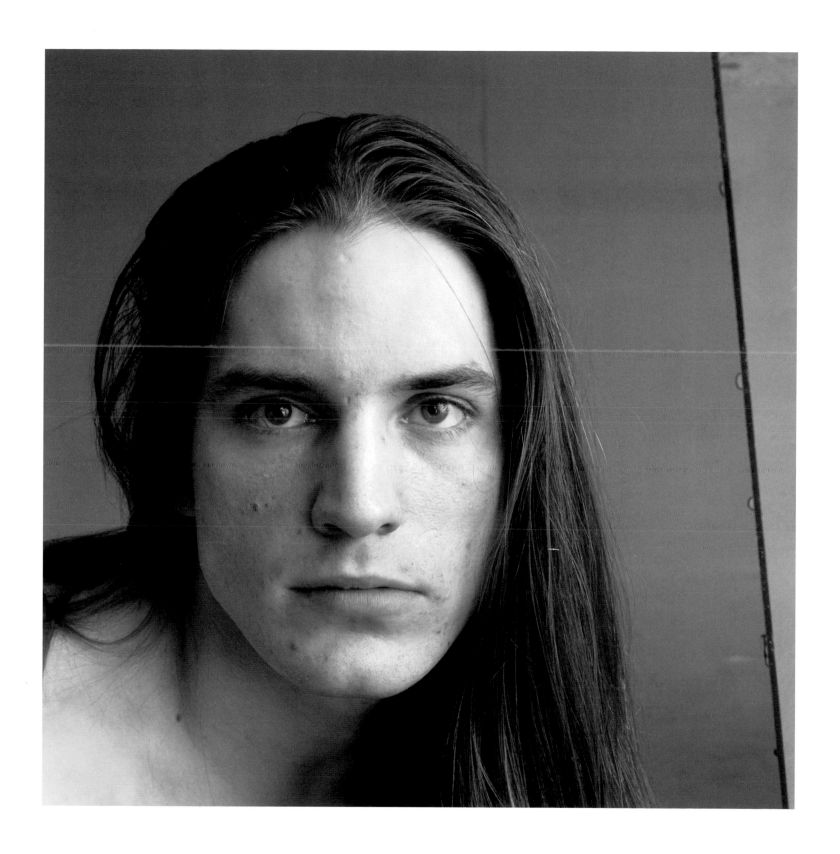

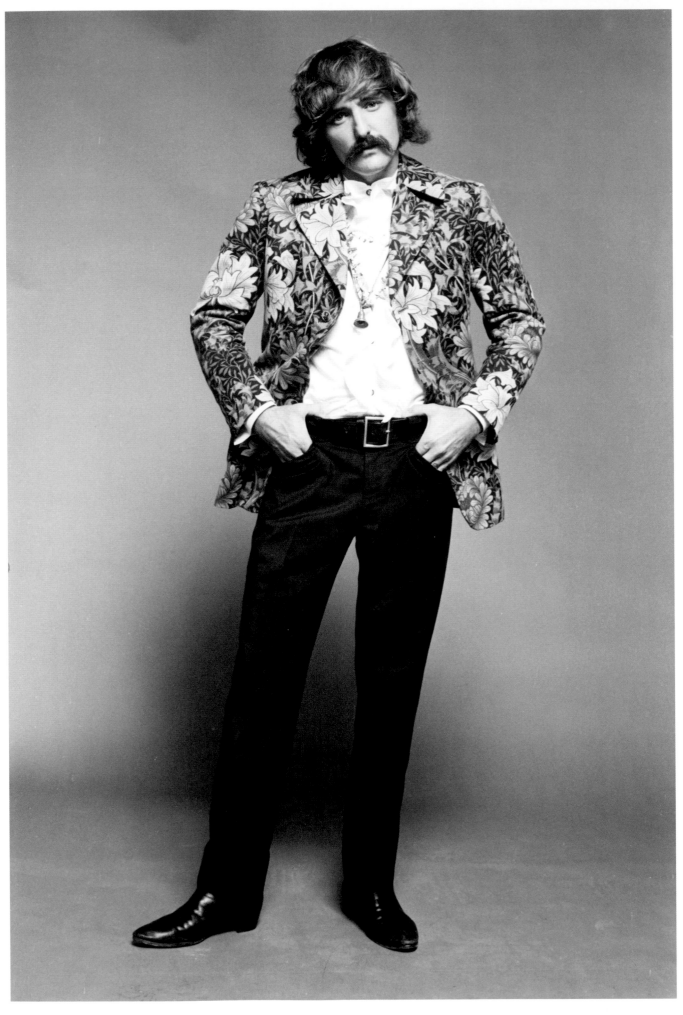

174 Dennis Hopper

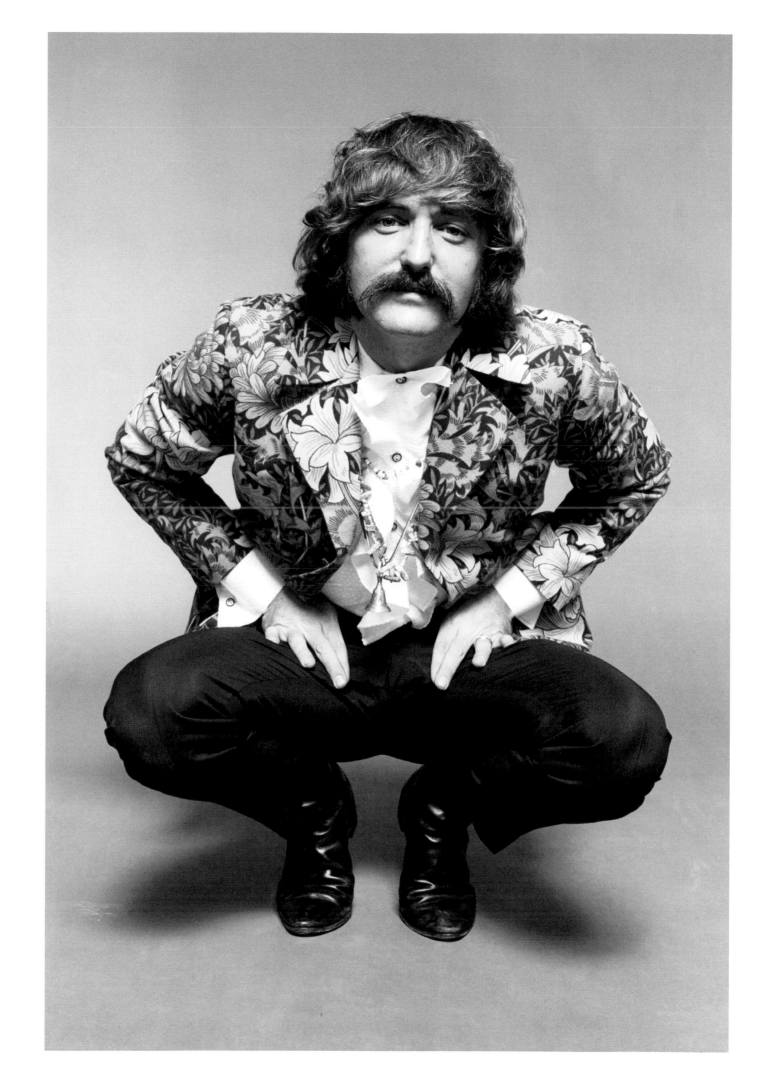

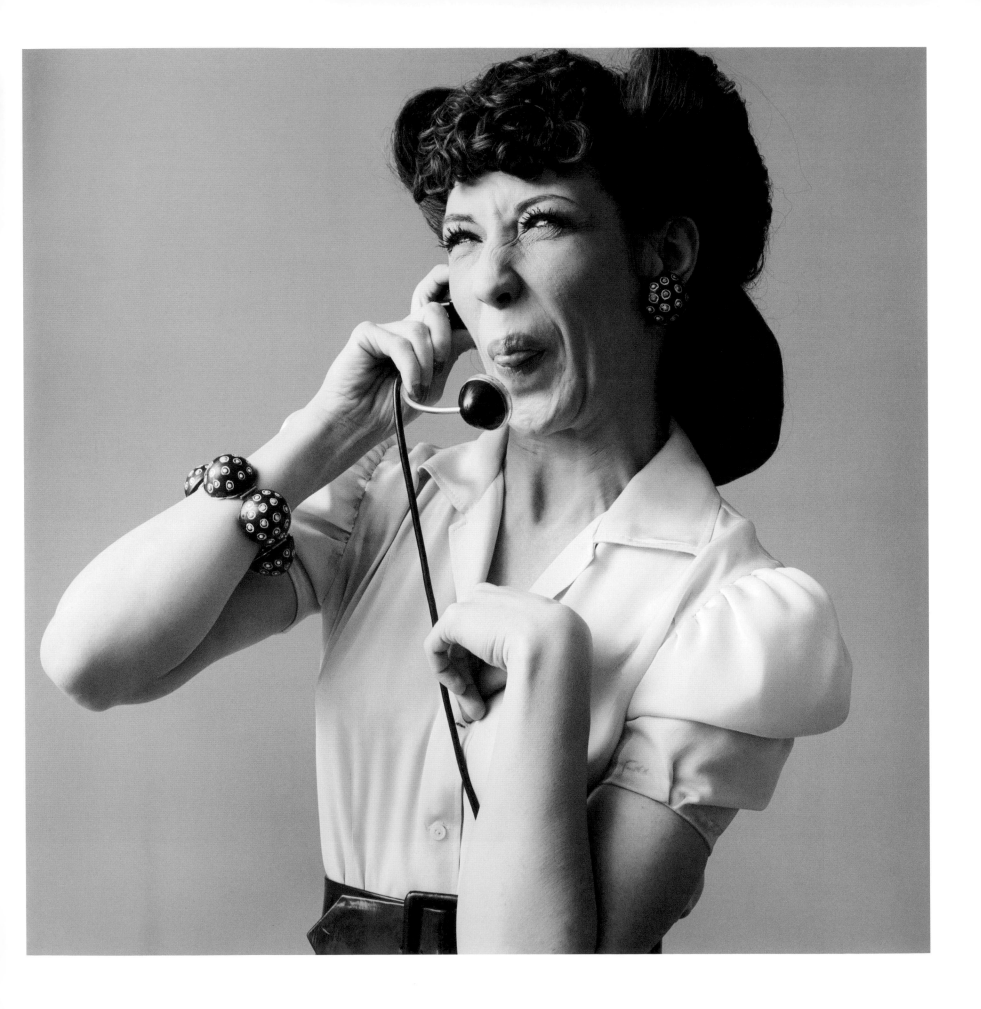

Lily Tomlin as Ernestine

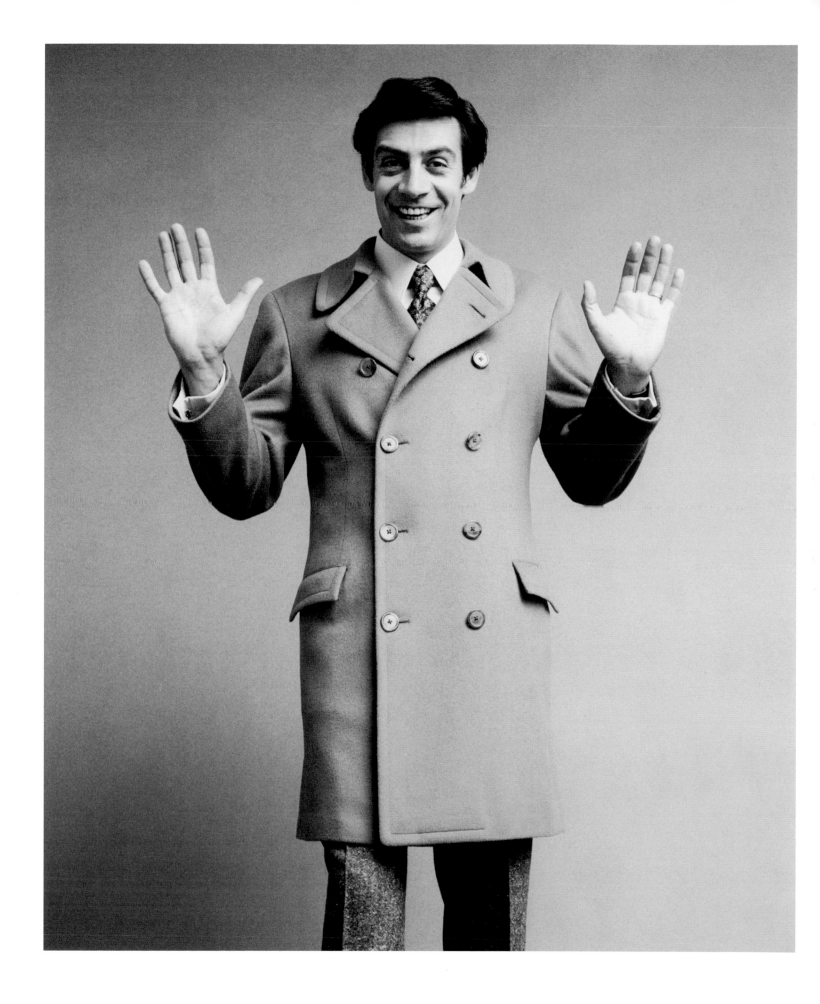

177 Jerry Orbach

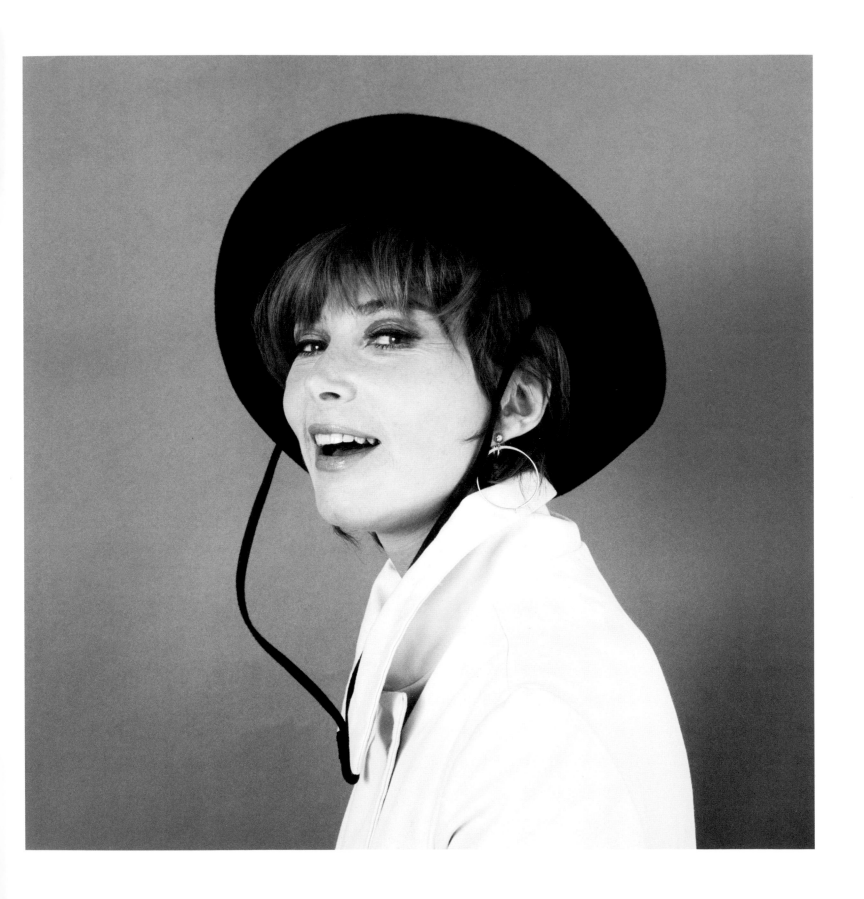

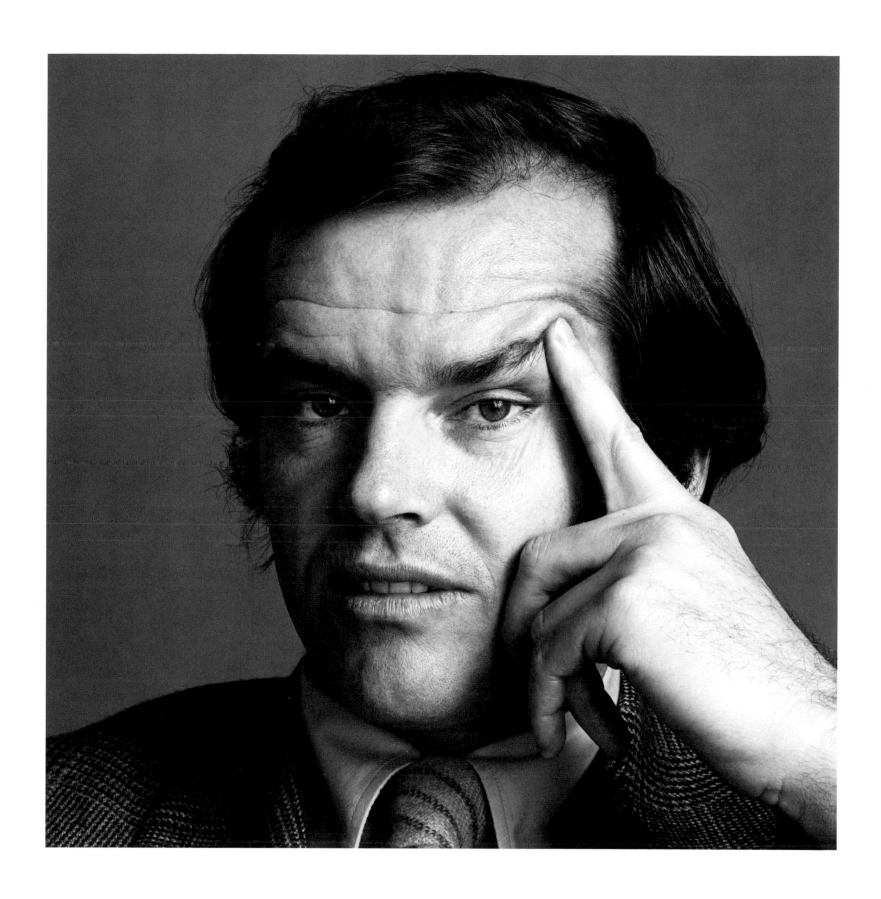

179 Jack Nicholson

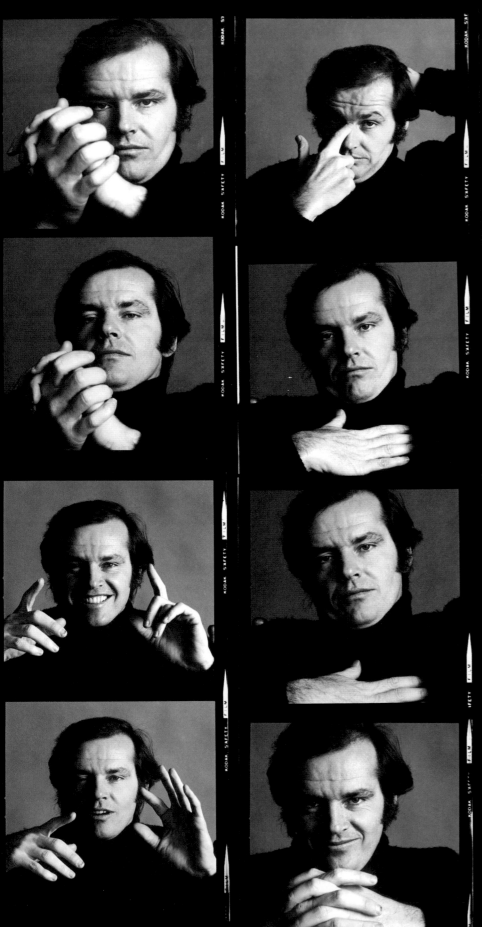
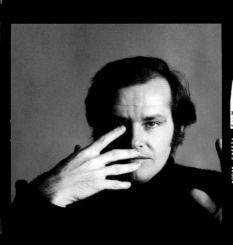
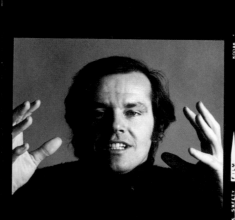

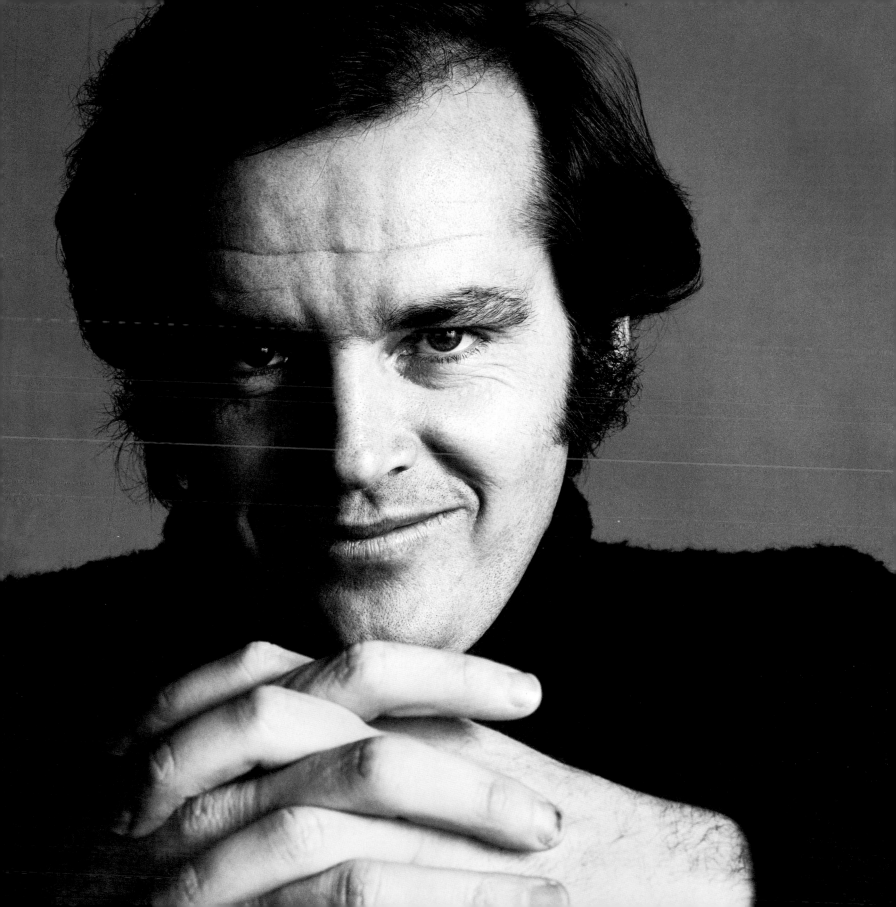

Commentary

1 Susan Carlson, Black-Eyed Susan of the Ridiculous Theatrical Company—December 21, 1970. Charles Ludlam created the Ridiculous Theatrical Company in 1967 in part as a reaction to the artistic pretensions of Off-Off Broadway. Here Black-Eyed Susan is seen as the High Priestess from the production of *The Grand Tarot*, described in *Vogue* as "deliriously ridiculous and tacky baroque, combining the broad performances of silent movies with the extravagant plotting of melodrama".

2 Jack Robinson self-portrait. New Orleans, early 1950s.

7 Cybill Shepherd photographed on October 27, 1971, in New York City (see pp.150–51).

8 Contact sheet of Suzy Parker, *c*.1958 or 1959, notes in grease pencil from Jack to Helena Rubenstein.

18 Hats on the Beach. Location assignment *c*.1959.

19–23 Diana Vreeland (1903–89) in her office at Condé Nast, March 28, 1968. Vreeland was editor-in-chief at *Vogue* from 1963 to 1971, and previously fashion editor at *Harper's Bazaar* from 1936 to 1962. She had asked that Jack take her portrait for an article that would appear in the *New York Post Weekend Magazine* titled, "She Gives Pizzaz to the Beautiful People". The article describes her office as "slick magazine Oriental" with "Chinese red walls" and "so damned dark in there, you have to feel your way around following her voice. ... She has pictures all over her pinboards, things she likes torn from magazines. Some are over twenty years old."

24 Carrie Donovan (1928–2001) photographed shortly after joining Diana Vreeland's staff at *Vogue*. A graduate of Parsons in 1950, Donovan had previously worked for *The New York Times* before moving to *Vogue*. She excelled at spotting fashion talent and worked on hundreds of assignments with Jack Robinson, both at *The New York Times* and at *Vogue*. After Donovan left *Vogue*, she moved to *Harper's Bazaar*. She helped bring Donna Karan and Perry Ellis to fame, and she matched

Elsa Peretti (p.27) with Tiffany & Co., feeling sure that Peretti would open the doors to a new demographic for the upscale company. Always displaying a good sense about "fashion for the masses", Diana Vreeland would tell Carrie, "My dear, you've got the common touch!" Donovan's trademark black dress and glasses made her a national celebrity in later life when she was "the lady from Old Navy" in television commercials.

25 Vera Gräfin von Lehndorff-Steinort (b.1939) was born in East Prussia, close to the borders of Poland, Germany, and Russia. The young Vera studied art in Hamburg and Florence, began modeling in Paris and Milan, and ultimately went to New York where she created a mysterious back-story and presented herself as "Veruschka". Her statuesque figure and dramatic looks endeared her to Diana Vreeland (pp.19–23), who gave her carte blanche on exotic *Vogue* assignments. Veruschka also became famous playing herself in a memorable scene in Michelangelo Antonioni's film *Blow-Up* (1966), opposite David Hemmings (p.138). In this shot of Veruschka, taken in New York on January 20, 1966, she models a "magnificent collier", designed by Mimi di Niscemi, that "flitters like a thousand fireflies".

26 Count Hubert James Marcel Taffin de Givenchy (b.1927), fashion designer, photographed October 30, 1967, as he inspects a model prior to a showing.

26 Giorgio di Sant' Angelo (1933–1989), fashion designer, photographed as he prepares a model for a show. The *Vogue* feature, "What a Boy is Giorgio!", published on April 1, 1969, claimed that Sant' Angelo makes fashion come together "with style—with wit—with joy"; "if there are such things as fashion geniuses, Giorgio di Sant' Angelo is one".

27 Elsa Peretti (b.1940), photographed outside Lincoln Center in New York on January 6, 1971, was born in Florence, studied interior design, and was a language teacher and ski instructor before becoming a model. Peretti settled in New York in 1968 and began a career as a jewelry designer working for Halston, Giorgio di Sant'

Angelo (p.26), Oscar de la Renta, and others. Peretti recounted how she began designing jewelry: "In 1969, I found a tiny flower vase in a junk shop and was inspired to design a bottle on a chain for designer Giorgio di Sant' Angelo." Since 1974, she has designed exclusively for Tiffany & Co.

28–9 Gloria Vanderbilt (b.1924)—photographed for a *Vogue* feature on the street in New York, March 25, 1972—is the daughter of the railroad heir Reginald Claypoole Vanderbilt and a member of one of the USA's richest families. She had a remarkable childhood and, in 1934, the 10-year-old Gloria was at the center of one of the USA's most scandalous custody battles. Although she was raised in great privilege, she worked hard to develop her considerable talents—artist, socialite, actress, novelist, fashion designer, and entrepreneur.

30 Gloria Vanderbilt and her sons Carter Cooper (1965–1988) and Anderson Cooper (b.1967) photographed on the bed at their home in Southampton, New York, on March 30, 1972. Anderson Cooper would become a star reporter and anchor for CNN.

31 Gloria Vanderbilt—March 24, 1972—shows off the style for which she has become renowned.

32 Model, actress, producer, and Warhol superstar Jane Holzer (b. 1940) was born as Jane Bruckenfeld. Also known as "Baby Jane", Holzer made regular appearances in *Vogue* throughout the mid-1960s. Diana Vreeland (pp.19–23) called Holzer the "most contemporary girl I know". Here Holzer is photographed on the street in New York in July 1967: "Jane Holzer knows it's the way to look on the city streets ... all blonde—and black—and sleek—and sexy."

33 The fashion designer Emilio Pucci (1914–1992) was a Florentine nobleman, the Marquis of Barsento, and a fervent sportsman who skied well enough to be on the Italian Olympic team in 1934 at Lake Placid. After the Second World War, he was discovered on the Zermatt slopes by a photographer, and when shots of his personally designed skiwear appeared in *Harper's Bazaar*, he was persuaded to

open a boutique, which in time became a fashion empire. He exploited new stretch fabrics, invented Capri pants, and became renowned for his brilliant colors and striking patterns, and for ranges of casual and sportswear that combined comfort with elegance. Photograph undated (early 1960s).

34 Fashion photograph undated and identified only as "House of Dior, Paris".

35 Lauren Hutton (b.1943), born in South Carolina but raised in Florida, discovered a love of travel early on and decided to become a model in order to pay for it. She successfully ran a dual career as a model and actress, appearing on the cover of *Vogue* twenty-five times and also appearing in films such as *Little Fauss* and *Big Halsey* (1970) and *American Gigolo* (1980). She is also an alumna of Tulane, Jack Robinson's alma mater. Photograph *c*.1972.

36–7 Berry Berenson (1948–2001) was related on her mother's side to the great couturier Schiaparelli and through her father to the distinguished art historian Bernard Berenson. After a period during which she was a model, Berenson became a fashion photographer in her own right. This photograph, which was taken in Berenson's apartment in New York, is from a six-page feature in *Vogue* titled, "Berry Berenson—A Natural Girl", which the magazine published on August 1, 1972. The article remarked on her "touching trust and openness" and her "unselfconscious dash and style that make her one of the great girls that spark up the New York scene". Here she wears a white wool robe and an African snake bracelet of ivory that was a gift from her sister Marisa (p.38). In August 1973, she married the actor Anthony Perkins (p.161). Berenson died when her flight to Los Angeles was hijacked and crashed into the World Trade Center on September 11, 2001.

38 A fashion shot of Berry's older sister Marisa Berenson (b.1947), a celebrated fashion model, "the queen of the scene", and a *Vogue* favorite. The photograph is undated but is believed to have been taken in 1970. Marisa would soon leave modeling

behind and go on to appear in many films, including *Death in Venice* (1971), *Cabaret* (1972), and *Barry Lyndon* (1975).

39 "Berry, Marisa, and Squashy the dog find The Greenery's window irresistible"—February 2, 1970. Berry and Marisa Berenson made appearances, either as a model or as a photographer, in virtually every *Vogue* issue throughout the mid to late 1960s.

40–41 The red-headed Suzy Parker (1932–2003), the highest paid and most famous US model in the 1950s, was the fourth of four daughters from San Antonio, Texas. Her older sister Dorian Leigh was a very successful model herself and was instrumental in getting the 15-year-old Suzy hired by Eileen Ford at Ford Models. "She was the most beautiful creature you can imagine," Ms. Ford said of Suzy. "She was everybody's everything." Parker's face made its first appearance in *Life* magazine that year. Jack Robinson photographed Parker on many occasions throughout the 1950s while she was working for Ford models. Photographs are undated although the image of Parker in the fur is believed to have been taken in February 1958.

42 Vidal Sassoon (b.1928)—March 7, 1969—is a British-born Israeli whose father was Greek and whose mother was Spanish. Sassoon decided that if he must be a hairdresser, he would have to be the best, so he went religiously to the theater to tune his ear and voice to "posh" English, and found work in the West End. He was the most significant hairdresser to emerge from the 1960s phenomenon of "Swinging London" and his "Nancy Kwan" cut and "Mary Quant" bob cut became defining looks of the era. Vidal Sassoon has been called "the founder of modern hairdressing".

43 Ralph Lauren and Bill Blass. The photographs of these two fashion designers together are undated but are believed to have been taken in 1970.

44 Ralph Lauren (b.1939) was born in The Bronx, New York. As a teenager, Ralph changed his last name from Lifshitz to Lauren and began creating his own sense of style, sometimes mixing army fatigues with tweeds. Designer Calvin Klein, also a native New Yorker, has said, "When I was a child in the Bronx, I would see him and think, 'Who is this person? Who dresses like that?'" Lauren showed early signs of entrepreneurship by selling neckties to fellow students at school and later he opened his own store, selling his necktie designs under the "Polo" label. In 1970, around the time of this photograph, Lauren had already branched into women's wear.

45 Bill Blass (1922–2002) came from Fort Wayne, Indiana, his mother a dressmaker

and his father a hardware salesman. In his autobiography Blass wrote that the margins in his school books were filled with sketches of Hollywood-inspired fashions instead of notes. At 15, he began sewing, selling evening gowns for $25 each to a New York manufacturer. At 17, he had saved up enough money to move to Manhattan and study fashion. He excelled in his fashion studies immediately and at 18 was the first male to win the *Mademoiselle* Design for Living award. He established his own label in 1970, around the time of the photograph.

47–9 Iggy Pop (b.1947), the "Godfather of Punk", was born as James Newell Osterberg. He started out as a high school drummer and one of his bands was The Iguanas, hence his stage name. Inspired by the performing antics of Jim Morrison, Iggy expanded on them with his group The Stooges. Jack Robinson photographed Iggy on February 26, 1970, just after The Stooges had released their second album, *Fun House*. *Vogue* describes the "wide-toothed singer with a Froggy-the-Gremlin voice" in "silver lame opera gloves and faded jeans, Iggy taunts and worries the audience with his drive and hype: I wanna be your dog".

50 The Kinks, formed in 1964, were a London band that fused rhythm and blues with English music-hall idioms. When photographed on February 2, 1970, the original members, the Davies brothers Ray (b.1944) and Dave (b.1947) and Mick Avory (b.1944), had been joined by John Dalton (b.1943). Four months earlier, they had released their concept album *Arthur (or the Decline and Fall of the British Empire)*, a working-class Everyman story. Quoting a line from a song on their previous album *The Village Green Preservation Society*, *Vogue* noted that with their "non-US accents and Regency looks, this group chirrup happily about 'little shops, china cups, and virginity.'"

51 Ray Davies was the lead singer and songwriter for The Kinks. His lyrics are some of the most literate and witty in the history of pop music. *Vogue* noted "quiet, remarkably observant, Ray Davies ... has a way of getting inside people's heads, even several generations' heads, in the Kinks album-novel *Arthur*. "'Snapshots,' he says 'so they won't forget.'"

52–3 Paul McCartney (b.1942) and John Lennon (1940–1980) holding a press conference on May 14, 1968, at New York's Americana hotel, to announce the launch of Apple Records. Lennon and McCartney met in Liverpool in 1957 and, along with George Harrison and Ringo Starr, formed The Beatles, the most successful band in pop music history. Six months after this

press conference, *The Beatles (White Album)* was released.

54–7 Elton John (b.1947)—November 6, 1970—was born Reginald Dwight in London. His father wanted him to go into banking but recognized his musical gifts and supported his training at the Royal Academy of Music. In 1967, he met his long-term songwriting partner Bernie Taupin and not long after changed his name to Elton John, derived from the Bluesology sax player Elton Dean and blues-singer friend Long John Baldry. At age 23 Elton had just released his third album, *Tumbleweed Connection* and his trademark appearance—the baby-face framed by oversize eyeglasses, and multi-colored garb—was already established. The feature in *Vogue* points out the role of Elton in the shift from electric guitar to piano-based music, noting his recent show piano-to-piano with Leon Russell at the Fillmore East. He "plays music touched by the blues and the classics, sings a conversational shout to suit his look ..., of a hip Christopher Robin (sideburns like kiss curls)".

58–9 Jazz great Herbie Hancock (b.1940)—November 22, 1968. The 28-year-old Hancock was described in *Vogue* as "a composer of incisive lyricism and a pianist with firefly fingers" and remarked that he was "unlabelled". The former sideman for Miles Davis commented that he writes music for commercials, soundtracks for movies, as well as touring with his jazz sextet and performing regular shows at the Village Vanguard.

60 Hugh Masekela (b.1939)—August 8, 1968—the South African trumpeter and human rights' campaigner was given his first horn at age 14 by the prominent opponent of apartheid, Archbishop Trevor Huddleston. A few years later, with the help of Huddleston, the violinist Yehudi Menuhin, and British musician John Dankworth, Masekela gained admission to London's Guildhall School of Music. He went on to the Manhattan School and, in 1963, recorded his first solo album. At the time of this photograph, Masakela had just released the song "Grazin' in the Grass", which sold over four million copies and was nominated for a Grammy.

61 Tony Williams (1945–1997), born in Chicago and raised in Boston, was the most influential and inventive drummer of the post-bop era and only 23 when photographed on November 23, 1969. Williams joked that he "employs a big cigar and a moustache to keep from looking 10 years old". When he was just 17, Williams was playing with Miles Davis and Herbie Hancock (pp.58–9) in the "Second Great Quintet". *Vogue* described Williams as

"the drummer of the impatient generation". "He takes percussion out of the supporting role and makes it a leading instrument of communication."

62 Bricktop (1894–1984)—February 1, 1971, in her "most deadly boa". She was a legend of inter-war Paris, and a celebrated party hostess, entertainer, and nightclub operator, with clientele such as Cole Porter, F. Scott Fitzgerald, and Ernest Hemingway. She gave the young Duke Ellington a Paris platform and made stars of Mabel Mercer and Josephine Baker. She left Paris when the Germans invaded and later set up clubs in Mexico City and Rome. Her real name was Ada Beatrice Queen Victoria Louisa Virginia Smith Du Conge and she came from West Virginia. Her nickname derived from her early flame-red hair and freckles; her dazzling legs moved Cole Porter to hire her to teach his friends the Charleston. His song "Miss Otis Regrets" was inspired by her fiery character. Bricktop was quoted in *Vogue*, "I may be 75, but I don't have any wrinkles 'cause underneath I'm still a baby."

63 Singer of soul, rhythm and blues, jazz, and folk, Roberta Flack (b.1937)—November 5, 1969—is described as a "warm, direct, deep-eyed singer with a haze of smoky hair ... singing and playing piano in a Washington D.C. nightclub" where "she leaves the customers crying". When this photograph was taken, her debut album *First Take* had just been released, including the song "The First Time Ever I Saw Your Face". *Vogue* also noted that Flack "is a wise young woman ... who has everything she needs—self-knowledge to match her talent".

64–5 The singer Melba Moore (b.1945)—July 28, 1971—was born in Harlem, New York, to parents distinguished in music. In 1967 she began her performing career in the groundbreaking Broadway musical *Hair*. Moore was looking forward to touring the country before returning to New York with *An Evening with Melba Moore* at New York's Philharmonic Hall. She speaks of stretching her range and vocal style and choosing the right examples: "go to the purest source, then with some intelligence and discipline, see where your head and your heart will lead you".

66 Buffy Sainte-Marie (b.1941) is a Canadian Cree, born in Saskatchewan but raised in Maine. She taught herself piano and guitar, and became a songwriter, philanthropist, anti-Vietnam protestor, and fierce advocate of Native-American rights. "Indians—we don't all look like nickels" she is quoted in a *Vogue* feature on March 1, 1969. Sainte Marie describes how her inspirational songs come down to her as if "from a hole in the sky". In the emerging culture of the 1960s, she sang in

coffeehouses, often performing alongside other Canadian contemporaries such as Leonard Cohen (pp.68–70), Joni Mitchell (pp.75–7), and Neil Young (p.78).

67 Folk singer, songwriter, and humorist Loudon Wainwright III (b.1946) is the son of Loudon Wainwright, Jr., columnist and editor of *Life* magazine. Wainwright claimed musical inspiration from seeing Bob Dylan performing at the 1963 Newport Folk Festival and he was working the folk clubs of New York and Boston when he was spotted and given a recording contract. Photographed on September 22, 1971, the 24-year-old Wainwright had already released the first two of more than twenty albums. He is the father of musicians Rufus Wainwright, Martha Wainwright, and Lucy Wainwright Roche.

68–70 Leonard Cohen (b.1934), Canadian songwriter, folk singer, poet, novelist, and philosopher, came from a middle-class Jewish home in Westmount, Montreal, his father a successful clothing-store owner. Cohen would go on to study at McGill University and then Columbia University. He published his first book of poetry in 1956 and his first novel in 1963. This photograph was taken on August 9, 1967, a month after Cohen's appearance at the Newport Folk Festival. A *Vogue* feature described Cohen as "a spare Canadian whose poems, novels, and music hang together on leashed lyricism". Loving and witty, his poems are "loved by the young".

71 The singer-songwriter Tim Buckley (1947–1975) was born in Amsterdam, New York, but when he was 10 his family migrated west to Anaheim, California. Obsessed with singing, he studied the greats from Nat King Cole to Johnny Cash, learning to breathe and deliver as they did, and then he went further, forcing his voice to be a musical instrument in its own right. He made his first album at 19 and immediately drew attention to his range and brilliance. When photographed on November 7, 1968, the 21-year-old Buckley had already released his second album, *Goodbye and Hello*, and was at work on his third, *Happy Sad*. *Vogue* described Buckley as the "found poet of new folk". "An instant waif with dimples, ... frail and wistful with hair like a nest of thrusting magpies", Buckley "cries love, hurt, war, and truth to the New Children". Buckley died in 1975 from a heroin overdose.

72–3 Boston-born singer-songwriter James Taylor (b.1948) spent his early years in the college town of Chapel Hill, North Carolina, where his father was dean of the U.N.C. Medical School. His was a musical family and Taylor chose the guitar. In 1966 Taylor moved to New York and together with a friend started a band, The Flying Machine. Soon after, Taylor moved to London where, after a year of playing, he found himself the first non-British act signed to Apple. When photographed on May 20, 1969, the 21-year-old Taylor's first album on Apple Records had just been released. Noting his "relaxed savvy", Taylor is described in *Vogue* as a "loping exclamation point with a down homey voice". Less than a year after these photographs were taken, Taylor would leave Apple and release a definitive album, *Sweet Baby James* (1969).

75–7 Joni Mitchell (b.1943) was born Roberta Joan Anderson in Alberta, Canada. She began playing guitar and singing in clubs in her hometown of Saskatoon, Saskatchewan, before busking on the streets of Toronto. After a failed marriage, which gave her the name of Mitchell, she moved to New York where other performers such as Buffy Sainte-Marie (p.66) and Judy Collins recognized her songwriting capabilities. Photographed on November 20, 1968, she had just released her first album and was about to appear in a concert at Carnegie Hall. In *Vogue*, Mitchell is described "with lake-blue eyes, hair poured like Chablis, and a voice that echoes through invisible hills". Although she did not appear at the Woodstock festival because of a television commitment, she wrote the song "Woodstock" after watching news coverage, and from what she heard from her then-boyfriend Graham Nash (p.79), who performed there with his band Crosby, Stills, Nash & Young (pp.78–9). She said: "The deprivation of not being able to go provided me with an intense angle on Woodstock."

78–9 On September 18, 1969, one month after their appearance at Woodstock, Jack Robinson photographed the newly formed supergroup of Crosby, Stills, Nash & Young. Earlier in 1969, David Crosby (b.1941), who had been a co-founder of The Byrds, Stephen Stills (b.1945), who had played with Buffalo Springfield, and Graham Nash (b.1942), who had been with The Hollies, released the album *Crosby, Stills & Nash* to great acclaim. Later they would be joined by Neil Young (b.1945) for the album that would appear in early 1970 under the title *Déja vu*. "Sharp thinkers all as well as onstage wits, they all write songs and sing soaring harmonies."

80 Joe Cocker (b.1944), rock and soul musician renowned for his unique stage presence, was born in Sheffield, England, and began his career playing in English pubs. He was particularly renowned for his Beatles' covers, and he hit number one in England in November 1968 with his version of The Beatles' "A Little Help from My Friends". Cocker was described in *Vogue*: "On stage, his delivery is spastic, arms flailing, eyes shut, his body a frenzied windmill as he grates soul, blues, and Beatles rock through a lusty North Country slur." Just three months before this photograph—taken November 21, 1969—Cocker was prominent performing through a major thunderstorm at Woodstock. In the year of this photograph, both his albums, *With a Little Help from My Friends* and *Joe Cocker!*, went gold in the USA.

81 Blues singer-guitarist Johnny Winter (b.1944) grew up in Beaumont, Texas, where he would frequent the black clubs and hone his talent. As a teenager, Johnny could play impressively enough to be invited by his idol, Muddy Waters, to sit in on a session. His first recordings were regional, and in 1968 he attracted attention from *Rolling Stone*, which featured him in a piece on Texas musicians. National labels fought to sign him, and his first album came out late in 1968. Photographed at age 25 on May 1, 1969, just ahead of his Woodstock appearance, *Vogue* described Winter as a man "hurtled into fame early in 1969 like a man jumping through a window".

83–5 The Who formed in 1964 and, when photographed on June 5, 1969, had just released their landmark rock opera *Tommy*, which was praised in *Vogue* as "celebrating the quiet divinity of explosion", seriously extending rock's musical range. The Who were John Entwistle (1944–2002), Pete Townshend (b.1945), Keith Moon (1946–1978), and Roger Daltrey (b.1944). Along with The Beatles and The Rolling Stones, The Who were part of "the holy trinity of British rock" in the words of *Rolling Stone* magazine.

86–7 The Sam & Dave Horn Section, photographed June 28, 1968, at Madison Square Garden in New York. The concert, called "Soul Together" and sponsored in part by Atlantic Records, gathered the great soul artists of the time together for one concert, with the entire proceeds going to the Martin Luther King, Jr. Memorial Fund. A *Vogue* feature called the Sam & Dave Horn Section a "dazzling performance of brass, beat, soul, and dance".

88 This photograph of the hugely popular singing and guitar duo, The Everly Brothers, Don (b.1937) and Phil (b.1939), was taken in 1958 as Jack Robinson traveled to Nashville to photograph the Everlys for their first album, released on Cadence Records. Those first Cadence records, often featuring family friend Chet Atkins (p.89), playing guitar, arranging, and producing, included such classic hits as "Bye Bye Love", "Wake up Little Susie", "All I Have to Do Is Dream", and "When Will I Be Loved". In 1986, The Everly Brothers were among the initial ten artists inducted into the Rock and Roll Hall of Fame.

89 Country music's Chet Atkins (1924–2001) was a prime mover in the creation of the Nashville sound, moving Nashville music away from its hillbilly roots and more into the mainstream. A guitarist and record producer, he made his debut at the Grand Ole Opry in 1946, and his first RCA recordings in 1947. Years later, he supervised the construction of Nashville's famous Studio B, and promoted the talents of many great artists including Jim Reeves, Waylon Jennings, Dolly Parton, Willie Nelson, Connie Smith, and The Everly Brothers (p.88). He was photographed on the stage of the Grand Ole Opry in 1958.

90–91 Just three years before Jack Robinson photographed Liza Minnelli (b.1946) in 1968, the 19-year-old star had become the youngest Tony winner ever. The year after these photographs were taken, Liza would earn her first Academy Award nomination for *The Sterile Cuckoo* (1969). She would go on to win the Academy Award for *Cabaret* (1973), as well as two more Tony awards. Minnelli was photographed by Jack Robinson many times but these photographs come from a session for the *Vogue*'s Own Boutique" feature. Opposite, Minnelli is seen with her first husband, the Australian songwriter and entertainer Peter Allen (1944–1992), whom she married in 1967.

92–3 Diana Ross (b.1944) is photographed here in New York's Grand Central Terminal for a *Vogue*'s Own Boutique" feature of September 15, 1968. The star of The Supremes is shown "cutting up ... in Saint Laurent chiffon". The Supremes had been Motown's biggest hitmakers and the most successful girl group of the 1960s. Just over a year after this photograph was taken, Ross would launch her solo career.

95–8 Tina Turner (b.1939), born as Anna Mae Bullock, began singing professionally as a teenager after meeting the established performer Ike Turner (1931–2007). In 1960 she stood in for a singer who failed to show for a recording session, and her rendering of "A Fool in Love" reached number two on the chart. Anna Mae was now called Tina, and the name of the act was the Ike & Tina Turner Revue. With hits such as "River Deep and Mountain High" and "Proud Mary", they regularly appeared in the music charts and on concert stages as they ascended to stardom. Photographed on November 25, 1969, while in New York on tour with The Rolling Stones, Tina is quoted in *Vogue*: "People seem to worry about how women suffer in the songs I

sing. They do, but they give it back. No man can get the best of any woman if she knows what to expect."

99 By the time she was photographed on October 30, 1969, few singers had fused gospel and pop with classical music as successfully as Nina Simone (1933–2003). Born as Eunice Kathleen Waymon in North Carolina, her early hopes of becoming a classical pianist were dashed by doors closed to her on account of poverty and color. She persisted, eventually singing in a nightclub to pay for her musical education, leading to her first hit, a version of Gershwin's "I Love You, Porgy". Simone's bearing and stage presence earned her the title "High Priestess of Soul".

100–101 Carly Simon (b.1945), American singer-songwriter, was 26 when photographed on July 9, 1971. It was her first magazine shoot. "The sandals were mine," she recalled in 2006, "I remember how uncomfortable they were and how they made big dents in my legs." Her debut album had not been long released and Simon would win the Grammy that year for Best New Artist. She was described in *Vogue* as "tall, lean, and talented" and as "one of a new breed of girl singer/songwriters". Simon would later marry and then divorce songwriter James Taylor (pp.72–3).

102–103 Cherilyn Sarkisian (b.1946) met Salvatore Bono (1935–1998) in Los Angeles in 1962, and the subsequent relationship evolved into Sonny & Cher, one of the most popular husband-wife acts in popular music history. Sonny had started his career at Specialty Records and then worked with Phil Spector in the early 1960s. Photographed on location in New York in 1966, after the duo had already released their first hits "I Got You Babe" and "The Beat Goes On", Sonny & Cher rebranded themselves in the early 1970s, starring in a hit television variety series, but split in 1975. Cher achieved a successful career as a solo performer and as an actress and she won the Academy Award for Best Actress for her role in *Moonstruck* (1987). Sonny went on to serve in the US House of Representatives. Opposite, Cher is photographed at the Waldorf Hotel New York—June 3, 1970.

104 Johnnie Ray (1927–1990), although he suffered from deafness from the age of 13, was a dynamic singer who first attracted attention while performing at the Flame Showbar in Detroit, an R&B nightclub where he was the only white performer. Ray made a startling debut in 1951 with his single "Whiskey and Gin" and in the following year, his recording of "Cry" soared to the top of the charts. His style was a precursor of rock and rhythm and blues,

and his singing was highly emotional and histrionic, causing such excitement among teenagers as to evoke condemnations from moral guardians. Photograph mid-1960s.

105 Pianist and conductor Daniel Barenboim (b.1943)—November 21, 1968. At the time, the 26-year-old Barenboim was described in *Vogue* as "a virtuoso pianist and formidable conductor who thrusts himself on stage like a conquering, amiable paratrooper". His gifts are "startling and awakening". A child prodigy, Barenboim gave his first concert aged 7, first played Carnegie Hall at 15, and made his first recordings at 21. In 1966, Barenboim had made his debut as conductor of the English Chamber Orchestra. In June 1967, at the Western Wall in Jerusalem, he married British cellist Jacqueline Du Pré (pp.106–7).

106–107 Pianist and conductor Daniel Barenboim, his wife the British cellist Jacqueline Du Pré (1945–1987), and violinist Pinchas Zukerman (b.1948) are photographed on November 24, 1969. Under the headline, "Super Trio—Super Brio", *Vogue* noted that "in rehearsal they call each other Pinky, Smiley, and Danny as they bicker and laugh". Both Barenboim and Zuckerman's careers would flourish as both performers and conductors, however, Du Pré's musicianship began to decline in 1971, and in 1973 she was diagnosed with multiple sclerosis, the disease that ultimately caused her death in 1987. Of Du Pré the article notes: "she is an English girl who seductively embraces her Stradivarius as she bows a flawlessly burnished sound".

108 The Japanese conductor Seiji Ozawa (b.1935) was born in China when it was occupied by Japan. Originally, he intended to be a pianist but a finger injury in a school rugby match ended that ambition. He studied under Herbert von Karajan and was engaged by Leonard Bernstein as assistant conductor of the New York Philharmonic. In a *Vogue* article published on April 1, 1970, about nine young conductors, Ozawa was noted for his cool hair-raising precision. Ozawa remarked "only the conductor counts" and "my baton is all I have". Between the years of 1964 and 1973, Ozawa directed a variety of orchestras, becoming music director of the Boston Symphony Orchestra in 1973. Besides his twenty-nine years at the Boston Symphony Orchestra, in 2002 Ozawa would follow in von Karajan's footsteps and become principal conductor of the Vienna State Opera.

109 Brooklyn-born Beverly Sills (1929–2007)—April 25, 1969—was a lyric coloratura soprano who became the USA's most popular opera star. She was an all-American success story—her parents were humble Jewish immigrants

and she trained entirely within the USA. The *Vogue* feature for which she was photographed notes: "Sills has surged to the top, reducing opera goers and opera critics to limp adoration". Two years later, she would land on the cover of *Time* magazine under the headline "America's Queen of Opera". Sills often appeared on television and her demeanor and approachability helped dispel the traditional image of the temperamental opera diva. After retirement, Sills became the Director of the New York City Opera and later the Chairman of Lincoln Center.

110 The composer and lyricist Jerry Herman (b.1931), born to middle-class Jewish parents in Jersey City, a short river hop from Broadway, grew up seeing great musicals and vowed at an early age he would make his contribution. His first full-fledged Broadway musical was *Milk and Honey* (1961). That was followed by two classic shows, back to back, *Hello, Dolly!* (1964) and *Mame* (1966). When Jack Robinson photographed the 38-year-old Herman on October 29, 1971, *Dear World* had already closed and Herman was at work on one of his personal favorites, *Mack & Mable*. Herman would go on to great heights again with *La Cage aux Folles* (1983).

111 Michael Tilson Thomas (b.1944), conductor, pianist, and composer, was born in Los Angeles to an artistic family; his grandparents, the Tomaschevskys, were prominent in Yiddish theatre. When photographed on December 11, 1969, the 24-year-old Thomas had recently been named the youngest-ever assistant conductor of the Boston Symphony Orchestra. He would go on to build a huge reputation in the classical music world, including seven years as principal conductor of the London Symphony Orchestra. He became the music director of the San Francisco Symphony and in 2009 received the American National Medal of Arts. In a *Vogue* feature about nine young conductors, Thomas notes his "tremendous faith in my generation ... musically".

112 Dancer, choreographer, and teacher Robert Joffrey (1930–1988) and his artistic director and dancer Gerald Arpino (1923–2008) founded the Robert Joffrey Ballet in the mid 1950s, and it became resident at New York City Center in 1966. Joffrey, the "small, gentle, muscleman", was born to an Afghan father and an Italian mother in Seattle, and Arpino, the "radical choreographer", was born on Staten Island. This dual portrait was taken on December 9, 1968. After Joffrey's death in 1988, Arpino took over the company, which, even after Arpino's death in 2008, still flourishes after more than fifty years.

113 The Italian composer Luciano Berio (1925–2003) was an outstanding orchestral and vocal composer who was perhaps most renowned for his works with solo voice. He was especially celebrated during his long residence in New York City for conducting his own works with the Juilliard Ensemble, which he founded. As well as instructing at The Juilliard School, he taught at Tanglewood and Harvard, and is acknowledged as one of the main forces in the development of modernist music and innovative sound sources, especially electronics. Photographed on February 5, 1970, the 44-year-old Berio was described in *Vogue* as a "shake-up composer with something to say and listen to".

114 The conductor Zubin Mehta (b.1936) was born in Mumbai, India, and studied in Vienna where he made his conducting debut. When photographed on December 15, 1969, the 33-year-old Mehta was music director of the Los Angeles Symphony and advisor to the Israeli Philharmonic. He would go on to be Music Director and Principal Conductor of the New York Philharmonic and Music Director of the Bavarian State Opera in Munich. In a *Vogue* feature about nine young conductors, Mehta was described as "passionate, magical, and driving" and quoted that "music is written with a microscope, great music is not square". Over the years, Mehta has received numerous awards including the Kennedy Center Honors in 2006.

115 Born in New Orleans, mezzo-soprano Shirley Verrett (1931–2010) was photographed on November 24, 1969. "Tall, fierce, dramatic even offstage" *Vogue* noted, Verrett was one of the world's leading opera singers before she was heard in a major house in her own country. She started singing at age 5, sold real estate to put herself through college, and turned a television appearance into a scholarship at Juilliard. She has performed in most of the world's main opera houses, but complained in her autobiography of the racism she sometimes encountered in the USA. "All of my training was American," she says "but it was Europe that wanted to hear me first."

117 Adrienne Kennedy (b.1931) with her son on September 25, 1969. The playwright was a key figure of the Black Arts Movement and won an Obie in 1964 for her first play, *Funnyhouse of a Negro*. Her work is poetic, symbolic, and often surrealist, drawing on her own experiences. In a *Vogue* feature, Kennedy is described as "lark-frail, her voice just more than a hum" and quoted: "Each of us is like a city within a cathedral, its streets, its stores. When someone speaks, that's what I hear, that's what I want to make other people hear."

118 The Irish novelist Edna O'Brien (b.1930) photographed on December 10, 1970, the year her novel *A Pagan Place* was published. O'Brien published her first book, *The Country Girls*, in 1960. This was the first of a trilogy that also included *The Lonely Girl* and *Girls in Their Married Bliss*. Authorities in Ireland disliked the sexual attitudes portrayed, and suppressed them. *Vogue* noted her "hair like an uncontained fire" and her "verdant, acute, and pervasive sense of country".

119 Born in Birmingham, the flamboyant British critic, essayist, and theatrical producer Kenneth Tynan (1927–1980) reveled in his enfant terrible literary reputation, and his iconoclastic drama criticism transformed London theater in the 1950s. He became the National Theatre's first literary manager in 1963. Photographed for *Vogue* on April 9, 1969, Tynan had recently staged the notorious taboo-busting hit *Oh! Calcutta!*, "an affectionate little erotic revue" with its intellectual jokes and contributions from twenty-one authors, including Samuel Beckett, Gore Vidal, Tennessee Williams, John Lennon (p.53), and Edna O'Brien (p.118), as well as featuring music and copious nudity. Tynan described the show as being for "the person who's had everything and wants it again". Tynan was described in *Vogue* as "a raky Britisher with responsive hands and insolent blue eyes".

120 Francine du Plessix Gray (b.1930)—February 11, 1970—is a Pulitzer Prize nominated writer and literary critic. Described by *Vogue* as a "moral militant", Gray is "tall, ibis-legged, with wonderous eyes, it looks as if she burned commitment like a reckless fuel". When photographed, Gray had just completed her first book, *Divine Disobedience*, a study of the radical Catholic movement in America.

121 Joyce Carol Oates (b.1938), born in Lockport, New York, is one of the USA's most prolific novelists. Her career began in 1964 with the publication of her first novel, *With Shuddering Fall*. When photographed on March 6, 1970, her novel *Them*, about a family caught up in riot-stricken Detroit, had just won the National Book Award. The 32-year-old Oates was described in *Vogue* as "tentative, hush-voiced, with the fixed brown eyes of a sleepwalker". "Most of my work", she is quoted, "is done in my head. When I sit down to write, it's like recording something that is already there." As a historical footnote, her session with Jack Robinson at his studio in Greenwich Village was interrupted by a loud explosion when a bomb being assembled by anti-war radicals the Weathermen exploded two blocks away.

122–4 Tom Wolfe (b.1931), born in Richmond, Virginia, spurned academic life after receiving his Yale doctorate to become a reporter, ultimately working at the *New York Herald Tribune*. He originated New Journalism, a staccato-adjective-laden style that reinvented subordinate clauses when writing a feature for *Esquire* on custom cars and hot rods. This piece would go on to become the title essay in the collection *The Kandy-Kolored Tangerine-Flake Streamline Baby*. Photographed in his office at the *New York Herald Tribune* for a "*Vogue*'s Own Boutique" feature published January 15, 1966, Wolfe is described as a "blazingly original dresser" who wore a pure white silk tweed summer suit one day in January "and it seemed to annoy people ... to my delight".

125 The art historian and curator Henry Geldzahler (1935–1994) arrived in the USA aged 5, as the Nazis were marching into his native Antwerp, Belgium. A graduate of Yale and Harvard, he became curator of American Art at the Metropolitan Museum of Art, and later the first curator of Twentieth Century Art. When photographed at the Metropolitan Museum of Art in August 28, 1969, Geldzahler had just opened the landmark exhibition, "New York Painting and Sculpture 1940–1970". Gregarious and outgoing, he numbered many artists as friends, among them Andy Warhol, Jasper Johns, William de Kooning, Frank Stella, Larry Rivers, and David Hockney. Later, Mayor Edward Koch would make him New York's cultural affairs commissioner and, as an openly gay man, he would do much to raise awareness in the fight against AIDS.

126 The conceptual artist Solomon "Sol" LeWitt (1928–2007)—August 21, 1969—is shown here in his studio on the Lower East Side of New York. LeWitt was one of the early proponents of minimal and conceptual art, and his works ranged from simple two-dimensional modular designs on paper to massive sculptures based on the cube. LeWitt is described by *Vogue* as an "artist more interested in the idea than the work". "Brainy, with an air of sweet fatality, LeWitt has taken art down from preciousness: 'Nothing lasts—not even art or us.'" Over his life, LeWitt was the subject of hundreds of gallery and museum shows including major retrospectives organized by the Museum of Modern Art, New York, and the San Francisco Museum of Modern Art.

127 Author and screenwriter Michael Crichton (1942–2008) was photographed on June 15, 1970. *Vogue* described the 27-year-old Crichton as "rosy, curly, scrubbed, tall as a chimney" with a "mind programmed like a computer". He had

taken his medical degree at Harvard knowing he would never practice medicine. Crichton wrote "novels, science fiction, thrillers, and movies". His seventh book, *The Andromeda Strain* had been a best seller the year before this photograph was taken and the movie would be released later in 1970. Crichton's "bouncy, outspoken chat, bloomy youth, and loose jointed energy are as misleading as an advanced nuclear device sewn into a Raggedy Andy". The prodigious Crichton wrote over thirty books in his lifetime, fourteen of which were turned into movies, the most notable being *Jurassic Park*, as well as directing seven movies himself and creating the enormously popular US television show *E.R.*

128 The minimalist artist Robert Smithson (1938–1973) was inspired to create his earthwork sculptures by watching dump trucks on the industrial wastelands of his native New Jersey. He discerned form even within the detritus of a debased landscape, and he wrote many essays on the aesthetics of his work. Photographed in New York on November 7, 1969, as part of a *Vogue* feature, Smithson is described as being "at the center of artists who are taking art out of galleries and museums". He had just covered a Vancouver island with broken glass and in 1970 he would create his most definitive work, "Spiral Jetty", a 1,500-foot coil of rocks and earth jutting out into the Great Salt Lake. He died in a plane crash in Texas in 1973, while surveying sites for a new earthwork.

129 Edward Ruscha (b.1937)—January 14, 1970—is one of the foremost figures of the American Pop Art movement. He grew up in Oklahoma City and in the mid 1950s, he settled in Los Angeles and worked in advertising. In 1962 his artworks were exhibited in Pasadena alongside those of Roy Lichtenstein, Jim Dine, Andy Warhol, and others, the first significant display of pop art in the USA. Ruscha described his work in *Vogue* as "just information". Among his notable works are a series of studies of highway gas stations, and a landscape-shaped book featuring a continuous ribbon of photographs of every building along the Sunset Strip.

131–3 Canadian actor Donald Sutherland (b.1935) grew up in New Brunswick, worked as a teenage radio reporter for a Nova Scotia station, graduated with a double major in engineering and drama at the University of Toronto, and then studied acting in London. His career break came as a proto-hippie soldier in *The Dirty Dozen* (1967). He was photographed on January 30, 1970, when Robert Altman's *MASH* was just about to be released, and according to *Vogue*, Sutherland's role had "dug him

out of obscurity into a blaze". "A man of wit and brain who damps his flash with deprecation, speaks softly ... comedy overtakes him like a synaptic reflex."

134–5 Appearing as Sutherland's buddy in *MASH* was Elliott Gould (b.1938), a Brooklyn-born actor who had reached Hollywood via Broadway. During the run of the musical *I Can Get It for You Wholesale* (1962), Gould met the young Barbra Streisand, whom he was to marry in 1963 and divorce in 1971. When Gould was photographed on December 6, 1967, he had just appeared on Broadway in the short run of Jules Feiffer's black comedy *Little Murders*.

136–7 Michael Caine (b.1933) was born as Maurice Micklewhite in the Elephant and Castle district of London. Drafted into the army, he saw action in Korea, and then worked in repertory, the British equivalent of stock theater. Photographed on December 9, 1966, in his suite at New York's Plaza Hotel. The article published in the "Men in *Vogue*" feature of the magazine on April 1, 1967, mentions his latest success in *Funeral in Berlin* (1966), *Gambit* (1966), and *Hurry Sundown* (1967), and comments that his "deceptively casual" manner is hidden behind slightly tinted lenses. Just nine days after publication of this article, the 1967 Academy Awards honored Caine's role in *Alfie* (1966) with a Best Actor nomination, the first of his six nominations.

138 David Hemmings (1941–2003), born in Guildford, England, was initially a boy singer and protégé of the composer Benjamin Britten. He performed in juvenile and post-adolescent roles in a number of films before attaining stardom as an archetypal catalytic figure of "Swinging London", a fashion photographer, in Michelangelo Antonioni's *Blow-Up* (1966), appearing in a memorable scene opposite Veruschka (p.25). He then appeared in the Hollywood version of the musical *Camelot* (1967) and also in a heroic role in *The Charge of the Light Brigade* (1968). He was photographed on October 7, 1968, and described in *Vogue* as "a roving consumer who buys wot strikes his fancy, anywhere".

139 Dirk Bogarde (1921–1999) had, by the time he was photographed on January 17, 1968, survived a long period as the pin-up idol of postwar British cinema to be recognized as an outstanding actor in films such as *Victim* (1961), *Darling* (1965) with Julie Christie (pp.140–41), *Accident* (1967), and *Our Mother's House* (1967). Most of Bogarde's best and most serious roles came after *Victim*, the film in which he first stretched himself as an actor. He received the first of his six nominations as Best Actor from the British Academy

of Film & Television Arts (BAFTA) for the film. Bogarde would later develop his writing talent to produce a number of autobiographical books, while still making distinguished appearances in films, mainly for European directors such as Luchino Visconti, Alain Resnais, Rainer Werner Fassbinder, and Bertrand Tavernier.

140-41 Julie Christie (b.1941)—December 18, 1965—was born in Assam, India, where her father was a British tea planter. Educated in England and France, she developed into a stage actress, and then appeared in television serials. The director John Schlesinger gave her a small, but scene-stealing part in *Billy Liar* (1963), leading to the principal part in his film *Darling* (1965), a role that won Christie the Academy Award. Photographed in New York, she was there to promote the David Lean epic *Doctor Zhivago* (1965). Jack Robinson followed Christie as "she beelined for every boutique in sight" and included a special trip to Kenny Lane's own workshop.

142 Malcom McDowell (b.1943) was photographed on October 22, 1971. Born in Leeds, McDowell had become known for his first film role in *if....* (1968), directed by Lindsay Anderson (p.143). The 28-year-old McDowell is described in *Vogue* as "his own sort of actor, with an English potato face and a manner that is charged with sly sex". His role in *A Clockwork Orange* (1971) had left McDowell "a walloping new culture here" and he would go on to appear in almost 200 roles in film and on television.

143 Lindsay Anderson (1923–1994) was born in Bangalore, India. While at Oxford he became an influential film critic, and later the director of outstanding realist documentaries. His feature films were few, but his impact on cinema was significant. When photographed on November 10, 1970, he was set to open *Home* (1970) on Broadway, for which he would be nominated for a Tony award for Best Direction. Already Anderson had made the classic films *This Sporting Life* (1963) and *if....* (1968), the first of an iconoclastic, satirical trilogy that deconstructed the British establishment, in this case represented by an upper-class private school, and starring Malcolm McDowell (p.142). *if....* would win Anderson the Palme d'Or at Cannes as well as a BAFTA nomination.

144 The French director Claude Chabrol (1930–2010)—September 10, 1970—was one of the Cahiers du Cinéma critics who became filmmakers. Chabrol's film *Le Beau Serge* (1958) is considered to be the first film of the French New Wave, a movement that revolutionized cinema in France and spread its influence internationally. He co-wrote the first serious critical examination of Hitchcock, and many of his films were intricate mysteries that derived from, and expanded, the ideas and techniques of the master.

145 Henri Langlois (1914–1977)—January 22, 1969—founded the Cinémathèque Française in 1936 and became the ultimate gatherer of film, amassing an astonishing collection, saving many masterpieces from destruction through indifference. Eccentric and haphazard, in 1968 he was fired by André Malraux, Minister of Culture, an action that was a spark for the May student riots. Concerted action by the film intelligentsia, "the children of the Cinémathèque" brought his reinstatement. Langlois was described in *Vogue* as a man who "loves to talk but hates to tell anything. To divert attention away from his non-answers, he uses a comedian turnout, stained sweater, flappy coat, grimaces, and calls himself 'just a St. Bernard dog rescuing films'". The feature also notes, "From eyes like one-way windows, Langlois sees absurdity: 'Most people advance through life walking backward. Those artists who face front are likely to be put in jail—or the madhouse.'"

146 The French actor Jean-Louis Trintignant (b.1930)—February 27, 1970—made among his early films Roger Vadim's *And God Created Woman* (1956) with Brigitte Bardot as co-star, but became prominent internationally in 1966 with Claude Lelouch's *A Man and a Woman*. In 1969 he won the Best Actor award at the Cannes Film Festival for his performance in the Costa-Gavras political drama *Z*. *Vogue* notes Trintignant's "offhand manner and dead-on grey eyes" have won over American women", "in spite of the fact he has never played a part in English". "To the tough deadpan accuracy of Humphrey Bogart" Trintignant "adds a smile that shoots across his eyes with startling accuracy, a grin that pounces in for the kill".

147 Italian director Bernardo Bertolucci (b.1940), born in Parma and the son of poets, was himself a published poet at the age of 18. He moved into films at 20 as an assistant director to Pier Paolo Pasolini, himself a poet turned filmmaker. When Jack Robinson photographed the 28-year-old Bertolucci on April 12, 1969, he had not yet started filming on *The Conformist* (1970) featuring the actors Jean-Louis Trintignant (p.146) and Dominique Sanda (p.148). In *Vogue*, Bertolucci is described as "a shy man who moves the way he speaks and smiles, gently but cautiously, with sleepy brown eyes on the lookout for the worst". As a filmmaker, he would achieve notoriety for *Last Tango in Paris* (1972) and over his distinguished career has received four Academy Award nominations for writing and directing, winning twice for *The Last Emperor* (1987).

148 The Paris-born actress Dominique Sanda (b.1948) was briefly a *Vogue* model in her late teens before being cast by Robert Bresson in the leading role in *Une Femme Douce* (1969). It was followed by star parts in Vittorio de Sica's *The Garden of the Finzi-Continis* (1970) with Helmut Berger (p.149), and *The Conformist* (1970), opposite Jean-Louis Trintignant (p.146) and directed by Bernardo Bertolucci (p.147). Sanda was photographed on October 9, 1970, for a *Vogue* feature titled "The New Movie Crush". The 22-year-old Sanda is described as "silky, sulky, unforgivably vulnerable, ... the newest sort of sex symbol, believable, ready for what she wants, yet remote and beautiful".

149 Helmut Berger (b.1944) was photographed for *Vogue* magazine on December 10, 1969, at the moment of the 25-year-old actor's "poison-green film debut" in Visconti's *The Damned* (1969), an epic depiction of the downfall of a Nazi industrial dynasty where Berger starred opposite Dirk Bogarde (p.139). He would go on to appear in more than fifty roles in film and on television including Vittorio de Sica's *The Garden of the Finzi-Continis* (1970) in which he appeared as the brother of Dominique Sanda (p.148).

150-51 Cybill Shepherd (b.1950) was born in Memphis, Tennessee, and after winning a beauty pageant became an enormously successful model. Shepherd had an All-American look and cut a fuller figure than most of the Twiggy-like models of the mid to late 1960s; this set her apart, making her very in-demand, and put her on numerous magazine covers, including *Vogue*, *Glamour*, and *Life*. It was from a *Glamour* magazine cover in 1970 that the director Peter Bogdanovich selected her to play a key role in his definitive film *The Last Picture Show* (1971). This photograph was taken on October 27, 1971, just five days after the release of *The Last Picture Show*. She would follow that performance with a role in Elaine May's classic comedy, *The Heartbreak Kid* (1972). Her career eventually moved from movies to television where she has been the star of several successful and popular television shows, including *The Cybill Show* and *Moonlighting*.

152 The distinguished stage and screen actresses Jane Alexander (b.1939) and Sada Thompson (b.1929) appeared together in a production of Eugene O'Neill's *Mourning Becomes Electra* for the American Shakespeare Festival Theatre, Stratford, Connecticut, in the summer of 1971. They were photographed on May 6 that year. Jane Alexander had by then appeared in *The Great White Hope*, both on Broadway (1968) and in the film version (1970), winning both a Tony and an Academy Award nomination. Sada Thompson had lately received a "shower of awards" for her stunning performance in *The Effect of Gamma Rays on Man-in-the-Moon Marigolds* (1970).

153 Mia Farrow (b.1945) was born Maria de Lourdes Villiers-Farrow, the daughter of film director John Farrow and actress Maureen O'Sullivan. Farrow first came to the public eye in the US television show *Peyton Place* in 1964. Her leading role in Roman Polanski's frightening satanic thriller *Rosemary's Baby* (1968) propelled her into film stardom. Farrow was still Mrs. Frank Sinatra when this photo was taken at a silver anniversary party for the lyricist Betty Comden and her husband Steven Kyle on January 8, 1967.

154 Julie Harris (b.1925) conquered the media of stage, television, and film, winning five Tony awards and a record number of nominations, three Emmy awards, one Oscar nomination, and a Grammy for a spoken word recording. She made her film debut in Fred Zinnemann's *The Member of the Wedding* (1952), reprising her Broadway role, originated the role of Sally Bowles on stage in *I am a Camera* (1952), and starred opposite James Dean in Elia Kazan's *East of Eden* (1955). When photographed on July 8, 1966, Harris was playing in the Broadway musical *Skyscraper*, adapted from Elmer Rice's *Dream Girl*, and was on screen in *Harper* opposite Paul Newman.

155 Faye Dunaway (b.1941) was born in Florida and, after graduating from Boston University, worked in theater, primarily at Lincoln Center. She made appearances on television and made her film debut in a small part in Otto Preminger's *Hurry Sundown* (1967) starring Michael Caine (p.136-7). Her third film, Arthur Penn's *Bonnie and Clyde* (1967), in which she played Warren Beatty's (p.156-160) partner-in-crime, made her an overnight star. Here, just four months after the release of *Bonnie and Clyde*, Dunaway was photographed on January 19, 1968, for a "*Vogue*'s Own Boutique" feature.

156-160 Warren Beatty (b.1937) dropped out of Northwestern University to study acting with Stella Adler. He made his film debut in Elia Kazan's *Splendor in the Grass* (1961). In 1967, Beatty teamed with director Arthur Penn to make *Bonnie and Clyde*, the real-life story of two Depression-era bank robbers co-starring Faye Dunaway (p.155). The film won the Academy Award for Best Picture and Beatty received his first nomination for Best Actor. Jack Robinson photographed Beatty on August 8, 1967, just as *Bonnie and Clyde* was hitting the screens,

and the *Vogue* feature describes the film as "grim, funny, completely absorbing". Beatty is described as "hell-on-wheels and vibrant with savvy" ... "Natural elegance, that's what this cat's got."

161 Anthony Perkins (1932–1992) was the son of the distinguished Broadway actor Osgood Perkins. He won an Academy Award nomination in just his second film, *Friendly Persuasion* (1956). In 1960, he appeared as Norman Bates in Alfred Hitchcock's thriller *Psycho*, and from then on Perkins was strongly identified with that one role. When photographed on May 21, 1968, Perkins had just made *Pretty Poison* playing a mentally disturbed man opposite Tuesday Weld. He was married to the photographer Berry Berenson (pp.36–7) and is said to have based at least some of his performance as a fashion photographer in *Mahogany* (1975) on his observations of Jack Robinson in action.

162 Lauren Bacall (b.1924) was born Betty Joan Perske in New York. As a young model on the cover of *Harper's Bazaar* in 1944, she was whisked to California to co-star with Humphrey Bogart in *To Have and Have Not*. They married and she made three more films with him in succession, *The Big Sleep* (1946), *Dark Passage* (1947), and *Key Largo* (1948). Bogart died in 1957 yet Bacall went on to become one of Hollywood's most durable stars. When photographed in her Manhattan apartment in the Dakota on March 20, 1970, Bacall was about to open on Broadway in the lead role in *Applause*, the musical based on the film *All About Eve*, and for which she would win a Tony.

163 James Garner (b.1928) dropped out of high school to join the Merchant Marine and later received the Purple Heart after being wounded in the Korean War. He first acted in a bit part in *The Caine Mutiny Court Martial* (1954) on Broadway and made his first film appearance in *The Girl He Left Behind* (1956). Garner soon moved to television as the title character in the hit television western series *Maverick* (1957). Through the 1960s he consolidated his stardom with films such as *The Great Escape* (1963), *The Thrill of It All* (1963), *Move Over, Darling* (1963), and *The Americanization of Emily* (1964), usually playing strong characters with easy charm. He was photographed on December 21, 1966, the same day as the movie *Grand Prix* was released.

165–7 Actor, director, and composer Clint Eastwood (b.1930) has compiled a remarkable seven-decade career, winning five Academy Awards. When Jack Robinson photographed Eastwood on July 10, 1969, for a "Men in *Vogue*" feature, *Paint Your Wagon*, Eastwood's only musical, was about

to be released. In the previous year, to show his prodigious output and his versatility, Eastwood had released three movies, *Hang 'Em High*, a western; *Coogan's Bluff*, a police manhunt; and *Where Eagles Dare*, a Second World War thriller. In the following year, he would begin filming his first role from the director's chair, *Play Misty for Me* (1971), as well as his first portrayal of the uncompromising San Francisco cop Harry Callahan in *Dirty Harry* (1971).

168 Musician, singer, composer, and actor Kris Kristofferson (b.1936) was the son of a US Air Force Major General and won a Rhodes scholarship to study at Oxford. He joined the US Army, became a helicopter pilot, and ultimately earned the rank of Captain. When Kristofferson left the Army, he went off to Nashville to pursue a music career. He cut his first single in 1966, and in 1970 released his first album, *Kristofferson*. He was photographed on December 31, 1970, and a *Vogue* feature describes the 34-year-old, with "his dead blue eyes and a silver guitar around his neck", as being on "top of the heap". With two movies finished, one of which, *The Last Movie* (1971), was directed by Dennis Hopper (p.174–5), now he can let his "tumbling, tumbleweed charm take hold".

169 Born in the Bronx, a football player at Michigan State, and for several years a rodeo rider nicknamed "the Jewish cowboy", James Caan (b.1940) was one of the most exciting and rugged stars to emerge in the 1960s. He was photographed on October 25, 1971, and is described in *Vogue* as the "unexploded star of *The Godfather* (1972)" and "a real comer who has yet to play a film role that needs his kind of acting muscle". Caan had made his debut as a sailor in *Irma la Douce* (1963), and he impressed audiences as John Wayne's sidekick in *El Dorado* (1967). His heart-breaking performance on television in *Brian's Song* (1971) confirmed his star status.

170 Richard Chamberlain (b.1934) was born in Beverly Hills, served in Korea, and turned to acting. He made his name on television playing the title role in the medical drama series *Dr. Kildare* (1961), and crossed over into films. Handicapped in roles by his "soft" image and boyish charm, he took to the stage and worked in England. Toughened up, he went back into films, playing Tchaikovsky in Ken Russell's *The Music Lovers* (1970), opposite Glenda Jackson (p.171). He was photographed on January 13, 1971, for a *Vogue* feature titled "Alas poor Ilyich, Richard Chamberlain doesn't know who he is". In the article Chamberlain speaks of his exile to England, "I left America because I was drowning. I didn't want the spotlight." Described as "sexy in a wounded kind of way, surprisingly skinny,

with hooded eyes and a deadpan West Coast accent, Chamberlain is remarkably easy about the risks ... 'I want to work, I couldn't care less about being Richard Chamberlain.'"

171 Glenda Jackson (b.1936)—January 16, 1971—studied acting at the Royal Academy of Dramatic Art, London, and was with the Royal Shakespeare Company for four years. She would soon win her first Academy Award as Best Actress for her performance in Ken Russell's *Women in Love* (1969). Directly following that role, she reunited with Ken Russell to star in *The Music Lovers* (1970) opposite Richard Chamberlain (p.170). Jackson was described in *Vogue* as "the British actress who plays unadmirable women to admiration, with a steamy swamp of a voice and a deep, rapidly accelerating laugh". At the time of this session, her bangs had been trimmed back for her role as Queen Elizabeth I in the BBC serial *Elizabeth R* (1971).

172–3 Joe Dallesandro (b.1948) was a prominent underground star as a consequence of his appearances in films made by Andy Warhol and Paul Morrissey. The most notable were the trilogy *Flesh* (1968), *Trash* (1970), and *Heat* (1972). Dallesandro's "Little Joe" tattoo on his upper right arm is a reference to his nickname, made infamous in Lou Reed's 1972 hit song "Walk on the Wild Side". Reed's lyrics tell the tale of a series of individuals and their respective journeys to New York City, and refer to several of the regular "superstars" at Andy Warhol's New York studio. The photograph was taken on December 2, 1970. Early the following year, Andy Warhol designed the cover of The Rolling Stones album *Sticky Fingers* using a picture of Dallesandro, complete with zipper.

174–5 Dennis Hopper (1936–2010) came from Dodge City, Kansas, and in his early days appeared in teleplays. Some of his first notable roles were in two James Dean films, *Rebel Without a Cause* (1955) and *Giant* (1956). These photographs were taken on December 14, 1967, for a "*Vogue*'s Own Boutique" feature, under the title, "Dennis Hopper is sharp as photographer, as actor, and as dresser—wow!" Here he's wearing the jacket his wife Brooke Hayward had tailored for him in London. Just eighteen months later, Hopper's watershed moment would come with the release of the road-movie cult classic *Easy Rider* (1969), an anthem for youth rebellion, which he directed, co-wrote, and appeared in with Peter Fonda and Jack Nicholson (pp.179–181).

176 Writer and performer Lily Tomlin (b.1939) made her name in the NBC comedy show *Rowan and Martin's Laugh-In* as Ernestine, the telephone operator with

an answer for everything. Jack Robinson photographed Tomlin on March 29, 1971, during her *Laugh-In* period. In a *Vogue* feature, Tomlin is described as a "slender, scrappy young woman with innocence-blue eyes and a smoke screen of brown hair". The feature describes the way she uses her characters to hit "corporate hypocrisy, government incredibility, pomposity, cant, untruth telling of any kind".

177 Born in the Bronx, Jerry Orbach (1935–2004) was a stalwart of Broadway, particularly musicals such as the 1955 revival of *The Threepenny Opera*, *Carnival!* (1961), and the long-running hits *Chicago* (1975), and *42nd Street* (1980). He also appeared in films and on television in *Law and Order* (1990). This photograph was taken on July 9, 1968, and later that year, Orbach would open on Broadway in *Promises, Promises*, a role for which he would win two Tony awards. When he died in 2004, Broadway dimmed its lights in his honor, and the Hell's Kitchen intersection of 8th Avenue and 53rd Street was later named after him.

178 Lee Grant (b.1927) began her career as an actress on Broadway. When she was just 21 years old, she received accolades for her role in *Detective Story* (1949). Grant reprised her role in the film version of *Detective Story* (1951) and was honored with her first Academy Award nomination. She would later fall victim to the anti-communist blacklist because she refused to testify in front of the House Un-American Activities Committee. She continued to work in the theater but would not return to films and television until the mid-1960s television show *Peyton Place* in which she starred opposite Mia Farrow (p.153). Photographed July 10, 1970, Grant was was described in *Vogue* as a "comic actress with reddish hair and crazy hats who would rather act tragedy". Grant laughs "after twenty-one years of acting, I guess I'm finally being discovered".

179–181 Jack Nicholson (b.1937) was acting in low-budget films for years before his breakthrough in *Easy Rider* (1969), directed by Dennis Hopper (pp.174–5). This photograph was taken January 26, 1970, and Nicholson was described in *Vogue* as "handsome, with unsettling light-brown eyes and the grin of a juvenile lead". His "hands are quick-signaling devices, interpreting everything he says", and although he is "serious about his work" he is often "wry or flip about himself". Nothing was the same after the just-released *Easy Rider*, "'I'll never have better reviews,' he says", yet he went on to become one of Hollywood's most enduring stars, with twelve Academy Award nominations and four wins.

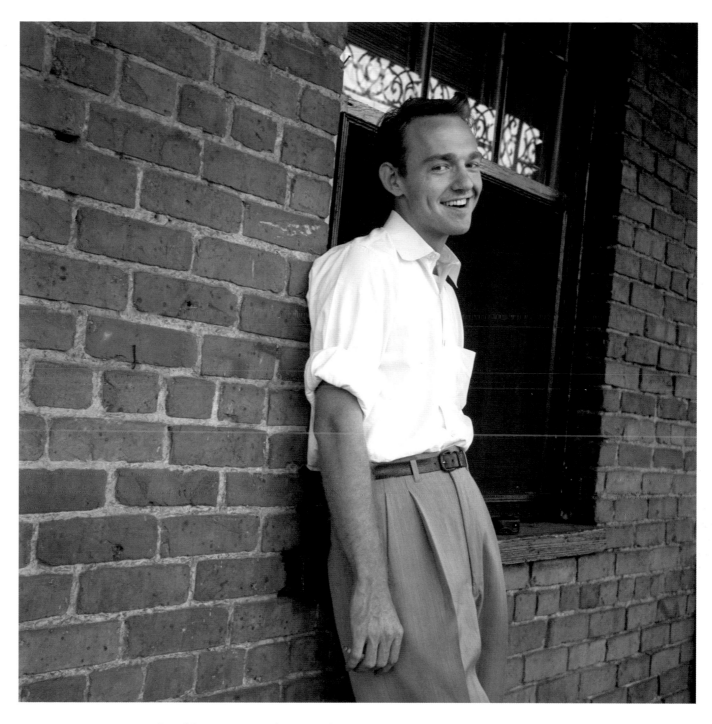

Jack Robinson, New Orleans, early 1950s

*"Jack was a joy to work with. He was very low key
and gave his subjects freedom to evolve according
to the spirit of the moment, which gives his work
 a refreshing spontaneity."* Gloria Vanderbilt

Equipment and Techniques

For studio work, Jack Robinson mostly used two Hasselblad 500C camera bodies, one made in 1958 and the other in 1970. He used three Carl Zeiss lenses: 80 mm/f:2.8 Planar, 120 mm/f:5.6 S-Planar, and 150 mm/f:4.0 Sonnar. The kit has 4-120, 6 × 6 cm film backs. He used mostly 120 film, shooting as few as two and as many as twenty twelve-exposure rolls per session.

For 35 mm work, usually sessions outside the studio, Jack Robinson used two Leicaflex SL 35 mm cameras along with a collection of Nikons. With the 35 mm cameras, Jack used primarily three lenses: 35 mm/f:2.8 Elmarit-R, 50 mm/f:2 Summicron-R, and 90 mm/f:2.8 Elmarit-R.

In the article "Jack Robinson Photographs *Vogue*'s Own Boutique", published in *US Camera* in April 1967, Jack commented that for these sessions he would take along four Nikon cameras and a Leica, shooting with Tri-X film. He also noted that, even though he mostly shot with natural light on these sessions, he did take along a flash; "nothing fits a small Honeywell flash unit like a Leica".

Jack commented on the difference between the available light boutique sessions and his studio experience: "Unlike the boutique sessions, I exercise total control; beginning with the look and finishing with the overall picture concept."

In his time in New York, Jack Robinson had several studio locations. Initially, when he was living at 57 E. 87th Street, Jack shared studio space with several other photographers, Alfred Wertheimer among them. In late 1958, Jack moved to 11 E. 10th in Greenwich Village. He would later petition the City of New York to allow him to convert this space into his living accommodation, studio, and darkroom. Jack Robinson would continue to live and work in this space until he left New York in 1972. Often, pieces of Jack's furniture would find their way into his photography sessions, with his Eames lounge chair, his brass bed, and his Steinway piano all making appearances in one session or another. Elton John on pages 55 and 56, Herbie Hancock on pages 58 and 59, Daniel Barenboim on pages 106 and 107, and Jerry Herman on page 110 are all photographed at Jack's Steinway.

Jack was fond of using a negative intensifier to bring up certain negatives. Unfortunately, what photographers of that time didn't know was that some of these intensifiers were not only very dangerous to handle, but also would ultimately cause irreversible damage to the negatives. Examples of the damage caused by intensifiers can be seen in the portraits of James Taylor on page 73, Malcolm McDowell on page 142, and James Caan on page 169.

Jack was also very fond of darkroom tricks to get a desired look. One of his favorite tricks was to scrape a negative with a sandpaper block to add depth and texture to an image. This technique can best be seen with the photographs of Elton John on pages 55 and 56, Buffy Sainte-Marie on page 66, and The Who on pages 84-5. Before Jack left New York in 1972, he printed a handful of his favorite photographs for a proposed gallery show; many of the images for this show, including those published here, were sandpapered.

It was his love of darkroom experimentation that first brought Jack Robinson together with Dan Oppenheimer when they worked on a darkroom solution to create etched glass. Oppenheimer's technique would later be used in the execution of Maya Lin's design for The Vietnam Veterans Memorial in Washington, D.C. and again with designer Maya Lin for the Civil Rights Memorial in Montgomery, Alabama.

The Archive

The Jack Robinson Archive preserves and promotes the legacy of Jack Robinson as a photographer and as an artist. When he died in 1997, Jack left behind thousands of negatives organized into hundreds of brown envelopes. Inside each were negatives in glassine sleeves and occasionally an original contact sheet. Also left behind were Jack's date books, correspondence, a multitude of advertising test prints, model releases, and *Vogue* magazine tear sheets, as well as a selection of photographs that Jack had printed in preparation for his first gallery show. In all, these boxes contained the complete output of a working artist, the sum total of a photographer's work from the early 1950s through the early 1970s.

Upon discovery of this treasure trove, Dan Oppenheimer and Susan Carr, he heirs to Jack's estate, created an organization that would expose to the world the art of Jack Robinson. Dan was intimately familiar with Jack's work as a stained-glass designer, but no one could have predicted the wealth of images in these envelopes. Working with Eric Rachlis, then of the Hulton Archive, they organized the envelopes into categories.

Over time, the envelopes were classified, removed from their original packaging, and stored in acid-free sleeves and files. Through research, the subjects were identified and, where possible, the photographs were dated. Quick scans were created of many of the images to ease the discovery process. Using her incomparable skill as a researcher, Professor Sarah Wilkerson Freeman paid special care in working through photographs from Jack's early years in New Orleans.

In 2003 Dan and Susan created The Jack Robinson Archive, LLC. Their ultimate goal was to fulfill Jack's dream of a gallery exhibition, a book, and possibly even a museum retrospective of his photographs. The Jack Robinson Gallery was opened in the South Main Arts District in Memphis, Tennessee, to display Jack's photographs and stained-glass designs, as well as to promote the work of other artists.

At the time of publication, thousands of Jack's photographs have been scanned and cleaned. The work, however, is far from complete. There is still a wealth of images that have not yet been processed, including thousands of fashion images from Jack's pre-*Vogue* period, from 1957 to 1965.

The Jack Robinson Archive website can be found at www.robinsonarchive. com. Some prints are available there for sale—along with this book, the publication of which means that another of Jack Robinson's dreams has finally come true.

Acknowledgments

The primary acknowledgment for this book goes out to Dan Oppenheimer and Susan Carr, the heirs to Jack Robinson's estate and the driving force behind The Jack Robinson Archive.

Other acknowledgments go out to early believers in this project, Clifton Phillips and Percy Clarke, along with Gary Walpole and Malcolm Aste; To our archivist Drue Diehl, whose diligence, artistic eye, and long hours of work have ensured the quality of our prints and proper preservation of our negatives; To Professor Sarah Wilkerson Freeman whose research on Jack Robinson's early life and his years in New Orleans has been critical to our understanding of the development of Jack Robinson as an artist; For their advice and encouragement, Anthony Petrillose, Christopher Sweet, Jeff Rosenheim, Melissa Lazarov, Etheleen Staley and Takouhy Wise at Staley-Wise Gallery, Erik Neil, Michael Galinsky, Suki Hawley, Leigh Montville, Gloria Vanderbilt and Anderson Cooper; To Jim Jaworowicz for his invaluable business and artistic advice; To Nancy Wolff and J. Martin Regan for their excellent legal advice; To Lucas Bond and Katherine Carr Bond of Bond Carr for their creative web support and advice; For tremendous archive support from Collier Calandruccio, Bruce Stewart, Susie Reuter, and Suzy Hendrix; For their creative input and their inspiration, Emily Oppenheimer and Haiz Oppenheimer; To James Eaton our darkroom printer and Denis Savouray our digital printer; To Condé Nast for their great support throughout this project; To George Perry for his knowledge and insight; To Cybill Shepherd for her creative input and her charming Foreword; To the folks at Getty Images—in New York, to Eric Rachlis, Senior Director at Getty Images, for his untiring efforts in first meeting with us in Memphis and promoting The Robinson Archive, and for the introductions he has made for us; in London, to Matthew Butson, Vice President of the Hulton Archive (a division of Getty Images), for showing us the ropes; and to Brian Doherty, master darkroom printer at Getty, for helping us set our standards so high; To Katherine Bebbington and Mark Getty for their early support; To Louise Garczewska at the Getty Gallery for hosting the first international show of Jack's photographs; To Rick Mayston, Director of Publishing Sales, Getty Images, London, for his support; To all the other people at Getty who have worked on the Robinson Archive project; And finally to all the designers and editors who put this project together, Colin Webb and Judy Barratt at Palazzo Editions, Mark Thomson and Rob Payne at Mark Thomson Design, and Eric Ladd at XY Digital. Their hard work and patience and their unfailing belief in this project has been a tremendous encouragement to us all.